£14

Home on the Horizon

Home on the Horizon

America's Search for Space, from
Emily Dickinson to Bob Dylan

Sally Bayley

Peter Lang Oxford

First published in 2010 by

Peter Lang Ltd
International Academic Publishers
Evenlode Court, Main Road, Long Hanborough, Witney
Oxfordshire OX29 8SZ
United Kingdom

www.peterlang.com

Sally Bayley has asserted the right under the Copyright, Designs
and Patents Act of 1988 to be identified as the Author of this Work.

© Peter Lang Ltd 2010

All rights reserved.
No part of this book may be reprinted or reproduced or utilised
in any form, by any electronic, mechanical or other means,
now known or hereafter invented, including photocopying and recording,
or in any information storage or retrieval system, without the prior permission,
in writing, of the Publishers.

A catalogue record for this book is available from the British Library

ISBN 978-1-906165-15-4

COVER ILLUSTRATION:
Edward Hopper 1882–1967, *South Carolina Morning*, 1955. Oil on canvas,
30^9/$_{16}$ × 40¼ in. (77.63 × 102.24 cm). Whitney Museum of American Art, New York;
Given in memory of Otto L. Spaeth by his Family 67.13.
© Whitney Museum of American Art, New York. Photograph by Sheldan C. Collins.

Every effort has been made to trace copyright holders and to obtain their permission
for the use of copyright material. The publisher apologises for any errors or omissions
and would be grateful for notification of any corrections that should be incorporated
in future reprints or editions of this book.

Printed in the United Kingdom
by the MPG Books Group

*To Nasir, who loved me enough to let me go,
and for whom coming and going is a plentiful and
brave way of life. With all my love and respect.*

Contents

	List of Plates	ix
	Acknowledgements	xi
	Introduction	1
Chapter 1	The Ideal Home	23
Chapter 2	Doors and Windows	61
Chapter 3	Hotels, Motels and Bathrooms	91
Chapter 4	Folding Frontiers and Lost Horizons	125
	Conclusion: Home and Horizon	153
	Notes	175
	Bibliography	197
	Index	211

Plates

The plates are located between pages 116 and 117.

1. Uncanny trespassing: *Watering Hole* (2005) by Amy Stein.
2. Picturesque designs #1: Andrew Jackson Downing, 'Small Bracketed Cottage' from *The Architecture of Country Houses*. New York (1854). Bodleian Library, University of Oxford. Shelfmark: 17363.d.390. Design II, opp. p. 78.
3. Picturesque designs #2: Andrew Jackson Downing, 'A Villa in the Italian Style' from *Cottage Residences, or, a series of designs for rural cottages and cottage villas, and their gardens and grounds*. New York (1844). Bodleian Library, University of Oxford. Shelfmark: Vet. K6 d.11. Design VI, opp. p. 124.
4. The picturesque home: *A Country Home* (1854) by Frederic Edwin Church 1826–1900. Oil on canvas 32 × 51in. (81.3 × 129.5 cm.). Seattle Art Museum, Gift of Mrs. Paul C. Carmichael, 65.80. Photograph © Paul Macapia.
5. Picturesque living: *Calculating* (1844) by Thomas Hicks. Photograph © 2010 Museum of Fine Arts Boston.
6. Picturesque reverie: *Repose* (1895) by John White Alexander. Oil on canvas, 52¼ × 63⅝ in. The Metropolitan Museum of Art, Anonymous Gift, 1980 (1980.224) Image © The Metropolitan Museum of Art.
7. Window longing: *Evening Wind* (1921) by Edward Hopper. Photograph © Trustees of the British Museum.
8. The uncanny threshold: *Cape Cod Evening* (1939) by Edward Hopper. John Hay Whitney Collection, Image courtesy National Gallery of Art, Washington.

9. Living in corners: *Corner Flat* (2007) by Bob Dylan. Copyright © 2007 Black Buffalo Artworks. All rights reserved. International copyright secured. Reprinted by permission.
10. Local disarray: *View From Two Windows* (2007) by Bob Dylan. Copyright © 2007 Black Buffalo Artworks. All rights reserved. International copyright secured. Reprinted by permission.
11. Jerry-rigged living: *Dallas Hotel Room* (2007) by Bob Dylan. Copyright © 2007 Black Buffalo Artworks. All rights reserved. International copyright secured. Reprinted by permission.
12. A purchased interval: housewife Laura Brown in Stephen Daldry's *The Hours* (2002). Paramount/Miramax/The Kobal Collection/Ferrandis, Guy.
13. Burrowing for memories in a motel room: Lenny Pierce in Christopher Nolan's *Memento* (2000).
14. Motel mind-games: Richard Linklater's *Tape* (2001). Detour/The Kobal Collection.
15. Zoned living: Lars von Trier's *Dogville* (2003). Zentropa Entertainment/The Kobal Collection/Konow, Rolf.
16. Western thresholds #1: John Ford's *The Searchers* (1956). Warner Bros/The Kobal Collection.
17. Western thresholds #2: Joel and Ethan Coen's *No Country for Old Men* (2007). Paramount/Miramax/The Kobal Collection.
18. A Ranch House on the hill: Andrew Wyeth's *Christina's World* (1948) © Andrew Wyeth. New York, Museum of Modern Art (MoMA). Tempera on gessoed panel, 32¼ × 47¾ in. (81.9 × 121.3 cm). Purchase 16.1949. Digital image © 2010 The Museum of Modern Art/Scala, Florence.
19. South Western sublimity: Robert Smithson's earthwork *Spiral Jetty, Lake Utah* (1970). Photo © George Steinmetz/Corbis. Artwork © Estate of Robert Smithson/VAGA, New York.

Acknowledgements

Many many thanks to:

Sue Neale, my picture editor, for her persistent patience, consummate professionalism and kindness during what was a very long drawn out and complicated project. This book would not have been possible without her.

Callie Gladman and Geoff Rosen of The Bob Dylan Music Company for their generosity in granting permission to reproduce three Bob Dylan paintings and a section of Dylan's *The Chronicles*.

Kiowa Hammons, Rights and Reproductions Assistant, Whitney Museum of American Art, for her assistance with Edward Hopper's *South Carolina Morning* and to Barbara Goldstein Wood of the National Gallery of Art for help with the reproduction of Hopper's *Cape Cod Evening*. Thanks must also go to The Metropolitan Museum of Art, the Museum of Fine Arts, Boston, the Seattle Art Museum, the New York Museum of Modern Art and Emily Jones of Scala, London, for her help with facilitating permission to reproduce Andrew Wyeth's *Christina's World*, an image at the heart of this book.

Darren Thomas, Picture Researcher at The Picture Desk for his efficiency with sending over the film stills and to Amy Stein for granting permission to use her extraordinary photograph, *Watering Hole*.

Chris Bessant for his impressively efficient copyediting of the manuscript and to Lucy Kellett for her precise and careful handling of the index. Thank you to Nick Reynolds and Peggy Struck of Peter Lang.

The biggest thanks go to those who read and encouraged early versions of this project; in particular, Alexis Kirschbaum for her enthusiasm in stirring up this book in its earliest stages and for urging me to write the book I wanted to write; William May and Andrew Blades for vital

conversations in tea shops and around the kitchen table, and to both for reading extracts; Alex Harris for taking the time to discuss the book's structure, in yet another kitchen space; Ben Morgan for continuing to encourage me to write; John Hood for taking the time to read parts of this book and for his kind and sympathetic support during the year of its emergence and the death of my mother. Thank you to Elisabeth Gray for reading the entire book in its early stages and for being my first proper reader.

Thank you to Suzie Hanna for sharing her creative responses to Emily Dickinson. Our collaboration in creating a Dickinson animation fed this book with vital energy during its final stages.

Thank you to Amit Chaudhuri for taking the time to read the book and for Sunetra Gupta for her keen enthusiasm for its topic.

A very big thank you to Tom MacFaul for reading the entire manuscript and offering vital suggestions on revisions; thank you for your careful and exacting pedantry over details large and small. Thank you for encouraging me to ignore the potholes of academic obsessions and to keep looking for the larger and more exciting picture. Thank you also for sharing your impressive repertoire of American reading and prompting vital thought and discussion.

Thank you to all the students who intellectually and imaginatively contributed to this book during my years of teaching American literature and culture in Oxford and elsewhere. This book grew out of this experience.

Finally, thank you to Nasir for teaching me the meaning of family and home and for loving me enough to let me leave. The love continues on the other side.

Introduction

> 'I dwell in possibility'
> — Emily Dickinson[1]

When America's devotedly stay-at-home poet, Emily Dickinson, declared her intention to dwell – and thrive – in the possibility of home life, she was encapsulating her culture's attitude towards the home space: as a place where inner and outer worlds might meet in conversation and where anything seems possible. It is at home that this grandly private poet hosts her ideal version of America, what she calls her 'mansion universe', the ever-expanding territory of her poetic interiority.[2] In Dickinson's universe, her poetic 'circumference' or internal territory is as limitless and influential as, historically speaking, America believed its frontier to be.[3]

'SPACE [is] the central fact to man born in America … I spell it large because it comes large here!' declares poet Charles Olson.[4] In an attempt to convert the bewildering experience of time and space into something manageable, the first settlers chose to order their experience around an everyday reality: the belief in a natural order of things as reflected in daily life. Accordingly, time and space were levelled and so divinity could be experienced anywhere at any moment: 'Why then at the Church stile, rather than in anye other place? Why at that time more than any other, if it be for the living?' queried the 1572 Puritan manifesto.[5] Dickinson converts the divine omnipresence of Puritan belief into her own domestic creed, in which home becomes a sacred vessel, a 'holy thing';[6] a site of cultural ideology and a ritual space for everyday living.

At the heart of this everyday experience of divinity was the American home, where Olson's gigantic 'space' is converted into a more familiar and habitable 'place'. At home, America settles upon its terms of engagement

with the everyday; its tastes and beliefs, its patterns and rituals of living. Home, then, signifies a conversion of space into place; a working out of a realisable idea, a lived manifesto of the everyday.[7] As geographer Yi-Fu Tuan notes, place gathers objects to itself and lends them familiarity.[8] At home, things become invested with personal meaning; become quickly folkloric.

Nonetheless, Dickinson's version of home life relies upon visits to the outside world, planned trips across space and time. A hoarder of the outside, she inhabits America's open spaces from her domestic interior, and into her cosily realised front parlour, bedchamber or kitchen hearth, she invites gigantic topographies and large vistas. Though firmly situated indoors, she moves out in poem 821 to play the role of 'emigrant', 'Away from Home' to practise what she calls the 'Habit of a Foreign Sky'; but always with the guarantee of her return.[9] In the opening line of 'Away from Home are some and I', Dickinson's speaker sends herself across the threshold, where she hovers awkwardly alongside the oblique subject group, 'some'. Socially speaking, 'some' are an undetermined and unsecured entity, and Dickinson's speaker hovers nervously in their company. Pushing herself across the border of her dashed punctuation, she moves hesitantly towards the role of the 'Emigrant' who is 'to be'. Her awkward syntactical shuffle suggests that her speaker's departure for 'Foreign Sky[s]' is not, as she puts it in the first stanza, 'easy', but rather, a 'difficult' transition. The 'some and I' that leave home in the opening line form a difficult union with 'we', outside the home. Commonality does not come easily to Dickinson's speaker, and the public space of other 'Homes' is something her feet (in both the metric and the actual physical sense) 'retire' from. The union of the sum of 'some and I', is perhaps what her speaker dwells in the possibility of being part of, but it is a community she finds difficult to join. Acquiring a foreign identity and its associated territories is a skill the speaker can imaginatively practise, but the passing through of foreign skies, of new territory, is nonetheless a difficult rite of passage:

> The Habit of a Foreign Sky
> We – difficult – acquire
> As Children, who remain in Face
> The more their Feet retire.

Territorial gain is a coming of age narrative that is peculiarly American. Tucked up at home, Dickinson imagines herself roaming the world: taking stock of 'Ports and Peoples', hunting in 'sovereign woods'.[10] Axing her way, as it were, through foreign territories, Dickinson moves through her ever-expanding interiority, her protracting 'circumference', her 'mansion-universe'. She reminds us that space, as the philosopher Georges Perec has nimbly demonstrated, is nothing more than the opportunity to extend oneself into more nothingness; to reach out for more.[11] In material terms, the threshold of her Amherst homestead is the limit of circumference, but in poetic terms, it is only the beginning: the place from which she launches herself upon the world. It is her version of frontiering.

On the Threshold

Following Dickinson's lead, this book will trace the figure of the threshold in American literature and culture – the doorways, passageways, windows and crossing points that negotiate the relationship between the ideological fixtures and fittings of the home life and the imaginable but unforeseeable out of doors. A point of embarkation or return, the threshold is a place where, as Dickinson reminds us, doors are frequently left ajar and lines of imaginative possibility can begin to run their course. On the threshold, doors swing open or close; new arrivals are greeted or ousted. It is the point at which hosting begins or ends and where viewing begins; the point at which, as Dickinson put it, 'spectacles ajar' begin to 'stir';[12] where interest in the wider world is piqued and the home body contemplates leaving. The place of the threshold marks a point of conversion between inner and outer, a line of interrogation between what is known and what remains unfamiliar, perhaps unfriendly. To cross the threshold of a home is to enter into and inhabit familiar terms; to become friendlier. Home, after all, is where family histories and legacies are written: stored up and remembered within proprietary lines of control. Thresholds signify boundaries as well as entrances; to 'thresh' is also to tread or to trample across a boundary, to enter Dickinson's holy realm.[13]

Standing on the doorstep of her home, the poet remembers the past, and what she loved; what she still loves. 'We are creatures of time, we are

creatures of the historical sense', Lionel Trilling emphatically states in his essay, 'The Sense of the Past'. We cannot live in an extended Now as though it contained 'all things'. The past exists and we carry it with us.[14] It is how we read literature but also ourselves: with a lively sense of the historical imagination pressing closely upon the present. And so it is that Dickinson, writing to her beloved sister-in-law, Susan Gilbert, gathers and consolidates not only past and present but also the future, and turns the direction of her longing for Susan towards the West: 'I slip thro' the little entry, and out at the front door, and stand and watch the West, and remember all of mine.'[15] 'Suzie' is all that she longs for beyond her front door, her beloved past, and Suzie lies westward. From the threshold of her home, Dickinson gathers the West to her as she gathers Suzie – what she presumes is hers. Like the sunset that sets over several of her poetic interiors,[16] Dickinson faces west and declares own manifest schema: it is from the 'silent West' that her love will come; beyond the threshold.

'I dwell in possibility',[17] the poet confesses, where possibility signifies the imaginative freedom to dwell both in and out of time and space; both indoors and out. For Dickinson, the threshold of her Amherst homestead was an imaginatively fecund place; a space of free play without the responsibility of social commitment; a place where she could gather up the commerce of daily life without sharing in its burdens. 'I am going out on the doorstep',[18] she announces in a letter to her sister-in-law, Susan Dickinson. A careful voyager, she notes that it is not the 'world' she is visiting, but the outermost limit of the home: the jetty between inner and outer, the familiar and the strange. Moored on the 'brighter' side of her 'mansion', Dickinson enters into that roomy space of free association that Coleridge called 'fancy'.[19] The doorstep offers her a cosy geography, a place of secure intimacy, but like the territory of her letter, its limits are sealed off. Settling into a corner, she remembers time spent in the same spot with her sister-in-law. And so the threshold space becomes a site for souvenirs, of memories gathered up like the green grass she picks; a place of settlement and resettlement; of historical readjustment.

American Acquisitions

In her poetry of imagined spaces and projections, Dickinson acutely reflects the process of American self-imagining and geographical emergence which, in historical terms, is one of extravagant and rapid expansion. In the early nineteenth century, following on from the War of Independence,[20] America began to gather up its major territorial parts. In 1803 under Jefferson's policy of imperial expansion, Louisiana was purchased and so 530 million acres were added to national territory. Jefferson's imperial scheme included an extensive scheme of administrative organisation, instituted by his earlier 1787 Northwest Ordinance, in which the western territories ceded by the British – the vast tracts of land north of the Ohio river and west of the Appalachian mountains – were divided into a series of gridded townships as territories converted into states.[21] Jefferson's tidy arrangements thus set the spatial patterns of America's Midwest and Plains; the rectangular forms of writer David Foster Wallace's boxy Illinois farmland;[22] the monotonous surface of western writer Wallace Stegner's plains mentality;[23] the chalked-in zones depicted by film director Lars von Trier's mountain township, *Dogville* (2003);[24] the several landscapes of American imperial geometry.

Jefferson's rectangular divisions were, in part, a logical response to the era's dramatic westward movement. In 1815, America's chief natural border was the Appalachian mountain range. By 1850, half of the national population was settled west of the Appalachians, and with the annexation of Mexico and California under President Polk two years prior, another quarter of America's current land space was secured. By 1890, according to historian Frederick Jackson Turner, America's dramatic frontier experience had come to an end.[25] America was now in full possession of itself and its frontier was 'closing' down. Turner's statement, although somewhat misleading in real terms (in 1890, America still had ample space to settle), nonetheless drew attention to the significance of the frontier mentality in terms of national self-understanding. America had come to know itself as a nation of voracious territorial consumption in which endless swathes of land bred limitless hope and possibility. As Dickinson put it, within the frontier mentality, America could dwell in the perpetual possibility of gaining more of itself.

From the beginning of colonial settlement, possession of land was synonymous with property, and the parcelling out of territory – a continuance of patterns of European feudalism. The sale of land was America's first big business, and following on from Jefferson's first Land Ordinance of 1785, territories were converted into units of measured space.[26] As Jefferson's style of accounting suggests, American territory was conceived as something intrinsically mathematical: forms of territorial addition and subtraction. In New England, the sums were made up of 6 miles by 6, and within that sum, a series of smaller divisions from which lots could be drawn.[27] In 1784 Jefferson converted his grids into townships, each measuring 100 square miles. The first settlements in New England were made according to township covenants, in which townsfolk collectively owned home lots. Fronting the main street of the town, these lots functioned as boundaries of common land, separating residences from farming land lying behind.

Before the Civil War, townships were considered the ideal unit of production for community life, a tradition continued by antebellum writers such as William Dean Howell, whose *A Boy's Town* (1890) records the nurturing benefits of life in a small community. The pattern of shared land distribution did not last long, however, and well before the Civil War, land derived from the British government was being sold off by wealthy proprietors to incoming settlers, who, in turn, subdivided and resold land for profit.[28] The grid pattern of townships assisted sales such that land could be sold off in easy parcels, quickly and easily owned.[29]

Separateness and individual ownership, then, lay at the heart of the American understanding of settlement. By the late nineteenth century, and with the development of America's cities, township-style lots converted into zones. Zoning laws emerged from the desire to differentiate between one area of the city and another; and so in 1880 Los Angeles saw the arrival of new zoning laws in order to restrict the location of such offending presences as Chinese laundries amongst local residences.[30] From here, the idea of a neighbourhood emerged, separating resident from outsider: an area of land espousing common principles of civic understanding and fellowship.

America's emerging cities meant more space to settle. In the words of transcendentalist writer Ralph Waldo Emerson, the city generated more 'spaciousness' – and perhaps another moral project – certainly 'ample room in which to grow', as he declared of St Louis. Beginning in

1630 with Massachusetts Bay Governor, John Winthrop's biblical vision of a 'City on a Hill', an image of the American Jerusalem quickly configured in the nation's imagination as a place of divine magnificence: 'well spaced at once, clean and handsome to the eye', extolled Emerson's acolyte, naturalist Henry David Thoreau. Winthrop's sermon set alight the American city's moral pursuit, a real New World that, in the twentieth century, took the form of functional and efficient forms of architecture: the clean and transparent surfaces of the glass office tower soaring skywards, an environment whose architecture reflected both technical and moral progress – sparkling newness and cleanliness.[31]

At the heart of the nation's civic development was the Midwestern city of Chicago. A nineteenth-century creation, Chicago readily lent itself to revised patterns of civic organisation, including a rapid adjustment to its infrastructure to accommodate the hub of the nation's new railway network. Improved communications facilitated the growth of new forms of housing, and in the late 1850s Chicago's suburbs began to spread away from its harbour and river front. From the suburbs, commuters travelled by omnibus, horsecar and railroad, as the commuter district grew to include smaller farming communities: the suburbs of Lake Forest, Oak Park and South Chicago with land neatly divided into purchasable lots.

City planning became a matter of efficient functionality and distribution of space, and in the early twentieth century, civic planners began to instruct administrators on the classification of roads and streets. Drawing upon the economic virtues of the rectangular method of Jeffersonian land distribution, city planner and urban theorist Charles Robinson Mulford created the American unit of the 'block' dividing one street and the next; the essential unit of civic space. Mulford understood that most residents desired land on the edge of the city, where they could live 'with light and air on all sides, privacy, and a garden'; some space between themselves and the adjacent dwelling – a hope bound up with the ideology of the home as a discrete dwelling offering quiet restoration.[32]

Across blocks citizens counted the duration of time and space between one locale and another, as does the dazed detective novelist Daniel Quinn, protagonist of Paul Auster's novel *City of Glass* (1985). Perambulating around Manhattan's blocked cartography, Quinn's only sure reality is the rigid predictability of New York's sequence of blocks; a bizarrely concrete manifestation of America's more ephemeral and undetermined sense of manifest destiny. In pursuit of the elusive Peter Stillman, Quinn's amateur

detective trail is the narrative equivalent of Dorothy Gale's yellow brick road experience: an inward and downward spiral towards a hallucinogenic and technicolour elsewhere. As Auster's narrator declares of the elusive Stillman: 'The old man had become part of the city. He was a speck, a punctuation mark, a brick in an endless wall of bricks.'[33] Stillman's trail leads, like Dorothy's road, to something quite other than home.

Daniel Quinn, like Dorothy, walks rather than drives around his defamiliarised urban America. But roads were nonetheless crucial to the network of urban communication emerging at the turn of the century, and while writer Frank Baum was creating the original version of the *Wizard of Oz* (1900), America was beginning to lay down its national infrastructure of roads. With the rise of the mass-produced American car, Ford's Model T, urban space quickly expanded and rural space contracted. Spurred on by an improved agricultural economy, the American farmer purchased his first automobile, and so began the gradual disintegration of life at the homestead. In 1908, the American farmer, according to *The American Agriculturalist*, was the largest group of car consumers in the nation. And yet, city dwellers had got there first, as the editor of *The Breeder's Gazette* confirmed, indignantly reporting in 1904 on the sights and sounds of careering urban dwellers driving through the countryside in their 'red devils'.[34] In the *Gazette*'s report we are reminded of F. Scott Fitzgerald's *The Great Gatsby* (1925) and the dangerous motoring habits of Daisy Buchanan, hurtling through New York's suburban Valley of Death, mowing down the innocent Myrtle Wilson in her careless wake. The world of *Gatsby* is the world of the 1920s American consumer, at the heart of which is the most effective consumer of time and space: the automobile. Daisy carelessly speeds from her privileged Long Island neighbourhood to the dusty New York suburbs, ignorant of the socioeconomic boundaries she crosses. Moving through a social landscape invisible to her, Daisy enjoys the freedom of movement and autonomous choreography that is the motorist's privilege as she motors downtown to the hotel that will supply her with further luxury: a purchasable and more decadent experience of home away from home.[35] And so Daisy blithely moves through a seamless, fairytale version of America: one built upon having.

Borders and boundaries are intrinsic to America's experience of space, and most travellers, thankfully, are not as woefully ignorant as Daisy Buchanan. Thomas Pynchon's novel *Mason and Dixon* (1997) offers an absurdly fanciful reimagining of the cartographical subdivisions of historic

map-makers Charles Mason and Jeremiah Dixon. In Pynchon's America, lines signify divisions between past and present histories, between imagined and projected versions of American parameters, where a burgeoning nation hopelessly fails to guard its heuristic borders and where anything and everything appears to cross over – what Dickinson, in metaphorical terms, calls the 'prowling booger': that is, the uncanny forms of ghosts or hobgoblins lurking on the other side of the threshold.[36]

In literature, Then and Now, as Lionel Trilling reminds us, are always related, as they are in history.[37] And so, within the Cold War culture of postwar America, Dickinson's prowling booger takes on the form of an enemy within: Soviet Russia slipping over America's domestic border with its dark shades of communist ideology. Tucked away from public scrutiny, the home quickly becomes the centre of Cold War suspicion and, in turn, a determined governmental investigation. In her study of Cold War confessional literature, Deborah Nelson cites the publication of 'The Eavesdroppers', a series of studies exposing the invasion of citizens' privacy by government authorities and corporations, as a seminal moment in the postwar privacy crisis.[38] Fuelled by the paranoia of domestic invasion, Cold War era writers and film-makers alight upon the home as the chief site of cultural anxiety. The wartime film of Alfred Hitchcock, *Suspicion* (1941), is a fine example of the aesthetic of American domestic gothic, in which a typical plot revolves around a couple whose relationship is undone by the suspicion that one or the other is involved in acts of betrayal. In the case of *Suspicion*, Lina McLaidlaw suspects her husband of trying to murder her. Clearly, Hitchcock's purpose in making his film was to expose the dynamics of a culture of domestic surveillance built upon false and forced confessions, false and unreliable assumptions. In Hitchcock's world of Cold War surveillance, husband and wife quickly turn enemy and the borders of the home are made fragile by paranoia.

Since the attack on Pearl Harbor in December 1941 – the year of Hitchcock's film – the invasion of America has seemed not only possible but quite plausible. Following on from the September 11 terrorist attacks, sixty years on from Pearl Harbor, the nation's borders have quickly become not only visible in the public imagination, but also frail, as a new language of 'homeland' and 'homeland security' peppers American political thought. In direct response to the terrorist attacks, the creation of an office and Department of Homeland Security made these terms politically concrete.[39] As Amy Kaplan has pointed out, this language of

'homeland' evokes a deep-rooted connection to an historic and perhaps mythical past; an American version of Volk. In other words, America's recent recuperation of an ideology of 'homeland' is a return to something folkish and fixedly domestic; this is an equation that, in turn, relies upon a pressing sense of the foreign. 'Homeland', then, suggests a rarefied version of American history, a prophetic and manifestly 'New World', albeit with discomforting and concurrent undertones of a fascistic fatherland – the German 'Heimat' bleeding into the Jewish Zion.[40] Home and homeland are fiercely emotive cultural structures which, in turn, solicit fierce protection.

What Home Could Be

The notion of home is always culturally and historically specific, but by 1815, as David P. Handlin has comprehensively demonstrated, America was beginning to achieve a sense of a coherent domestic ideology. At home, the nation was negotiating its identity; trying and testing what it could be. From the threshold of the home, one could gain a 'view of the future of humanity', declared Swedish author Frederika Bremer in her study of American home life (1853).[41] In other words, from the position of home, America could determine its view on things, and so the home naturally became a social institution, through which fundamental cultural tenets – religious and moral codes – were run.

Under the leadership of men such as Hartford Congregationalist Horace Bushnell, the home was secured as a place of 'Christian nurture'; a place of practical production. Announcing the end of the 'Homespun Age', Bushnell espoused an era of domesticity encouraged by the rapidly expanding networks of communications: roads, railways, steamships and newspapers. Here was the 'Day of the Roads', which would advance American civilisation, but also, Bushnell feared, threaten to reduce it to new forms of barbarism. The solution was effective educational practices, and the holding place for these cultural improvements was the home. At home, the American child could develop a 'domestic spirit' that would teach him to live organically. Scriptures partly fed the spirit, but the child should also be closely involved with his parents and their

surroundings; children were both the subjects and the objects of home life. Bushnell's *Work and Play* (1864) promoted a picturesque notion of home life and was sufficiently influential to be adopted by several magazines of the day. *The Happy Home and Parlor*, along with novels such as Catherine Sedgwick's *Home* (1935, Sedgwick being the most popular writer of her day), fed the nation's appetite for picturesque living: homes in which religion, education and architectural structures and interiors aligned to benefit the 'domestic spirit' of their inhabitants. The result was an unspecified ideology of what songwriter John Howard Payne entitled 'Home, Sweet Home'.[42] 'Home feeling' provided an atmosphere of good intent and edifying practices made cosy by sympathetic relations between children and parents; between families and their décor. But 'home' was also clearly something made up: an undetermined and unfixed ideology that roamed the early American imagination, lingering outside of space and time. While Sedgwick and Payne strongly hinted at an ideal home, there were no definite constitutional characteristics. Home was first and foremost a spirit of place like no other.[43]

For Amherst poet Emily Dickinson, home was closely aligned to a sense of God. 'Some keep the Sabbath going to Church – / I keep it, staying at Home'.[44] Home was where one 'kept' God, and at home, and in the peculiarly American and intransitive sense of the verb, one 'visited with' divinity.[45] In other words, one conversed with God in private, and thereby transported the idea of 'Heaven', the ultimate resting place of the Christian soul, into the private spaces of home life. For Dickinson, God was as much part of the furniture as anything else in the domestic world, where every object potentially served a divine as well as a domestic purpose: 'a Bobolink for a Chorister – / And an Orchard, for a Dome'.[46] In other words, the domestic world supported, through its objects, the symbols of the divine world.

The domestic world of Dickinson's poetry is one in which divinity, nature and the indoor life hold a close rapport. As a statement of faith in home life, her poem, 'I learned – at least – what Home could be'[47] is a testament to a picturesque world of happy relations between inner and outer worlds. Through a series of quaint Victorian cameos, we drift from the fireside to the garden, by way of memory and religion. Operating on the level of the quotidian, the historical and the divine, Dickinson's version of home stores several storeys of meaning. It is at once a pretty surface, pure decoration – a pretty 'Ruffle – or a Tune' – as well as a

place of memory, a storehouse of familial history. At the same time, it is site of religious instruction and language, where the function and location of church life and home are barely separate – as was the case in Dickinson's actual Amherst home, set close to the local cemetery.[48] And so the boundaries between first and second stanzas fall away upon the open murmur of 'Hymn', whose final, indefinite and murmuring syllable, 'mn' (mm) suggests an onomatopoeic relationship to 'Him' but also an extended sound of assent. In other words, Dickinson's speaker affirms belief in 'Him' through 'Hymn[s]' sung, as she puts it, awkwardly, in church. Churches are awkward places, and so what the speaker offers is an alternative location – Home – in which to continue a more comfortable and cosy version of Christian worship.

The separation between church and home continues throughout the poem as the membrane between the second and third stanzas is dissolved by a wash of assonance: the sound of a 'Celestial Sea'. From the sea, which also serves as the poem's conceit for memory, the speaker leads us into the garden where humming bees rephrase the sound of humming choristers, and we are carried back to the pretty surface of sound, the 'ripple' of the tune's 'Theme'. Surface, then, is both sonic and visual effect, where 'ripple' is both the surface of the sea and the effect of rhythmic melody punctuating the surface of the ear. At this point, our auditory and visual imaginations are sufficiently stimulated that we begin to leave the everyday world behind. An extension of the home, the garden enters the poem as part of the speaker's atemporal wander through an order of being that is beginning to move towards a wider horizon: a 'Covenant' with a 'diviner care' or purpose. And so it is that we drift back and forth across the threshold of home life, never quite leaving it, but all the time enjoying a more homely and comfortable arrangement of the church's 'awkward' hymn. It is in a place neither quite inside nor out, neither quite domestic nor quite rudely undomesticated, that the poet's version of Heaven resides – her ultimate model of Home; a place nonetheless well kept in the form of its earthly equivalent.

It is at this point that Dickinson's domestic imagination moves closer to that of transcendentalist writers Ralph Waldo Emerson and Henry David Thoreau, whose work came to her through the influence of her friend and literary mentor, writer and minister, Thomas Wentworth Higginson,[49] and through her earlier mentor and legal associate of her father, Benjamin Franklin Newton, who in 1848 gave her a book of Emerson's poetry.[50]

Newton's gift opened Dickinson to a lifelong commitment to Emersonian self-reliance with its emphasis on the 'integrity of the private mind'. Thoreau's family history was known to her through the Concord connections of the Loomis Todd family – Mabel Todd being her brother Austin's lover and a regular intruder of the Dickinson homestead.[51]

Thoreau's *Walden* (1854) is a vision of home life led away from home, out in the Concord woods, where he visits only with himself. Writing from his self-built house on Walden Pond, the naturalist Thoreau declares his need for 'pasture enough' for his imagination – enough space between himself and the horizon in which to imaginatively roam. It is his version of a homely heaven. Dickinson manages a similar thing, ensuring that boundaries between home and world, home and the divine, are kept fluid and harmonious. Dropping from stanza 3 to 4, her speaker drifts, euphonically, from the open, feminine sound of 'tune' to a picturesque, romantic cameo of 'Afternoons – Together spent': an image of contemporary female fellowship involving 'ministry' to the poor. Feminine charity, then, a cliché of Victorian Christian life (Coventry Patmore's angel in the house), is carried home in the single line parading between stanzas 6 and 7, 'And then Return – and Night – and Home'. Along this line runs a split between the cliché of the angelic female undertaking charity work in the public domain and the private woman who returns home to a 'new' order of being quite hidden from public sight.

The 'Return' home is one that passes first through 'Night', where 'Night' signifies an obliteration of visible identity; some camouflaging of the social self, a slipping away into the privacy of Thoreau's woodland retreat, whose mission statement was a period of time spent 'fronting the essential facts of life'.[52] Dickinson's poetic construction of the home projects a mode and method of being that, like Thoreau's Walden Pond experience, suggests a self working itself out in relation to the world; an individual putting together the materials of belief in something larger. Setting the coordinates of his location from the point on the horizon 'half a mile off', Thoreau defined the integrity of his retreat in relation to the proximity of the horizon.[53]

Walden is an account of a frontier life that considers the working relations between a man's inner life and his natural environment. For Dickinson, home is a place where methods and means of being are also worked out; a place of hopeful projection for what 'could be'; a place of ontological possibility. What is certain is that home and horizon dwell

together, each offering perpetual possibility of renewal of the 'Covenant' – a contract, historically speaking, built upon a Puritan theology of grace and faith between God and man.[54]

The place that 'could be', then, is a place of pure faith fuelled by grace. The final stanza of poem 944 suggests that home is more a matter of 'not' being what it seems. In other words, 'Home' is a matter of grace and faith, requiring careful construction, and including several necessary exists and entrances: 'way[s]' out. The only constant backdrop is the diurnal cycle of sunrise, sunsets and dawns: the visible world of nature with all of its splendid and picturesque, sometimes sublime, effects. Picturesque nature is never far from the speaker's doorstep.

Taken inside, the picturesque forms an essential part of Dickinson's homely aesthetic. Clinging to a rich sense of internal décor, the fixtures and fittings of her poetic interiors are quite in keeping with nineteenth-century notions of domestic comfort and cosiness: interiors built around inglenooks, fireplaces and alcoves.[55] 'I learned – at least – what Home could be' is a poem foregrounding intimacy, privacy and a pointedly picturesque aesthetic whose route from fireside, garden and twilit lanes leads back home, where the speaker finds courage to reconsider the nature of being. Dickinson's poem fastens itself to domestic interiority, surrounding the less certain world of public engagement (the 'ministry to poorer lives') with cosier scenes of domestic security. As Diana Fuss has stated, Dickinson's poetry reverses the public/private split of the Victorian home, translating interiors into public events and exteriors into places of private retreat. Read as such, her poem is a clear indication of the growing distinction in nineteenth-century America between public and private space; a division of space in which the home could legitimately serve as a refuge from the workaday world of contracts and obligations met by her father's legal practice.[56]

Interest in the private life of the home was a relatively new concern in nineteenth-century America, signalled by the rise in popularity of plan book designer Andrew Jackson Downing, whose *The Architecture of Country Houses* (1850) sets the tone and pattern for the 'beautiful, rural, unostentatious, moderate home of the country gentleman'. Following the traditions of the rural picturesque and pastoral conventions made popular by eighteenth-century poetry, Downing and others advocated the habit of retirement to a cosy English-style cottage or country house, and set out models of picturesque architecture along the lines of John Ruskin's

model of environmental integrity.[57] Downing's picturesque but elegantly integrated home was precisely the sort of home sought by Emily's father Edward Dickinson, when, in 1855, following dramatic refurbishments, he moved the family away from the Pleasant Street home she had inhabited from the age of nine, back to the family homestead on Main Street. And so Dickinson's classic Federalist home – a wooden framed dwelling with a central chimney breast providing the central nerve of the home – was replaced with a Victorian home designed to reflect the aesthetic standards and principles of the day.[58]

As Downing decreed, interiors should serve to reflect the external environment in which they found themselves: 'take up a handful of earth at your feet & paint your house that color', he declared.[59] For Dickinson, interiors were places of abundant self-expansion, to which the external world of nature and the public world could be brought and rehoused and rearranged: visited with. And yet her home is also one of exact arrangements, betraying the sort of discrete allocation of space and gender roles typical of the Victorian home. Neither a place of unified space nor of sentiment, it reflects the tenets of domestic designers such as Downing – one of the first to prescribe an individuated 'expression of purpose' for each living space – a fact she makes clear to her friend, Elizabeth Holland, following on from her father's death:[60]

> My House is a House of Snow – true – sadly – of few.
> Mother is asleep in the Library – Vinnie in the Dining Room –
> Father – in the Masked Bed – in the Marl House.[61]

Dickinson's lyrical letter is a lamentation for her father, now buried in the 'Marl House' or mausoleum, but also, metaphorically speaking, for the family hearth: a significant centre, a more sentimental order of things. The doubling of 'House' betrays a desire for another version of home less atomised and chilly than her own; houses in which family members do not live as though snowed into separate rooms.

As well as mourning her father, Dickinson mourns the loss of an integrated household and its coherent symbols. In the twentieth century, as Witold Rybczynski explains, the loss of the American hearth is translated into a new concern with function, as domestic space is ordered according to the exigencies of technology. Space becomes efficient and domesticity, a practical science. Designs for more efficient living take precedence, as a

new breed of American domestic managers and manual writers – Mary Pattison, Lillian Gilbreth and Ellen Richards famously among them – began to instruct home owners to regard their homes as 'ready-made character[s]'. Gilbreth's domestic management manuals, beginning with her *The Psychology of Management* in 1914, encouraged a psychology of individual 'standards' for each household according to their 'convenience'; and so domestic 'standards' became a way of assessing the habits and needs of individual household functions.[62]

In the realm of architecture, twentieth-century architect Frank Lloyd Wright took the American home into a new relationship with the outdoors, practising in architectural terms what Dickinson does in her poetry: encouraging nature to visit at home. Faithful to Thoreau's desire for the sights, sounds and textures of nature to take up close residence alongside him, Wright's prairie house, whose earliest designs date from 1893, became the prototype of what Thoreau decades earlier called the 'new house'.[63] Wright's designs sprung directly from his Midwestern childhood where, working on his uncle's Wisconsin farm during the summer months, he developed a deep regard for nature that was later converted into an association of horizontal lines with notions of domesticity, democracy and freedom.[64]

Central to Wright's design was the lit fire, burning 'deep in the solid masonry of the house itself', bringing with it a feeling of home that had come 'to stay'. Walls were no longer boxy enclosures, but rather, screens that would permit as much light and air into them as possible. And so the house would begin to relate more closely to its environment – the ground and the air around it – converting space into a lived place.[65]

Space into Place

This local alchemy begins with the sacred transference of familiar reference points. As Thoreau discovered in his house at Walden Pond, the conversion of space into place is almost always an aesthetic project; an order of creation incurred by the sequence of objects to subjects: what goes where.[66] At Walden, Thoreau dreams of an alternative, 'golden' home; and along with Scott Fitzgerald's generous host, Jay Gatsby, declares an

open house policy. Radically open to space and time, Thoreau's home is neither explicitly European nor yet overtly American, but hovers around a vision of American domestic life that is fundamentally ahistorical and atemporal: a house that stands inside a 'golden age'. Ushering the outside in, Thoreau's home offers a democratic topography in which everything can be seen at once: from domestic utensils, to the inhabitants and their visitors; a transparent space, 'as open and manifest as a bird's nest'. This is a home without secrets, where the vast distances of the outside world are compressed and made cosy, where the language of the parlour snuggles up with its symbols. Thoreau greatly objects to the technique of the 'modern' host who keeps his guest at the greatest distance. He would have the distancing 'metaphors' and 'tropes' of domestic relations reduced to a single type: a homogeneous language reflecting a homogeneous space. In other words, less palaver (idle talk) in the parlour and more real kinship.[67]

In the twentieth century, Dickinson and Thoreau's desire to visit with the outside world continues in the figure of folk singer Bob Dylan. Despite the hidden and gnomic qualities of his lyrics, Dylan's autobiographical *Chronicles* (2001) – the account of his early years – reveals a man who lives with an open and honest relationship to his environment. Here is a man who scans and rearranges the rooms that host him in order that they be in Thoreauvian 'plain sight'. Here is a man who, as his recent paintings make clear, prefers to see the world through open doors and windows.[68] Dylan inhabits a domestic world, albeit radically itinerant, not dissimilar from Dickinson's threshold experience, where doors left 'ajar' yield more possibilities for passing subjects to enter into lyrical arrangements.

'The Soul should always stand ajar', Dickinson's speaker tells herself in poem 1055, lest 'Heaven' pay an unexpected visit.[69] Being 'ajar' to the world is to live uncommitted to space and time: with a sense of doors and windows left open; with broken routines and alternative arrangements whispering their seductions. Rooted in the old English word for 'char' or domestic odd jobbing (hence 'charwoman'),[70] Dickinson's fondness for the transient state of being 'ajar' to the world betrays an idle relationship with domesticity and its orderly continuums. A charwoman picks up domestic work and puts it down again. An itinerant pair of hands, she comes and goes between one household and the next. Dickinson is more of a charwoman than a housewife, and her commitment to the home life and its daily routine was perhaps more fickle than she might make out. Writing and reading, after all, were her principal domestic

occupations and her tone is condescending on the matter of dealing with 'cooking stoves' – a subject she scornfully relegated to 'broad daylight' and the superfluous tasks of the quotidian.[71] At home, she shares in Dylan's imaginative habit of roaming and rambling between places, the domestic itinerancy of Dylan's early years, and the difficult relationship between host and visitor, host and guest, to which the soul, she suggests, should always stand a little ajar.

Place, as Dylan tells us in his *Chronicles*, is an inventory of things; a sequence of objects that rear into view as they rear into conscious existence. 'Place' is a word he finds himself repeatedly struggling to define, such that any location he describes inevitably ends up sounding like a motel or hotel room; a temporary residence. And because every room he inhabits at this point in his life – the early 1960s – belongs to someone else, his sense of place is furnished and identified by the character to which he has attached himself – in this case, Ray Gooch, a New York wayside buddy, who figures, in Dylan's imagination, like one of the characters from his lyrics: a roamer through romances and deeds. Dylan's 'places' are a series of temporary wayside stops with adventurers in the American political and cultural underground; locality resides in the figures and histories of these innkeepers, the real 'occupants of the place'. At Ray's, the young Dylan orientates himself with a quick reckoning of the view from the window across the New York skyline and reads it through the spinning 'windvane' of his mind.[72] But disorientation seems to work to Dylan's creative advantage, providing him with more sights and sounds, more characters and more corners of rooms in which to hole up his visual imagination.

This book will attempt to draw together the relationships and purposes of America's home places to the wide open spaces of the American outdoors. Moving from Dickinson's nineteenth-century homestead to Dylan's itinerant language of place, my starting point in the first chapter will be the idealised sanctuary of the nineteenth-century picturesque home and its twentieth-century suburban reproduction. From the sacred centre of the hearth, I will cross through doors and windows, and in the second chapter, contemplate some of the possibilities of threshold moments in American domestic life. On the other side of the American home lie its outlying areas: the front porch, front lawn and back yard that make up the complete territorial home body. All three constitute extended aspects of home.

A social space, particularly in the balmier south, the porch calls the homebound into a larger sense of self. An extension of domestic space, it offers a convenient half-way house between the hospitality of the home and the less hospitable outdoors. The porch is a place to keep unwanted visitors at bay, or, alternatively, a place in which to see and hear more.[73] The harsh facts of life can be seen and heard on the porch; and so it is that Harper Lee's judicious Atticus Finch, lulled by the mollifying rhythms and cadence of the porch swing, delivers to his children the harsh facts of southern life: that the life of a black man is worth far less than a white man's. Gently, surreptiously, emerging from the tradition of southern porch talk, the fraught cultural plot of *To Kill a Mockingbird* (1960) begins unassumingly on the relaxed space of the front porch.

Front of house, the world waits upon the citizen, the citizen upon the world. It is the beginning and end of the journey home and away, a point of personal contraction or expansion depending upon the nature of events in between. Around the back of the house, the twentieth-century suburban home provides its citizens with the outdoor privacy of the back yard. In the back yard, we encounter America's struggle to retain privacy. Within a clear hierarchy of space, the back yard features as one of postwar suburban America's most privileged spaces precisely because it maintains the cause of privacy. Visitors enter into the back yard, a place of familial retreat, only if they are known to the family. Intruders are a threat to the quiet consistency of the back-yard dynamic, and remain largely unwelcome. And yet, back-yard borders remain unstable and violable as contemporary photographer Amy Stein has show in her startling series of back-yard images in which bears, foxes and wildfowl transmute into predatory and uncanny forms of trespassers and voyeurs.

From the back yard, I will cross beyond the borders of the home and in the third chapter explore other forms of American inhabitation: the often illicit spaces of the public bathroom, hotels and motels that lie outside of home life but nonetheless lay claim to a sense of the homely and familiar and the continued necessity for privacy. 'Unheimlich' or unhomely,[74] these alternative habitats frequently threaten the sacred codes of American domesticity. Beyond the everyday, hotels encourage alternatives, unhomely and often untidy fantasies. As Alfred Hitchcock's *Psycho* (1960) infamously proves, motels are sites for the seedier underbelly of American fantasies. 'A quiet little motel, tucked away off the highway', the director sinisterly informs us from his movie trailer as he directs us

around his set. Next to the motel stands 'an old house, a little more sinister looking than the motel itself'; an abandoned clapboard house looming out of the darkness, highly reminiscent of painter Edward Hopper's *House by the Railroad* (1925). In Hopper's gothic composition, the line of the railway creates a threshold, dividing the viewer from the painting: a line that encourages us to recreate the building's history in our imaginations. A 'lonely House[s] off the Road', as Dickinson put it in gothic terms, the motel site lies outside of daily purpose; literally and figuratively, by the way side.[75] Here is a fantasy space in which plots and props take revenge upon the everyday: murder and decaying maternal corpses; ear-splitting screams in the motel bathroom.

For Hitchcock, bathrooms are opportunities for dramatic transgressions of privacy, staged interruptions that yield a tense and titillating scene: Janet Leigh, mouth wide open in the shower. In the bathroom there are 'goings on' that may not be fully seen or known. They are not meant to be. Likewise, Blanche Dubois of Williams' *A Streetcar Named Desire* (1947) spends every moment she can in the bathroom, extending, for as long as possible, her regression into fantasy, the 'belle rêve' of her youth. She emerges only for one event: the arrival of a gentleman caller with its opportunity for more indulgent self-reconstruction.

The bathroom is a hotly contested space, and the American bathroom, often significantly larger than its European counterpart, permits the hosting of events; some bathroom theatre. The locus of sexual transgression, it is a place in which the theatre of the sexual imagination can develop its full riotous plot. The bathroom being a site of fantastical and neurotic spillage, what goes on behind its door need not be known: need never be shared.

From the off-road sites of hotels and motels I turn, in the final chapter, towards the receding and perpetually imagined horizon: the expanding 'circumference' of the American outdoors where space confounds and overwhelms and nothing is discrete; where anything is possible. As Thoreau reminds us in *Walden*, the American experience was one of '*fronting* the essential facts of life' as a way of locating the 'compass points' of one's inner life; a deliberate confrontation of the 'vastness and strangeness' of the American landscape modelled by the historical frontiersman Daniel Boone and his fictive version, James Fenimore Cooper's Natty Bumppo. 'Fronting' the unfamiliarity and formlessness of nature offered a means of determining the 'extent of relations' between inner

and outer worlds, negotiating the distances and gaps in one's own life. Thoreau's verb underlines the face-to-face encounter of the American citizen with his environment; the outward gaze upon the landscape, the source of his emergence.[76]

For Emerson, the horizon signified an expansive view; a line of hopeful viewing, of good promise. The best self, the self that had transcended the world, could be read along the length of the horizon: that point on the cusp between earth and sky. Across the long distance of imaginative projection, the transcendental self figured as a 'transparent eye ball', a membrane through which 'the current of Universal Being' (God) could 'circulate'.[77] It was pure sight and pure seeing, with none of the apparatus of the world; none of its close and jostling proximities. In other words, the horizon promised a place of spiritual transformation, an ever-receding line of hope and promise: an improved view of man and the world.

This book is not a work of 'psychogeography', a field growing in popularity, particularly in the United Kingdom, though it does share some of that field's interests and aspirations. The American psychology of space is, I would suggest, rather more provisional than that of the Old World. America is fonder of new starts, of emptying out spaces in which new slants can be placed upon experience, new games can be played, and new selves can be fashioned. The difference is that between the palimpsestic, layered archaeologies of space that we encounter in authors such as Iain Sinclair, Will Self and Peter Ackroyd in England, and the heuristic, experimental approach to space that we see in American writers such as Thomas Pynchon and David Foster Wallace. America is always on the point of becoming, never quite achieved.

As the young Laura Ingalls Wilder extolled of the Nebraskan prairies in the nation's classic paean to the home life, *Little House on the Prairie* (1935), America's open space is hopeful; it yearns with possibility. The broad horizon is the summation of the viewer's hope; it generates will, grit and determination. In the mind of the hopeful pioneer the horizon spurs one on, as it did Laura's Pa.[78] Open space runs into the arms of the hopeful horizon;[79] it induces perspective but it also requires a starting point. A home is just that: a place from which to gaze out upon the wider world. Installed in her new prairie home, Laura enjoys a relationship with the silvery lines of the moon, pressing its form against the bottom of her window. She 'fronts' the perspective of experience created by nature. Safely stowed within the contained limits of her home, Laura enters into

a relationship with the 'edge of the big bright moon'; a new and larger point of consciousness.[80] This book will broadly examine the often faulty and faltering lines of communication between home and horizon, what Wilder calls, in pioneering terms, the relationship between the settler's wagon – the first point of historic and familial settlement – and the 'perfect circle' of the sky, curving down to touch the wagon sitting upon a ridge of land: the basic constituents of the settler's landscape and the starting point of his imagination.

1

The Ideal Home

The Picturesque Daydream

If we are to believe her poems and letters, we get a clear sense that Emily Dickinson was strongly attached to the idea of exits and entrances, doors and windows, and spent a deal of time hovering around their openings. In Dickinson's orbit, the threshold is a charged space offering a quick way in or out, and it was under such arrangements that she met with her beloved sister-in-law and reading companion, Susan Dickinson: in the back serving hall of the family homestead – a room offering 'alternative exits' – a space protective of her privacy.[1] As Lyndall Gordon's recent biography makes clear, in the Dickinson homestead thresholds hummed with secrets. This, after all, was a home where an adulterous couple – her brother Austin and his lover Mabel Todd – were just as likely to be tucked up in the library or dining room; a household where crossing from one room to another might just give the adulterous game away. In Dickinson's domestic world, thresholds were quite literally dangerous and condemning. If Austin and Mabel were making love in the dining room, Dickinson had no access to her second writing desk; if sequestered in the library, she was unable to cross into the conservatory – another of her favoured terrains. From late 1883 onwards, when the lovers first began to meet regularly in the Dickinson home, room-crossings became a risky business.[2]

And yet, her notion of home is clearly idealised, homely and secure. As she writes to her brother, Austin, the story of the ideal home begins

with the anticipation of familiar arrivals; doors opening and ushering in loved ones: 'I wished so many times during that long evening that the door would open and you come walking in.' The life force of the home is 'fairer' and '*brighter*' than the external world;[3] its emotional palette more vivid.

Dickinson's version of the home is quite clearly picturesque, in the sense that it offers up discordant continuities of time and space – separate spheres of existence – and grants them shelter under one roof. Central to her manifesto of the home life is the idea of home as a place where unity of thought and feeling is possible. For Dickinson, the home functions as a sort of imaginative hold-all, a concept in part supported by contemporary theories of architecture whose picturesque principles stressed the coherence of disparate parts of the home.[4] In other words, in the picturesque imagination the home works to maintain an agreeable and harmonious propinquity.

The modern American home is rooted in the notion of a unified self-sufficiency. From the nineteenth-century home, this chapter will move towards its twentieth-century equivalent in the suburbs, tracing the picturesque tradition of the homestead to the efficiency of the modern home. At the heart of this history is a story of self-possession and autonomy; the home as a unit of discrete self-possession. It is this history I will trace here.

As Sandy Isenstadt notes in her recent study of the American home, in a predominantly agrarian culture, the early nineteenth-century homestead was a humble attempt at offering a popular but independent dwelling. Smallness was not a deficiency; what mattered was the quality of the life lived within. In a new nation, the size of the home was not as important as the experience of autonomy. Self-possession and privacy meant more in a country new to democracy; in his small plot of land, the private homeowner held the right to vote.[5] Above all, the free-standing dwelling encouraged unity of thought and feeling, a coherent domestic identity, and a typically American sense of individualism; a comforting singularity away from the world.

This is precisely the thought Dickinson expresses to her sister-in-law, Susan Gilbert Dickinson, of her niece, Martha Dickinson's cottage: 'I realized as never I did before, how much *a single cottage* held that was dear to me.' Crossing over into Mattie's cottage from her own home, Dickinson is able to simulate a sense of both home and away, a synchronicity with

Mattie's environment ('it is sweet and like home at Mattie's'), as well as a feeling of movement away: a degree of foreignness. Behind the reassuring, bolted cottage door, Dickinson and her niece dally with daydreams, passing in their chatter from one imagined universe to another. In its eddy of travelling currents, her letter reads much like a metaphysical poem, crossing instantaneously from one 'universe' to another; from the interior and private space of the cottage parlour to the public world of 'statesmen' and 'kings'.[6]

Philosopher Gaston Bachelard has noted that doors are the locus of daydreaming, admitting the creatures of the unconscious access to the mind, mixing memory and desire.[7] The symbolic architecture of Dickinson's writing is frequently structured around doorways and lintels. In Dickinson's universe, the threshold generates strong poetic friction, a place of devising. A house without a door is a place without dreams. The poet's imagination feeds off the uncertainty of what lies beyond, the foreshortened vista, the limited perspective: 'Doom is the house without the Door / 'Tis varied by the dream / Of what they do outside'.[8]

And yet her speaker is too attached to the cosy, picturesque view of the family homestead – the idealised nineteenth-century American home life – to leave it. This is the view of the home described by Susan Fenimore Cooper, daughter of writer James Fenimore Cooper, in her essay 'A Dissolving View' (1852): a perspective bathed in the aquatints of daydream. Cooper's picturesque landscape is so because it is read through human scale and endeavour: the small motifs and curlicues of quotidian life; smoke curling from a cottage roof, a pretty thatched cottage with a single bay window, an old country house with 'chimneys, angles, cornices and additions'. Her wandering eye, like Dickinson's, is easily distracted by the small things – a 'roving bee' attracted by the flowers in her hand – shifting the focus of her recording lens from the civic topography of a village or hamlet to a source of immediate aggravation: a bee alighting upon her hand.[9] It is the small and immediate details that hold her attention; the cosy.

And it is cosiness that lies at the heart of the domestic manifesto of Dickinson's contemporary, transcendentalist writer and naturalist Henry David Thoreau. Writing in *Walden* (1854), Thoreau rails against the 'solitary confinement' of the modern home and the distance between guest and host – the tendency towards atomised living spaces that becomes the standard design of the twentieth-century American home. At the hub of

Thoreau's domestic policy is the parlour, a space he regards as marooned from its own symbolic value, its function as an intimate space lost in the superfluous symbols of modernisation: slide doors and dumb-waiters. The net effect of this symbolic clutter is a loss of the language of intimacy. Now the parlour hosts only idle gossip. In terms of the Victorian home, the 'parlour' or 'parlor', rooted in the old French *parleur*, from which is derived *parler*, 'to speak', was a space at the front of the home for receiving guests; a room for chat and conversation.[10] As Thoreau makes clear, the parlour was a space for intimate chat. Following its British counterpart, the American parlour was designed as an enclosed room in which intimacy and a sense of comfort could flourish: a space sealed off from the main thoroughfare of the home where secrets might be told.[11]

Like Dickinson, Thoreau would reclaim the chatter of the cottage parlour, a linguistic architecture built upon familiar tropes and symbols, easing guest and host into the comfortable patois of old friends. He would reduce the distance between rooms, the gap between insider and outsider. In his domestic imagination, décor takes precedence over drama; it is what furnishes the space that determines the quality of thought – and so the clutter of the parlour, often stuffed to the brim with the showy superfluity of luxury, must go.[12]

Thoreau's dream house is a piece of poetic reverie, and, as Gaston Bachelard has suggested, reverie liberates us from reality of pure function.[13] Explicitly designed for this purpose, Thoreau's home is a place of solitude where memories form mental tableaux and society is replaced by a world apart. Time is left behind, and the home extends out into a mental space, fulfilling the picturesque dream of reciprocity between lived space and the life of the mind.[14] A common figure of nineteenth-century symbolist art was the middle-class woman in a state of repose, draped, as in John White Alexander's composition, over her drawing room settee.[15] In order to keep tidy and calm the life of the mind, designers decreed that particular spaces should render particular states of mind. Reverie, associated with a feminine sensibility, involves withdrawal from society; an interval outside the chronology of social advancement and the work of men.[16] Plan-book writer Gervase Wheeler stressed the importance of clearly defined roles for each room; a bedroom space upstairs, for example, where the women of the house could retire to read and write letters.[17] Such a space would be the equivalent of Dickinson's upstairs bedroom above the front parlour where, from 1855 when the family first moved

into the homestead, she began writing at 3 a.m., beyond the duty-bound temporality of daytime housework, from whose morning activities, until noon at least, she was freed with the permission of her father. Equipped with a four windows, a Franklin stove and an 18-inch cherry table-desk, she developed the habit of late-night writing but would also withdraw at will.[18] Well-kept women meant a well-kept nation.

Like its British counterpart, the nineteenth-century American home revolved around its women; as such, the home reflected a privileged cultural space where ideal forms of femininity could be well kept and preserved.[19] In line with a wider cultural policy of separate spheres for men and women – a uniformly accepted part of nineteenth-century life – the domestic roles of women were very much conflated with the public role of men. Consequently, theories of domestic reform drew upon male-led political models, and in the case of America's most celebrated domestic manual writers, Catherine and Harriet Beecher Stowe – Harriet, along with her reformist brother Henry, both guests to Austin Dickinson's home[20] – it was the ideologies of Republican Motherhood and the Cult of Home Religion. According to such ideologies, the role of mothering became an extension of professional male roles, and one that might feasibly involve rearing America's future leaders. And so following the principle of raised status, the kitchen was brought up from the basement to the ground floor and thrust firmly into the centre of a productive domestic life. Shelves and utensils were to be arranged according to a 'divine order', and cooking was elevated to the level of a divine ministry, according to the popular Cult of Home Religion, in which women functioned as divine domestic priests. *The American Woman's Home or Principles of Domestic Science* (1869), for example, began instructing women in laying out their homes like churches: a public entrance with a Gothic-arched recess in which a small table for holding the Bible could be arranged; and a conservatory where plants might be grown as symbols of God's nature. In the Beechers' ideal home, there was no need for a separate parlour for men and women: a well-trained housewife was quite capable of ruling as 'sovereign of her empire'.[21]

According to contemporary cultural prescriptions, the picturesque home functioned as a synecdoche of nation and an idealised civilisation.[22] Andrew Jackson Downing's popular plan book, *The Architecture of Country Houses* (1850), envisaged the picturesque cottage as a place affording contemplation and privacy. Downing's architectural ideals,

resting upon those of English critic John Ruskin, advised a love of place, harmony of reason, and the enjoyment of beauty in repose – all invigorated and intellectualised by a degree of energy. His notion of absolute beauty, the expression in material form of 'ideas of perfection which are universal in application', referred to forms and structures found in nature. Relative beauty, on the other hand, was written into the moral design of a house, in which particular aspects of home furnishing might signify moral attributes. And so the family hearth, the central emblem in the design and layout of the home, becomes a symbol of the beautiful and the good.[23]

Like Thoreau, Downing and the Beecher sisters foresaw the danger of clutter, and preferred to fuse the beautiful and the useful together. In the Beechers' ideal Christian home, things must be close and compact, without waste of space or labour. Time and space are precious economies.[24] For Downing, the useful should supersede the beautiful, and beauty itself should only be understood or judged in relation to nature.[25] Thoreau and Downing both laud the role of the imagination, nature, individualism, and the cultivation of their fellow human being, but unlike Downing, Thoreau is averse to the process of domestic prettification. Indeed, *Walden* is an explicit undoing of the pretty ways of the domestic life – he goes into the woods, after all, to 'front the essential facts of life' – an experience which has little to do with Downing's plans for cosy domestic nooks.[26] For Thoreau, the picturesque was to be found in the 'unpretending' lives of the common inhabitants of log cabins and cottages, not in their 'surfaces'.[27] There is no time for architecture, he suggests, when the poorest Americans still hanker for essential provisions.

In terms of the moral lessons of both men, Downing's vision for the country home is fundamentally opposed to Thoreau's wilderness-downsizing in one respect: while both would cultivate their fellow citizens, Downing's programme is related to the improvement of décor and surfaces; the belief that beautiful homes and gardens will 'better' humankind.[28] Downing's moral prescriptions traipse through fashion and style; Thoreau's stridently undo any affections of style and champion the primitive and the rude, the essential. Downing would replace the log hut of the hunter-pioneer with 'smiling lawns and tasteful cottages'; reinforce a sense of national security through the privatisation and specialisation of space (porches that will encourage contemplation), and so secure 'truthful' homes that will assist in the refinement of character.[29]

Yet Downing's vision of the American home is one weighed down with symbols. The enforcement of the symbolic value of the home – an ornamentation that reflects man's 'elevated and refined ideas'[30] – offers a cluttered moral logic. Ornamentation will not, as Thoreau argues, lead the home owner into real contemplation. In his house there will be no 'gingerbread work' because this is a concession to fashion, and fashions are victim to an ever-decreasing rate of time.[31] True contemplation exists outside of space and time. Ultimately, Thoreau's domestic vision is one of cosmic reverie: a substantive vision of the national self in which the contemplative life will lead to a new world; single images containing whole worlds.[32]

Dreamy Kitchens, Tidy Parlours

Dickinson's poetic worlds frequently draw upon the salvific qualities of the home, and like a poetic cabaret act, the poet dons the role and costume of the good housewife who keeps an orderly house. Grafted to the domestic world, heaven is but an extension:

> The grave my little cottage is
> Where 'Keeping house' for thee
> I make my parlor orderly
> And lay the marble tea.[33]

But there is too much performance in Dickinson's housewifely role, too much commitment to role-play to be a sincere realisation of the Beechers' Christian housewife. What is more, Dickinson's speaker adopts the voice of a buried child who continues her housekeeping while she awaits Judgement Day. In other words, the daily duties of the housewife have been left behind: this is a child who has skipped adulthood and gone straight to Heaven. Slipping back and forth between the grave and the cottage parlour, the poem operates around an essential doubleness, or 'two divided' as the second stanza claims. The ritual of a parlour tea collapses eternity (the marble coffin) into quotidian time and space, and so the silenced body of the dead child in the first line is hauled across the

threshold of the home into the courteous space of living, daily conversation: into a more common parlance, a 'strong[er] society', as the poem's final line declares.

A place of conversation, the Victorian parlour courteously negotiated the threshold between inner and outer, public and private worlds: as a place of private conference between family members but also as a reception room for visitors. For those who could afford it, a separate living or drawing room reserved for family life freed the parlour for the exclusive function of hospitality. But as Katherine Grier has argued, the parlour was a place where the competing claims of comfort and gentility meant that one was typically sacrificed for the sake of the other. Too often it meant that a middle-class family was obliged to surrender its privacy for a good show of hospitality; for the sake of its public face.[34]

The true art of the housewife was making felicitous domestic arrangements: those that would accommodate family and guests alike. Harriet Beecher Stowe's *The Minister's Wooing* (1859) is in part a study of the designation, production and composition of domestic space as outlined in her domestic manuals. The opening sequence brilliantly simulates the circumlocutory style of parlour chit-chat and the flurrying arrival of visitors:

> Mrs. Katy Scudder had invited Mrs. Brown and Mrs. Jones and Deacon Twitchel's wife to take tea with her on the afternoon of June Second A.D. 17–. When one has a story to tell one is always puzzled which end of it to begin at. You have a whole corps of people to introduce that *you* know and your reader doesn't; and one thing so presupposes another, that, whichever way you turn your patchwork, the figures still seem ill-arranged.[35]

What is most irksome to Stowe's narrator is that she finds herself 'ill-arranged' to welcome her character-visitors as the voice slips through the meandering course of informal discourse. As the parlour occupants stack up higgledy-piggledy in awkward groups, the narrator is found still arranging her narrative décor. But there is some attempt at social grouping, and upon arrival, her characters are ordered according to the form of architecture they inhabit; Widow Scudder, for example, is not rich because she occupies a one-storey farmhouse with a 'gambrel roof' – architecturally speaking, a modest dwelling.

The second chapter tells the story of antebellum domestic space: the divide between private and public spheres; the lines drawn between the family and outsiders. Stowe's chatty, bouncy narrative is the boastful voice of the house-proud, Dickinson's play at a virtuous housewife. Following Downing's philosophy, the 'best room', the parlour, is a display of virtue, as is the cleanliness of the kitchen: 'for you must know, clean as our kitchen is, we have something better'.[36] The reification of space is the story of social hierarchy. And yet, Stowe's narrator lingers nostalgically over the kitchen, reluctant to move out of the relaxed and sleepy state it offers, disinclined to move into the more formal parlour space. Here, again, is the picturesque daydream of Dickinson's cottage kitchen, an emblem of a future resting place – a place where Time drowses, between intervals: 'How dreamy the winter twilight came in here … when the crickets chirped around the dark stone hearth … while grandmother nodded over her knitting work, and puss purred.'[37] Folkloric, this is a place of fairytales and nursery rhymes, of fireside tales; where time stands still and the gossip of the parlour is silenced. Here is dream time.

Joan Hedrick has established the clear role of the antebellum parlour as a cultural locus for the germination of public opinion, a combination of 'press' and 'pulpit'. In Stowe's household, where the members included student boarders, household servants, an orphan child and 13 biological offspring and a steady stream of visitors, the parlour was a veritable congregation. In Stowe's parlour, letters were read aloud, and in the Litchfield, Connecticut community of her youth, the parlour would often function as an amateur literary society: a performance space for the delivery of poems and essays.[38] The Beecher women wrote letters often charged with a sense of performance – their particular cosy groupings arranged as characters around the parlour fireside – the centre of the familial story: 'I am seated upon one side of the table in our parlor Ann upon the other Mary between us', writes Isabel P. Beecher to Catharine Beecher; 'Sarah is sitting on one side of the fireplace knitting Uncle is in the rocking chair on the other side'.[39] These are missives of domestic choreography, the table settings of familial characters: a geography of immediate propinquity. Their preference is to deal with what is close at hand; to relate the correspondences and contiguities of relationships across small and intimate intervals. Underpinning all of this is a keen desire to keep a tidy record of the relations between family members; a housekeeper's book of relational accounts.

A catalogue of domestic placements, the Beecher letters often resemble the contemporary vogue for parlour theatricals. Mirroring the gentility of parlour chat, a theatrical typically took the form of an expressive charade, farce or tableau, and was, in part, designed to reinforce a middle-class sense of propriety, indicative of the relationship between middle-class modes and manners and cultivated theatrical performance.[40] Writing to her friend Mary Dutton, Harriet Beecher Stowe draws out a comfortable tableau of parlour life and its tender arrangements:

> We have our Olmsted stove moved into the parlour & use only one part of it & it keeps the room delightfully warm here we eat our meals, near enough to the fire to toast our bread as we go along which I think is the ne plus ultra of a sociable cozy breakfast or tea – Mr Stowe reads german books & translates sometimes as he goes along …[41]

Stowe's letter suggests a harmonious domestic life contracted to neat, tidy spaces; her husband's letters betray something more fractious.

> You have no idea of either time or place. I want prayers and meals at the particular time, and every piece of furniture in its own place … it seems to be your special delight to keep everything in the house on the move, and your special torment to allow anything to retain the same position a week together. Permanency is my delight – yours, everlasting change.

And:

> You and Anne have vexed me beyond all endurance often by taking up my newspapers, and then instead of folding them properly and putting them in their place, either dropping them all sprawling on the floor, or wabbleing them all up into one wabble, and squlching them on the table like an old hen with her guts and gizzard squeezed out.[42]

If we are to believe Calvin Stowe, Harriet's husband, there is nothing tidy about his wife's mode of housekeeping. Indeed, husband and wife are domestically poorly tuned: untidy and untimely in respect of their differing domestic needs.[43]

The coordinates and coordination of domestic relations were a common subject of contemporary New York artist Thomas Hicks. His

1887 canvas, *No Place Like Home,* depicts a rustic kitchen scene in which the tenebrous form of the hearth provides a backdrop to a husband and wife pair.[44] A looming presence, the fireside is the principal character of Hicks' canvas, its receding form suggestive of the recesses of mental retreat. Husband and wife sit at a slant to one another, locked into separate trains of thought as the fireside both unites and distances the pair. Hicks' composition is a study of conjugal relations: the infinite and recurring distance of disparate subjectivities amidst familiar symbols. At the fireside, husband and wife can comfortably experience difference without any of the cross words circulating through the Stowe household.

But the fireside was naturally meant to encourage more cheerful unity. Hegel would argue, perhaps, that the fireplace was the most perfect form of symbolic architecture, creating a ritual of space, and a felicitous place – an opinion the narrator of Melville's short story, 'I and My Chimney' would almost certainly share.[45] The chimney is not only a reminder of the American past – the settler's imagination that took itself to the cosy hearth and there declared a centre for all things 'American' and homely – but also a talisman of the non-American stoking the narrator's fantasy life. And this life is distinctly led elsewhere: alongside the pyramids of Egypt and the rituals of the Druids. The chimney structure also serves as a support structure for the inner life, its form, a kind of labyrinthine layout of rooms and passageways, all leading off from a central nave. And so the fireside is a site for both the homely and the unhomely; both flicker through its flames.[46]

Thomas Hicks is concerned with the relations between the fireplace and thought, and like Harriet Beecher Stowe, with the hearth's potential for an assembly of divergent stories. Contemporary New England artist Eastman Johnson also shared a taste for fireside narrative. Johnson's *The Other Side of Susan Ray's Kitchen – Nantucket* (1875) is devoid of human figures, but brimming with signs of human occupation; a wide, open space fenced in with the furniture of domestic ritual: a mirror and dresser stand at the back end of the room; a small writing table to the left of the canvas, and on the right, a large and arresting hearth.[47] The room is reminiscent of a Dutch interior but stripped of human forms. Instead, the implements and forms of domestic life hem in the room, and the entire canvas is bathed in the warm hue of earthenware. The narrator of *The Minister's Wooing* extols the roomy virtues of the New England kitchen: 'remember your grandmother's floor … remember the ancient fireplace stretching

quite across one end … across the room ran a dresser … Oh, that kitchen of the olden times, the old, clean, roomy New England kitchen!'[48] The roominess of the kitchen floor thus serves as a trope for the roominess of memory; the familiar warmth of the kitchen encouraging reminiscence, mental relaxation, and so, remembering.

Memories shore up stories, as Mark Twain's eponymous narrator of *The Adventures of Huckleberry Finn* (1884) is quite aware; and nowhere more so than in the country parlour. Ensconced within the Grangerford family, Huck Finn provides an account of the family home and its bricolage-style parlour. A collage of assorted tastes and styles, the parlour is an inventory of family history: a jumble sale of heaped major and minor narratives whose texts are a series of fossilised objects. The chief conceit of this space is a scrap book belonging to a deceased woman, filled with obituaries and stories of suffering. A pastiche of the lives of others, the book, like the room, teems with forms of life. But Twain's narrator begins his domestic travels from the front door, providing a travelogue in miniature: he moves from front door to parlour hearth in the space of a single sentence, a rapid advancement into the domestic interior. The young narrator has no confusion as to where the centre of home life lies – around the red brick hearth, the maintenance of which he proceeds to describe in exacting detail, drawing comparison with other hearths in other towns; all the time maintaining a strong sense of 'elsewhere'.

The parlour throws up a plethora of curio and exotica, the stuff of travel: stuffed parrots, cats made from crockery, portraits of people and places, histories. Here is the vocabulary and stuff of nineteenth-century material culture, the tyranny of things whose 'fearful extent' Emerson foresaw and gave warning to in his transcendentalist manifesto 'Nature', before it turned into the mass consumerism of the twentieth century.[49] These are cultural artefacts, capsules of time and space, disparate chronologies. Sensuous and sentient, they are souvenirs of both deceased and contemporaneous beings. Huck's delivery is chatty and colloquial, a version of parlour chitchat; and much like our roaming hero, the narrative wanders off course, only to return to a sense of itself: 'As I was saying …'.[50] We are quite aware that the objects delivered up to us are only those that carry a particular significance for young Tom; the drawings of the deceased Emmeline Grangerford, for example, strike the itinerant Huck as worthy of comment, worth logging. This is a manifestly subjective view of one family's history delivered to us from an outsider, a

foreigner. Huck is not a parlour man; uninitiated into the gentility of its conventions, he can only note that this particular parlour, unlike several he has seen in 'town', does not have beds in it. He is unaware that parlours without beds reflect a nineteenth-century desire to consolidate on gentility rather than practicality; that the array of assorted scenes lining the walls of the Grangerford parlour are part of a wider cultural investment in the parlour as a place of instruction and self-improvement; and that the parlour is, in fact, carefully arranged to this end – clearly a tidier place than Huck's mind.[51]

Facts are rarely clung to, and much of what is spoken is imagined, entangled in a poetic vernacular: a jumble of sights and sounds whose messy arrangement imitates a distracted young mind. Superlatives abound: and so the fruit bowl in the centre of a table – the showpiece of the room and a near-hallucinatory sight – is filled with fruit 'redder and yellower and prettier' than any other. Here is a still life more real than the real; a surrealist's fruit bowl. The sequence ends with a sort of dreamscape, a framed fantasy piece: 'Well as I was saying about the parlor, there were beautiful curtains on the windows: white, with pictures painted on them, of castles with vines all down the walls, and cattle coming down to drink.'[52] This is the stuff of an ideal childhood, a longed-for Arcadia; Dickinson's picturesque cottage nowhere transferred to a 'somewhere'.

History still loosely operates in the Grangerford parlour. A national identity wafts through the adolescent gawping of Twain's young narrator, and so the printed speeches of presidential candidate Henry Clay pop up alongside portraits of 'Washingtons and Lafayettes' and one called *Signing the Declaration*. History is a series of caricatures, loosely remembered and poorly curated; squashed and compressed. But it is, nonetheless, there. In Twain's parallel parlour sequence, 'The House Beautiful' in *Life on the Mississippi* (1883), American history is a much stiffer, starchier version of itself. A more mature narrator describes the appearance of the 'best dwelling', the 'finest' mansion along the banks of the river between Baton Rouge and St Louis. As with the Grangerford parlour sequence, we move quickly from the imposing frontage into the parlour, but with more circumspection.

But, as a synedoche of nation, this parlour is perhaps more representative than that of the Grangerford family. Here is a space overstuffed with conflicting tastes and sensibilities, a swelling emporium of things poorly assimilated but well meaning, sprouting tufts of ideologies and

fragments of history: a piece of embroidery on the wall, a 'pious motto' of the 'God Bless Our Home' variety of sentimental domestic 'commerce'; a minor gallery of historical and biblical scenes, sandwiched in between a pro-nation, Americana-style family portrait whose presiding presence is diluted by souvenirs of European ancestry – a glass French clock dome and a lithograph of Napoleon crossing the Alps. Here is America unfurling into its European ancestry, a veritable museum of American history told through an inventory of bric-a-brac of the variety Twain himself accumulated.[53] In keeping with contemporary trends, American culture and history is crudely on display.[54] But this is a more cynical parlour, less fantastical and dreamy.

For a start, the fireplace has been replaced with a stove, a 'new and deadly invention'; and the wax fruit adorning the mantle is exposed as a 'rude' imitation. The fads and fashions of parlour décor are poked and prodded, reprimanded: the preference for amateur art work ('an outrage in watercolor, done by the young niece that came on a visit long ago, and died'); the impracticality of horse-hair chairs that 'keep sliding from under you'; the family portraits whose members are all 'too much combed, too much fixed up', all appearing stiff and uncomfortable, like the several objects filling the room. Twain's parlour is a failed attempt at comfort, and certainly, as a performance in gentility, its efforts are crude and misplaced. Indeed, misplacement seems to be the major criticism: too many objects ill-assorted and arranged. The overall effect is dyspeptic. Where is the room for reverie and contemplation; where is the space for memories?

Bachelard reminds us of the dreamy relationships between domestic spaces and memory, conjuring up remote, autobiographical memories of the house of one's childhood. Memory is a fossil that 'abides' in space, not time.[55] Martha Bianchi, Dickinson's niece, recalls her aunt's parlour as a static space, abiding in anachronistic décor:

> The walls were hung with heavily gold-framed engravings … and other chastely cold subjects. The piano was an old-fashioned square in an elaborately carved mahogany case, and the carpet a fabulous Brussels, woven in pattern. It had in the centre a great basket of flowers, from which roses were spilling all over the floor to a border of more flowers at the edge. It enjoyed a reputation of its own …[56]

The parlour's gothic tones recall author George William Curtis's description of Hawthorne's house: the 'golden tinted paper-hangings', the 'mysterious stairs' and the 'touch of twilight' that suffuses Curtis's recollection. Like Dickinson's front parlour, the Hawthorne home enjoys a mnemonic 'reputation of its own'. It holds its shape well across space and time.[57]

Threshold Dramas

Bianchi's recollection of her aunt's home continues with an account of a visit from the contemporary writer and friend of her aunt, Helen Hunt (Jackson). This is the 'excitingest' memory, and one that unfolds across the threshold of the Dickinson homestead: the passageway between the secret chat of the pair in the library and the young narrator out at the front gate. The tension lies in the waiting: the description of the pacing horses awaiting Hunt's return from beyond the threshold, her crossing of 'the terrace steps', the to-ing and fro-ing action of an active imagination held at bay.[58]

Bianchi's record is memorial tribute to a central Dickinson trope: the drama of a poetic imagination that scurries back and forth across thresholds. Dickinson's is a poetry of glimpses and glances, of a speaker loitering around the doorways and windows of the domestic world. Her poem, 'They called me to the Window', is a study of the glassy borderland between inner and outer; a report on the world spied from windows. The speaker offers an account of her vantage point, its capacity and scope, the extent of her gaze, moving from short- to long-range vision. The immediate point of interest is the event of sunset, the occasion that raises the curtain upon the world beyond the window:

> They called me to the Window, for
> 'Twas Sunset' – Some one said –
> I only saw a Sapphire Farm –
> And just a Single Herd –[59]

Along with the speaker's travelling gaze, we are dragged from 'Sapphire Farm' and its cattle, close at hand, across soil and hills, towards the sea.

Size and scope increase, until finally, we spill out grandly upon mountains, sea and skies. This is a fugitive imagination, but also one testing its own limits; the poem ends with the poet-Showman calling herself back home. Dickinson's language of seeing is one of theatrical entertainment, the parlour theatrical with its props and accoutrements outside the window:

> But in their stead – a Sea – displayed –
> And Ships – of such a size
> As Crew of Mountains – could afford –
> And Decks – to seat the skies –

The grandeur and size of the vast outdoors converts into a theatrical, to entertain not only the speaker/viewer, but also the consorts of nature herself: 'Decks – to seat the skies'. There is a double world of theatre here, a doubling of size and effect, of expansion and contraction, operating through the conceit of the windowpane. Two worlds kaleidoscopically and telescopically combine; there is length as well as breadth, depth as well as focus, and so we travel far and wide, hither and thither. Finally, the speaker returns to the world within, bringing back aspects of the Grand Tour tradition of travel,[60] to where she first began: the declarative commentary of the peering observer, dwelling within.

Millicent Todd Bingham's account of the Dickinson houses bolsters this sense of an expansive topographical imagination. Todd Bingham, only child of David and Mabel Todd – the first woman to be awarded a doctorate from the department of geology and geography at Harvard, and an early editor of Dickinson's work – constructs a careful cartography of the local geography of the homes. Her account is saturated with the language of enclosure and spatial measurement:

> The two Dickinson houses, beneath tall trees, stood side by side at a distance of a few hundred feet upon a strip of land bordering Main Street. A dense evergreen hedge was hemmed in by a fence in which there was a front gate for each house with a carriage gate between.[61]

What is described is a geopolitical space 'fenced in' from the gaze of passers-by; a space offering views upon the world, but permitting little opportunity for return stares. Here, the poet's gaze can 'wander' freely

to the far end of her domestic horizon, across 'an open field', towards 'a little brook at the far end'; and here the family can snatch oblique glances at the outlying terrain, their wider geography: the fault line between the 'Pelham and Holyoke ranges' and the 'depression in the sky line'.[62] Dickinson's editor taps a central poetic nerve: the sight lines of viewing and seeing that run from hearth to horizon; the territorial negotiations between inside and out.

Raised upon the culture and associations of the historical Concord transcendentalists – Emerson, Thoreau, the Alcotts and Hawthorne[63] – Todd Bingham's description shares a similar taste for window-gazing to that indulged in Hawthorne's gothic dramas. Clifford and Phoebe Pyncheon of *The House of the Seven Gables* (1851) share a conjugal hobby: peering out upon 'the life of the street' from the second story of their gothic mansion. While they screen themselves from return stares, husband and wife profit fully from the wide dimensions of the gothic-style arch, converting the city into an exhibit space for potential drama. From his window, Clifford observes, as does Hawthorne in gothic architecture, the 'multitudiousness', the 'majesty and minuteness' of an emerging modern landscape.[64] And so Hawthorne's narrator intersects the 'minute' sound cape of a lady's footfall with the torrent of noise emitting from the railway. These converging life cycles are a modernised version of the 'everywhere and nowhere' of the Puritan imagination; God in the everyday; the all-pervasive analogy of the contract between the natural and the divine.[65] From his window retreat, Clifford muses upon his longing for the outmoded and the anachronistic; his own spectral state in the passing moment based upon a view of the current age that is already defunct. In his window situ he contemplates the limits and relations of his personal and cultural horizons: their contingencies and differences. In the manner of the gothic tradition, Clifford positions himself on the threshold of his home as a reminder of the essential unhomeliness of the gothic house: Poe's House of Usher with its 'bleak walls' and 'vacant eye-like windows'.[66] He takes up the position of the window-eye, and converts unhomeliness into a form of critical gazing. And so through Clifford's 'eyeing' up of the street, Hawthorne provides us with a passing procession of sights and sounds of the American past; a veritable historical carnival: the hissing of the scissor-grinder's wheel, old stagecoaches, square-top chaises, the 'antique fashions of the street'.[67] The 'majesty' of history viewed from the second-storey window of the family home is less intimidating because it

is presented through a series of selected vantage-points. Ramified by the personal and 'stalwart' Puritan history of the Pyncheon home, Clifford is secure in his purview of the historical-street.

Describing a parlour 'call' upon Hawthorne's home by Emerson and Thoreau, author George Curtis concludes that the whole visit was a total failure. Had the men congregated around a riverbank or taken a stroll through Thoreau's blackberry pastures, the encounter would have passed easily and the rich and silty treasure of their minds would not have been wasted. As it was, the confines of parlour proprieties damaged the possibility of vital discourse. What Curtis seems to conclude is that gothic imagination thrives upon relations between inner and outer: the 'talk' between the house and the scraggy apple boughs.[68]

In the later writing of Henry James, whose *The Europeans* (1878) Dickinson followed in serialised form in *Scribners*,[69] the gothic aesthetic is converted into a larger cultural choice, in which the place of the threshold stands for a negotiation between two domestic aesthetics: the Old World and the New. His tale 'The Jolly Corner' (1908) is a fine example of this sort of cultural hovering and sees his protagonist, Spencer Brydon, struggling to choose between the purchase of a house that fulfils his sentimental needs, his Old World history, and the skyscraper house of his new money. The entire story unfolds across a threshold, a slew of comings and goings through doorways. Entrances offer vistas and perspectives on characters and place; they also offer an opportunity for aesthetic assessment. Visiting the old house on the Avenue with his friend, Miss Staverton, Brydon enters into an aesthetic and sentimental evaluation of his property. He rehearses a contingent life – one he *could* live – if he were 'merely' to embrace the 'shape of the rooms', the 'sound of the floors', the 'feel, in his hand, of the old silver-plated knobs of the several mahogany doors'. As with Hawthorne's viewing-protagonist, domestic vantage-points offer an overview of history; and so we move from an aesthetic assessment of the house to an historic one. History is tactile; an extension of the décor: 'the silver-plated knobs of the mahogany floors' convert into the less material 'microscopic motes' in the air. The viewing pair move between 'intervals' of time and space; historic and non-historic, their conversation falling between the subtle insertions of the narrator and the discussed 'reasons' for not choosing the older property. Likewise, intimacy is directed towards intervals; pausing-points on the tour of the house between one room and another where the tone of their relationship is given a wider survey:

They were thus back in the hall for departure, but from where they stood the vista was large, through an open door, into the great main square saloon, with its almost antique felicity of brave intervals between windows. Her eyes quitted that long reach and met his own a moment …[70]

Geographer Doreen Massey has summarised the experience of space as a 'simultaneity of stories-so-far'. If we follow this line of thought, Brydon and his companion are traversing narratives; in moving from one point to another, their experience of space is characterised by a 'dimension of plurality' and 'discrete multiplicity'; in other words, several stories told at once, funnelled through a series of competing vantage-points.[71] The question is: which story will win out; which view will arrest them, suspend time and space?

And yet, the outer world lurks, ready to 'assault' them with its version of actuality. James's narrator takes pains to emphasise the cost of re-emergence from this cloistered enclave; the 'antique felicity' of this domestic tour. As with Hawthorne's narrative, the home is a place where wider narratives – history and the pains of 'actuality' – can be compressed, edited and rearranged. The gothic imagination feeds both texts and is contained within what Hawthorne in *The English Notebooks* (1870) terms the 'strange delightful recesses' of architecture; a lived spatial structure that nourishes the imagination.[72]

And so Spencer Brydon leaves behind the 'real life' of history and society for the 'recesses' of antique style. With the closing of the 'great house-door', he crosses over into the 'beguiling' surfaces of domestic architecture and décor. He swaps the public language of the world for the private language of taste and comfort. He shrugs off history and, with it, the public face of his house, its façade. He returns imaginatively home, where he explores the childhood grounding of his conception of style.

Public and Private Perimeters

James's tale pivots around a discrete notion of concrete reality as it is performed in public spaces, separate and distinct from the private space of the home. Brydon retreats from the 'assault' of public life behind closed

doors, where he is imaginatively restored to a former and more formative version of himself. His misfortune is that he retreats too much for his own good, into a place of psychotic imaginings; and so he begins to role-play. As his fantasies expand, so does the extent of his mansion: space multiplies and folds in upon itself: 'nooks and corners', 'closets and passage', the 'ramifications' of an ample sense of space and time, free from public discourse, 'the cynical lights of New York'.[73]

In domestic life, the division of public and private space is a perpetual negotiation. As Dickinson confidently states, the soul desires 'her own Society', behind closed doors, where notions of Nation are informed by intimacy: the company of one rather than several.[74] In *The Decoration of Houses* (1898), co-authored with interior decorator Ogden Codman, Jr, writer Edith Wharton maps an ideology of domestic space in which the home is firmly fixed as a place of sacred retreat. In this late-nineteenth-century practical guide to domestic taste, the focus is on the maintenance of boundaries: the sacred perimeters of doorways, windows, hallways, vestibules and staircases as markers of territories.

Recalling his friendly sojourn at Edith Wharton's country home, The Mount, in Lenox, Massachussetts, Henry James describes the experience as one that offered both 'concentration' and 'conversation … the play of social relation'. For James, Wharton's home was built upon strict notions of privacy in which parts of the home were 'sufficiently withdrawn and constituted, not to constitute a thoroughfare'. In other words, unlike the tense Dickinson homestead where one was likely to run into an unwanted invader – Mabel Todd, for example – the gothic 'recesses' of Hawthorne's imagination were here served up within the design and layout of the home. James approved of the discrete separation of space, the floating units of privacy honoured at The Mount. Spaces for the servants were entirely separate from the rest of the house, with each of the rooms allocated a discrete function: on the ground floor, the servant's kitchen, scullery, laundry and dining room; on the first floor, the cook's, housekeeper's and butler's workrooms; and on the second floor, the maids' closets, sewing and linen rooms. There were separate spaces for social engagement, and so, on the first floor, a large hall divided service rooms from a long gallery that ran the length of the house, connecting the den, library, drawing-room and dining-room. These were combined with private spaces: Wharton's suite of rooms in the eastern wing of the house, her husband's room and bathroom, and three guest rooms – which included James's – all separated by

a long corridor.[75] Above all, Wharton and Codman exhorted the need to combine taste with comfort; the 'golden mean' was to arrange rooms with a view to comfort and convenience. At the heart of this doctrine was a careful patrolling of the perimeters between public and private spheres.

The authors of *The Decoration of Houses* recognised the need for specialised space. Chief among the wants of domestic inhabitants was a careful positioning of doors, windows and fireplaces. Identified as the focus for 'every rational scheme of arrangement', the hearth was the centre of domestic arrangement; in particular, the geometrical relationship between hearth, doors and windows – the 'tidy' arrangement of space. The design of rooms, therefore, would entail a careful negotiation of the distances of intimacy and closeness on the one hand, and the proportions of privacy on the other. How near or far doors, windows or fireplaces stood from one another was crucial to this. In their opening remarks, the authors clearly assert the need for individuality, taking account of the particular 'tastes and habits' of the occupants.

A relationship must be developed between the space and those who occupy it, and the successful decorator is he or she who can establish this. Wharton and Codman decree what is almost a mechanistic view of domestic decoration, in which separate rooms, and aspects of rooms, are regarded as 'parts' in a higher order. The essential components are those surfaces and openings offering dimensionality: floors, ceilings, wall-spaces and openings. A sense of order will come from due attention to the relations between these parts, but what should come first and foremost is the livability of a room: the position and placement of objects in relation to its dwelling subjects. Cluttering rooms with too many things is anathema to good taste. It is the *position* of things that determines the rationality of a room. A cluttered living space will clutter the mind, and with it, the ability to maintain a proportionate sense of reality; a happy layout.

This is perhaps the problem with Spencer Brydon's atavistic abode. His mind roams from room to room, object to object, surface to surface. It cannot settle. Mark Twain, an infamous collector of things, was also clearly not at home in his Connecticut house stuffed full of objects. Having called in a set of Tiffany designers and decorators to remodel his home, he complains of the unbearable toll this exercise brings upon his household: the 'housekeeping slavery' his wife is subjected to.[76] He would have done well to heed Thoreau on domestic comfort, who discerned that domestic distance is essential to comfort: the luxury of providing 'interval[s]'

between the sentences of guest and host; a compatible but natural boundary between one utterance and another, one body and another.

Thoreau's *Walden* analogy is that of bordering nation states: 'Individuals, like nations, must have suitable broad and natural boundaries, even a considerable neutral ground, between them.' Domestic comfort requires a geopolitical lag between one occupant and another. Intimacy, therefore, is best achieved through intervals of space, and conversations with native inhabitants should be conducted across boundaries. There is much to be said for conversation with one's self, and true dialogue – that is, dialogue with one's inner life – can only be managed in a state of retreat. However, space is limited, and if one is to begin to rehearse lofty and grand disquisitions, there is a need for more room than a house can provide. Roominess is a fundamental necessity, but within that, a strong sense of design or order, position and placement, not only of one thing to another, but of one subject to another. Thoreau concludes that valuable or credible conversation must permit a degree of room. Space, then, furnishes a kind of gentility: in order to manage good conversation or dialogue, there must be plenty of space between subjects, and subjects and things.[77]

In this sense, and perhaps unwittingly, Thoreau conforms to the nineteenth-century mode of the genteel parlour – the chat room of its time – whose preferred layout was one in which furniture lined the walls, thereby creating a spacious central nave for free-flowing traffic.[78] Space permits freedom of movement, and a spacious home encourages its inhabitants to move *beyond* the idea of shelter, towards venture and adventure.[79] Open indoor spaces reflect back a positive view of wider spatial relations; they draw the mind into bolder considerations of the public life.

Furthermore, as Wharton and Codman maintain, the secure maintenance of domestic boundaries is at the heart of a successful family life. The correct placement of objects in space is also crucial; rooms should provide 'intervals' for thought, and so the right space for a writing table, for example, is the interval between the two windows of the drawing-room. The hearth is the central node of the household, providing the family with its base logic. As such, there should be no 'gaps' in its sacred enclosure. Gaps in the surrounding walls encourage breaks in the familial logic: an opportunity for trespassing eyes to pass through. Domestic logic is built upon a sharp and incisive divide between public space and private. The family must have distinct places of refuge: a clear sense of

itself apart from the hubbub of contesting social groups and identities; places of consolation and consolidation.

At the crux of *The Decoration of Houses* is the proper and serviceable use of rooms. The purpose of any room is to provide a solid and discrete set of spatial identities, reflecting a clear set of social roles. A room determines the identity and purpose of its occupants and there should be no blurring of these distinctions. A drawing-room should not bleed into a hallway; a library should be kept out of the drawing-room. Above all, doorways must be strictly preserved in order to prevent the interference of one room-identity with another. Poor regulation of boundaries will lead to 'a faulty and illogical structure'.[80] Such is the nature of Wharton's domestic hygiene.

The Geography of Intimacy

Like Wharton, her good friend Henry James was passionate about the ordering of domestic space. In his journalistic voyage across America, *The American Scene* (1907), James comments on the code of hospitality practised by New York clubs: in particular, the largesse and expansiveness of its scale – a peculiarly American sense of luxury. For James, a healthy degree of separation between one room and another generates a clear correspondence between 'home' and 'away': he occupies a room with the knowledge that other rooms lie vacant, and entertains the idea of places not yet reached. James calls for a distinct 'place of passage' between one room and another; in other words, the passageway itself (and in the club or hotel, this is the corridor) – an interval of time and space for crossing from private chamber to public, from bedroom to drawing-room.

This call for domestic intervals is as much a cipher of James himself in the role of 'restored absentee'; the returning American native in the process of cultural rehabilitation. James returned to American an 'alien', as he phrased it, but contested the line that divides alien from native in a country first devised 'under the jealous eye of history'. Where does the alien end and the native begin with the frown of history so closely looming over his head?[81] America is new; to be American is novel and the nation has always reckoned with itself and its vast terrain. No American is ever

really at home in all of its disparate territories and geographies. On the local level, American identity consistently resists homogenisation. But James himself required an interval of time in which to adjust himself to forgotten practices, cultural codes and rituals; time to re-Americanise following on from his years in Europe. *The American Scene* was his written attempt at such, delivered as a travelogue and cultural catalogue of America's disparate parts.

And for James, the club or hotel corridor is the place where he can adjust his collar and tighten his buttonhole before entering the public domain of the drawing-room. He insists upon a crossing. What he finds particularly disorientating is the lack of distinction between indoor spaces; the paucity of variegation in the contemporary domestic world. He would have a better-marked domestic map; a more determined sense of time and place; a more developed series of 'room-characters'. As a visitor, James asks that rooms speak of interiority – and particular versions at that. Interiors should retain distinctive traits; they should resist 'the effacement of difference'. The bee in James's proverbial bonnet is the contemporary architectural tendency towards homogenisation – the cultural whitewash which was already busy at work in the nineteenth century, and which would in some respects determine American identity in the twentieth and twenty-first centuries. James particularly objects to the democratisation of interior space, the opening up of doors, arches, passages and windows to the outside; the levelling of interior time and space with exterior. He is irked by the vague dispersion of rooms, and longs for what Bachelard has recognised as the home's capacity to integrate being, the benefits of its continuities and consistencies.[82]

Why flatten and broaden interior vistas and vantage-points, make every part of a house 'visible, visitable, penetrable', James asks? Individual rooms, like the American landscape itself, offer a specialised terrain and topography, challenging the visitor with their novelty. Visitors and residents alike prefer difference, alteration of light, colour and mood. Rooms should suggest particular tones and timbres, reflective of particular moods and activities. They will host better conversation if they are allowed to play a part in social relations; if their role as host is not denied them. James's critique of the modern home is that it offers no familiar landmarks, and so the visitor is left groping his way through foreign scenery. Like Thoreau, he would have rooms function as nation states, with clear border crossings; definite beginnings and endings. The civilising function of rooms

– good conversation – can transpire only if there is a sense of enclosure. No visitor likes to be given 'away' by the space they occupy.[83]

James realises that comfort in the home is to be found in its support structures, the vertebrae of its doors, windows, arches and porticos, whose function is not only structural but also personal. Reduced openings breed security; individual words are guarded; a visitor or resident begins to ease into a relationship with his domestic environment, under no obligation to take the wider world into his 'confidence'. At home, no one should feel obliged to make a large impression upon the world. The perimeters of the home take care to 'front' the world for him – the porches, verandahs, lawns, gardens, grounds – that seal off the resident from any immediate interface with strangeness.

At all costs, James wants to avoid a domestic culture of what he calls 'raking': that is, the accumulation of things on the part of the resident simply because a world of things has been opened up to him. Neither does he wish to encourage subjects to be treated as objects on view. Viewing and being viewed is not a restorative exercise, and the merger of subject and object should be avoided. At home, one should not feel on show.[84]

Yet this is precisely the case with Gertrude Wentworth, emerging from her home in James's *The Europeans* (1878), where a generous view of Gertrude's domicile, democratic, open and inviting, is offered up to the reader:

> The doors and windows of the large square house were all wide open, to admit the purifying sunshine, which lay in generous patches upon the floor of a wide, high covered piazza on which several straw-bottomed rocking-chairs and half a dozen of those small cylindrical stools in green and blue porcelain, which suggest an affiliation between the residents and the Eastern trade, were symmetrically disposed.[85]

In fact what James gives us is a sample design of the Wentworth home, the pattern of its layout in miniature: a cross-section of its intimate geography. And yet, we are never permitted direct access to the home; we hover on the 'piazza', awaiting an invitation to enter – which never comes. James' narrator is canny: he observes the rules of his own distinct and developed sense of gentility. Gertrude's family home is never completely on display. The egress of the piazza is as far as we are permitted to venture. The 'sum'

of these picturesque parts that he alludes to, rather self-consciously, in the closing lines of this passage, is limited.

Eventually James does let us in, and we follow Gertrude around her home in a one-to-one intimate tour of the sort of daydreams encouraged by being at home, alone. Like Thoreau in his Walden Pond home, Gertrude retreats into a reverie described by the narrator as a 'golden age' of 'New England silvery prime'. In other words, she moves beyond contemporaneous time and space, regressing into daydream, just as the front door of the house opens up to a wider angle, 'unguarded', and we, as reader, enter. Just as we cross the home's threshold, so its inhabitant moves further into mental regression. We cannot 'rake' Gertrude along with the household items that surround her; we follow her, but she roams 'free' in mental space. The intimacy of her familial geography, the particular points of her mental crossings as she drifts from room to room, are never quite ours.[86]

Domestic Territories

For Godfrey St Peter of Willa Cather's *The Professor's House* (1925) – well within the twentieth century – a new home offers a sojourn in childhood. St Peter's retreat is regressive: in the quiet corners of his home he bids a mental retreat, receding into the familiar landscapes of his youth. Particular spaces are sites of sentiment and sentimentality, carefully guarded. His study, a retirement den, is one of these. Doubling up as a sewing room, this space houses his happiness, the 'fixations' of that state rooted in childhood;[87] a territory 'isolated' and 'insulated' from 'the engaging drama of domestic life'.[88] This is a territory in which no one else 'tramps' or roams; a non-familial space, a space where history is written: a study of *Spanish Adventurers in North America*. It is in this room that the *adventure* of European imperial history – the story of its advancement into North America – is written out and recreated. 'Fixed' in a happy state of regression, St Peter manages to script and shape his history. However, the only 'actual' adventures he undertakes during the fifteen-year period of writing consist of 'two summers in the South-west on the trail of his adventurers, another in Old Mexico'. Otherwise, St Peter's

text of conquering and plundering adventurers unfolds entirely within the mental space of his study. It is surely no coincidence that the room is so closely associated with sewing and fabric; it is here that the Professor 'weaves' together his text, 'sorting' and 'digesting' his records and notes into a coherent pattern. His desk is a 'shelter' to hide behind; a 'hole' into which he retreats for creature comforts: the established habits and rituals of his thought-life.[89] Apparently, the professor can only 'conquer' his historic texts if he can hide himself, like a retreating soldier, within his study-bunker. Here, then, is Bachelard's 'felicitous space', 'eulogized' for the generosity of its imaginative capacity.[90]

Published in 1925, *The Professor's House* is nonetheless a story of a wearied Victorian patriarch whose histories of male conquests have quite worn him out. In creating St Peter, Cather – whose chief subject had typically been the pioneers and settlers of the mid-American plains – retreats into the imagined narratives of conquistadores and pilgrims, and so moves back to the European roots of American history and culture. In his full name, Napoleon Godfrey St Peter, the professor honours the course of two conquering westerners: the French despot and Godfrey of Boulogne, as well as the head of the Catholic Church; in other words, the historical figure of a founding father and, behind him, a conquering religious institution. The form of his academic history, collated from notes and records, but also, we suspect, partly imagined, is encouraged by the space in which he writes.

In many ways, St Peter's felicitous study space does nothing more than conform to the Victorian plan-book designs for middle-class houses: homes isolated and surrounded by scenery that both encloses and protects, whilst providing a keen sense of spaciousness. Set in idealised locations, remote from time, place or history, the plan-book design house encouraged the Victorian family to live far from actuality.[91] Accordingly, the home should offer 'a protective dike against the corrosive force of modern life'; and at the turn of the century this was still the basic premise for home life.

The professor's study, like the plan-book drawings, is suspended in time and space, offering a view over Lake Michigan to the site and sights of the professor's childhood. Its location in time and space is vague. What is more important is its relationship to an aesthetic of the past, a visible sight line from study to scenery that is the narrative and mythos of the professor's child self. St Peter's study is a *place* as much as it is a space.

Doreen Massey has argued that place is as much an *event* as it is a locale. In other words, a sense of place involves a constellation of events moving at different times and speeds, all clustering around one site. In a particular place, histories merge and combine, and the spatiality of those histories, the dimensions of competing and conflicting trajectories, come together. The experience of place involves a sense of 'then' as well as 'here'. Place simulates the experience of travel, a shuttling back and forth across multiple trajectories. Travelling between places is movement between clusters of trajectories, in which the traveller chooses which paths or tracks he or she will pass into.[92] Enveloped away in his study, St Peter travels mentally between 'here' and 'there', and Cather carefully marks the distinction between the current place and the places of the past he travels back to:

> Sitting in his study, long afterward, St. Peter reflected that those first years ... were the best of all. He liked to remember the charming group of three he was always coming upon, – in the hammock swung between the linden trees, in the window-seat or before the dining room fire.[93]

A series of picturesque family tableaux, the Professor's memories are carefully selected and curated. He observes the 'prettiest' of his 'fancies': those scenes most readily rendered picturesque, and like the notes and records of his research, he weaves together the story he most desires to tell.

Hopelessly attracted to the picturesque, St Peter arranges his experience of space and place accordingly – as we suspect he does his histories. If we adhere to the notion, as Downing did, that the picturesque view of the home aims at a unity of structure and feeling, a Romantic cohesion of self and environment, then the main repository of this feeling is the Professor's study. Here is a place that generates an idealised, nostalgic view of family life precisely because it is a space 'on sabbatical' from domestic life.

'We are rapidly learning to value our own personality and privacy', wrote one contributor in a 1905 edition of the *New England Magazine*.[94] And yet the net result of these bywords is isolation, the elimination of shared public spaces, in which the parlour, for example, is exchanged for a set of monadic rooms. In the twentieth century, the life of the home begins to shift towards principles of standardisation and increased technological efficiency. As servants disappeared from the household, houses shrank

in size and so efficient household management became paramount. In the Progressive model of housing, espoused by the likes of Mary Pattison (*Principles of Domestic Engineering*, 1915), the family home is suddenly transformed into an efficient organism in need of scientific management. Pattison's treatise aimed at eliminating waste of time and energy, and encouraged the co-operative efforts of 'the masculine and feminine mind … in the industry of home-making'.[95] Domestic engineering meant clean, efficient spaces built around standardised designs. Gone are the whimsical spaces of the professor's house, the den-retreats. Domestic spaces are fully declared and ready for inspection. The aim of the newly regulated Progressive household was a highly functional, streamlined family mechanism. With the smaller homes arose the need for a more extended visual space; the difference between a space that is 'actual' and a space that is artificially created. In other words, rooms needed to trick the eye into 'reach[ing] out into the woods', as glass-maker Libbey-Owens-Ford put it. The responsibility of the new picture window design was to create a more generous sense of spaciousness; to bring the outdoors in and so encourage greater imaginative travel.[96]

Twentieth-Century Thrown Togetherness

Many such efficient households sprang up in the established Victorian suburbs of major American cities: New Brighton on Staten Island; Llewellyn Park in New Jersey; Chestnut Hill adjacent to Philadelphia; Lake Forest thirty miles north of Chicago – all the result of post-Civil War lines of transportation from 'down town' to residential areas.[97] Chicago was the prototypical city of suburbs: a thrown-together hotchpotch of urban developments that promised luxury living to its professional businessmen and their families.[98] In the 1920s, sociologists Robert Park and Ernest Burgess at the University of Chicago established a model of city living whose blueprint remains today. Delivered as an ecological metaphor of organic growth, Park and Burgess figured the city as an organism springing up from a downtown genus and moving across a series of concentric zones, each yielding an endemic species. Taking Chicago as their prototype, their model was a simplistic rendering of city life, in which the

wealthiest inhabitants 'naturally' gravitated to the most far-flung areas – those regions clinging to the lake shore.[99]

Lake Forest, Chicago, is the residential location of Toph and his family in Dave Eggers' *A Heartbreaking Work of Staggering Genius* (2000). The landscape of Eggers' autobiographical novel, a story of orphaned siblings in search of a functioning form of family life, is a scattering of ad hoc rented apartments. But for the young family in a post-traumatic state, domestic space quickly becomes nothing more than a string of squatting sites in which James's experience of 'dispersion' is the norm. If we take 'home' to mean a space in which there is a 'regular investment of meaning' – a personalised space in which those 'at home' exercise a control which regulates and determines meaning – then, for Eggers' narrator and his siblings, this investment is entirely lost; wholly dispersed.[100]

What Massey has termed the 'throwntogetherness of space' requires 'negotiation'.[101] For the Eggers siblings, 'throwntogetherness' is a mode they live by, and from the beginning, the novel is wired around a central fuselage of a language of the home life that is splintered and incoherent. There are no signs of pattern-book designs in this household and certainly no Progressive – in the truly American sense – efficiency. Things are held together on a wing and a prayer.

The incoherency of home life is established early on, in the young narrator's comments on his family's 'inconsistent' sense of design. The twentieth-century ideal for the postwar family home was a strident social policy of familial 'togetherness', of which the tightly knit 'village'-style suburbs, simulating a sense of community hum, were the ultimate emblem.[102] The ideal postwar home would offer a family a relaxed space in which to take refuge from the demands of the modern world. Furthermore, materials should be cheap, and during the depressed 1930s, companies such as the Anderson Corporation began to produce prefabricated window units as a way of providing cheap windows, installable in minutes. Thriving upon the economic deprivations of the war, the Anderson Corporation produced scrapbooks providing images of affordable dream homes for future home buyers: the imaginative fuel for the postwar housing expansion. Architects such as Royal Barry Wills were quite aware that economic and efficient designs were essential in order to entice prospective buyers to purchase. Modern homes, by which Wills meant, in particular, the one-storey ranch house, should provide a flexibility of space in

which dining-rooms might combine with kitchens, the study with the guest-room, the kitchen with the laundry-room, and terraces that could also serve as extensions of the living room, dining room or bedroom. Multiplicity of function was essential, thereby providing a more literal sense of Dickinson's 'dwelling in possibility' – a home built upon a perpetual sense of expansion.[103] Above all, the home should solder a sense of togetherness against the outside world, and so space was to be flexible but also easily managed: coherent.

But this is an impossible realisation in Eggers' Lake Forest home. The living room – regarded as the most important room in the house by early-twentieth-century architects and, in effect, the parlour replacement – is, in Eggers' novel, transferred to the 'family room': a space repeatedly conjured by his young narrator in a desperate attempt to stimulate solidarity.[104] Here is the family's history, its sense of itself; here, like St Peter's eight-volume history, several decades have been written into the furniture and fabric of the room:

> But the family room, the only room where any of us has ever spent any time, has always been, for better or for worse, the ultimate reflection of our true inclinations. It's always been jumbled, the furniture competing, with clenched teeth and sharp elbows, for the honor of Most Wrong-looking Object ... and save for a general sort of decaying of its furniture and walls, has not changed much in the twenty years we've lived here.[105]

The family's experience of itself as lived space – at home – is a series of spatial contingencies: hushed, rushed conferences in the kitchen and in doorways; eruptions of crises; hurried and 'thrown together' emergency plans. In retreat from the fixed and regulated patterns of family life, the siblings hover in entranceways, upon thresholds: transit and fugitive and waiting for the ghastly end. This is no standardised postwar family home, but a spectral space, a bunker-retreat. The 'interior spaciousness' of postwar living envisioned by Frank Lloyd Wright is a lost vision in Eggers' suburban home. The architect's preference for efficient floor plans designed to reinforce family life is a failed enterprise in Eggers' home.[106] Efficient floor plans require efficient management, and behind the closed curtains of this hideout, domestic management of the sort prescribed by Mary Pattison is untenable. Clinical thinking is replaced by a series of knee-jerk responses to the imminent threat of death.

The family room is where their mother dies: the ghastly place from which the family remnants – Eggers' narrator, his younger brother Toph and his sister Beth wrench themselves – and move along a 'slow upward trajectory' away from tragedy, towards another place. In search of 'newness' and craving the 'freedom to move' – traits identified by the French traveller St John de Crèvecoeur as peculiarly American – the orphaned family head for California, moving like fugitives from one awkward space to another.[107] The first apartment they share is with their older sister, Beth, and her best friend; the hope for this space is a recreation of domestic life 'from scratch'. Most important is freedom of movement, a desire which maps itself onto the layout of the various apartments they inhabit: spaces painstakingly recorded in which they can act out a pattern of settlement. In Beth's apartment a continuous line from 'deck-to-stairway' and the 'glide' of wooden floors incites a game of 'sock sliding' in which the siblings act out a version of America that ends with 'a Mary Lou Retton arm-raise and back arch. *Yes! America!*'[108] Their game is a ritual of arrival, a consolidation of domestic space that acknowledges the territorial nature of their temporary home. Eggers' accompanying architectural drawing enhances this sense of hard-won territories: an unbroken expanse running from the back deck of the apartment, past the kitchen, living area and WC, towards the front. Hunting down suitable homes becomes a family occupation, and the amount of space they can afford, a comment on their social 'decline'. The benchmark is the 'sublet' second home of their parents, the 'golden house in the hills' saturated in 'glass and light': a Frank Lloyd Wright prairie home fantasy with arms wide open to nature.[109]

The suburban open-plan design of the middle-class home promoted by Wright and others, the 'vague dispersion' of rooms so abhorrent to Henry James, is precisely the sort of space sought out by Eggers' itinerant orphans. Rooms without boundaries encourage a quick and easy familiarity with one's living space; an accelerated sense of ownership. The orphaned family benefit from the therapeutic principles of modern architecture pursued by the likes of Richard Neutra, whose housing designs drew architecture into gestalt psychology in which glass doors opening onto terraces simulated the effect of infinite space. The philosophies of Neutra and others like him insisted on replacing the abrupt sequence of single rooms with a more lithe and easygoing relationship to space.[110] In an open-plan home there is room for restoration and rehabilitation.

Living among the receding and generous lines of an open-plan home suggests horizons not yet met, a future not yet known.

The orphans' second house, a small Adobe house in Oakland, more atomised in its design than the first, reflects the dispersed and segregated nature of the neighbourhood. Individuated identities emerge from separate spatial identities, and the siblings initiate a colour scheme to mark out each room. And yet the layout of the house still generates a 'flow' of space, a line running from 'one end of the house to the other' as far as the front door; a sequence of 'zones' rather than rooms.[111] There is 'room' for expansion; space for the grand role-play of parenting thrown prematurely upon a young man left in charge of his eight-year-old brother. The division of space encourages a division of labour: 'the completion of a bare minimum of household chores' to keep the household running. And yet, despite all the efforts at familial rehabilitation, the family room remains in a constant and 'perpetual state of disrepair'. An intervention becomes necessary, what Thoreau at his Walden home termed a 'parliamentary' measure: a 'State of the Family Room Address' and a call to order.[112] The regulation of domestic zones is quickly translated into the regulations of a domestic routine; and so the period of settlement ends by the inauguration of 'something like a schedule': 'relative order'.[113]

Domestic Frontiers

In Eggers' novel, 'sock sliding' is adolescent short hand for a peculiar form of frontiersmanship, a pattern of settlement that the western writer Wallace Stegner has identified as part of the normative American experience of 'migratoriness', and which Gertrude Stein famously termed 'a space filled with moving'.[114] Uprootings and adaptations: these are the experiences validated by the literature of the West; by Mark Twain's *Roughing It* (1872) and Owen Wister's seminal cowboy story, *The Virginian* (1902) – the story of 'the standard American orphan'.[115] Tired of the 'stuff' that he shunts from place to place in an attempt to recreate a sense of their former family home, Eggers' young narrator wishes he could dispose of it all. In the midst of his mental cataloguing, his younger brother yells at him to lock the front door. He responds. Both siblings are acutely aware of the insecurity of their

domestic borders. The 'stuff' of history, so irreplaceable, is easily lost and stolen. Migration, they realise, is a risky and leaky business.

Eggers' novel is a portrait of an orphaned American family in flight from its recent past and in search of more reliable domestic frontiers. Jonathan Franzen's 2001 novel *The Corrections* is the story of a family whose domestic horizon is rapidly shrinking and folding away. Like Eggers' household, the stability of the home rests upon spatial formulae. In the Lambert family, space is specialised and personal; rooms atomised into a series of cells. In place of migration there is stagnation and stasis. This is a drama of domestic implosion, of unravelling familial relations. The novel's emotional landscape is structured around metaphors of ill-fitting fixtures and fittings, malfunctioning domestic apparatus and a series of alienating and ostracising room spaces. The novel's emotional currency plays off the idealised suburban formula of the single family on its individual lot of land: single units of familial happiness. For Alfred Lambert, his allotted unit of space is the basement, his hideout retreat; a self-imposed border between himself and his wife, Enid, and a means of surviving domesticity.

Franzen pays acute attention to the relationship between domestic accoutrements and household members; the apparatus of husband and wife in their respective 'alchemical lab[s]': Alfred in the basement, Enid in the kitchen.[116] The postwar suburban home and lifestyle extolled by President Nixon as the essence of the American good life is exposed as a toxic wasteland in Franzen's novel. According to Nixon, the 'American way' modelled a domestic utopia of advanced domestic appliances and distinct gender roles – a continuation of the Progressive methods espoused generations earlier. The suburban ranch house, stuffed full of the latest appliances, promised security against the threat of communism; promised a secure domestic frontier.[117]

The suburban home is the smallest geographical unit making up the suburban landscape, of which the ranch house, the Colonial Revival house and the bungalow were the most popular postwar types. The central pattern of settlement of these homes was the single family home on its individual lot within a large-scale, self-contained subdivision. Here was a new type of frontier experience, a temple to the family resting in solitary isolation – away from the economic transactions of the city – and yet, built from them.[118] Central to the suburban lifestyle was the feeling of ownership. The Lambert house – suggestive of a Lloyd Wright

prairie-style home – reeks with the 'fact' of ownership.[119] The head of the household, Alfred Lambert, has followed what Crèvecoeur identified as the twinned principles of ownership and enterprise, central tenets of American individualism.[120] Down in his basement 'lab', Alfred, victim of Parkinson's Disease and retired engineer, wrestles with a box of Christmas lights and moves through a personal disquisition on the corrosive effects of modernity. Attempting to rescue the Christmas lights from the fate of the trash bin, Alfred recounts a mantra to the value of individual objects in an age of individuals. His 'individual' and 'designated' space seems to lend him encouragement, and spurs him on through a nexus of thoughts on the disposable nature of modern technology. As much as anything else, Alfred is repairing his value system and identity as an American citizen: a hardworking, white-collar, loyal employee of a railroad company which had patented his design for railway tracks and in doing so had stolen millions of dollars from him. Alfred is a sufferer of corporate exploitation whose public life is now stored away, like the malfunctioning lights, down in the basement. He understands the value of privacy, the most precious aspect of his American identity. And yet it is a forlorn thought that what Emersonian individualism and self-reliance have led to is the privilege of locking oneself away.[121]

But the Lambert house does not fulfil the design principles of the postwar home: the open, shared spaces of the family home. Instead of transparency, the home has created a set of individuals who expend a great deal of energy on 'staying out of sight'.[122] What Franzen's novel represents is the coeval existences of this cellular household in which each member follows a 'gospel' of 'taking responsibility for yourself'.[123] In her kitchen space, Enid Lambert experiences the silence of complete isolation. There is more noise in Thoreau's Walden[124] than in Enid's domestic silence: 'The quiet in the house after lunch was of such density that it nearly stopped the clocks.'[125] For Enid, domestic time and space are units of cripplingly inertia. She can only make sense of herself in relation to others – in this case, the arrival of her son and grandson for Christmas – and so she waits out the interval of time in which they are still absent. Her house holds no significance, no sound and no meaning without them. She waits upon the arrival of another story, the story of her children and their lives. It is the convergence of their stories with their particular intimate and pre-possessed geographies that will convert her house into the 'place' of an event that her story seems to lack.[126]

Chapter 1

Border Crossings

This is also the case for Sylvie, the eccentric aunt of Marilynne Robinson's 1980 novel of domestic displacement, *Housekeeping*. It is in her return to the family home in the small town of Fingerbone following the death of her sister, to take up the care of her two nieces, Ruth and Lucille, that Sylvie's flighty and unpredictable history, literally and metaphorically, meets a brick wall. Robinson's narrative spirals cochlea-like inward, mapping Sylvie's return to the architectural history of the family home: the 'oddly' terminating stairs which Sylvie climbs to reach her room, the sudden appearance of a wall at the top of the stairs – an 'essential' support to the structure of the house – but a wall her grandfather could not bear to 'cut another door' into.[127] Sylvie's bedroom is a place of reduced circumstances, 'a narrow dormer with a curtain closing it off from the hallway', barely furnished. Surrounding her return is an unspoken history at odds with the house she left, now 'shifted and settled' into new arrangements. There is nothing vast or audacious about the space she finds herself in, and to her nieces, the sight of her sitting in the kitchen with her coat on is a statement of her essential transience (symbolised by her hall bedroom); her refusal to be 'settled', her need to remain 'unhomely'.[128] Sylvie exists in a permanent state of leaving, moving like a restless animal from inside to out; and as her niece notes, 'every story that she told had to do with a train or a bus station'.[129]

America's earliest writers understood themselves as a people of boundary-crossers: transient and not-yet-settled. Ann Bradstreet's 'Upon the burning of our house, July 10th, 1666' is a Puritan's paean to her lost home:

> When by the Ruines oft I past
> My sorrowing eyes aside did cast,
> And here and there the places spye,
> Where oft I sate, and long did lye.[130]

Bradstreet's sense of home has evolved from stasis: the practice of stillness, a meditative mode of being ('Where oft I sate, and long did lye'). Remaining still is the only way to combat the early American experience of place as, in Stein's terms, 'a space filled with moving'.[131] Her poem mourns

the loss of home as a still place; it is an elegy to the American home. It is also a confessional surrender to the experience of the unhomely – that which lies beyond – in this case, the divine. Bradstreet clearly understood that the holiness of home can only exist alongside a clear acknowledgement of 'elsewhere': a desire to wander.

Returning to Fingerbone, Sylvie is both familiar and strange. Both like and unlike the girls' mother, Helen, she estranges the girls from their memories, 'blurring' their mother's outline, displacing her. Displacement is what Sylvie is best at, encouraging traversals, movement outwards. From the start she is associated with passageways, extended trajectories and projections outwards, the hallway that slopes at a sharp angle, running down to greet her at the front door.[132] She sleeps off the hallway passage, something Edith Wharton would have crossly frowned upon, the hall, in her opinion, offering nothing more than a passageway to living rooms.[133] Displacement and 'disarrangement': this is the language surrounding Sylvie's existence. Shortly after her arrival, the lake around the house floods, water 'pour[s] over the threshold', and the family is forced up to the second floor.[134] Sylvie and the flood are allies in estrangement, both 'pouring' themselves over thresholds, both conduits of the strange and uncanny. Her presence is a reminder of the puritan 'errand into the wilderness':[135] what Anne Bradstreet called the 'dream of things beyond',[136] and what Huck Finn meant by his declared intention to 'light out for the Territory'.[137] Stationed, a still 'effigy' at doors and windows, Sylvie is a form of the uncanny, a revenant of the past – a dreamer of the great 'beyond'. She longs to protract time and place, and like the young Huck Finn, her intention is to extend herself and her alluring history.

Sylvie, perhaps, would have felt more at home in a Frank Lloyd Wright home, where space, no longer bounded, opened out from within – through swinging casements.[138] And so it is that she moves downstairs into her mother's room, where glass double doors open onto an arbour.[139] Brimming with the American sense of manifest destiny, the promise of self-extension, it is with this state of mind that she begins her housekeeping project – to throw open doors and windows to the scrutiny of the atmosphere. Sylvie lets in air and, with it, lets in the American landscape. Her housekeeping is thus as much an invitation to consider the landscape as it is a consideration of cleanliness. Her real project is an incorporation of the wide open spaces that sit behind her, beyond the 'cool' 'aquarium water' of her window-position. She hovers over housekeeping as she

hovers around doors and windows, waiting for an enlargement of her domestic 'civilising mission'. In the tradition of westering championed by the lyrics of girl band The Dixie Chicks, she wills herself to strike out alone and find 'a foundation of stone' beyond the home; 'the shape of a place out west'.[140]

Sylvie is born to cross borders. She can remain at home only if she fixes her eye unwaveringly on the big outdoors. Eventually, that is where she goes. She inhabits the domestic world as part of a larger, impermanent space. She lives with an understanding of home as a place of flux, comprising shifting and restless territories. Her home occupation is permanently uneasy, quickly forsaken. In contrast, Alfred Lambert lives as if home were a place of frozen territories; a series of crossings never made. Sitting in his basement room, he hopes 'that someone would come and disturb him'.[141] He longs for territorial dispute, for his borders to be unsettled. He dreams of an alien invasion. Like Dickinson, he solicits the experience of doors left ajar to a more 'Foreign Sky'.[142] He hopes for visits: somebody to call him into account; to take him towards the grandeur of the sunset Dickinson's speaker glimpses beyond her window pane.

2

Doors and Windows

This Side and Beyond

Sitting alone in his basement, Alfred Lambert watches the shadowy light of late afternoon drop like a 'captive' into his window wells.[1] A hostage to his version of home, he waits for his story to be extended, for something other than the light to pass through. Conversely, Sylvie Fisher, a natural wanderer, cannot stay indoors for long. A Huck Finn-style itinerant, she opens up the home to a larger geography, forcing her family into a relationship with the natural environment. Following on the heels of Sylvie and her nineteenth-century counterpart, Dickinson, this chapter will move through the doors and windows of the American home and explore ways in which America at home looks out upon the world; turns its gaze yonder. On the other side of the threshold lie extended domestic territories – the front porch, front lawn and back-yard spaces; outposts of the twentieth-century domestic world. Extensions of the modern home life, these are places offering larger views, a glimpse of a wider horizon; an opportunity to reflect upon the life led within.

Gaston Bachelard reminds us that metaphysical thought is always framed within a dialectic of inner and outer, a geometry that confers 'spatiality upon thought'.[2] And so it was that the Puritan settlers of New England conferred a sense of inner space upon the geography they found. The 'city upon a hill' imagined by John Winthrop was as much an inner dwelling, a place of faith, as it was an actual geographic location.[3] When

the physical location failed to manifest, hope and faith became necessary requisites; the fuel to their mobility.

Musing upon the mobility of the American Republic, French travel writer Alexis de Tocqueville concluded that a 'restless spirit, immoderate desire for wealth, and an extreme love of independence' informed the cause.[4] Mobility, then, was written into the earliest version of American identity. De Tocqueville's 'restless spirit' implies an inability to settle. If we read Dickinson, we hear the restless pacing of her poet-speakers between a 'here' and 'there', 'home' and 'away'; a pacing of the floorboards anxiously awaiting arrivals, the delivery of news, a longed-for expansion of the home environment – more room in which to move. Separation, a commonplace experience, translates into the anticipation of figures at the door, a form at the window. Writing to her loved ones, Dickinson discusses the nature of separation, the tug-of-war between 'here' ('home, and parents and country') and 'there' (city, and smoke and dust').[5] The experience of being 'away' presents a lag in time and space: a geometrical division between inside and out; what can be seen and what can only be imagined. Separated from her brother, Austin, Dickinson can only imagine him in a state of away: not-here. In order to be with him, she must first pass over an imaginative threshold, which is precisely the purpose of her correspondence.

It is well known that towards the end of her life Dickinson was refusing to cross the threshold of her house in Amherst: 'I do not cross my Father's ground to any house or town.'[6] And yet she trades extravagantly and richly in the metaphor of the threshold, the border between inner and outer. What is it, then, that the figure of the threshold yields? In the language of architecture, openings vitiate the border between inside and outside, and, in turn, conjure a theatre of exits and entrances. As Georges Perec tells us, doors and windows offer 'fixed punctuations' in solid wall-surfaces; they open the interior to the exterior with all the rich anticipation of the expected and the unexpected, the seen and the unseen, the known and the unknown. Doors anticipate the human form passing through it; windows, the offer of light and visibility to the interior, but also another vantage-point: a view. By closing a door we barricade ourselves in; we draw up lines of division; we separate ourselves off from others and we prevent osmosis.[7] By closing a door, we hem ourselves in.

In architectural terms, and according to the fifteenth-century treatise of Leon Battista Alberti, doors and windows have always offered, firstly,

use; secondly, decoration; and thirdly, symmetry: a series of interrelating horizontal and vertical axes. Written into the latter is a sense of 'appropriate form' or decorum; doors as emblems of social order carried in the figure of the entering and exiting individual. Doors are designed to accommodate the human form, while windows offer a good proportion of light. The dimensions of windows will vary according to the 'geography and orientation' of the particular building. In other words, windows correlate directly to the immediate external environment: what lies beyond.[8]

In a letter to an unidentified recipient, her famous 'Master' figure and a marital fantasy,[9] Dickinson conjures from the figure of her own front door the figure of a portal, heaven's gateway, and through this holy aperture, a sighting: the passing figure of 'Spring'. Spring is an event, a visitor who brings tokens of the changing demeanour of the outside world. There is something of the apocalyptic Puritan in Dickinson's visiting figure, in which the doorway of the home – locus of movement and transformation[10] – is tinged with the promise of Winthrop's New Jerusalem, a coming to a new order.[11] The figure of Spring at the door translates into a poem she sends to her sister-in-law, Susan Gilbert Dickinson, whose subject is the tug-of-war of changing seasons fought upon the liminal territories of doors and windows:

> Spring – shakes the sills –
> But – the Echoes – stiffen –
> Hoar – is the window –
>
> And – numb – the door –
> Tribes – of Eclipse – in tents –
> Of Marble –
> Staples – of Ages – have
> buckled – there[12]

Signifiers of crossing-points, three of her six lines end on 'sills', 'window' and 'door', and translate, in the final line, into a strange sense of 'there': an undetermined and unsettled borderland between seasonal landscapes, what Siri Hustvedt, writing of the mental geography of her childhood, describes as 'yonder': somewhere 'between here and there'; a middle region of the imagination.[13] Within this borderland, time gathers and accrues, the 'Staple of Ages' – like the frost on the windowsill.

Doors and windows, then, anticipate arrival. But Dickinson's guests often remain theoretical, anticipated but never received, the gateway between herself and the arrival remaining closed. Writing to her Norcross cousins Louise and Frances, Dickinson promises to visit. Her promised 'coming' is immediately followed by the announcement of her sister-in-law, Lavinia, having 'gone'. Since then, Dickinson tells her cousins, she has not dared to open a window and dreads the front door opening 'at the dead of night'. The relation between inner and outer is quite clear: the prospect of an imminent 'opening' of herself to another space and place, another set of junctures, sends the poet scuttling into retreat.[14]

Comings and goings are a consistent imaginative partnership. But what the poet seems most intent on is the expression of immediacy, the invocation of presentness. Indeed, many of Dickinson's letters are an exercise in making present what is absent, what she calls the 'sweet premium' of 'here always'.[15] This is nothing new to the American artist, for whom the abundance of space leads naturally to a language of imagined traversals. As Dickinson herself warmly declares to her epistolary companion, Colonel T. W. Higginson, anticipating his traversal from Boston, 'You would find … a spacious Welcome'.[16] In geometric terms – a language Dickinson understood well – she promises Higginson a symmetrical balance, an equivalent portion of the space he will cross to reach the Amherst home to the space she, as host, will offer in return.

Edward Hopper and Hovering

Dickinson, then, anticipates crossings, the overcoming of separation by the cruel barriers of space and time. In the twentieth century, the artist Edward Hopper takes on the often uncomfortable and disjointed experience of subjects hovering in unaccountable periods and portions of space. Hopper is just as devoted to the notion of imaginative embarkations as Dickinson, his hallmark composition being a figure staring into middle-space launched upon a train of thought. His subjects hesitate and hover, but the line of their thought, the point of their gaze, remains invisible and unseen. We have no idea where their sight lines end; all that we can see is an intermediary point, the form of a door or window that functions

as the primary point of cognitive and compositional focus. As viewers of Hopper's works, we act as go-betweens, between his subjects and the unquantifiable, unknowable form and content of mental space.

In an early sketch, *Evening Wind* (1921), a young woman crouches naked at an open window, staring outwards. We are not privy to the extent or aim of her view; the only indication we have of the external world is the window frame that underscores and etches out the act of seeing. We see her exposed but we cannot see what she sees; we also cannot see her looking, her hair covering her face and her head turned away from us. The relationship between inside and outside, the crossing-point between the two, is rendered by the billowing movement of the curtain lifted upon a breeze. The outside 'event', then, is the entry of the wind, pushing the curtain back into the room, and from our vantage-point, it touches the face of the young woman. Anonymous, Hopper's female subject appears to be meditating upon or longing for something; a relationship or continuum between inner and outer; an identity in the world.

East Side Interior from the following year continues this relationship. Here the female viewer is more clearly stationed in her interior environment. Positioned at her sewing machine, she has an occupation, but something has disturbed this activity and Hopper captures her locked into a moment of reverie, staring out upon the environs of New York City. Exterior space is more defined than in *Evening Wind*: a colonnade and hand rail, leading up to an apartment building, situates the apartment within a wider social space. Hopper's composition urges his daydreaming young woman towards a relationship with a context in which she can come to know herself socially. And so the painter encourages dialogue between a lost and anonymous private self, and a self who reaches for a wider scope of reference: a community.

In Hopper's compositions the window typically signifies a reaching after a broader identity; a desire to level the distinctions and tensions between inner and outer space. Wallace Jackson has noted that Hopper's understanding of composition renders experience as 'the rhythmic interplay of forms',[17] and in particular, the interplay, often unconsummated, between a private interior and a public context. In spatial terms, Hopper's paintings deal with the experience of space lived as well as space represented, and within this dialogue, the suggestive, often invisible representation of mental space.

Henri Lefebvre has determined the more discursive aspects of what he deems *lived* space; that is, space in which particular symbols and images form complexes of meaning and meet with particular lived-with objects. Lived space need not be particularly cohesive in terms of its complex of meaning because it is 'alive'; that is to say, it has 'an affective kernel or centre' which may shift and change.[18] It is a space easily dominated by 'conceived' space – the space constructed by architects, for example – and so just as easily subsumed within an ideology and practice, within forms of cultural knowledge, signs and codes.[19] But in terms of Hopper's compositions, subjects seem to hover awkwardly in an incomplete translation of lived space. This space may not be the 'conceived' space of Lefebvre's analysis: abstract and easily coded, the domain of experts. Instead, the space they occupy seems more relational, fluid and dynamic; lived, but also mentally limited. And so Hopper's characters reach out towards the new and the unknown, the unquantifiable, asserting a desire to extend the lived and limited space of their lives. The space they occupy is mental and the paths they track extend towards unseen, untraceable horizons.

And yet there is a persistently articulated longing for a relationship with the outside, and in this sense, Hopper's subjects gaze in a direction similar to the modernist architectural ideologies of Frank Lloyd Wright. It is well known that Wright's fundamental premise was a desire to open up the box of traditional architectural models, the manipulation of solid geometric forms, and the extension of long, low horizontal lines by which space could extend outwards.[20] Wright's lateral extensions were a reaction to the stuffy containment of Victorian designs, an undoing of confinement and enclosure.[21] In his prairie house design, first set out in his *Ladies Home Journal* essay, 'A Home in a Prairie Town' (1901), space was decreed no longer as commensurate with the length and breadth of walls, but as the amount of light entering the interior: just how much of the outside was permitted to come in.[22] Recognising the influence of the prairie space upon the home, Wright encouraged the prairie, with all of its environmental benefits, to pay a visit.

Wright's spatial configurations served, as he himself declared, as an 'implement to characterise the freedom of the individual'.[23] The horizontal line, he stated, was the line of domesticity; in other words, the line offering most possibility and hope of extension – simulating freedom through space.[24] Hopper's paintings encourage us to look at looking and, in doing

so, to insert ourselves into the canvas as another longing and looking subject. Sight lines are at the centre of Hopper's compositional arrangement; lines of desire faltering and hesitant, often broken and incomplete, almost always partial. His characters offer us partial views and partial sightings. Operating within limited lines of sight, they simulate our own frustrated view: our curbed range of vision. Drawn to the experience of the audience, Hopper's paintings often take as their subject staged performers or their equally staged and stagey onlookers.[25] *South Carolina Morning* (1955; see front cover), is a fine example of Hopper's interest in retreating sight lines, but also a comment on his subject's frozen pose and state of being. Here, a young black woman in a striking red dress stands, arms folded, on the threshold of a southern house. The house shutters are closed and she stares away from our view of an open landscape stretching towards a horizon. The central lines of the composition are lateral and horizontal; lines extend away from the side of house and porch, where the young woman is positioned, one foot pushed forward, hovering upon the boundary between hallway and front step. Hopper's composition stages a moment of self-doubt, of private regression in the midst of an unenclosed and unmarked natural space: the wide-open spaces of the prairie landscape that engulf her choice. The front door is hidden from view, perhaps tucked away behind her; receding into the hall, but out of sight. Only the dark, shuttered windows and the tenebrous form of the roof serve as reminders of her mental imprisonment, a condition easily forgotten if she were to look out behind her, upon the bright blue sky and light-coloured prairie grass that make up a significant proportion of the canvas.

Windows seem to signify choice. In Hopper's *High Noon* (1949), a semi-clad blonde woman appears on the threshold of a white clapboard house. A shadow cuts across the house, extending from the roof in a continuous sharp line. Ending at the base of the front door, it points down towards the threshold space. Windows surround the figure on all sides, symbols of clamouring choice. But the female figure remains hesitant, her left hand tentatively clutching the open parting of her dress. What the composition seems to state is that, although surrounded by potential views, Hopper's subject remains in limbo, unable to choose. Long, horizontal lines run along the canvas, from the delimited line of the horizon to the bottom left of the painting. These lines are stubbed and curtailed by the competing vertical lines of the house running up towards the chimney at the top of the canvas – a reminder of the limited extent of

artistic as well as lived space. The house itself sits flat packed against the blue sky, perched tentatively like the young woman, on top of flattened prairie grass; like Dorothy's wind-blown house in *The Wizard of Oz*,[26] it appears to have landed out of nowhere.

The proportions of Hopper's canvas rely upon an understanding of geometry, Dickinson's 'best witchcraft';[27] the proportion and ordering of parts; the division of space into fractions of sky, grass and house. The relationships between these constituent parts determine the nature of reality for Hopper's looking subjects, as they do for us, the viewer. As Hopper's wife, Jo Hopper, noted, her husband was 'interested in empty space that is not empty', a space filled with consciousness.[28] It is 'space consciousness' with its splayed cognitive axes that Dave Eggers' young narrator speaks of in the opening lines of his autobiographical novel, *A Heartbreaking Work of Staggering Genius* (2000):

> Through the small tall bathroom window the December yard is gray and scratchy, the trees calligraphic. Exhaust from the dryer billows clumsily out from the house and up, breaking apart while tumbling into the white sky.[29]

There are several Hopper-esque cameos in Eggers' writing, moments in which the Eggers siblings find themselves staring out into middle space – defamiliarised by death and its cruel displacements – trying to figure out the relationship between themselves and their environment. Early on in Eggers' memoir, the older sister, Beth, is figured in a Hopper-style composition: a network of open doors and windows. Awake early one morning, she finds the front door of the family home open. Turning from the sliding glass door of the kitchen into the family room, she sees that the curtains 'surrounding the large front window were open, and the light outside was white'. The window transforms into a movie screen 'lit from behind', upon which the image of her father coming into focus can be seen kneeling in the driveway. But the real focus of the window-screen is Beth herself, her 'squinting' and 'adjusting' vision coming into focus, unable to bear the visual record of her dying father.[30]

Eggers' memoir is a map of mental decimation and disintegration played out across a series of crossing-points – doors and windows, sight lines that run short of perspective and short of hope. From his apartment window in San Francisco, the young Eggers describes the view: a senior

citizens' home whose residents 'sit on their balconies watering their flowers, looking at nothing' as they stare through his window.[31] The tableau is a bizarre redoing of Hitchcock's *Rear Window* (1954)[32] and Eggers' narrator, a younger and mentally dysfunctional version of Jimmy Stewart's voyeuristic Scottie – without any of the happy neighbourhood antics. It is hardly surprising that Eggers' paranoid and increasingly psychotic narrator ends up in the tradition of American voyeurs. There is a lot of looking, but not the intense gazing of Hitchcock's characters; and none of the visual titillation of live murder.

In Hopper's paintings, windows direct the viewer towards something unfamiliar, something unknown. His characters are often in a state of leaving, at odds with their dwelling place. In his 1939 *Cape Cod Evening*, a man and a woman hover around the door and windows of a house that we assume, but are never told, is their home. The woman stands with her arms folded in resignation, her back turned away from the blank window-screen behind her, her body turned towards, we imagine, her husband. In close proximity, but paying her no heed, the male figure sits on the steps with the door closed behind him. The sense of the house is of a space sealed off, defunct and aimless. The door is not a functioning entrance or exit, and we are unsure whether Hopper's view of the house is from a side angle or from the front. The entire composition is oblique and incoherent. The only signs of occupation come from nature, who steals up, intruder-like, through the sandy-coloured grass that serves as a lawn and through a clump of dark and menacing trees to the side of the canvas – a reminder of the early American experience of the wilderness as a potential moral intruder. Unsettled, the house floats like a synthetic unit across the sea-like surface of the grass. Like many of Hopper's houses, this is not a home; in fact, everything about the composition suggests uncanniness: the dark, morose trees with their intrusive finger-branches; the opaque glass of the front door; the obscured, sealed windows – all this amounts to an environment of broken relations. In front of the man and woman a dog stands lost in the hazy perspective of the grass, his head turned away from his owners, aligned with a diagonal line reaching out and away from the canvas. Hopper's adversarial trio reads as a dark antithesis of the feel good family saga of *Lassie Come Home*.

Martin Heidegger has drawn a well-known distinction between 'building' and 'dwelling', in which dwelling involves a kindly concern for the inhabiting environment: the land, creatures and people and their

contingent states of becoming.[33] Dwelling involves the acquisition of habits in a place that permits something more than mere existence. Hopper's narratives are antagonistic to Heidegger's concern with embodied dwelling; his buildings offer no completion of the four-fold relation between earth, sky, people and a spiritual source ('the gods'); no securely defined worldly horizon.[34] Space sits awkwardly around his subjects, baggy and unclaimed. There is no sense of place – something phenomenological geographer Edward Relph argues can only emerge by the invocation of 'insideness'.[35] Instead, Hopper's canvases evoke outsideness, and in the case of *Cape Cod Evening*, this experience unfolds along the strong line of the threshold running beneath the seated male figure, unseating him with its vibrations of 'elsewhere'.

Hopper's subjects suffer from an existential sense of outsiderness. They hover around windows but receive no gesture of invitation to enter in or through their frames. And yet, traditionally, windows offer a dynamic of openness, a frame upon the world inside, an invitation to peek in. As architect Thiis Evenson presumes, windows present a 'face' and demeanour; a personality from an inside world pushed outwards. Through jambs, sills and lintels, windows lead out.[36] They offer futurity, the promise of movement, the threat of leaving. Ruth, sister of Lucille and narrator of Marilynne Robinson's novel *Housekeeping* (1980), applies the figure of the window to bonds between siblings and friends:

> like sitting at night in a lighted house. Those outside can watch you if they want, but you need not see them. You simply say, 'Here are the perimeters of our attention. If you prowl around under the windows … we will pull the shades.'[37]

Within this figurative logic, windows provide a 'smug' surety of the continuity of familial bonds; the secure line of the 'threshold' and 'sill' that Dickinson confidently patrols; the domain of the familiar.[38]

Windows draw attention to themselves and encourage patterns of settlement. Upon entering a room, people are typically drawn to windows, following a natural desire to linger, to settle down near light and air.[39] Windows offer prospects, good terms of domestic settlement. Returning to his family home from Lithuania, Chip Lambert of *The Corrections* steps into the Lambert front-room and immediately recognises the patterns of 'permanent' settlement written into the 'wood-framed' windows of his

parents' suburban home. In and through these windows he senses the 'prairie optimism' of the early Puritan settlers; an optimism arising from an unlimited experience of virginal space. Looking through the front-room windows, Chip can 'apprehend' his 'homeland' and greet a familiar version of America. He reads the 'cursive script' of national history in the window panes of his home, the 'wildness and entitlement' of an 'unfenced', pre-settlement version of America. He can 'dwell' in the imaginative possibilities of a long tradition of American aspiration.[40]

Lived Circumferences

On the other side of this 'prairie optimism' is the illusory reality in which Enid Lambert, Franzen's stay-at-home mother and domesticated prisoner, dwells. This is not a 'real' world, but a synthetic construction of domestic routine severed from any outside connection. Slavishly committed to awaiting the arrival of her family for Thanksgiving, Enid Lambert stares out upon a world that does not return her gaze. Standing at the kitchen window, she drifts into the 'quiet density' of a domestic silence that holds no form of life. Hers is an eerie and defamiliarised experience of 'insideness', an alienating domesticity that extends to her view of the outside, where clouds are figured as a 'ceiling', a piece of décor matching the defamiliarised theme of her inside life.[41] For Enid, windows are a screen through which she watches, helplessly, a ruthless form of modernity march across her family map; a dispersed form of modern life that may not bring her sons home for the holidays.

Similarly, in William Gass's short story 'In the Heart of the Heart of the Country' (1968) the window is a surface upon which the narrator and the world 'meet': a point of convention and tension. Gass's writer-narrator positions himself indoors while he looks out upon a version of Midwestern America in crisis. The window-screen yields slow-moving images. This is no high-speed action film, but a sequence of ghostly apparitions throttled by the gradual onset of a temporal rigor mortis. As for Enid Lambert in her kitchen, the slow progress of domestic time inverts reality: 'swung the wrong way round', the boundaries between 'world and I' collapse.[42] Gass's narrator speaks from a place of psychotic 'reversal', a mind turned

completely 'inside'. This is a place where the weather drives individuals 'inward'; a Midwestern prairie-state-of-mind; where fog creeps around the windows, and where paranoia breeds in abundance. Here, house and world are one, and the habits of dwelling have been replaced by mental obsessions, short cognitive circuits. On the windowpane, the traffic between inner and outer is one-way: there is only movement inwards.

Gass's foreshortened Midwestern view is an extended metaphor for a 'running sore' version of America. The inverted view from the window frames a nation suffering from too much 'sports, politics and religion'; a nation with little regard for global context. There is nothing 'pioneer' about Gass's Midwestern dwelling, no 'new language' by which America may be viewed, and reconfigured. The 'cursive script' of American prehistory that Chip Lambert reads in the suburban windows has translated, in Gass's story, into an uncertain community model; a neighbourhood filled with nothing worth watching out for – what Dickinson scathingly labelled the 'show' that is 'not the show'.[43]

In a letter to her preceptor, Colonel Higginson, Dickinson pours scorn on the neighbourly 'menagerie' that she observes from her window.[44] The lines between home and community are drawn; the domestic drawbridge is up, and the solidarity between home and neighbourhood is broken. Underlying this severance is a discontinuation of essential patterns of social engagement: social traffic producing social customs and conduct, duties and obligations; the rubric of public–private relations.[45] The neighbourhood spied from Dickinson's window has become a 'menagerie' precisely because she has stopped engaging with it. While Dickinson consolidates her inner world and draws up the limits of her lived circumference – through her poetry – the outer world, nonetheless, continues to exist. And so Dickinson becomes a 'menagerie' to those who visit her, what she herself terms the 'Mystery of the House', the display case that is Emily Dickinson at home.[46] The danger is that the inside world will itself become nothing but a menagerie – as is the case for singer Joni Mitchell's housewife in 'The Hissing of Summer Lawns', whose Chippendale furniture seems to have taken up the entire dimensions of her inner life.[47] Mitchell's housewife, like Enid Lambert, is another disrupted housewife-dweller. Ensconced in her 'ranch house on a hill', she has become the subject of her own domestic menagerie; and while she presents a 'show' of material status, she has no audience. The domestic stage is rigged up – a schema of gothic chiaroscuro – but the

drama of light and dark projected through the window-screen remains unwatched, unseen.

Mitchell's is a suburban frieze, a narrative stuck in space and time. The lady on the hill 'sees' and 'hears' the sights and sounds of community from her windowsill but has lost access to the customary habits and rituals of communal forms. Dwelling has become a reduced form of existing.[48] The 'I' that watches from the ranch house window perceives a certain version of reality; but it is not her own. 'Positioned within what Lefebvre calls a certain 'spatial practice' by her 'master', she is disinhabited and disinherited. In her 'ranch house on a hill', nothing 'lived' or living is produced.[49]

In Mitchell's domestic menagerie, the sun 'squints' into 'blue pools'. The relations between viewer and viewed, observer and observed, are muggy and unclear. The sun sees, but badly, and the blue pools are at once elements of scenery but also visual tools: both swimming pools and eyes. The composition is disordered and disorientating, and the source of agency, the viewer, is uncertain. To use Emerson's term, the relation between the 'circumference' of the eye and 'the horizon which it forms' is unclear. In Mitchell's suburban world, perceived objects are just as likely to become perceiving subjects. There is no evidence of Emerson's 'primary figure': the circular 'nature of God' whose centre is 'everywhere' and circumference 'nowhere'.[50]

Mitchell's homebound housewife exists within a circumscribed cultural horizon with no chance of a widening circumference. Novelist A. M. Homes's *Music for Torching* (2000) is an extended portrait of diminishing suburban horizons. In a desperate attempt to rid themselves of the site of their unhappy suburban lives, Elaine Weiss and her husband, Paul, enter into a bizarre compact to burn down their home. Homes's novel is a fibrillated surface of home tensions, a rising and falling pulsation of uncontainable anger and angst that sets a pattern of private spillages in public spaces. A sort of domestic revenge drama, Homes's novel frequently sees her characters exiting the home space in an effort to control nerves. And so hanging up the phone from a conversation with a career counsellor, Elaine moves outside to the kitchen steps, a pattern she repeats 'with the regularity of a cuckoo clock': hourly.[51] This ritual of domestic retreat shares a similar colour-scape to Mitchell's lyrical setting: the lurid Technicolor of director David Lynch's suburban lawn in his 1986 *Blue Velvet*: the colours of psychosis and the hyperreal. Unlike Mitchell's suburban 'lady',

Elaine is 'master' and deviser of her own world. But unlike Dickinson, or Emerson even, she has not 'mastered' her own circumference. She is both nowhere and everywhere, running from back yard to front lawn, desperate for some domestic orientation: some habits of place.

Following the fire, and having lost all meaningful sense of locality, Elaine appropriates neighbourhood characters in random efforts to acquire signs of belonging. And so, from across the road, Mrs Hansen is gathered up as an object of reassuring quotidian ritual: a volunteer-housekeeper with a penchant for the bottle. A kindly but unknown entity, she is enlisted as part of a programme of emergency provisions; a feeble and flabby attempt at what philosopher Michel de Certeau has termed 'the practice of everyday life'.[52] But Elaine's sense of space is not, in any sense, well practised. Her only rituals are related to flight; a series of knee-jerk responses to the loss of any form of domestic policy or governance. Elaine and her husband exist only for the breathing spaces in between blind panic.

Paul and Elaine Weiss are stuck in between one version of America and another; an idealised version of suburban life and a gothic reversal of that life; a suburban nightmare. As Sylvia Plath put it, there is 'viciousness in the kitchen'; and in the studio-kitchen of Plath's postwar poem 'Lesbos' (1962), 'it is all Hollywood, windowless'. The 'cute décor' of postwar domesticity has fallen into ruin; the 'kittens' have been 'stuck' out on the windowsill.[53] In Plath's poem, the kitchen is a stage for the acting out of domestic dysfunction in which the lighting, filtered through the colours of rising panic – red and white – demands more space than is on offer. When the poem does open up more space, it is to the ambitious space of revenge: the space of an extramarital 'affair', a meeting 'in another life'. This other life is acted out through choreographed rituals of leaving in which the poem's male persona is positioned down stage left, so to speak, 'down by the gate / That opens to the sea', where the view is larger and wider.[54] Like Paul and Elaine Weiss, Plath's husband persona moves outside the house to consider alternative perspectives; other lives. And like the Weiss couple, Plath's husband and wife figure act out alternatives to the home life; they perform rituals of leaving.

Out on the Porch

Dramaturgically speaking, Plath's poetic personae hover in between commitment to the home life and its overthrow; in a state of domestic revolution, or at least, revision. In the architecture of the American home, it is the front porch, particularly in the South, that most aptly signifies this place of in between. The porch lends itself as a performance space for the acting out of scenes and rituals. It is a sort of miniature public theatre, as Hopper's 1960 canvas *People in the Sun* demonstrates: an entertainment site or viewing station in which nature, the surrounding landscape, offers the seated occupants a spectacular show; something sublimely good to gawp at.

As southerner Eugene Walter puts it in his memoir of southern life, the porch is a concept as well as a place; it yields a life of its own.[55] And in southern culture, the porch is a place of congregation for the sharing of tales and talk, the consolidation of local news and gossip. For Walter, the southern porch was a sort of 'open-air parlor', whose climate permitted an opening up of the domestic characters and setting to public view. The porch is an event, both public and private: attached to the internal life of the house, but with a strong regard for the life of the street. The cultural roots of the American porch derive from blurry boundaries: the porticos of Greek temples and the ceremonial houses of the Mississippi Indians encouraged a slippage between the rituals of the inner sanctum and the populace positioned outside. Porticos, banquettes and plastered pillars served as emblems of the transition from high ceremony to low; from the rites of the initiates to the chat of the populace.[56] As poet Sue Bridwell Beckham explains, sitting on the porch 'was an event in those days / for which one freshened up'; located close to the street, a porch-dweller became immediately 'accessible', ready to 'to visit, to chat and receive'.[57] Sitting out on the porch involved a duration of time; it was a protracted 'occasion' for which one prepared and to which one committed.

With its origins lying in the southeast region of the United States, the American porch was an admixture of several cultural forms: the Indian bungalow, the Haitian 'shotgun' house, and the French side and back 'galleries'.[58] While the Dutch brought with them the 'stoop', an uncovered platform in front of the house, the French brought the all-around porch into the Mississippi region.[59] But the porch came into its own through

the Gothic revival style of architecture disseminated by Andrew Jackson Downing and Alexander Jackson Davis, where it served as a deliberate blurring of inside and outside.[60] By the middle of the nineteenth century, porches were a regular feature in American homes, and vacation homes built after the Civil War invariably included a purpose-built sleeping porch, following the trend of suburban homes. Providing a partially enclosed space formed from an array of semi-permanent surfaces, the porch was designed to fend off the elements; a layer of skin between the body of the house and its internal organs.[61]

The Greek Revival style plantation home, the setting for Tennessee Williams' *Cat on a Hot Tin Roof* (premiered 1955), typically included a surrounding gallery-style porch – a distinct characteristic of pre-Civil War southern architecture. Williams is quite clear in his 'Notes for the Designer' that the central locus of the play is an upstairs gallery 'which probably runs around the entire house', including two pairs of wide doors opening on to the gallery; a Victorian house 'with a touch of the Far East'. The playwright is typically exacting about the layout of the home set, including a source for the mood of the piece: an old photograph of the veranda of Robert Louis Stevenson's home on a Samoan island, where he spent the last years of his life. It is the tones of the porch furniture to which Williams pays particular attention: the cast of tender light falling upon faded bamboo and wicker furniture, the evocation of time passing – of having passed – out on the porch. Williams is suggesting that the porch 'brings to mind' something, across an extended period of time. Out on the porch, something can be delivered up. This is a mental space, a space in which to work things out; and so Brick moves out to the gallery in order to 'cool' down and settle his thoughts. Characters move up and down the gallery like overheated, caged animals. In the emotionally stifled atmosphere of southern familial dysfunction, the gallery is an extra piece of territory in which to traipse through heightened feeling. Out on the porch, characters disseminate, disperse feeling. And so Big Mama calls out for more air to circulate, while Brick stands on the gallery singing to the moon.[62]

In Williams' stage directions, characters suddenly 'appear' on the gallery as the number of occupants of the house swells, along with the number of claimants to the family estate. The play engages with the figure of space: the promise of its rich yield in terms of the family estate, the 'twenty eight-thousand-acre plantation' at the sound of which Gooper

and his family swoon. Acreage extends out of the house from the gallery: at the mention of the huge extent of the estate, Margaret is described in Williams' directions as going out to the gallery and 'calling softly to Brick', the first son and rightful inheritor.[63] She calls Brick back in from the gallery to claim his position in the inheritance battle.

Cat on a Hot Tin Roof is about the size of America and its gross fertile yield: the 'twenty-eight thousand acres of the richest land this side of the Nile'. The size of the land permeates the house, making it hotter, shrinking its capacity to hold and contain the sweaty tempers of its inmates. As E. Martin Browne states in his 'Editorial Note', 'the family is clothed with the atmosphere of the South as with a garment', an atmosphere that leaks out of the 'thin-walled house'.[64] Out on the porch, the home is opened up to the more uncertain experience of space. From the security of place – tracked through Williams' very specific stage directions – characters move out onto the gallery, where they confront the indeterminate interrogations of vastness: the unknown quantities of space on view, despite the specific sum proffered (28,000 acres).

In Carson McCullers' southern tale, *The Ballad of the Sad Café* (1951), the porch is the emotional locus for a tale of tortured love: a strangely defamiliarised and forgotten place that, over the course of the tale, slowly reawakens to its own history. Through an extended description of an abandoned house, a history of deformed love unravels. As the narrative warms up, we are invited by McCullers' narrator to step up and onto the porch – which is where we remain for a significant part of the ballad tale – the point of narrative issue. McCullers' porch-stage is a frontier for the single female protagonist, Miss Amelia, a Calamity Jane figure of the local community who keeps a tight regulation of her premises: the boundaries between her store and her home. Local men are kept on the porch after hours and never permitted access to her back rooms. Miss Amelia 'claim[s] kin with no one'. But boundaries are crossed with the arrival of the man she will foster and adopt: Cousin Lyman, the hunchback.[65] With the arrival of the hunchback, the porch, until now a measure of the distance between Miss Amelia and her fellow humans, undergoes new terms. Like a nineteenth-century southern territory, newly purchased, Miss Amelia settles into new terms of emotional engagement: she falls in love. As she crosses the porch with the hunchback, she traverses an as yet unplundered territory. And so the hunchback alters the map of Miss Amelia's premises; and having drawn a strict delineation between

the front street and the porch – both of which she owns – Miss Amelia opens up the geographical and political boundaries of her home. She redraws the lines between public and private space and sanctions a new set of relations between them.

As McCullers' tale becomes increasingly familiar – more like a love story – the porch extends into a place of public convention, gathering an audience to itself and its action. Men 'group' on the porch to watch this new 'showing' of Miss Amelia; a new and unravelling plot. The theatricality of the performance heightens as they watch the descent of Cousin Lyman from the upper rooms of the house: a grotesque version of Scarlett O'Hara, the southern debutante, descending down a sweeping staircase into the admiring company gathered below: 'The hunchback came down slowly with the proudness of one who owns every plank of the floor beneath his feet.'[66] His proud descent is the haughty ceremony of a 'beloved' who recognises the extent of his claim to his lover's emotional estate. He now occupies a 'place' in her heart, and dressed in the costume and props of Miss Amelia's familial legacy – a chequered shirt and a snuffbox in blue enamel, objects 'known well' to the audience – he performs the sort of show only a boastful claimant could reproduce. As the evening progresses, the performance moves from a sort of bear-baiting to something more festive; tensions disperse and latecomers are disappointed not to find 'some drama' at the 'entrance' to Miss Amelia's premises. A new 'transaction' emerges from the hunchback's porch-show, something more 'joyful' and festive. It is the beginning of the local café: the conversion of Miss Amelia's 'premises' to a communal 'place'. And so space transforms into place as it acquires definition and meaning.[67]

Williams and McCullers both deal with versions of spatial conversions: the experience of space as place and vice versa. For Brick and Margaret, space is inadequate and jeopardises privacy, which in turn jeopardises the capacity for intimacy and familial resolution. The plantation home is just too cosy; Reverend Tooker, for example, 'appearing' between the gallery doors, stalls the dramatic tempo between father and son, the plot of primogeniture. As Big Daddy says, 'its hard to talk in this place'.[68] In McCullers' tale, the public space of Miss Amelia's porch is converted to a more intimate place with the arrival of the hunchback. Through him, we are taken into the back rooms of Miss Amelia's; her home becomes *the* place, the central locus for community identity; a cardinal point in its oral history.

Porch Talk

The Ballad of the Sad Café is a portrayal of a threshold existence: an unnamed southern town whose cardinal point is a home-cum-café; a community with little geographical or temporal identity. The quotient point of the community is the relationship between a 'lover' and a 'beloved'; seemingly the only hope for 'company and genial warmth' and a communal legacy.[69] The tale of Miss Amelia and Cousin Lymon must be told in order for history to continue. There must be a 'place' to talk, a place for relating their tale of woe.

McCullers' fable is an exploration of spiritual loneliness, a realisation of what Alexis de Tocqueville diagnosed as the end-point of American democracy with its compulsive individualism.[70] Despite the lack of landmarks of her southern towns, McCullers evokes a potent sense of place. In her 1940 novel *The Heart is a Lonely Hunter*, place is the atmosphere of the front porch:

> The twilight was blurred and soft. Supper was almost ready and the smell of cabbage floated to them from the open hall. All of them were together except Hazel, who had not come home from work, and Etta, who still lay sick in bed. Their Dad leaned back in the chair with his sock-feet on the bannisters. Bill was on the steps with the kids. Their Mama sat on the swing fanning herself with the newspaper. Across the street a girl in the neighborhood skated up and down the sidewalk on one roller skate. The lights on the block were just beginning to be turned on, and far away a man was calling someone.[71]

The porch constructs a familial unit, distinct from but also related to a wider context – a neighbourhood. It is a place indicative of hospitality even if, in frenetic, contemporary America, as Michael Dolan has suggested, its symbols of hosting are left unused – its cosy rockers and wind chimes.[72] Anthropologist Victor Turner has identified the liminal state induced by certain rituals in primitive cultures: a state of 'betwixt and between'; a state of transition.[73] A liminal space, the porch sits between the culture of the family and the wider culture of the neighbourhood. It is a place of assembly, where family members can each hold a position and play a role. The porch encourages the staging of family life: a

'showing' of familial relations. In McCullers's porch scene, each member occupies a particular area: Dad on the banisters, Bill on the steps with the kids, Mama perched on the swing. The porch gathers up the missing members – Hazel and Etta – and the entire family is read against the broader canvas of the life of the street. An elastic space, the porch is a thoroughfare between indoors and the public sphere, ensuring safe but contained movement.

The young female protagonist, Mick, is quite aware of the competing experiences of space and she divides her experience into 'two places': the 'inside room and the outside room', the latter connected to the public world of school and family, the former to the 'foreign countries' of her own mind. The porch space is the crossing in between. And so, decorating the family home for a party, she moves from the hallway to the porch, out onto the street and back again, simulating the experience of entering the house 'for the first time'.[74] Here, the space of the porch presents the opportunity for a revisionist glance at the home, a new 'approach' to looking at the familiar. Moving back and forth across the porch, space and time work together to construct distance and perspective: revision. Distance belongs to the objective realm, but distance can only be known as such as long as there is a horizon in view. As soon as the horizontal plane of distance stretches beyond the remote horizon, viewing is over. Nothing more can be seen and nothing more objectively can be known.[75] Mick's porch run-up earns her just sufficient distance that she can reassess what is, by now, too familiar: the proportions and presentation of her home. It is distance that Hopper's young black woman of *South Carolina Morning* seems to fear: the effect of objective distance, a reckoning with the subjective spin of home life.

In McCullers' novel, the southern porch receives changes in mood as it does the elements. It is a mood-receptor precisely because it is a space of transformation and transition: from public to private discourse, from public to private identities and vice versa. In southern culture in particular, the porch is a place of oral history and memory, a place of story, in which the listener participates as much in the conspiracy of telling tales as the teller. Folklorist Zora Neale Hurston was alert to the rich oral tradition of southern African-American culture, the 'mule talk' or tall tales that form the backdrop for her 1937 novel *Their Eyes Were Watching God*. In Hurston's novel the 'talkers' are 'the center of the world', and time and space are created through the movement of talking. For the African-American

community, porch talk was a way of displaying not only words, but also bodies, and in Hurston's novel in particular, an anthropological gathering up of bodies of tales related to forms of seeing. Hurston's tale-tellers relate what it is they see, aspects of their community; they are 'big picture talkers', making visible that which might otherwise remain invisible.[76]

As Hurston recognised, talk passes through time and space; it moves, lyrically, across landscapes. Texan singer-songwriter Robert Earl Keen translates the experience of being 'out on the porch' into a framed landscape:

> This ol' porch is just a big ol' red and white Hereford bull
> Standin' under a mesquite tree in Aqua Dulce, Texas,
> He just keeps on playin' hide and seek with that hot August sun[77]

Keen's 'Front Porch Song' carves out curvilinear time and space from a static place. It is the 'porch talk' of the lyricist that generates movement, and so the bull under the tree avoiding the sun is a moving composition whose launching-point is the position of the speaker on the 'ol' porch'. As the lyricist of 'Porch Song' by the southern jam band *WideSpread Panic* tells us, the porch offers up a surreal land in which, following a nap, he opens his eyes 'to see / A land of sunny rocks and funny trees'. Time and place shift with the direction of the breeze; this is a dreamscape, moving from 'today' to 'matinee' to 'moontime': an unmarked time and space of 'play'. 'Moontime' is the timeless zone of the porch; a place that is static, yet also perceives and conceives moving, the lyricist sings: 'from here I watch the world go by'.[78]

As Gertrude Stein noted, America is a space always 'filled with moving'.[79] From the front porch, activity breeds: in conversation and story telling, and from the lives of the passers-by. Going out to the porch allows the tissue of home life to breathe, opening the domestic pores to the ever-expanding skin of the neighbourhood and the world.[80]

The Lawn

Beyond the porch lies the front lawn, the most manicured of American pets.[81] Since the eighteenth century, the American lawn has been an aesthetic example to the neighbour or passer-by; a showcase of the wealth and prestige of the middle classes and an indication of prosperity.[82] It is a contribution to the collective aesthetic of the neighbourhood; a surface of social unification first conceived by landscaper Frederick Law Olmsted shortly after the end of the Civil War. Olmsted, commissioned to design one of the first suburban communities of modern America, conceived of a landscape in which neighbouring families would live among a seamless extent of green: a single park. And so it was that the American lawn, that national grid of patchwork green, began to spread.[83]

Like the parlour rug, the front lawn is a formal space, a place of reception and socialisation. As Frank J. Scott (protégé of Andrew Jackson Downing) noted in his study of suburban grounds, 'A smooth, closely shaven surface of green is by far the most essential element of beauty on the grounds of a suburban house'.[84] It is a place into which one welcomes friends and neighbours.

The lawn is a testament to America's subjugation of its natural environment: an end to the wilderness. A lawn requires constant tending if the mess of the wilderness is to be kept at bay and America's pioneering history is to be respected and preserved. It is a reminder to the American family of how far it has come: from the regional landscapes of local vegetation to a homogenised national landscape of groomed grids. In the nation's capital, the lawn yokes institutional power and domesticity, and many a photo shoot of the president and his entourage are shot on the Whitehouse lawn. A unified, continuous and well-kept surface, the Whitehouse lawn is a potent metonym of nation. A reflection of domestic policy, the neat front lawn is an indication of domestic control and contentment. As Downing noted, smiling lawns are an indication of order and control; of a culture settling down.[85]

And the lawn is a space to be crossed, a velvety traversal between the public street and front door. Jay Gatsby's chauffeur does just this one Saturday morning, crossing Nick Carraway's lawn with 'a formal note from his employer': a letter of invitation. The culture of the American lawn is inherently competitive precisely because it represents money, time

and labour.[86] And so Gatsby calls Nick away from his modest acreage of green turf to partake of the extravagant 'momentum' of his own runway lawn; to share in his wider economic and territorial reach.[87] Gatsby's front lawn is a place of consumption, where men stand around 'looking a little hungry' and feed upon the extravagant offerings of his wealth. Invitations to his front lawn are like a series of issued bank statements.

The lawn is also an extravagantly consuming territory. Its upkeep is costly. Annie Dillard, writing out her childhood in Pittsburgh, remembers gathering buckseyes from neighbourhood lawns and noting that 'Buckseyes were wealth', the windfall of economic hunting and gathering.[88] An intact lawn signals an intact home, a measure of democratic success – the green emblem of the self-made American family. Its trim edges are also a measure of moral intactness; moral neatness. But inherently unnatural and relying upon a continuous 'chemical warfare', the well-groomed green often remains an illusory surface, prey to all kinds of blighting weeds.[89]

A corruptible surface, then, the American lawn has hosted a series of famously illicit scenes. Writer Vladimir Nabokov's iconic pursuer of pre-pubescent girls, Humbert Humbert, goes out onto the lawn of 342 Lawn Street to distract himself from his cravings; to cut the lawn. Pumped up with gin and pineapple, he wrestles with the dandelions as he does with his own 'unkempt' impulses, and dances, clumsily, through the motions of his desire. An expert voyeur, Humbert has calculated the precise angles and distance afforded him between his desire – a glimpse of his darling Lolita – and the imminent return of respectability in the form of Mrs Humbert, Lolita's mother. The front lawn provides the perfect length of grass, a perfect geometry for his perverse angling:

> As I lurched and lunged with the hand mower, bits of grass optically twittering in the low sun, I kept an eye on that section of the suburban street. It curved in from under an archway of huge shade trees, then sped towards us, down, down, quite sharply, past Old Miss Opposite's ivied brick house and high sloping lawn (much trimmer than ours) and disappeared behind our front porch which I could not see from where I happily belched and labored.[90]

Despite the messy intoxication of his desire and his clumsy lawn work, Humbert is nonetheless aware of the suburban codes attached to the front

lawn: neatness as a reflection of good domestic management. And so he casts himself in the role of good neighbour while illicitly converting the activity of mowing into an opportunity for indulging in his favourite sport: spotting nymphets. Humbert goes out onto the lawn to gain a 'slant' – not the 'slant' of received insight that Dickinson records,[91] but the slant of voyeurism whose end-point is deviancy. He wangles an angle, and like the leaning female of Hopper's *Cape Cod Morning*, reaches for an extended view of the neighbourhood – to suit his morally dubious purpose. For Humbert Humbert the lawn functions as a rectangular container of his paedophilic desire, and he trips out onto the lawn as a pervert.

The opening sequence of director Stanley Kubrick's 1962 version of *Lolita* is an iconic shot of the American front lawn breeding a tantalising danger. Sporting herself upon the verdant green, Lolita is dressed for a pantomime show of seduction. In Kubrick's visual schema, the lawn is a dangerous place, a 'sudden burst of greenery' emitting a 'blue-sea wave' of swelling desire and infatuation. With all its precocious need for tending, the lawn breeds infatuation instinctively: 'from a mat in a pool of sun, half-naked, kneeling, turning about on her knees, there was my Riviera love peering at me through dark glasses'.[92]

And finally, and most dangerously, the lawn becomes a graveyard. Driving back into the suburban neighbourhood, Humbert receives his environment, cinematically; a surface of sheer mesmeric charm: 'The cicadas whirred. The avenue had been freshly watered. Smoothly, almost silkily, I turned down into our little street. Everything was somehow so right that day. So blue and green.'[93] But danger strikes: Humbert's infatuation is exposed, and between the angles of the front lawn the death of Charlotte Humbert (Haze) unfolds. The silky smooth lawn enfolds tragedy, from the 'roll' homeward of Humbert's car back to Lawn Street, to the violent confrontation at the threshold of the home, climaxing in the accident on the street in front of the house. In the final image, the instrument of murder – the 'big black glossy Packard' – lies like a beached whale upon Miss Opposite's sloping lawn, 'an angle from the sidewalk'. In Nabokov's suburban world, the view from the lawn is morally off-kilter; lopsided and dangerous.

Sofia Coppola's 1999 film adaptation of Jeffrey Eugenides' *The Virgin Suicides*[94] brilliantly captures the dangerous allure of suburban greenery, a paradisial dreamscape of leafy elms and iridescent summer lawns

bestrewn with budding young female forms. Lying out on the front lawn grass, Lux Lisbon (Kirsten Dunst), the oldest of five creamy California-style beauties, is a 1970s version of Humbert's Lolita: a fairytale image of American adolescence. Cinematographer Ed Lachman returns repeatedly to the image of the dewy front lawn as a sort of outdoor lounge – agreeable host to the floppy and dreamy inactivity of teenage girls. Sunlight floats like flotsam and jetsam over the camera lens; blinking at the blinding green and golden light, we are drawn into the fantastical, curlicue plots of the teenage mind.

Eugenides' fable is set in mid-Seventies Detroit, however, not California. The greasy reality of the automobile industry lies behind the dappled sunshine, and out upon the lawn another ghastly plot is breeding: the ritualistic suicide of five beautiful girls born into one family. The final comments on this suburban horror show are measured by the uncut state of Mrs Lisbon's lawn as she staggers across it to pluck a snapdragon from her neighbour's garden.[95] Eugenides' subtle comment on the untidy state of her lawn is a yawning understatement of the domestic mayhem lying behind the Lisbons' front door. In the tidy mind of nineteenth-century garden designer Frank J. Scott, Mrs Lisbon's lawn displays all the signs of a 'slattern'.[96]

In the dark imagination of director David Lynch, the suburban lawn breeds all kinds of pestilent forms of life. Lynch's masterpiece of a domestic horror show, *Blue Velvet* (1986),[97] upsets all the notions of sunny suburbia set up by 1950s sitcoms *Leave it to Beaver* and *Beaver knows Best* – shows that invariably opened with a casual invitation to cross the lawn and thereby enter the friendly neighbourhood household. Lynch's film is a suburban dystopia in which the character of the lawn in the opening sequence takes vengeance upon its friendly caretaker, the good neighbour lovingly tending to his green carpet. Following the conceit of the surface, Lynch's invasive camera crawls through thick, viscous blades of grass, exposing a habitat breeding pernicious and predatory insects: a dark underworld beneath the glossy green turf. The wrapping of red roses, a blue sky and a pristine white picket fence that is the film's first image – the 'smiling' surface of Andrew Jackson Downing's lawn-idyll – is converted into a Pandora's Box of creepy-crawly monsters. The armies of beetles marching beneath the lawn – a Darwinian display of survival of the fittest exoskeleton – reveals a warring horde of life that the American lawn does its best to conceal.

Like Nabokov's *Lolita*, the essential drive of Lynch's film (and, indeed, perhaps all film) is voyeurism.[98] His later film *The Straight Story* (2000)[99] also dramatises lawn culture. But unlike *Blue Velvet*, this view of the lawn is positively bucolic. The opening sequence begins with a dreamy montage of small-town America – Laurens, Iowa – the camera dipping gently down towards the image of a large woman sunning herself upon a neatly mown lawn. The film continues with the narrative of Alvin Straight, a war veteran who sets out upon a road trip-pilgrimage to visit his brother across hundreds of miles of tarmac road – on a lawnmower. Alvin's journey is an attempt to 'mow' back the years, a life tossed out only in hints and suggestions, along with the sputtering rhythms of the lawnmower, but a life that certainly included the traumatic effects of war, alcoholism and an act of negligence that led to one of his grandsons being burned. Alvin's road trip is as much a journey towards redemption as it is a visit to his dying brother.[100] The lawnmower vehicle is elected for its symbolic worth as an image of domestic caretaking, a symbol Alvin literally rides into the ground as he pays penance for years of domestic negligence; his failure to maintain a healthy turf.

Bare in the Back Yard

The Straight Story begins on the back-yard lawn: a private and more sheltered space than Gatsby's front lawn showcase. After the Second World War, family homes were increasingly designed with porches on the back of the house, overlooking a back yard or garden. And so the front yard or lawn took second place to the back-yard patio, as the driveway to the garage was foreshortened: an acknowledgement of the dominance of the automobile in contemporary family life.[101]

Arthur Miller's *All My Sons* stages the postwar back yard as a place of confession and secrets; a place of 'secluded atmosphere' and limited access; a place with a foreshortened view of the world, as the poplars obscuring the view of the driveway hint at in the opening stage directions.[102] In Miller's back-yard play, secrets are gradually laid bare: private, familial secrets, but also the secrets of a nation. Despite its lack of view, the back yard is a deeply political space, a synecdoche of the nation-state with all

its penetrable and vulnerable borders. Indeed, the dramaturgy of Miller's play is built entirely around border-tensions: narrow spaces of limited access through which only the familiar and known may pass – as Frank Lubey passes through a 'small space between the poplars' in the opening scene.[103] As a trusted neighbour, Frank is privileged with easy access; he 'saunters' through the gap in the poplars. He knows the way in and out of the Keller household. He has access to its secrets.

The topology of the back yard is the topology of the neighbourhood and, in turn, a topology of America. Annie Dillard recounts the memory of her Pittsburgh neighbourhood as an extension of territories moving away from the suburbs, out through the 'peopled' towns of the highways, leading augustly out towards the great mountain ranges of the Rockies and Appalachians. Within this topology, the back yard is the first and essential unit. Dillard recalls the poplar trees separating one space of the neighbourhood 'maze' from the next, one back yard from another.[104] Like the poplar trees in Joe Keller's back yard, Dillard's trees are an indication of the skin separating family life from the events of the world, a hermetic space breeding myths and misinformation. As Don DeLillo notes, the family is the 'centre of the world's misinformation … Not to know is a weapon of survival.'[105]

America has always employed moats of space as a means of identifying herself, and the fenced-in space of the back yard has always been a political one. Writing to Mabel Todd in 1885, Dickinson signs off with biting irony to her 'Brother and Sister's dear friend' as 'America': a signature denoting defiant territorial independence; in other words, get out of my back yard.[106]

'Back-yard' America is American politics at home, the politics of the everyday citizen. Annie Leibovitz speaks for the majority of American citizens when she states, 'I feel a responsibility to my backyard. I want it to be taken care of and protected.'[107] Cold War America, from which Miller's play emerges, is a nation fraught with fear for its own privacy, the erosion of its domestic borders and the infiltration of foreign bodies (communism) into the sacred space of the home. Privacy is the constitutionally sacred privilege of all autonomous home-owning families. As Deborah Nelson reminds us in her study of the confessional literature of Cold War America, the removal of privacy is a betrayal of a constitutional right, a betrayal of the Supreme Court's 'fashioning' of a right to privacy.[108] Sitting in his back yard, Joe Keller would prefer to read

the 'want ads' rather than the national news; fend off the public voice of national headlines; deal only with small, local transactions.

Stepping into the back yard, one steps into the fenced territory of familial myths. The backs of houses – typically less perfectly proportionate than the front – intimate private lives. From the back yard, one stands closer to intimacy and inclusion. It is the equivalent of the Victorian back parlour: for family matters only. Ray Bradbury's *Dandelion Wine* (1946) is a portrait of familial intimacy spilling out into a back-yard reverie. Like novelist Don DeLillo's *White Noise* forty years on, Bradbury's semi-autobiographical novel is a study of the American soundscape, but in this case, one closer to home. The sounds of the back yard are syrupy: a slow, mellifluous outpouring of familial voices, a chorus of memories rechanted by young Douglas Spalding. A form of sound-trafficking blurs the divisions between the domestic world and the outside world. The rocking chairs on the back porch simulate the syncopated chirp of the crickets in the back-yard lawn; female voices inside the house waft out upon the night breeze and join in with the voices on the back porch: a circuitry of sonic currents.[109] As Bradbury's novel demonstrates, back-yard living is the experience of recondite relaxation and synaesthetic recall. Around the hub of back yard noises, forms of memory hover and gather. Family history is lived and then remembered, recounted. Through the off-duty postures of the back yard, stories unfold, are spun out.

Since the 1970s, American homes have been increasingly designed with the back of house more in mind for living than the front. Front doors provide only symbolic entrances, but are an impressive greeting mainly unrelated to daily life. Most family traffic passes through the garage and kitchen door, from the side or back of the house. Living rooms are clustered around the back of house, near, in the case of upper-middle-class family homes, the swimming pool and the back lawn.[110]

Director Sam Mendes' 1999 box office hit, *American Beauty*,[111] provides ample evidence of the layout of modern homes and the cognate dysfunction encouraged by these scattered spaces: the icy-cold dining room at the front where the family confronts itself in a chilly ritual of forced candlelit intimacy; the view from the back yard through the kitchen window, where father and daughter are deadlocked within a distinctly uncosy cameo; the back-yard pool, whose cinematic unveiling through gleaming white French window blinds is the job of Carolyn Burnham, desperate suburban mother and real estate agent. *American Beauty* is a

diagnosis of the failed designs of suburban living. The contented twitter of Bradbury's back yard soundscape is replaced by the banging and scraping of chairs against French polish, the slamming of mahogany doors and screened windows, the argy-bargy of domestic scrapping. Carolyn Burnham's dramatic appearance at the front door of the home she is commissioned to sell is the equivalent of Scarlett O'Hara's appearance at the top of her mansion-home stairs in the 1939 film adaptation of *Gone with the Wind*: a stagey gesture of self-announcement.[112] But this front-door appearance has little to do with the real plot. In the modern home, family life is spent out back. There is little tolerance for the casual caller. Invited guests know to go round the back.

In America, the separation of public and private space is an ongoing fact of daily life. Indeed, the suburban home is built entirely upon the premise of the desire for more space – a larger lot of land – and therefore more potential for privacy. And because suburban America is mainly reached by automobile, most postwar home owners desired a back-yard porch in which to sit away from the noise of passing cars.[113] In the back yard, the private citizen can find peace and relaxation. He can forget the noise and crushed routines of the modern world.

From the back yard we enter the back quarters of the family home and into the most intimate quarters, areas dedicated to privacy: the quiet reserves of the back-yard porch, the sunroom, the family room – the continued nineteenth-century tradition of distinguishing private from public space.[114] The American bathroom, like the back yard, is a place of personal consolidation. It is one step removed from the back yard; it is the solitary individual alone with himself, removed, momentarily, from family life. For America's most famous literary salesman, Arthur Miller's Willy Loman, the bathroom permits an escape from the present. Like Bradbury's back yard, Loman's bathroom is associated with reverie and his tendency to flashbacks, his so-called 'imaginings'; time out from his flagging public and familial self. Sitting in a restaurant with his sons, he recalls a sales trip to Boston during which he took a woman back to his hotel room. A knock at the door forces Willy to secrete her away inside the bathroom. But the man at the door is his son, Biff, and his detection of the affair means that Willy's role as upstanding citizen and family man is badly scathed. For Willy, the bathroom is a site of shamefully stored secrets. His bathroom-flashback punctures the play with more personal guilt; it is another reminder of his sense of consummate failure in both

public and private arenas. For Willy Loman, the bathroom or restroom is not a place of private recuperation or relaxed bowel movements.[115] It is not part of the comforting hold-all that Dickinson imagined the home to be. Neither is the snug, predictable space described by architectural critic Witold Rybczynski, remembering his parents' 1950s three-bedroom bungalow and bathroom: a place of comfortably familiar memories.[116] It is a haunted space: a place of revenants and regression.

3

Hotels, Motels and Bathrooms

Behind the Bathroom Door

Behind a hotel bathroom door, Willy Loman hurriedly bundles the source of his shame away from the intrusive enquiries of his son, his moral inquisitor. Shut up in a hotel room, he anticipates anonymity and privacy; a place in which he can experiment, in private, with his own failings.

'But who is not vulnerable, easy to scare and jealous of his privacy?' asked poet W. H. Auden in his 1962 poem 'Thanksgiving for a Habitat'. As a British expatriate-turned-citizen living in Cold War America, Auden voices the religion of his adopted nation: the inviolable right of every citizen to a protected private space. 'Territory' and 'status', he concludes, are paramount concerns of the modern citizen, a 'toft and a croft' where the self may choose which people he will be 'at home to'.[1]

And as Auden recognised, no one is more at home with himself than behind the bathroom door. For the long-term New Yorker, the bathroom was a place of privileged withdrawal, a 'sacrosanct political right'; a version of Dickinson's upstairs bedroom 'chamber' – not somewhere to spend a lifetime – but certainly a place where one could 'withdraw from the tribe', and in Dickinson's case, write. His ode to the bathroom, 'Encomium Balnei' is a paean to the 'unclassical wonder of being all by oneself' and a celebration of the one-way lock of the bathroom door. Behind this door, the exhausting roles of parent, spouse or guest can be dropped. Off-duty and off-guard, the bathroom offers a space for confession, a place of private musing: as Auden admits, 'where else shall the

average Ego find its peace?'[2] This chapter will trace ways in which, firstly the bathroom, and then the hotel and motel spaces of America, offer its citizens places in which to escape their public duties – in comfort. Despite promising a sense of home away from home, the American hotel and motel culture has not always produced such comforting effects. In the corridors and cubicles of such discrete spaces, the fantasy of privacy often turns grotesque, even darkly horrific. As Jack Torrance of Stanley Kubrick's masterpiece in hotel gothic, *The Shining* (1980),[3] memorably demonstrates, it is not always a good thing to find one's self sequestered alone within a hotel or its bathrooms.

As Jack Torrance finds out, the American bathroom is not always a place of peaceful recuperation, a 'restroom'. Historically speaking, this was certainly true. It was not until the mid-nineteenth century that plumbing arrived in America, and for the colonist, the bathroom was nothing more than a chamber pot. Before that, it was a case of open fields, forests and running water. Over the course of the eighteenth century, the outhouse gradually became commonplace, an indicator of social position. William Bryd, New England magistrate, took this rather literally and based the design of his outhouse seat around his seat in court. In the nineteenth century, Thomas Jefferson designed an outdoor privy at his Monticello home around a pulley system carrying chamber pots in and out of an earth closet, and at his Poplar Forest home in Virginia, he included two octagonal brick outhouses to match the shape of the main house.[4] Clearly, the status of the bathroom was on the rise.

With the emerging hotel culture of the 1940s and 1950s, the American bathroom achieved a new level of sophistication as a vital item in the display of luxury. Modern-day American 'worship' of the bathroom (bragging about the number of bathrooms one has is a common method of advertising one's home) has its roots in the fledging Victorian hotel industry.[5] The crucial transition from public to private bathroom took place among the earliest luxury hotels, and in 1844 when the New York Hotel opened, it offered the choice of both hall bathroom and private bath.[6] By 1853, every bedroom at the Mount Vernon Hotel at Cape May, New Jersey, included a bath with hot and cold running water. Championing privacy, American architects perhaps regarded the English habit of plodding down the length of the hotel corridor in order to bathe, as absurd and unnecessary. By the turn of the century, hotel plans had begun to include bathrooms in between bedrooms. A precedent had been set.

Mirroring the development of the public bathroom, the rapid sprawl of bathroom luxury continued into the private home. According to Witold Rybczynski, this meant that what had been 800 cubic feet of trim space holding only a basin, bathtub and toilet, expanded extravagantly into a room that seemed to hold as much potential for hosting events as it did for bathing. What incited this sense of 'event' was the arrival of bathroom décor. And so companies such as KB Home formed collaborations with celebrity interior designer Martha Stewart to produce luxury designs along the lines of the Victorian boudoir (patterned wallpaper), coupled with a Hollywood-style glamour (sparkling white tub) and designer chic.[7] The effect was bathroom theatre.

But the division between public and private bathroom is acute in a nation where the public bathroom has long been a politicised space, an arena for the reinforcement of social and cultural boundaries. Until the Civil Rights movement of the 1950s and 1960s, bathrooms were segregated along racial lines. Sexual propriety, decorum and morality all arise from bathroom 'discourse', and at the heart of this discourse is the segregation of gender.[8] Public 'restrooms' are clearly quite different spaces from private bathrooms. In the public restroom, men and women commonly meet to discuss the other sex. In Mike Nichols' 1983 film *Silkwood*,[9] for example, the female employees of a plutonium plant congregate in the bathroom to discuss the latest safety breach by their male employers and the latest victim of that breach. Their restroom chat is resistant, probing the power structures that structure their existence as employees and as women. The factory restroom marks the transition from an individuated form of identity, to the clinically white, androgynous jumpsuit and headgear of regulation uniform. It is a place of conversion: from private to professional self; from 'Karen Silkwood', the film's protagonist, to an employee number in a factory of numbers.

The public bathroom or restroom confirms heterosexual identities and the props of those identities. It is a place of cosmetic self-construction and deconstruction, but also a place where confidences concerning identity are shared. When Karen (Meryl Streep) compliments her co-employee Thelma on her new hairdo, Thelma, in an act of frank divulgence, confesses to the fact that her hair is a wig. She passes on her cosmetic secret and in doing so reinforces the private bonds between employees that will later serve to strengthen the more public cause of the factory's infringement of employees' safety regulations.

The gender segregation of public bathrooms encourages sexual conspiracies. In director Neil LaBute's *In the Company of Men* (1997)[10] the two male protagonists, Chad and Howard, concoct a devilishly misogynistic revenge plot against a mute female employee in the corporate bathroom – a plot designed to avenge a failed heterosexual relationship. Against the Japonaserie of a stylish corporate interior, Chad and Howard plot against the female state. Chad, chief deviser, emerges from the bathroom cubicle and recounts to Howard, ensconced in the adjacent cubicle, his first plotted date with Christine – their 'vulnerable as hell' target. 'Sweet' and 'giving', Christine is the 'perfect' target for their misogynistic revenge plot. The men meet in the bathroom to give updates on their progress, and so the space functions as an alternative boardroom, where Chad often feels less than the fittest corporate player. A locus for revenge plots against the other sex, the corporate restroom is a container for an excess of male spite.

And the bathroom is just that: a container for excretions and excesses; a holding place for private thoughts and interpersonal transactions; an interval in which to recompose oneself apart from the unwarranted attentions of the public world.[11] At times, it is a place of illicit secrets: smoking, sex, narcotics, murder even. The bathroom contains all the filth, shame and self-disgust associated with western codes of cleanliness and pollution. As such, it is a place of confession, a potential broker of secrets. Harold Little-Smith of John Updike's novel *Couples* (1968) visits the bathroom to take aspirin for his headaches. Like his 'occasional call girls', Harold regards aspirin taking as 'hygienic': a behind-the-bathroom-door activity.[12]

One visits the bathroom, then, for more than one form of relief. In Alfred Hitchcock's 1963 *Marnie*,[13] the film's eponymous kleptomaniac spends extended periods of time in the bathroom. Following on from her first theft, she changes in the bathroom from brunette back to her natural blonde colour, washing away the residue of a constructed double self. But the bathroom is also a place of entrapment. Having been 'caught' by her next victim, her employer Mark Rutland, she is forced into a marriage with Rutland in which roles are reversed, and Rutland plays the role of husband-psychoanalyst, and she, the deviant wife-patient. To avoid his psychological probing during their honeymoon cruise, she retreats into the cabin bathroom where she spends, according to her husband's time keeping, 'exactly forty-seven minutes'. As Rutland, played by Sean Connery, concludes: 'The battle ground of marriage is not, contrary to

the movies and *The Ladies Home Journal* … the bedroom. The real field of battle is the *bath*. It is in the bath and for the bath that the lines are drawn and no quarter given.' Held hostage to a single identity, Marnie begins to unravel. She retreats into the bathroom as she also retreats from an enforced singular identity: as Rutland's wife. The bathroom is her hidey-hole, a place of escape from the psychological scrutinising of her husband and the confining institutes of marriage. For a whole forty-seven minutes, Marnie's role as wife is suspended.

For Hitchcock's heroines, the bathroom is often a place of reconstitution. The same goes for Blanche Dubois, the unsurpassably stagey heroine of Tennessee Williams's *A Streetcar Named Desire*. With little room to spread her theatrical wings, Blanche colonises the bathroom as a fantasy space, a dressing-room in which she tries out imagined selves like costumes. In Winston Graham's novel *Marnie* upon which the film is based (1961), the heroine-narrator describes the ritualistic cleansing that a private bathroom permits her: the 'skinn[ing] off of old contacts with things and people'; and the rebirth as she steps out of the bathtub. Stepping from her bathroom, Marnie Elmer is a 'real person again', no longer a fraud.[14] She returns to a version of herself that is less of a performance than the self that steals.

For Esther Greenwood, heroine of Plath's *The Bell Jar* (1961), a period in the bath converts into an existential ablution whereby the more baleful aspects of New York City slickness are washed away. New York has covered her in a 'sickness' of the Sartrean sort. She looks to the bathroom ceiling for a new pattern of existence; and she recounts the various shapes and sizes of the bathroom taps and soap holders in which she has immersed herself: the cleansing apparatus that offers her, symbolically, a way out of her existential mess. For Esther, the fixtures and fittings of the bathroom are a way of 'dissolving' the larger cultural forms that haunt her. And so, in a hot tub of water, she 'dissolves' the apparitions of those uncanny forms that cling to her – the various cultural doubles of herself – the sexy Doreen and the squeaky clean Betsy she has toyed with as experimental aspects of herself. All these identity 'try outs' she washes away in the steamy bathwater of a New York hotel. And through the steam, even New York dissolves into something more 'pure' and Esther steps out of the bath 'pure and sweet as a new baby'.[15]

Geographer Yi-Fu Tuan has noted the spatial dimensions between pronouns as indicators of the measure of distance from self. Personal

pronouns, demonstrative pronouns and adverbs of location form a relationship based upon distance: '*I* am always *here*, and what is here I call *this*. You is "there"; and he or she is "yonder".'[16] Through pronouns, versions of self are kept apart. In bodily and spatial terms, the bathroom separates one version of self from another. Marnie enters her private bathroom as a decoy version of herself, as 'Mary Taylor'. She 'dissolves' Mary in the bath and emerges as 'Marnie Elmer'. Marnie Elmer is now 'here', Mary Taylor, 'there'. That she delivers herself in the third person suggests her adeptness for exchanging versions of herself, her ability to exist through a series of 'hers'. But her first-person identity does not, perhaps, return so easily. Several layers must be washed off before the 'her' in 'I' or 'me' is fully dissolved.

Hitchcock enjoys 'dissolving' heroines. In *Vertigo* (1958), Judy's double dissolves into the phantasmagorical 'Madeleine' (both roles played by Kim Novak), the object of desire of the film's male protagonist, Scottie. Instructed by Scottie in how to fashion herself as 'Madeleine', Judy retreats into the bathroom to complete her makeover. As she emerges, the camera conspires with Scottie's desiring gaze and emits a 'haze' of heightened subjectivity. Judy emerges from the bathroom, then, in a new role, under a new signifier: still as third-person pronoun, but with a different surface presentation. In terms of the film's plot, this is a significant event, announcing in the most blatantly visual way Hitchcock's 'double' motif.

Unlike the British 'loo' or 'toilet', the American bathroom is just that: a *room* large enough to hold events, including radical personal alterations. The problem for the Jewish son in Philip Roth's *Portnoy's Complaint* (1969) is that he is never able to dissolve in peace: there is always the insoluble form of his mother on the other side of the door. The looming form of the Jewish mother makes a nonsense of bathroom privacy. As Roth informs us, Alexander Portnoy spends 'half [his] waking life locked behind the bathroom door', the 'Raskolnikov of jerking off'. The indicator of his shame is precisely the *lock* on the bathroom door, something his father equates with public bathrooms, what he terms the urban jungle of 'Grand Central Station' where the threat of invasion is perhaps more imminent. Portnoy's father resents the fact that his son has turned a home into a public space by locking the bathroom door; and so it is that the family bathroom becomes a territory in a war zone of unresolved family dynamics. Mother and father stand on one side of the door, the son on the other, the bathroom lock between them. In the mind of young

Alexander, the bathroom is a place of necessary sexual transgression; a place of teenage sexual exploration. But it is also a site of interrogation and potential forced confession: 'Open up, I want you to open up this instant', his mother screams through the door.[17] In the Portnoy household the bathroom lock is the fragile mechanism upholding decency and decorum, the small but essential device that keeps the looming Freudian wolf from the door.

In the Rothian theatre of sexual transgression, then, the bathroom is a central *mise-en-scène*. It is a carnival site of sexual misdemeanours. For the eponymous hero of Roth's *Sabbath's Theatre* (1995), it is a dressing-room for sexual fantasy and erotic dressing up. Undressing in the bathroom of the teenage daughter of his friend Norman, Sabbath takes a bath. In his picaresque imagination, the 'girlishly pretty' bathroom incites opportunity for pornographic role-play, and he takes a photo of Deborah into the bathroom where he becomes the 'saboteur of subversion' of his own devising.[18] Interrupted by Norman, Deborah's father, Sabbath's pornographic play is brought to an embarrassing end.

Interruptions appear to be the plight of Jewish men in the bathroom. In J. D. Salinger's 'Zooey' of *Franny and Zooey* (1961), we first encounter Zooey Glass inside the family bath tub. Zooey is a Jewish beauty; an art object whose place of safe exhibition is the tub. As readers, we are encouraged to visit his surface and physical dimensions; we evaluate his aesthetic value: we admire him. But for Zooey, the tub is also a safe container for meditation and recollection, a place in which to gather together the parts of himself. But his rehearsal is interrupted by the sound of his mother's voice, 'importunate, quasi-constructive', addressing him beyond the door. And so Mrs Glass makes her 'verbal entrance', providing, as Mark Rutland does for Marnie, a precise account of the minutes her son has spent in the tub: 'exactly forty five'. With the appearance of Mrs Glass, the bathroom is translated into a theatre, and the shower curtain that maintains modesty between mother and son is adapted as a form of stage curtain.

Her extended invasion of privacy soon becomes a full-scale bathroom symposium on familial relations, including a disquisition on the inconvenience of her older son's attachment to his privacy. Meanwhile Zooey, held hostage to his tub, maintains what he parodically terms 'polite bathroom talk'. As several pages pass, the bathroom gradually assumes the role of character, and becomes 'oddly still for a moment'. There are intervals in the drama, broken up by the props of the bathroom space: the bathroom

cabinet whose extended list of contents Bessie Glass peruses and then updates. Opening up the cabinet, she reveals a world of American pharmaceuticals and cosmetics – 'Anacin, Bufferin, Argyrol, Musterole' – nuzzling up alongside a snapshot of 'a fat black-and-white cat asleep on the porch' and 'two sea shells' – the mementoes of snatched moments alone. Like Sabbath, Bessie is a 'saboteur of subversion', prising open capsules of privacy, as she prises open her bathing son. Her interrogation of the bathroom facilities is analogous to her interrogation of her family's mental health: 'I'd like to know who washes their hands and then doesn't clean the bowl up after them', she declares, another way of voicing her doubts about the 'cleanliness' of her family's emotional state.

And so through symbols of hygiene and cleanliness, Salinger explores the Glass family relations and their suffocating proximities. Bessie passes her son a 'washrag', a term he rejects, as he rejects her presence. The 'three steps' she makes in order to pass him the 'washcloth' emphasise her dangerous proximity to his sense of decency – and all the unnecessary and unwarranted complications of implied Freudian readings. As the disquisition unfolds, the shower curtain separating mother and son thickens its protective layering; and, as the bathroom scene extends and his bath water goes cold, Zooey 'closes off' to his mother's propositions.

The extended exchange between mother and son is an arch theatrical performance of invaded privacy, in which the steamy bathroom plays an integral part of the show; a hammed-up theatrical space with shifting scenes and moods. Bessie Glass plays the part of director of the space, instructing her son to use the bathroom mat-prop properly, before she leaves for a break in her performance. Following her departure, there is a scene change: Zooey stands before the basin, shaving. This time, Salinger includes stage directions: 'The window had been raised halfway, the bathroom door had been set ajar to let the steam escape and clean the mirrors; a cigarette had been lit, dragged on, and placed within easy reach on the frosted glass ledge under the medicine-cabinet mirror.' And so with Zooey left solo on the bathroom-stage, we return to a voyeuristic peek at the rituals of the bathroom occupant, 'all alone'.

When Mrs Glass does return, it is with as much sham show of respect for privacy as she left with, her hand hovering over the doorknob, 'a portrait of spurious hesitancy' poised on the edge of another invasion. Her territorial recapture of the bathroom reflects the wider experience of the Glass Manhattan apartment as a space entrapped by a cumbersome

family history. Apartments encourage thoughts of predecessors, previous tenants, antecedents.[19] A discrete and isolated capsule, the family apartment floats five storeys somewhere above Second and Third Avenues. Saturated in a history of precocious childhood fame, it is resolutely non-contemporaneous; it floats in a Dickinsonian 'nowhere', as, it seems, does the mind of Franny Glass, the current family problem child. The apartment, like the bathroom cubicle, hovers, not in the America of 1955, but in events of the past: the extended years of the radio show that launched the careers of the Glass children. Apparently, these years (1927–43) are the only years worth recording; and it is around 1943 that family history ended. In filmic terms, this is the subjective 'point of view shot' of Bessie Glass and her family apartment. No other views are yielded. There is nothing else worth telling.[20]

Living off the Hotel Corridor

As in Hitchcock's 1954 *Rear Window*,[21] the point of view shot of the Glass apartment is fixed and static. There is only 'a single, southern exposure'. In Hitchcock's film, the atomistic apartment boxes of the film's set dramatise the isolated individualism of the city dweller. Stewart's rear window gazing only heightens the sense of spaces 'visited' rather than lived in, and as his gaze continues to roam, the neighbourhood fractures into a series of temporary frames, constructed only for viewing. Franny Glass stretched out upon the living room sofa, emotionally and mentally immobile, is the ultimate artefact in a space cluttered with historic relics. For Franny, the apartment is a mental retreat, a space in which she can abandon the continuities and unities of time and place: the here and the now, the 'this' and the 'there'. Franny is an isolated visitor to the apartment, not an inhabitant.

But 'Zooey' is also a portrait of an entire family in retreat from the world, a family holed up in a space made up of a series of discrete, safe places. The only threat to the boundaries of these places is other family members. The Glass family are New York's 'cliff dwellers',[22] isolated urban dwellers whose practices of living are similar to Dorothy Parker's apartment-based stories, where the lines between apartment and hotel

frequently blur. The couple of Dorothy Parker's story 'Too Bad' live in an apartment that exudes all the drab anonymity and cheerless routine of hotel living. Mrs Weldon makes several efforts to lift the décor of her apartment-home with 'touches' of feminine embellishment, but the gap between herself and her husband renders these efforts at homeliness futile. And so the space remains as lifeless as their dinner table conversation, as uncommitted to original ornamentation as the mechanics of their married patois.[23]

Henry James was quick to note that the American hotel discouraged 'living'. For James, it was the Pullman car, that early emblem of American caravanning, which struck him as the 'supreme social expression' of an American lifestyle.[24] Stationed at the front of the hotel, the Pullman is a reminder of what James terms the 'promiscuity' of American caravansary: an appetite for rushing off to some social event in a 'gorgeous golden blur'. As the lobby of the Waldorf-Astor demonstrates, the American taste for luxury is theatrical and extravagant; an aesthetic that warrants a 'playhouse of the richest rococo'. But there is a tug-of-war between American luxury and a counteractive urge to appear 'respectable'; and this, James suggests, is the root of the American desire to remain homogeneous, even in the consumption of resplendent luxury. Luxury must be managed and monitored for the sake of social equilibrium. Too much of the wrong sort of 'living' would disrupt the principle of social homogeneity upon which American identity hangs itself. And so hotel decadence must be kept in check; the appetite and luxury for imaginative consumption, abated by a reliable 'sameness'.[25]

In *The Portrait of a Lady* (1881), the nature and reputation of American hotels is the subject of fierce debate. To the Anglophile sensibility of Mrs Touchett, the hotel experience is something of a 'struggle'.[26] Although Mrs Touchett does not elaborate on the precise nature of this 'struggle', what she implies is that the aesthetic of the American hotel does not suit her visiting, imported sensibility. It is easy to imagine how the entrepreneurial spirit of the American hotel industry, with its forthright display of luxury and overt concern for customer service, might be regarded as nothing more than a vulgar capitalist show.

As a member of the established American middle class, Mrs Touchett would have been quite justified in her suspicions of hotels. This was a business, after all, that threatened the middle-class model of domesticity: one of organic wholeness. Driven by processes of individuation

and subdivision, the hotel spawned a new model of urban hospitality that, in turn, inspired a new form of urban living: the apartment building.[27] By the mid-nineteenth century, the 'lovely home atmosphere' of middle-class family life, eulogised by Theodore Dreiser,[28] was under threat by the demand to live more efficiently, and by 1870, the residential landscape of New York had turned towards the apartment building as a more pragmatic form of residence. Dreiser's model of living, built around the single, private family home, was dependent upon labour-intensive forms of housekeeping – and so apartments were welcomed, particularly by women, as an efficient alternative to traditional domesticity. By the twentieth century, the Manhattan apartment was considered an entirely acceptable middle-class residence, and the fashion for building private family homes came almost to an end.[29] The layout of the new apartment drew a clear distinction between the lower-class tenement and the more prescriptive elegance of the urban bourgeoisie. Apartment plans were sold to the middle-class buyer with the offer of a pleasing yet practical spatial experience – and with several technological trimmings. For the wealthier classes, those built on the Upper West side of Manhattan, for example, were sold as replacement homes, but with the added benefits of new domestic technologies: central refrigeration and vacuuming appliances, water filtration systems, telephone switchboards.[30]

In Boston's Hotel Pelham, built in 1857, the prototype for hotel living was laid out. The Pelham was a response to the history of transient hotel living by prominent Boston families; indeed, in many cases, hotel living had been selected by Boston's elite as a means of staking out social status.[31] With the advent of the Pelham, such families could now consider a hotel a permanent residence and settle in. Plans followed designs for shared public spaces and centralised services: guests ate in a common dining-room served by a central kitchen; the hotel included laundry services and stores, a concierge and porter. The Pelham design set the standard for several of the nation's first apartment buildings, all of which included shared public spaces.[32] Efficiency had replaced privacy as the zenith of middle-class life.

The downtown hotel and the downtown apartment are products of the same plan for living, both resolutely twinned to the late-nineteenth-century capitalist surge. As Mr Touchett tells the young Isabel Archer, there is always a room somewhere if you are prepared to pay for it. But the new apartment buildings that sprang up in New York from the 1870s

onwards recklessly threw strangers together. Residents lived in and around collective spaces: a single front lobby, a chain of public corridors, staircases and elevators, one front door. Indeed, several of the emerging apartment designs were based upon notions of a hotel-apartment or 'family hotel' as the architect Henry Hudson Holly put it: apartments located on street level with individual private entrances, front doors and stoops.

The apartment-hotel was designed to reflect a superior sort of tenant, of which the Manhattan Stuyvesant Apartments of 1869 were a leading example; here, according to one real-estate agent, 'the most respectable people can live upon flats precisely as the gentry and even the nobility do in many of the leading capitals of Europe'.[33] Individuation was considered an essential part of developed urban identity; and if a tenant could afford these 'individual' marks, then he could stand out from the rest.[34] A middle-class apartment dweller loathed to see his residence fall beneath the murky shadow of the tenement house. Class distinctions were essential; but in the modern apartment building, privacy and individuation, the insignia of middle-class comfort, would cost more. One had to purchase a sense of place.

Dorothy Parker was a great fan of the residential hotel and in 1954 moved into New York's Volney hotel. Her play *The Ladies of the Corridor* (1953), co-written with Arnaud D'Usseau and based upon her years at the Volney, is a tribute both to the perks of hotel living – no cooking, cleaning, or laundering – and to the incredible isolation. Parker's play is a study of a group of emotionally homeless older women who live off a hotel corridor, an emblem of the long artery of loneliness running through their lives. As the stage directions make clear, the 'Marlowe hotel' is of another era, sealed off in lost notions of New York gentility. To the audience, the front entrance and view of the street is invisible, but to those perched on the lobby sofa, the vista of the street beckons, invitingly. A keen interest of the play is the geography of the hotel room: its layout and perspective, its limited topography. And so, in the second scene of the play, we meet Lulu Ames, a middle-aged widow, who spends the entire scene trafficking between bedroom and living room, pet dog in arms; a middle-aged woman moving through the choreography of a transient. The limitations of Lulu's existence are made quite clear, as is the limited space she has to roam through her new life. Lulu's new frontier is the 'corridor door' that establishes the boundary between her two-roomed apartment and the public space from which her personal life branches off.[35] The corridor is

a territory that 'trails off into the shadows' of lonely hotel living, where 'Do Not Disturb' signs indicate a huddle of retreating souls.[36]

Here, the retired female residents can only indicate what they are through their furnishings, and so these must be comfortably distinct and clearly indicate their means. And so Mrs Nichols, along the corridor from Lulu, gestures towards quite a different set of means in her 'heavy', tapestry furniture. She has more money and must remind herself of the fact. She can afford a genteel identity. These are women, after all, who live in permanent storage, and so décor and room dressings mean a great deal; they are the landmarks of a personal language that turns a hotel room into a home. Missing personal objects cause great distress. For Mrs Lauterbach, a missing blue ashtray turns the landscape of her room into a foreign place. But, in the Marlowe hotel, foreignness lies all around, in the long length of the corridor that forms the hotel 'neighbourhood' where adjacent rooms store adjacent yet landlocked lives.[37]

But for Dorothy Parker, the aesthetic of hotel-anonymity was something she could relax into, covert even, as her story 'I Live on Your Visits' (1955) suggests. In Parker's story, the mirrored surfaces of the hotel room deflect attention away from the room and its occupants and their various histories. The contents of the room are ill-fitting: the photographs paraded around the place nothing more than another 'twinkling' surface, pushing the characters of the story, a mother and son, further away from the more meaningful content of their lives – their relationship to each other. As the narrative implies, home 'visits' are not the same as hotel visits. Unlike the family home, the hotel room is open to anyone with enough money. It is a space easily bought, but also one easily abandoned – as Parker's itinerant mother demonstrates, whose domicile regularly shifts from one hotel room to another.

Hotel rooms host strangers and strangeness, and when an unfamiliar 'true friend' emerges between the visit of son and mother, the current of filial feeling is pushed further away. The 'true friend' is a substitute for 'true' feeling. Seated on the hotel sofa, a strange and monstrous apparition, she is a rival 'visit' to the son; another random and ill-fitting object in an already ill-fitting relationship. At the end of the story, the mother is so 'removed' from any experience of propinquity that familiar objects are now only 'souvenirs' of a life she can 'visit'; a son she knows only as a visitor. Her life is nothing more than the series of suitcases she carries between one temporary domicile and another.[38]

Along Parker's hotel corridor we haven't reached quite the level of horror and psychosis of film director Stanley Kubrick's notorious Overlook Hotel corridor in *The Shining* (1980), but it is possible to see where hotel anomie could take Americans when the pioneering spirit is stuffed away beneath artificial lights and floating cubicles. In *The Shining*, the commodity of space takes vengeance on the luxury-devouring hotel consumer, and hotel anomie is violently translated into a current of blood surging its way down vast, alienating corridors. Time has evaporated and space unfolds its decadent revenge as a tidal wave of blood explodes against the corridor walls – where minutes before the child innocent, Danny Torrance, pedals his bicycle as happily as he would in his neighbourhood park.

Watching Kubrick's famous corridor scene, it is the bold geometric pattern rising from the hotel carpet that reminds us where we are: in a 1970s hotel avalanched by space. We fall along and through space, as we do in his earlier film, *2001: A Space Odyssey* (1968), the carpet opening up before us, as does the landscape of the Rocky Mountains that we approach earlier in the film – with the same rapid speed that Danny peddles the corridor. Hanging precipitously over Jack Torrance's car, we zoom through a corridor-length of western landscape, a test drive moment for what will become the far more dangerous ride with Danny. Carrying the landscape inside, we confront a space where a strange and looming species of corridor shapes and figures ambush our imagination. In Kubrick's film, hotel décor is no friend, only another threatening and alien presence.

Corridors proliferate in Kubrick's film; every scene seems to end up in a corridor cul-de-sac. The red bathroom where Jack Torrance (Jack Nicholson) goes to clean up following a collision with the hotel waiter, Delbert Grady, yawns like a red and white clinical cavern – an alternative to the vast ballroom-lobby that the men have just exited. Here, Torrance and Grady descend into a bullying rhetorical stand-off, pulling punches at their respective private identities. Each accuses the other of an alternative life, a double history: 'Mr Grady, you were the caretaker here', says Torrance. Grady replies, 'you've always been the caretaker … I should know sir, I've always been here.' The men up the ante, and the blows fall increasingly low: towards direct and sexual insults. Grady accuses Torrance's son of bringing an outsider, 'a nigger', into the situation; a 'nigger cook'. But neither side is sure of its aims, and the camera resists partiality, jumping suddenly from one side of the pair to the other, unsettling any idea of best

or better sides. The camera gradually draws closer, and as the distance between the two men reduces, the bathroom space shrinks.

Locked into the myopic gaze of paranoia, we peer between Torrance's rage-locked eyes, and then back towards the marble-cool façade of his antagonist, whose unruffled English suave continues to deal its deadly blows. Here, in the hotel bathroom, we meet the unmediated savagery of the abject: 'niggers', cooks, wives, children, failed and murdering husbands, 'corrected' wives – a familial revenge drama as grotesquely paranoiac as Macbeth's deadly concoction or that of Joseph Conrad's Mr Kurtz in his savage jungle den. Kubrick's bathroom is a mental corridor with no way out. There are no signposts out of here – no personal décor, nothing cosy. Indeed, private histories and personal details turn against their owners. It is what is not known that torments Jack Torrance and Delbert Grady; what could be the case – if only they were less paranoid about the facts. These men can never hope to know themselves; they carry nothing about them that is securely owned or identified. In a space absorbed by soft furnishings, they possess no furnishings of their own to soften the blows of their dispossessed psyches.

Hotel Roaming

As Dorothy Parker's stories iterate, living off the hotel corridor enacts a peculiar sense of removal from anything like an everyday world. Finding a place in which to settle throws the occupant of the hotel room into a state of anxiety about his relationship to things. This is precisely the subject matter of several of the recent paintings of Bob Dylan: canvases that lay out the quiet, colourless anomie of hotel, motel rooms and unoccupied apartments. For a man whose professional life has turned him into a drifter and a wanderer, a man for whom 'trains and bells' were the soundtrack of his life, it is hardly unsurprising that Dylan turns to the corners of rooms as a place of visual rest and settlement.[39] Many of his compositions follow the adroit angles of rooms and the intersection of planes amongst loosely arranged objects. Like Dickinson, he is clearly an artist who deals in geometry, and his autobiographical *Chronicles* is filled with protractions: the measurement of relations between himself

and the world of things in which he finds himself, peculiarly deposited. The opening of the first volume of *Chronicles* is the equivalent, in words, of several of his paintings:

> I sat up in bed and looked around … Above the fireplace, a framed portrait of a wigged colonial was staring back at me – near the sofa, a wooden cabinet supported by fluted columns, near that, an oval table with rounded drawers, a chair like a wheelbarrow … a couch that was a padded back car seat … a low chair with a rounded back and scroll armrests – a thick French rug on the floor, silver light gleaming through the blinds, painted planks accentuating the rooflines.[40]

Place, for Dylan's narrator, is an inventory of things; a sequence of objects that rear into view as they rear into conscious existence. 'Place' is also a word Dylan finds himself repeatedly struggling to define, such that any location he describes inevitably ends up sounding like a motel or hotel room; a temporary residence. And because every room he inhabits belongs to someone else, the sense of place is furnished and identified by the character to which he has attached himself. In this case, it is his host Ray Gooch, a New York wayside buddy, who figures in Dylan's imagination, like one of the characters from his lyrics: a roamer through romances and deeds. Dylan's 'places' are a series of temporary wayside stops with adventurers in the American political and cultural underground. Locality resides in the figures and histories of these inn keepers, the real 'occupants of the place'. At Ray's, the young Dylan orientates himself with a quick reckoning of the view from the window across the New York skyline and reads it through the spinning 'windvane' of his mind.[41] But disorientation seems to work to Dylan's creative advantage, more sights and sounds, more characters and more corners of rooms in which to hole up his visual imagination.

But the characters that inhabit these corners often appear to have arrived deus ex machina: someone emerging out of nowhere. *Corner Flat* (2007), a series of three paintings with almost identical constituents, depicts a seated character in the corner of a room resting his back against a windowsill. Hemmed in on both sides by flat windows, the subject perches self-consciously, awaiting direction from the artist-viewer. The room is airless and mechanical, and the scene outside the window offers no vital relief. Viewed through flat, missable windows, the life of the street

is as gridded and marked out as the contents of the room, and although the paintings suggest an apartment, the space is as depersonalised as Dylan's actual motel or hotel scenes, or indeed, any of his interiors.[42] Overwhelming, the rooms evokes visits rather than habitation.

View from Two Windows (2007), perhaps an outlook from a hotel room – the discrete differences between hotels and apartments blur in Dylan's interior world – is a series of six paintings built around the right angles of a subjectless void. There is an air of the casual abandonment that belies something more concentrated and deliberate. Things appear to have been gathered together in a rush, in a scurried rush to leave, from the large sack-like shape of the curtain hastily pulled across two intersecting panes, to the television and table and chair forced up into a corner. What Dylan seems to be getting at is a sense of local disarray, a difficulty in belonging. In one of the six versions of the piece, the lurid purple of the canvas seeps between the room and the buildings beyond, in the same way that the floating cubicles of Edward Hopper, a painter Dylan clearly holds in mind, trail out through windows. Colour is applied as a sealant across mismatched planes, an attempt to bring order to the jumble sale of places accrued along the roadside.

Hotel and motel rooms exist only for one or two nights and then are quickly forgotten. For the roaming Dylan, places do not stick. As Georges Perec candidly declares, 'I would like there to exist places that are stable, unmoving, intangible, untouched and almost untouchable, unchanging, deep-rooted; places that might be points of reference, of departure, of origin.'[43] But such nesting places are not to be found in motel or hotel rooms, where the only real occupants are the ubiquitous furnishings: beds, bedside tables, lamps and the view. Dylan's *Dallas Hotel Room* (2007) is a canvas afflicted with vertigo: everything off-centre and slightly ill at ease. The four versions of this piece – each altered slightly by colour – present queasy and at-sea hotel experiences. Compressed and airless, the objects in the room appear to be shifting and shifty; a jerry-rigged shack of snatched living whose unsettled contents suggest a soul out of sorts. In Dylan's room-universe, objects are the real inhabitants, and the view itself, as in this Dallas hotel room, is but another random object, poorly collated and never quite integrated.

Table and Chair near Window (2007) is a Chinese box composition of ridges. Here, the charcoal ridge of a window ledge and the dove-grey line of a radiator lying beneath it converge. To the left, the grey length of

a radiator pipe runs down the wall to meet the charcoal-grey outline of the headrest. A study of planes, Dylan's room-void is an exploration of the meaningless of unmarked space; the often unremarkable but iterated lines of travel. In Dylan's composition we have hit the point at which travelling becomes simply moving forward, a relentless propulsion towards somewhere other than here. These lines are something like the train tracks he writes of in his *Chronicles*, the underscoring of his childhood in which tracks pointed to 'some level place' – a sense of 'everything fitting together' – a time when living was comfortable and a destination held real meaning.[44]

Artist Edward Hopper was the first to admit that the American hotel could be less than a comfortable experience. His 1931 *Hotel Room*, like Dylan's Dallas room, is a cluttered and uneven space in which occupying subject and objects sit awkwardly together. A young woman sits reading a note on a spartanly covered bed. Dressed only in her underwear, her privacy is invaded by our stare. And she is not well arranged: her luggage abandoned at the end of her bed, her coat and shoes sprawling like abandoned pets around her. Within the foreshortened lines of the room's boxy dimensions, elegance is granted little space. The lines of the bed point away from the window, towards, we imagine, an unseen door; but her luggage blocks her in, and so there is little chance of a graceful exit or entrance. Hopper's composition speaks loudly of the frayed relations between the self who sits on the bed, undressed and unready to go out, and the self who entered the room, clothed and bearing luggage – full of the hopeful intentions for new compositions that a private space can yield a new visitor. But the space disappoints, and the large blank space of the window behind her intimates at an individual not fully devised; as yet incoherent and unrealised. As with Dylan's interiors, there is a clear discrepancy between room and occupant, room and viewer; and none is comfortable with the arrangement.

Hotels, it would seem, are not conducive to a coherent sense of self. Typically favouring a layout of formal décor and furniture, a hotel lobby can leave its occupants stranded without any clear sense of direction or purpose – as is the case in Hopper's *Hotel Window* (1955), where the lobby washes up an ocean of space. Lost in a landscape of flat, seamless walls, a well-dressed middle-aged woman stares out of a dark window that lends no real view. The painting's quiet oppression lies in its relentless flatness, its disregard of any focalising object which might offer the

seated woman or the viewer some sort of comfort. But no small offer of refreshment is brought our way. Hopper's canvas brings no visual comfort; instead, it suggests a total lack of human comfort in which a figure, surrounded by luxury, is nonetheless bereft, suffering a genteel form of emotional abandonment.

Hopper's hotel lobby is not the spectacular carnival parade of James's earlier description. There is no lively throng; no buzzing social space. The sights and sounds of luxury that Henrietta Stackpole in *Portrait of a Lady* champions so vehemently are cruelly missing.[45] As the gateway between private room and the public space of the streets, the turn-of-the-century lobby was the crossroads in the social exchange of transient guests, residents and locals. A generous host, the lobby offered temporary accommodation to members of the local public for personal meetings, business transactions, or a spot of straightforward loitering. Anthony Trollope observed the breed of young male loiterers who adopted the lobby as a 'public-lounging-room'. Unlike Hopper's study of isolation, the late Victorian hotel lobby was a space charged with community, where 'human species of every kind may be seen variously occupied'.[46]

Laurel and Stella Dallas of Olive Higgins Prouty's 1923 novel, *Stella Dallas*, form part of the genealogy of hotel species that trail around hotel lobbies in search of entertainment. Laurel and her mother are permanent hotel loiterers, regular patrons who frequent only the most 'elaborate affairs', looking for some hotel-action and atmosphere to class their tawdry lives. Their hotel-homes are chosen for their extravagant dimensions and ornately textured atmospheres; nothing scanty. What they want is more class. And yet, the Dallas women can only afford the 'cheapest' of rooms, tucked away within the hidden recesses of the hotel, where space is at a premium and dimensions are shabbily reduced. They live to inhabit the grandeur of the 'ground floor rooms': the lobby, the front office, the ballroom and the dining room. Here is the real hotel glamour: the communal stage of 'bright lights, bright music', and long luxurious stretches of thick and yielding carpet.[47] Amongst the classical Greek pillars of the hotel foyer, Laurel Dallas can find an imaginative play space; cast herself as Isadora Duncan, a 'sylvan creature' among other fantastical lobby creatures. In the lobby she can unfurl; escape the squalid, imaginatively limited proportions of her hotel room.

And yet, Laurel Dallas is painfully cognisant of the behind-the-scenes nature of the 'little room' she shares with her mother. Offstage, her mother

is unfit company for the glamorous hotel setting: a 'fat, shapeless little ball of a woman' who spends her time 'off stage' dressed in shabby and neglected nightclothes. Stationed among the outer reaches of the hotel territory, Laurel is forced into a reckoning with the aesthetic let down of her bedroom: the ill-health and shrunken physique of that space. Replacing the luxurious garnishes of the downstairs rooms, she sees only the grimy marks of former occupants along her bedroom walls; the histories of other diminished lodgers forced to abandon glamour. Everything is makeshift and borrowed. The promise of the hotel, 'a worthy home away from home',[48] is possible only if one can pay for it, and Laurel is acutely aware of hotel taxonomies, moving as she does from the cheapest hotel room with her mother, to the more respectable hotel where she lodges during the period when she visits her father in New York. Here, her hotel is a 'luxurious three-roomed apartment' fitted with all the props of childhood fantasy that money can buy.[49]

Brought up on hotel living, Laurel is uncomfortable with its domiciliary rival, the private home. She experiences the home of Mrs Morrison, where she is sent while her father is away on business. Here is a movie set, 'lovelier' than any luxury hotel-apartment. But she is unsure of how to inhabit this space; whether someone will come and carry her bag upstairs, or whether she should do so herself.[50] Laurel hasn't learnt to manage herself. Raised with servants, she is not well versed in Emersonian self-sufficiency. In the world of the household and its domestic codes, she is a foreigner.

But residing at Mrs Morrison's, Laurel learns what it is to feel proprietary care for a space; ownership. Without a retinue of ladies maids and valets, she experiences the intimacy of place and, in turn, of domestic relations. Outside the commodity space of hotel culture, Laurel relaxes into a new set of terms for living: more human, less costly, and certainly, more private. Henry James noted that the highest luxury, the 'supremely expensive' commodity of American society, is 'constituted privacy'. Privacy in hotels is limited by the other great luxury of the hotel environment: good service. But service undermines privacy.[51] Butlers, chambermaids, valets, ladies maids, all have eyes and ears, no matter what degree of anonymity is maintained. They can all talk.

Service is a problem for Stella Dallas after Laurel moves away for the summer. She tramps between exclusive hotel resorts and cheap boarding houses, sliding up and down class ranks, in flight from the spectre of her

encroaching destitution and several unsavoury men. Lodged at the King Arthur hotel, Stella is reluctant to employ a new servant for fear they might talk, or ignore the 'hard-and-fast rules' of hotel etiquette which Stella is keen to hide behind.[52] And so, while her daughter is educated in the rules of private homes, Stella retreats further into the formal codes of hotel life and becomes irreparably rootless, unable to find that 'home away from home' she so keenly desires. She slips closer towards the hotel's poorer cousin: the often insalubrious motel.

Off the Road and in the Dark: The American Motel

While the commercial hotel that James describes is traditionally located downtown – a direct result of nineteenth-century railroad travel, with the railway terminus also located downtown – in the twentieth century, the American motel serves the ever-extendable geography of the roadside. A sign of increased mobility and an indication of the shifting patterns of the traditional household, the post-Second World War motel boom offered an affordable pause along the highway. Promising a 'home along the road', the motel is a reassuringly reliable environment where a standardised level of décor, fixtures and fittings offers the tired motorist nothing terribly surprising. Indeed, surprise is deliberately kept to a minimum in the motel setting, where the mobile population of America can be guaranteed a space instantly recognisable and quietly homogenised.[53]

The motel emerged from the cabin and cottage industry of the 1920s and 1930s that simulated the idyll of rural America: a Walden Pond away from home. As Warren James Belasco in his study of roadside America puts it, the auto camper, like the cabin, was an easier version of camping but still had an edge of Mark Twain's 'roughing it', injecting a dose of the vigour of adventure into family life and encouraging a reconnection with nature.[54] But the modern-day motel is not always conducive to the revitalisation of familial and communal spirits. Motels are also places of isolation and retreat, and the motel room itself, a blank and unchartered space. As one turns off the highway in the dark, the forecourt is not the most convincing reception space, and the ubiquitous 'rules' mounted on the door of the motel room are a reminder of the temporary nature of

the arrangement. The strict adherence to departure time and the series of regulations concerning the damage of property, the risk of theft and fire, and the chain on the door, are all reminders of the limited safety of the motel room, as well as its rather scanty gestures at hospitality.[55] In a motel, one is constantly reminded of what is not on offer, rather than what is.

Like the hotel, the motel can invite the experience of strangeness. But unlike the hotel, the division between inside and outside is less marked, the security of one's privacy, less sure. There is none of the extravagant dimensions of the hotel entrance; the long space between lobby and private room. Locked into a motel room, one is surrounded on either side by strangers, also in transit, also with a bolt on the door. Christopher Nolan's 2000 film *Memento*[56] tells the story of a young, bereaved husband, Lenny Shelby (Guy Pearce), locked away in a motel room, burrowing for the pieces of his memory following the trauma of his wife's death. Suffering short-term memory loss, Lenny's temporal configurations are shot through. And as he declares, without a sense of time, there is no healing.

Nolan's film is a bric-a-brac of broken narrative sequences, jumping skittishly from a series of short black-and-white shots of the motel room where Lenny pieces together his campaign of vengeance for his wife's death. Surrounded by memento – diagrams, wall charts, photographs, handwritten notes – Lenny builds a fractured and incomplete story of the immediate past now lost to him. Simulating the incoherent geography of the space, Nolan's camera jumps, blinking, from one aspect of the room to another: across the broken lines between closet and sink, window and bathroom. 'You really do need a system if you are going to make it work', Lenny tells himself; a means of moving between past and present.

Lenny's motel room is a metonym for his shattered memory, but also for a peculiar form of cultural amnesia. In search of the 'tracks' leading back to his short-term past, Lenny's associate, Teddy (intermittent suspect for the murder of his wife, depending upon the drift of Lenny's logic), lampoons his attempts to play 'Pocahontas' – a jibe that speaks of the wider cultural resonances of the film. Lenny, a sufferer of short-term memory loss, is also a cipher for America's sense of itself, an America that has wandered from hearth and home, a sense of its own history, its cultural and historical 'trail'. As a temporary dwelling, the motel is part of an itinerant consciousness, a modern self in search of adventure, but still in need of some vestiges of security or 'home'.[57] Locked inside his motel

room, removed from time and space, Lenny is marooned in a version of American that is precisely 'nowhere' but also 'somewhere'. But like the facts of Lenny's past, that 'somewhere' remains undetermined.

Emerging from his motel room, his private identity shattered, Leonard's challenge is to survive the public world; life on the other side of the cheap fire door. He repeatedly returns to the motel lobby, where he is reminded of his name and room number; the facts of his public identity. In an 'anonymous room' with nothing in the drawers, Lenny can work on building up a case against his blank identity; he can construct his own investigation room. 'I need my own place', he tells himself, a secure history, a system of living that 'works'. In the motel 'nowhere', the facts of one's identity become arbitrary, highly selective. As Lenny realises, here it is possible to live exclusively within one's mind. By the end of the film, his memory, injected with new facts and theories of the past – several alternative dénouements – has become a form of self-pleasuring; a mind-game.

Richard Linklater's 2001 low-budget movie, *Tape*,[58] based on a play by Stephen Belber, is a direct exploration of the mind-games that emerge from this cheaply bought nowhere. Like *Memento*, this is a film about the dangerous, swampy territory of memory and the saboteur's pleasure of perverting the facts; the cruel pleasure of juggling balls with someone's past. We are in the territory of Nicholson's paranoiac Jack Torrance again. The plot is, loosely speaking, a high school reunion that takes place in a cheap motel room in Lansing, Michigan. After several years, Vince, a small-time drug dealer and volunteer fireman, played by Ethan Hawke, arranges to meet Jon, now a film director (Robert Sean Leonard). The dialogue follows a round of quick-fired bullets of machismo slaps on the back before the conversation plunges into darker terrain. Shot in digital video, the film's rough, grainy surface and jerking camera movement reinforce the casual nature of the setting and, indeed, history between the men. The plot accelerates towards a love triangle with the promised arrival of a mutual former flame, Amy (Uma Thurman). The men share versions of their histories; something Vince, as it turns out, has planned. What Vince wants is a confession of Jon's involvement with Amy, which is what he gets – on tape. With concrete evidence of Jon's betrayal of Vince (Vince was Amy's boyfriend at the time), the scene is set for Amy's entrance.

This is a film about talk and the ways in which talking easily converts into confession within a seductively casual setting. And this is a highly

casual film, opening with a glaring downward shot of Vince gurgling in the bathroom, then lumbering in an 'off-camera' way around his motel bedroom. The location is far removed from the well-choreographed pirouettes of James' well-dressed lobby creatures. It is a film about the effects of dressing down and of being dressed down, the main action of the film coming from Vince aggressively addressing his old friend, as he moves from present to past with increasingly charged psychological material.

Vince and Jon move through some pretty clumsy talk before the talk accelerates to full-scale aggression when Jon realises he's been 'had' – stuck on tape. The small and compressed dimensions of the dimly lit room intensify, as do Vince's talking snares. The cruelty of the dialogue accelerates, diminishing the status of friendship. As the men argue over the possession of the tape, the camera lurches back and forth across the paltry latitude of the room, and we realise that we are watching a crude spectator sport; a sort of motel gangsterism with both men cast in film noir shadows. By the time Amy arrives, there is little room for manoeuvre between the two, as Amy's gawky entrance, stumbling through the door into the narrow confines of the room, further suggests. Three, as it turns out, really is a crowd, as is always the case in noir, and the material descends into an ugly rehashing of the past which must ultimately exclude one of the three.

What emerges from all this talk is a confession from Jon of having date-raped Amy. At first, Amy denies this, but as the talk becomes more convoluted, and the past, more and more displaced, she responds to Jon as though he had raped her. She plays along with her putative role of rape-victim, before finally turning both men in for their cruel stunts in the capacity of her current professional role as Assistant District Attorney.

Like Linklater's camera work, his film draws our attention to the unsteady nature of truth in a postmodern era. Located outside of time and space, the motel room is an unreliable host of factual confession. As the film proves, in this transient space, everything is too relative: a relationship, roles, even language itself become obscenely causal at times. The outlines of past and present blur, breeding anamorphic reformations: too many competing variations. The version of the past on tape is no more reliable than the version of history told off tape, and just as Leonard Shelby must decide which version of his wife's death he will pursue as actuality, truth becomes simply a matter of choice; an aesthetical more than an ethical selection.

The motel is not the place in which to seek out a concrete version of reality. A cheap form of lodging, it does not suggest a big commitment to place. Like the hotel, it is a simulated version of home, and self-confessedly transient. Motel management relies upon a quick turnaround in its visiting population. Beds are hastily remade, bathrooms replenished; the evidence of last night's occupants rapidly removed. Motels are more honest about their transitory function than hotels; there is perhaps less elaboration of the facts of its existence: as a cheap and temporary pause along the highway. Motels rely upon motion, the speedy but casual discourse of Linklater's film.

And because the motel guest moves on, quickly, there is plenty of room for unreliable histories, fantastical deposits. In this sense, the narration of Nabokov's deviant protagonist, *Lolita*'s Humbert Humbert, who claims to be 'exaggerating a little', is well suited to motel lodgings.[59] Wandering the road with his beloved Lolita, Humbert's self-narration winds through 'secondary circles and skittish deviations', an unruly and reckless form of gypsy-travel. Humbert's zigzag tour of America is an extended flight of illicit passion, a playground adventure into the 'American wilds', punctuated by a series of tawdry nightly pauses at cheap motels. The motel room suits Humbert's purpose; it is a 'clean, neat' and 'safe nook', ideal for 'sleep, argument, reconciliation' and 'insatiable illicit love'; it is, as the 'Functional Motel' openly declares, a workable space just off the highway.[60] Humbert's adventures take him through a veritable catalogue of roadside accommodation, a Darwinian chain of 'roadside species' snaking towards a 'hard, twisted, teleological growth'.[61] His report on these various abodes is debasingly ironic, a crushing set of portmanteau words and phrases taken from a tour book résumé: the 'brick unit, the adobe unit, the stucco court … the plain whitewashed clapboard Kabins'. Humbert and Lolita stand apart from these squalid units, a superior sort of transient with a particular breed of illicit love. But then motels have always turned a blind eye to the illicit and the profane.

The history of the motel is a difficult one. As motel historian Michael Karl Witzel reminds us, before the franchised motel chains of the 1950s, motels were often viewed with suspicion – as places for retreating criminals, gunmen, extramarital affairs and prostitutes. The motel was a hive of clandestine activity and local vice, a perfect place for the rectifying presence of the Gideon Bible that found its way into room drawers in the first decade of the twentieth century. Motels denoted class and class structure,

and slipping standards were a reflection of the moral standing of the establishment.[62] As Michael Kang's 2005 film *The Motel*[63] unflinchingly states, motels are frequently seedy places where drunkenness, domestic abuse and anonymous sex permanently reside. Kang's family-run motel is a sleazy, hourly-paid joint where drunken proprietors bring cheap girls for sex, all viewed through the eyes of chubby Asian adolescent Ernest Chin, who cleans up rooms with his mother. As Kang admits, the motel setting was directly related to the genealogy of seedy rural motels in Kubrick's 1962 film version of *Lolita*.[64] There is nothing decent about the rural motel, a place whose proprietor is just as likely to be a 'reformed criminal', a con-artist or a 'madamic female'. Even the room layout invites residents to flout decency. As Humbert Humbert notes, the double unit design of the bedrooms he rents, each containing two double beds nominally separated by an incomplete partition, is a 'pharisaic parody of privacy'. The visible communication between the two beds promotes, if nothing more, an 'honest promiscuity'.

The motel being an accessible lodging for families partaking in recreational holidays, Humbert's motel hopping is a dark parody of its original intention. His recreational vacation is illegal and, in the eyes of the majority, virulently immoral. The 'home away from home' of Humbert and Lolita is a dark subversion of the sanitised middle-class vision of America at leisure. Unbeknownst to their 'operators', these thin-walled, kitschy establishments are housing an antagonist to the American way of life. It is hardly surprising, then, that Humbert avoids the more 'old-fashioned' and 'genteel' establishments littered with remnants of family life, and plumps, instead, for the more anonymous, 'plainer' motor courts whose low-lying, cost-cutting integrated rooftops attempt a sort of cheap discretion.[65] Anonymity, after all, is largely what the motel promises.

Humbert and his precocious gypsy-companion 'consume' America from the viewpoint of the low-lying motor court roof. Nabokov's deviant hero simulates a sense of going places, but where he ends is a cheap motel room at night. With no 'definite destination', the only horizon is a low-lying roof; the manifest destiny of the doomed pair, yet another Sunset Motel or Skyline Court with kitschy thin walls, electric fans and built-in radios requiring a regular feed of quarters. Furthermore, as Humbert's teenage love has 'no eye for scenery', the 'Arcadian' charms of the American landscape are lost upon her and disappear through the narrow grooves of her teenage sensibility – behind popular music and candy.

1. Uncanny trespassing: *Watering Hole* (2005) by Amy Stein.

2. Picturesque designs #1: Andrew Jackson Downing, 'Small Bracketed Cottage' from *The Architecture of Country Houses*.

DESIGN VI.

A VILLA IN THE ITALIAN STYLE, BRACKETED

3. Picturesque designs #2: Andrew Jackson Downing, 'A Villa in the Italian Style' from *Cottage Residences, or, a series of designs for rural cottages and cottage villas, and their gardens and grounds.*

4. The picturesque home: *A Country Home* (1854) by Frederic Edwin Church.

5. Picturesque living: *Calculating* (1844) by Thomas Hicks.

6. Picturesque reverie: *Repose* (1895) by John White Alexander.

7. Window longing: *Evening Wind* (1921) by Edward Hopper.

8. The uncanny threshold: *Cape Cod Evening* (1939) by Edward Hopper.

9. Living in corners: *Corner Flat* (2007) by Bob Dylan.

10. Local disarray: *View From Two Windows* (2007) by Bob Dylan.

11. Jerry-rigged living: *Dallas Hotel Room* (2007) by Bob Dylan.

12. A purchased interval: housewife Laura Brown in Stephen Daldry's *The Hours* (2002).

13. Burrowing for memories in a motel room:
Lenny Pierce in Christopher Nolan's *Memento* (2000).

14. Motel mind-games: Richard Linklater's *Tape* (2001).

15. Zoned living: Lars von Trier's *Dogville* (2003).

16. Western thresholds #1: John Ford's *The Searchers* (1956).

17. Western thresholds #2: Joel and Ethan Coen's *No Country for Old Men* (2007).

18. A Ranch House on the hill: Andrew Wyeth's *Christina's World* (1948).

19. South Western sublimity: Robert Smithson's earthwork *Spiral Jetty, Lake Utah* (1970).

Lolita remains unmoved by the epic American quest for space and yet more space. Distinctly unimpressed by the roominess of her national landscape, she would rather be holed up in an indecorous motel room playing popular tunes and chewing gum. She experiences America only through the darkened shades of a motel room. Adrian Lyne's 1998 film version catches the drowsy aesthetic of the motel room filled with dust motes and worn eiderdowns, in which slow-moving ceiling fans pay tribute to a character in moral retreat. Lyne's film is shot through with sickly yellowy filters, tints of the southern malaise of Tennessee Williams's Blanche Dubois, for whom claustrophobia becomes a perpetual mode of experience. The motel scenes pin the pair morally down; to sweaty eiderdowns and yellowing sheets; to furtive peeks behind cheap curtains.

Like Blanche, Nabokov's insalubrious hero is in search of privacy and personal space; an indecorous love nest. Claustrophobia is a welcome friend. He wants no prying eyes to 'detect' his vice, and even in nature looks for a claustrophobic spot in which to partake of his perverse obsession. *Lolita* is a parody of the roaming individual, the outlaw-hero, the spirit of the American West whose gigantic topography Humbert and his love carelessly pass over. In a sense, Humbert benefits from the western spirit of unlimited potential; he has plenty of room in which to practise his vice, a large map to sprawl across. But the 'twisted' nature of his route keeps him mostly to the roadside, a place from which he can beat a quick retreat if necessary.

Playwright Sam Shepard understood the persistent drive to preserve personal space. His characters are in search of far-flung places away from the prying eyes of government regulations, the burdens and strictures of citizenship. Shepard exploits the American tradition of claustrophobic drama that fixes his characters in small-scale spaces: motel rooms and suburban kitchens. Surrounded by vast quantities of space, they nevertheless limit their high-octane emotions to foursquare walls. Shepard's characters can afford to be lyrical (hysterical and paranoid), not only because they are far-removed, but also because they are safely contained. In *Fool for Love* (1985), Eddie and May are holed up in a yellowing motel room on the edge of the Mojave Desert. From the formica floor to the bathroom door, yellow signifies emotional retreat, a desert landscape where little is nurtured. Penned in by cheap synthetics, plastic tables, chairs and curtains, Eddie and May are as divorced from the natural

environment as any city dweller; the surrounding desert as synthetic a character as their motel décor.

Locked into a brutal choreography of emotional violence, May and Eddie scuttle like caged animals around the boxy dimensions of the motel room: between bedroom, bathroom and front door. This, after all, is a play about large emotions shoved into small spaces. May spends a great deal of time rushing back and forth between bedroom and bathroom, desperate for more emotional leverage, a space in which to gather up and spin out her fraying emotional threads. Limited to a jerky sequence of halting and retracting movements, the couple are unable to unfold fully; one or the other is always in the process of leaving: 'May makes a move toward the door, then stops and turns to Eddie.' Outside movement alters the choreography, bringing the outside in, and with it, more dramatic space – and others. Car headlights flashing through the window distract from dramatic immediacy, the heated dynamic of Eddie and May. And with the car comes another man who threatens Eddie's position as dramatic priority.

But what in fact emerges outside is something ordinary, an 'ordinary date', with none of the mythic proportions of the leading lady and her man, none of their history.[66] The confrontation between Eddie and Martin is played out like a saloon shoot-out, a mythic re-enactment of the western male confronting his cowboy-rival. But the scene is diminished by the location, the plastic motel room in which the expansive scaffolding of myth is forced to collapse into domestic pathos. In the meantime, the car outside is identified as Eddie's other woman, May's rival, who wreaks havoc on Eddie's parked vehicle, the same as any other gangster-outlaw. Characters suddenly double, and in a space that does not permit expansion, Eddie and May are forced to reckon with the dramatic reality of their usurper; that most precious of quantities, personal space, is suddenly under threat.

Fool for Love works with two versions of space: the vast panorama of the desert landscape that hovers on the edge of the motel room, and the room itself, small and shrunken. The petty proportions of Eddie and May's romantic squabbles vanish within the far larger proportions of the landscape and history that surrounds them. Their narrative is outdone by a myth of greater durability. In the theatre it is the space between what is there and what isn't that is the central experience. It is the non-represented that Shepard validates, the missing myths of nationhood that he calls out from the corners of the stage, from the dramatised spaces of his settings.[67] His *Motel Chronicles*, a series of wandering jottings on

road trips and scattered childhood memories – Dylanesque moments of acute displacement – take place against the backdrop of motel rooms. A common leitmotif in all of these is the quest narrative, an off-the-road search for colour and texture as a form of aesthetic relief from the barren homogeneity of the highway. To the truck driver, the motel room offers a degree of aesthetic quirkiness, a textured garishness – red velvet flocked wallpaper, a red velvet rug, a red sink, red curtains – the Americana equivalent of Jane Eyre's red room experience or the Hotel Overlook bathroom. In Shepard's sketch, red signifies excessive consumption, and so the colour of the room is a sign of the culture of superfluous materiality from which the space emerges: a 'vengeance' in red velvet.[68] There is no relief from the red as there is no deference to good taste; there is no need. This is a space of pure, unadulterated excess, where drugs can be recklessly consumed – as Vince in Linklater's film knows only too well – with little fear of detection. Drugs and chemicals are an essential part of this aesthetic of undiluted excess; and so, emerging from the redness is the smell of cleaning fluids, a reminder of the cultural chain of synthetic compounds that have created this space.

Synthesised and highly produced, a place of emotional valences, the motel room indulges in excessive fits of colour. In the sink, primary colours bleed out of synthetic materials, the colours of the expressionist's palette. A red shirt is left drip-drying for days, a frozen stalagmite of motel time where temporality is left hanging, like the phone ringing off the hook – indefinitely. Anonymity and irresponsibility are the rewards of the motel dweller. The phone stops and no one bothers to imagine who might be on the other end. In the mind of Shepard's motel dweller, objects hold no functional value. A black phone is just a black phone. It has no further use.[69]

In the same aesthetic and cultural tradition as Shepard's play, but almost a decade earlier, is Joni Mitchell's song 'Blue Motel Room' from her album *Hejira* (1976). Mitchell's lyrics suggest a form of motel expressionism in which the blue bedspread of the motel bed provides a cheap and synthesised version of the 'blues' inside and outside the singer's head. Itinerant, drifting across 'two dozen states', Mitchell's singer is far from foot loose and fancy free. Drawn to the painful dichotomy of the road and her home town, she exists in a fit of moody contemplation of what she lacks: her home-town love. Mitchell's ballad, built upon the trope of a Cold War impasse, is a tribute to the emotional fluctuations and instabilities of motel trudging – of life on the road. The sorrow of her singer

is that no matter where she roams, she carries with her the same body of feelings; on the road, time and space collapse into one heavy emotional centre. Her state of blueness is a state of lack – a deep coloured centre that is the ultimate referent to life on the road, into which everything falls: a blue-black hole in the heart.

Motel living encourages 'fit[s] of uselessness'. Time is experienced in fits and starts. More often than not, an arbitrary and casual selection from several of the same, the motel room resists routine, everydayness. In Shepard's *Motel Chronicles* (1983), a motel routine is only a temporary construct and related to the temporary existence of film production, film making being the ultimate exercise in the displacement of reality. In this sense, the motel is a lived extension of the displaced and temporary nature of the film set. In one sketch, an actor lives by a daily 'routine' of an early wake-up call and breakfast in the Kettle Pancake House, before crossing into the motel lobby for his mail, and out to the front of the motel where a driver takes him to the open-air location. Regular characters and settings feature in this motel 'set': an early morning jogging waitress, a Motel Manager in the lobby, a Driver waiting outside, Two Actors in the car beside him. In search of his own 'Character' profile, however, Shepard's protagonist develops his own bit-part of improvised action within the plotted 'routine'. But his character is unable to follow the lines of the plot; he strays too far into imagined territories. He lacks a grasp of the facets of the plot and the part he plays within it. He cannot read the codes of the cameraman whose lens frames him, is unable to associate his character with those around him. Finally, he steps outside of the scripted plot and into a story of his own devising: one that leads him towards death, the ultimate transfiguration of his character.[70]

Motel rooms lend themselves to filmic representation precisely because of their transient, itinerant life cycle; in this sense, they reflect the nature of the medium itself as well as the fleeting experience of spectatorship. Motels reinforce the notion, as do films, that all reality is unfixed and relative; that time can be measured out in units of nights, not days; that the fixed 'routine' of life lies beyond its thin wall. David Lynch's *Wild at Heart* (1990)[71] sets the motel room within a sprawling, surrealist nightmare that unfurls along the road between Cape Fear, North Carolina, and Big Tuna, Texas. A campy part-tribute to *The Wizard of Oz*, Lynch's film undoes the 1930s studio-solid reality of MGM's yellow brick road, presenting a road movie that presumes to be heading fender first into

the fabulous American dream. But as we all know, the *Wizard of Oz* is all fabrication; and the reality of the matter is that Lynch's film throws up the stuff of nightmares rather than dreams.

Lovers Sailor (Nicolas Cage) and Lula (Laura Dern) are in flight from Lula's mother, Marietta Fortune, and spend several nights sequestered in motel rooms, their frenzied love-making interrupted in daylight hours by a typical Lynchian assortment of oddities and grotesques. Recently released from prison and defying the terms of his probation, Sailor is cast as the Elvis of the road, riding alongside his Marilyn-style blonde bombshell towards the California horizon, a state line they never manage to cross. Indeed, Lynch's film is more concerned with inertia and stalling engines – with overblown, distracting and ultimately obstructive visual paraphernalia, all drawn from the fetid and fumy imagination of the motel room where the lovers spend most of their time lolling. And Lynch's film is chronically anti-romantic. A close-up of Lula's early pregnancy-induced vomit on the carpet in the Iguana motel room, Texas, followed by a virtual visual dissection of a cockroach feeding from the residue, is where Lynch's lens takes us; right into the guts and innards of the grotesque. Later that night and still saturated in the stench of vomit, Lula announces her pregnancy to her criminal-lover. Despite the fact that Sailor tells her that its 'okay by [him]', Lula isn't so sure, in the light of 'the way some things is going'. And the way 'things is going' is more and more in the direction of nowhere. Sailor is unable to get work and so resorts to armed robbery; and Marietta, fast on their heels, soon appears on the scene. Sick and queasy, Lula spends the days in bed conjuring nostalgic thoughts about her life with Sailor that has nothing to do with the doom-ridden present. Finally, the road trip is brought to a crashing halt when Sailor is thrown into jail. At the end of the film, Lula's daydreaming abstractions are brought onto the screen, and her imaginatively devised sunset-flooded frame of Sailor and herself embracing in the middle of the highway, reconciled after six years of jail time, brings up the credits.

Moving nowhere fast, Lynch's roller-coasting lovers are desperate to achieve a broader and bolder horizon, to convert the steamy passion of the present into an enduring future, to convert romance into something more workable. But they get stuck along the roadside, and in a motel room their wheels stop turning. Bogged down by a flotilla of surreal and over-projected imagery, the film mimics the stammering progress of the runaways in search of that landscape of 'awe' that is Dickinson's quest;

what becomes a geography of impossibility: 'Three Rivers and a Hill to cross / One Desert and a Sea'.[72] Lula and Sailor never meet the awe of the Californian sunset. Projected through a landscape of aberration and distortion, even their romantic ending is a filmic recreation – salvaged from Lula's earlier nostalgic recordings in the Iguana motel. Lula and Sailor emerge from Lynch's film as a pair of trapped lovebirds whose flight path is blocked by an obstructing genie of a director who holds them captive to his surreal playground of obstacles.

The anonymity and homogeneity of hotels and motels lends the idea of a good getaway place. But what is it that is being got away from? In David Hare's screenplay of Michael Cunningham's novel *The Hours* (1998), the character of Laura Brown drives to The Normandy Hotel in order to escape the deadening nullity of her domestic routine. (In Cunningham's novel, we are told that she first considers a motel as a cheaper option but is uncertain of its code of conduct. 'It would feel too illicit', 'too sordid', she tells herself. Motels lie outside her social range of experience.)[73] Laura drives to The Normandy Hotel to contemplate suicide; an ending to her domestic life. Updike's Rabbit Angstrom drives his wife to a motel to bring to a ritualistic ending a tragic episode in their domestic history: the death of their child. 'Burrowing' away between motel sheets, Rabbit and Janice restore themselves to the familiar warren of their former life together. In the motel room they retreat into pure 'interior space'; they return, like Donne's lovers, to a metaphysical understanding of themselves as husband and wife. They fall asleep reconstracted. Similarly, Laura Brown drives away from The Normandy Hotel recommitted to her life, selecting one version of an ending within several versions of a single day; competing plot choices for her life. Laura Brown may wish to disappear from her own life, but she finally chooses to return to her responsibilities as mother, wife and homemaker. The hotel room offers her a synchronic interval in time and space, as Virginia Woolf put it, the novel's foremother, a 'moment of being' in which to digest herself outside of her cultural history: her *Ladies Home Journal* version of herself.

Escape is central to the American hotel and motel experience, as the couple in Sam Shepard's *Turista* (1967) know only too well, as they travel to a Mexican hotel to 'relax and disappear'. Crossing from America to Mexico, Salem and Kent are on the run from the strictures and regulations of American citizenship, the responsibilities of a membership to a western cultural order. The play's conceit is one of exchange: the substitution of

American identity for a surreal and fantastical version of the American self abroad. Kent falls ill with a high fever and lunges backwards into a maelstrom of a revenge plot upon the Mexican witchdoctor who comes to treat him. He 'disappears' into a forest landscape, a trope for his confused and fugitive state of mind. An *Indiana Jones*-style action-narrative unfolds with extended chase sequences, in which Kent casts himself as the role of fugitive outlaw, a Billy the Kid of the Mexican interior.

In the premiere production of the play performed at the American Place Theatre, New York (1967), the motel set was cast in garish colour, shades of the token exoticism of an 'elsewhere': 'bright canary yellow wall[s]', a yellow desk, 'a bright orange door in the wall to stage right with the words, "CUARTO DE BANQ" printed on it in red letters'.[74] Both Kent and Salem appear with the effect of 'bright red skin'; yellow lights suffuse the stage, the palette of tribal war paint. This, after all, is a play about cultural warfare – from within and without. Kent is as much at war with his own cultural identity as he is with the imported exoticism of Mexico in the form of the witchdoctor. Indeed, Mexico and the witchdoctor is just a displaced voodoo doll of his anger against his homeland. This is a play about power and its transferral across borders.

In the second act, the set is translated into the subdued colouring of an American hotel, all tan and grey; here Kent receives treatment from 'Doc', the same character who played the witchdoctor in the first act, for sleeping-sickness. The American setting comes about by a simple switch of palette and language. Shepard's point is that Mexico and America are separated only by language and perhaps a switch of aesthetic. The motel room levels the difference in time and space, providing dramatic continuity and a sense of the arbitrariness of cultural and geographical borders. In his state, it does not matter whether Kent is in Mexico or America; at this point in his mind-game, reality is only relative. Doc's cure for Kent's sickness leads to Kent being transformed into a Frankenstein's monster. From this emerges an extended nightmare narrative that begins with the arrival of a 'sneaky type' of 'monster', a door-to-door charlatan of the type Kent recalls arriving on the doorstep of his family home as a child – in the middle of prairie-land America. Kent is eventually pursued by Doc in the guise of monster through the Mexican rainforest, a wild flight of the mind that converts into a paranoiac witch-hunt for the 'sneaky type' of salesman that lies behind a cultural promise of economic self-betterment: America's Willy Loman.

Kent's story is a surreal and inverted version of Laura Ingalls Wilder's resolutely happy prairie existence told in her *Little House on the Prairie* series. Pa's description of 'finding the homestead' reads like an advertisement for real estate, prairie house style:

> It's just right in every way. It lies south of where the lake joins Big Slough, and the slough curves around to the west of it. There's a rise in the prairie to the south of the slough, that will make a nice place to build … On the quarter section there's upland hay and plough land to the south; and good grazing on all of it, everything a farmer could ask for. And it's near the townsite, so the girls can go to school.[75]

Shepard's prairie house is the dystopian inversion of Wilder's pioneering virgin zeal; the excitement of the prairie incomer, happily installing themselves in their small nook of land. Everything about Kent's narrative is unsettling, unhomely and foreign. There is nothing comfortably native about Shepard's disorientated American, who pursues the tracks not of a possible homestead, but of a beast in the jungle. Kent's ravings eventually project him entirely out of his mind, through the collapsible walls of the motel set, the punched-out form of a cartoon character. He leaves behind a cut-out silhouette; the two-dimensional form of an American citizen who wants out of anything homey; anything American. His traces are far from the marks of identity of writer Wallace Stegner and his dreamy disquisition on western settlement set down in *Wolf Willow* (1994). Stegner's vision is of a biblical homestead springing up like a miracle narrative from the tracks left in the soil from the settler's wagon – the moment at which he first imagines a line of Dickinsonian possibility running from homestead to horizon.[76] The motel promises everything that the homestead does not: a pause in the relentless 'tracking' down of the American dream; a respite from the strictures and expectations of domesticity; an opportunity to dwell, for a limited period, in an antithesis to the little house on the prairie. Finally, Kent busts through the paused space-time continuities of the American motel, because one leaves a motel to return to the road. And the road is always heading somewhere, and that somewhere, in the end, is home.

4

Folding Frontiers and Lost Horizons

The Frontier

Crossing the American border, Sam Shepard's frenetic characters are in search of an alternative homeland – a holiday, as Dickinson put it, 'away from home'.[1] What they find, perhaps, is the dubious 'some' the poet's speaker uncomfortably leaves with: a surreal alternative population. Dickinson's speaker is hesitant, but nonetheless, she leaves. Searching for an imagined 'metropolis', she projects something curious on to its 'Face' or façade – that curious, even heuristic device that is, in the penultimate line, the feet of the final line that will carry her there. Turning her feet westwards, she 'remains in Face'; she appears bold and faces west like a man.

Dickinson's speaker does not 'retire' from the intent to find her 'metropolis'. Metaphorically speaking, her 'emigration' is the equivalent of America's historical push forward across territorial frontiers. *Frontier* has always been a word tightly lodged in the American psyche, both for its historical significance and also for its ongoing cultural resonances. Frontiers divide up space and convert them into place; they are lines and barriers identifying membership and ownership, inclusion and exclusion, territories of inside and outside.

Frederick Jackson Turner's legendary oratory on the matter, 'The Significance of the American Frontier' (1893) lay claim to the term to denote the landscape of the historical west; figuratively speaking, it reflected a form of national self-imagining. In the latter sense, the edge

of the frontier marked the tip of American progress: what the Puritans had imagined as an 'identity in progress',[2] or what twentieth-century poet Adrienne Rich described as 'a place on the map within which … I am created and trying to create'.[3]

America's western progression, according to Turner, had 'called out' certain traits in its national identity which were peculiarly and gloriously American: 'coarseness and strength combined with acuteness and acquisitiveness'.[4] In front of the American Historical Association, he spoke of the closing of the geographical frontier as a potential threat to the national imagination – a possible curtailing of its hopes and ambitions. And yet, although the American census of 1890 no longer recognised the locality of the frontier – the cause of Turner's timely anxiety – his speech effected a significant and powerful conversion of the American frontier from an historic place to a series of cultural spaces reflective of national self-development. The historical frontier may have disappeared, but America's ideological frontier was a keener ideal; a sharper cultural tool.

In the twentieth century, these spaces took on charged cultural meanings in the mouths of politicians who appropriated tropes of American space as references for technological and sociopolitical developments: 'There are vast continents awaiting us of thought, of research, of discovery, of industry, of human relations, potentially more prolific of human comfort than even the Boundless West', declared President Hoover in his 1932 'Commonwealth Club' address.[5] The translation of this rhetoric was made clear by the time of the famous 'kitchen debate' between Vice President Richard Nixon and Premier Khrushchev (1959), in which Nixon asserted American superiority in terms of the availability of colour televisions over the Russian ability to 'thrust' rockets into space.[6] Consumer goods, apparently, reflected a new form of American 'fronting', and through her refrigerators and colour TVs, as the Eighties pop band Dire Straits mockingly sang, America would also 'thrust' forward as a global superpower.

The following year, John F. Kennedy's Frontier speech for the Democratic nomination seized upon the frontier as a term to incite the American public to political action: 'I am asking you to be pioneers on the new frontier', he bluntly demanded.[7] Kennedy's figurative frontier denoted pioneering within America itself, but it is a fact that post-Second World War America was just as concerned with the geopolitical nature of its frontiers as it had been during the Civil War, or before that, the War of Independence. Mass migration into the west from the east was equalled

by large numbers of immigrants surging over the American borders from Mexico, Central America and Asia.[8]

And in the east, Russia loomed as a threat to its imperial ambitions in space and atomic warfare, and as an enemy to America's capitalist rhetoric. As José Salvidar has noted, since the Reagan era, America has waged a border battle with desperate Mexican immigrants entering from the south, involving the immigration department, the local police and the National Guard.[9] America's frontiers, in other words, have never been still.

The trampling across American soil by non-natives throws into crisis an essential part of American self-understanding – not just the craving for movement and space that Gertrude Stein identified, but also for social amelioration. How is an ever-expanding nation to manage self-improvement? Turner managed to convert his own frontier trope into a new figure when, in 1920, he urged belief in the 'new frontiers of unwon fields of science, fruitful for the needs of the race; there are frontiers of better social domains yet unexplored'.[10] Americans are fixated upon progress and improvement; in America, the Old World must become a better New. The frontier has always been a mythical place, a perpetually forward-moving line simulating the nation's sense of growth and progress in the wider world. But the frontier is also a horizon forever in the process of being lost, for ever receding. It is place filled with conflicting myths. In the historic sense, it is the point at which husbandry and cultivation met the untamed wilderness, an intersection of old and new; a line of progress.[11]

The westward moving frontier of the pioneer was a fantasy space, an Eden reclaimed and rediscovered. Early investors in American soil clung to reports of a 'delicate garden abounding with all kinds of odiferous flowers'.[12] Turner joined in with this rhetoric, conjuring the figure of the 'great American West' taking 'European men, institutions, and ideas ... to her bosom; a maternal figure who 'opened new provinces, and dowered new democracies in her most distant domains with her material treasures'. His frontier is a beneficent, magnanimously bestowing dowager aunt into whose bosom the pioneering male stepped as both son and lover.[13] Jay Gatsby converts the longing for an idealised motherland – the 'fresh, green breast of the new world' – into a nostalgic longing for Daisy. Indeed, Daisy becomes Gatsby's frontier experience, a figure inducing awe and reverence, a territory in which all of Gatsby's 'fronting' of economic and material success is converted into something more: a figure

from Paradise. In Daisy, Gatsby rediscovers Eden; the human realisation of his green light.[14]

But there can be no sense of a far-flung horizon if there is no sense of home, the point of origin. Andrew Wyeth's haunting postwar canvas *Christina's World* (1948) takes as its central symbol Joni Mitchell's 'ranch house on the hill' and the painful attempt to reach that place.[15] Wyeth's is a painting of acute exile, a sore rift running between self and home, a narrative of attachment anxiety and the fear of separation. His composition runs along the lines of a painful dialogue between a young disabled woman crawling through prairie grass and the farm buildings on the hill that she struggles to reach: her home. Hers is an excruciating odyssey through the transcendentalist desire for organic unity, a kind and reciprocal gesturing between hill, horizon and the buildings and inhabitants that rest upon it. But the length of Christina's journey is immeasurable; the painting's obviating perspective makes it impossible for us to calculate the distance between her and her home. And in any case, this is a uniquely subjective experience of the homeward journey. This is Christina's world. Wyeth suggested that he might paint the same composition but with Christina absent.[16] To have done so would have been a further tribute to the painting's central subject: Christina's view on the world. Without her, there is only a swathe of flat grass stretching up into a hill. The perspective of experience is all hers. It is impossible for us to imagine what mental frontiers lie between Christina and her ranch house on the hill. Flat land unfolds before her, and in the painting's deceiving perspective, this means nothing.

As Wallace Stegner states in *Wolf Willow*, ownership of land is partly recorded by the relationship between viewing subject and object, the distance between the pioneer family situated around their wagon and the flat land receding into the horizon.[17] These are the coordinates of ownership claimed by viewing individuals. Landscape and the experience of owning the land become a way of seeing, the epistemological relations between a viewing subject and surrounding objects.[18] The objects in Wyeth's painting are mastered by an honestly announced aesthetic of detachment: between the buildings on the brow of the hill, and Christina herself. But even she becomes subject to pure detachment, largely because we cannot see her face: she is turned from us, and we can only presume that she views a line of sight and wrestles to bring that line under her control; to dwell in possibility – to imagine succumbing to home.

Distance only works through the receding and diminishing lines of perspective, and a sense of home provides just that: a contracted space in which to look out again upon the world; to 'front' reality, as Thoreau did at Walden Pond.[19] Christina faces distance, and an imaginary frontier. In the American experience, the frontier is always imagined, never invented,[20] an invisible line marking a culture's sense of itself and its circumference. It is a horizon, a boundary line, as far as the eye can see.

For Emily Dickinson, the language of circumference and horizon is related to circumscription, 'finity': 'I fear me this circumference / engross my finity', she confesses.[21] Dickinson would resist finitude, always stretching, in her poetry, to make her conceit as elastic and extendable as possible; to create distance and motion between herself and her reader, herself and her homestead, herself and God. Perspective is the pleasure of commanding a view of the distance, determining the extent of the horizon and its vanishing-point. This is her poetic faith, her poetic frontier. Like Wyeth's Christina, Dickinson resolutely occupies her own world and defies even God to pass through the 'Crystal Angle' that separates her point of view from the Absolute. In Dickinson's world, she and God are equal partners in creating subjective angles of reality.

Wyeth's *Soaring* (1950) is a study of perspective in which hawks straddled across a prairie sky offer a vertiginously tilted point of view. The canvas projects an omniscient bird's-eye view of the land lying beneath their wingspan. Eight years in the making, *Soaring* is an epic telling of the distance between earth and sky, the vastness of the American experience of land in which man-made structures – the matchbox-small buildings lying like specks on the sandy plain – appear dwarfed and inconsequential. Here is Dickinson's projection of 'Her Father', God, 'as high / as the Palm – that serve the Desert – /To obtain the Sky', the soaring perspective of the Puritan faith that saw a New Jerusalem on a hill in Winthrop. Wyeth's composition reflects the transcendental experience of American space, Whitman's unbounded vision of a 'Beautiful world of new superber birth', 'a limitless golden cloud filling the western sky'.[22] Whitman's lyric feeds an expansive emotionalism fed by the broadest of perspectives, the 'unfenced range, the trackless mountains, and the open sky'.[23]

Dickinson pursues conceits of size and magnitude; she revels in expansion and contraction. She drafts a broad horizon on her poetic board, and then folds it tightly away – like her handwritten, miniature fascicles. Located behind the 'Doors' and 'Windows' of a prosaic homestead

existence, she is led by her conceit outdoors, into 'seeing' more. Just as Wyeth's broad canvases encourage a bold topographical sweep, Dickinson soars into 'The Gambrels of the Sky' and 'gather[s]' the 'Paradise' of the frontier imagination to her.

In the tradition of the transcendental creator, Dickinson would leave her mark upon the land, a scattering of body parts across the imaginative territories through which she moves: 'An Artery – upon the Hill – / A Vein – along the Road'. She is a hunter-gatherer of found objects which she 'spreads wide' through her 'narrow Hands'.[24] The sunset is the ultimate mark on the land, what Cormac McCarthy terms the 'blood meridian or the evening redness in the west'. Drawn to the image of the sunset for its sense of dramatic unity, its 'finity' of ending, the sunset denotes a daily revolution from East to West. It stakes out a passageway between two shores: east and west coast America, a national antinomy bleeding into one.

In historic terms, the passage between eastern and western America is the story of the western frontier gathering to itself all of its baggy and loose mythology. In the West, the sun sets on those myths: 'Blazing in Gold and quenching in Purple / Leaping like leopards to the sky', as Dickinson narrates it.[25] Her leaping leopard is the savagery of the West that rips ferociously across writer Cormac McCarthy's bloody landscapes – landscapes much like Dickinson's landscapes of the soul, undraped and unadorned. Unsung and far-flung transients people his landscapes, a handful of motley men existing at the edge of the world along a barbarous and reimagined frontier. McCarthy's is an unpeopled landscape where men must map themselves from within in order to survive. In his 1985 novel *Blood Meridian*, the sun sets like an 'endless swale' and 'a cold wind sets the weeds to gnashing'.[26] McCarthy's lonely riders are symbolic effigies of the bareness of pure existence. Like Dickinson, McCarthy is interested in lost horizons, the daily revolution of lost temporality signified by the setting sun. His Manichean landscapes are made up of bars of light and dark interrupted by violent explosions of red, the primitive colours of life and death: 'Blood red clouds' scud across prairie skies, out of which rise 'desert nighthawks like fugitives from some great fire at the earth's end'.[27] In McCarthy's west, the apocalypse is a daily reality, and unlike Dickinson's setting suns, there is no journey home. Dickinson's landscapes acknowledge the home as the point of return; her sun sinks back down into the quiet pastoralism of the homestead, away from the 'old Horizon' of the historic westward drive. Her sun is not dispossessed;

it returns home to the gentle and convivial form of the barn roof and meadow. She brings her conceit back home, whereas McCarthy's bloody sun is left strolling in a God-forsaken wilderness.

It is the difference between the postcard view of the picturesque hamlet described by Susan Fenimore Cooper[28] and the 'terrible precipices' of Jefferson's view of the Blue Ridge water gap, where mountains are 'cloven asunder'. Here, the horizon is something snatched, 'a small catch of blue', where the eye must fish across an 'infinite distance'. The gigantism of the American landscape encourages grand thoughts.[29] Its size readily evokes drama. McCarthy's *Blood Meridian* is a novel about the dwarfing size of landscape in relation to a diminutive band of scalp-hunters who move across its surface. In an environment that diurnally threatens to undo them, these men are paltry players. What they possess is their ability to read landscape, to master its shifting moods and directions, its seismic plots and fault lines. In the game of survival, they must always look up and ahead. And along McCarthy's western meridian, the only true outlaw is the land itself.

The aesthetic heritage of *Blood Meridian* is the films of John Ford and the American western, the chiaroscurist's canvas in which cowboys stand in darkened doorways looking out upon a blazing expanse of land, whose natural enlightenment threatens to undo their own heroically gathered instincts. McCarthy's novel in no way reclaims the heroism of the western man; rather, he puts him through his paces, frequently denying him noun or definite article, abstracting him, as Dickinson often does God, to the third person. There is a weighty fatalism to McCarthy's men. The plot of the landscape owns them; they are nothing more than found objects being moved from one point to another. Self-reliant they may be but self-determining they are not, their skeletal characters picked bare of any fleshy personalisation.

Blood Meridian emerges from a decade in which America's frontier-horizons were being snatched up and stuffed into capitalist pockets. Reaganism was a reclamation of the 'old horizon', in which the 'Wild West' of the frontiersman was played out in the form of the personality cult of a former film star. Denuded of personality, McCarthy's western men are far removed from the overplayed and overhyped presence of the film star president who played cowboy in dress-up. In essence, Reaganism was an unconvincing attempt to resurrect the Old West, a restaging of the image of the frontiersman, a throwback to the 'old horizon'. A politicised version of the frontier myth ballooned, into a culture of imperial middle-age

spread. Reagan imagined an America 'carved from wilderness by pioneers', a band of 'heroic individuals' independent of the state.[30]

The result of an economic settlement between Congress and settlers, the West was built upon a sales transaction: commodities of land. For the salesman of the 1980s – the men of playwright David Mamet's *Glengarry Glen Ross* – property is territory, and the salesman is a cowboy-charmer cruising the blue horizon; what Miller's *Death of a Salesman* terms 'riding on a smile and a shoe shine'.[31] Mamet's salesmen are enthralling raconteurs and poised actors. They are staking out territory, after all, through a slippery but sharp-ended language, firing round upon round of linguistic bullets on the unsuspecting consumer.

Reaganism was the net result of a postwar conservative culture in which private property, the inviolable right of the American citizen, led to the urban sprawl typified by the Long Island development of Levittown: a model of domestic living pioneered in the West. The postwar penchant for western architecture reflected the cultural spread of frontier mythology. And so it was that the ranch house became the emblem of the modern American home, appearing in architect's plan books from the early 1940s, offering a style of home that evoked the wide open spaces of the West with 'plenty of elbow room.'[32] The president's ranch house, Rancho del Cielo, nestled in the hills around Santa Barbara, California, was the ultimate ranch house in a nation of ranch-house procurers. In eliciting the frontier myth, Reagan was appealing to a myth of nationhood in which 'westering' reflected the pinnacle of an idealised form of American self-expression. Crucial to the defence and maintenance of this ideal was the American home: the ultimate frontier in the fight against deviant forces. Here, 'mom' would continue what she had always done for the nation: inculcate her children with the necessary attitudes towards the evil-doers,[33] of which the communist-enemy was but one in a long line of outlaws.

John F. Kennedy's inauguration speech, exactly twenty years prior to Reagan's, likewise evoked the 'pioneers of old', enlisting their ghosts to support an administration whose policies turned upon a grandiose rhetoric of New Frontierism.[34] Reagan continued to spin the same rhetorical line. Standing on the West Front of the White House, he was the ultimate cowboy-hero, hauling the nation into a new decade with his high-flying rhetorical lassoing. Careful to set himself against a backdrop of geographical gigantism, he evoked the large historical bodies of his forefathers: 'Standing here one faces a magnificent vista … at the end of

this open mall are those shrines to the giants whose shoulders we stand on.'[35] Under Reagan, political frontierism and the tradition of the cowboy-hero fused in a presidential figure whose primary personality was that of the movie screen idol.

The cult of the western burgeoned into a recognisable cinematic expression in the postwar films of John Ford – he of *Stagecoach* (1939), *My Darling Clementine* (1946) and *The Searchers* (1956). Like McCarthy's West, Ford's western aesthetic is bathed in expressionistic colour: black and red skies with brilliant, low-scudding clouds. Shot through with startling Technicolor, the 1949 *She Wore a Yellow Ribbon*[36] evokes the bright sunshiny days of the Old West of artist Frederic Remington. Remington's backlit blazing desert whiteness is there in Ford's films, the apocalyptic whiteness of the white male settler burning his way through the native's territory that also functions as an illustrated storybook western shot for the Sunday matinee. A dusty horse-backed John Wayne appears diminutive against a strongly carved vertebra of valleys. The rhapsodic music of Victor Young lifts the scene into the level of spiritual endeavour and hardiness.[37] The brigade Wayne leads is what Sam Shepard ironically termed the 'true West': epic, heroic, but not without a certain rugged desultoriness. These are men, after all, without home lives.

In the following decades, Ford and his protégé, Budd Boetticher, are still 'lending' a strong aesthetic influence. In the second volume of Quentin Tarantino's *Kill Bill* series (2004),[38] the rocky desert California landscape of Boeticcher's *Seven Men from Now* (1956)[39] becomes the environment of swordfighter 'Budd', the assassin brother of Bill.[40] In the *Kill Bill* films, the frontier is converted into a dangerously unlimited and priceless aesthetic of violence. Here, violence is so removed from its direct source, so overwhelmingly mesmeric – beautifully choreographed in balletic kung-fu sequences – that the revenge plot often goes missing. Indeed, violence has little to do with plot. It is enlisted by fantasy, and to fantasy there is no end. Tarantino transposes the mystique of the gunfighter, the violent lore of Wild Bill Hicock and Wyatt Earp, into the eastern discipline of Kung Fu fighters and sword-wielding Japanese warriors. In the first part of the sequence, buckets of blood are shed. Indeed, blood is the film's main deposit. But blood is an easy premium when removed from the historical reality of the issuing bodies.

The image of America as a 'gunfighter nation', an historical cliché of a national self that feeds off myth – America as a civilising force fending off

savagery – continues to breed its mythologies today.[41] From this fusion of myth and history emerges a moral landscape, but one increasingly in submergence. *Kill Bill* toys with the idea of America at the end of its moral line. Violence issues from threats, swelling egotistical oaths of vengeance. As Uma Thurman's grimacing assassin-character declares in the opening sequence of part two, 'I've killed a whole lot of people to get to this point and I will kill Bill'. The language of revenge is spat out like a round of bullets, a virulent speech-act of the promised bloody revenge plot. Tarantino's films turn upon a mythology of moral deserts, a code of honourable vengeance. Historical actuality and legend blur, but it is legend that excites the scale of the plot: 'the incident that happened at the Two Pines wedding chapel that put this whole gory story into motion has since become legend', Thurman's bride assassin vainly declares. Shot in silvery move-matinee black and white, the wedding chapel scene is a direct tribute to the dazzling chiaroscuro effects of John Ford's screen; the dark figure of a character looming in the doorway of the church gazes out upon the scorching light of the Texan desert. Like Ford's, Tarantino's aesthetic is Manichean; your fate depends upon what side of the door you stand on: it is a matter of stepping into the light or moving towards a dark ending. Thurman's strangely sphinx-like gleaming white face – fed by strong light as she lifts her wedding veil – is gradually translated into a tapestry of blood, dust and gore. Her increasingly filthy face carries the historical traces of her deeds, the tracks of her violent trail.

But in the genealogy of violence, one deed stacks up on another and the point of origin is lost. No one knows the beginning or the end. The plot becomes too epic, and historical sediments are washed away by a torrent of legend. There is no moral perimeter, no visible end to the frontier violence – perhaps because there is no home life. For Bill's brother Budd, home is a trailer with a strong sense of the film trailer about it. And so, quite legitimately, in terms of the film's aesthetic drive, the trailer becomes yet another site of violent mayhem: a series of stagey studio-shot killings. Thurman's assassin mission is weakened by the fact of her daughter, her role as mother. Her death drive falters somewhat, twisted vicariously through problematic relations to her 'target'. The man she must kill is also the father of her child. Home is certainly not where the heart is.

Cormac McCarthy's *No Country for Old Men* (2005) is another 'gory story' shot on the ever-receding frontier line of the Texas–Mexico border. Here, McCarthy's America, delivered in the most deadpan of prose styles,

has arrived at a moral nowhere. America's identity crisis is literally stuck out and dying in the desert. Another vengeance tale, home is also a dusty trailer in the back of beyond. Set in 1980s America, McCarthy's novel gives us little sense of place, but plenty of space. At the centre of the action is the Texan desert, the site of a massacre whose littered aftermath is discovered by Llewelyn Moss. As with *Kill Bill*, there are plenty of bodies but, typical of McCarthy, few owners.

Ethan and Joel Coen's 2007 adaptation of the novel made much of the unmarked desert space as a reflection of the lost America of the Eighties.[42] The cinematography of Roger Deakins lights the film in shadows, just to remind us, in case we had forgotten, that this is a film about a moral apocalypse. Once a nation quits its manners, the end is pretty much in sight, Sheriff Bell (Tommy Lee Jones) tells us. And the end-point of this Coen brothers' film is the psychotically fixed stare of another assassin, this time, a Frankenstein's monster of a man, Chigurh (Javier Bardem). With the character of Chigurh we are beyond any sort of human horizon. Stomping his way through a systematised ritual of violence hanging on the spin of a coin (a personal philosophy of chance), Chigurh hunts down Moss who, along with twelve dead bodies in the desert, also stumbled across a two-million-dollar stash. An assassin–automaton, Chigurh might as well be anywhere, doing anything. The fact that he doggedly pursues Moss to his death in a motel room says nothing about the relationship between one man and the other, but more about the arbitrariness of his method of killing: chancy but supported by a steely undergirding of fateful belief.

Just as place has little meaning in McCarthy's text, Chigurh's killings contribute nothing more methodical than pure amorality. For the Sheriff and his men, this is a new beast, and offers them few clues or markings as to the mind of the man they pursue. Chigurh is no typical outlaw. He is apparently motiveless, indifferent to the real value of money, following a line of enquiry in which unlimited violence unravels from the flippant spin of a coin. Like the antelope tracks he hunts down in the Texan desert for sport, Moss is pursued by a killer with an agenda larger than himself. And it is the traces of his sorry ending that remain more alluring – for those investigating his killing – than his life.

Tracks and trails, these are the traces of the savage frontier life that McCarthy recognises in borderland, small-town America, towns in which the home life is a trail petering out. Sheriff Bell clings to home – the figure

of his wife – as the only hope for redemption for lonely frontiersmen like himself. He shrugs off the strong, solitary stereotype of American mythology and admits to the need for propinquity: 'I don't believe you can do this job without a wife.'[43] Bell confesses to an overwhelming imperative to keep in step with time and place, to embrace the reality of the home life, to stand back from the myth. American history is already, he admits, pretty shameful. He won't talk about the Vietnam War and he won't frame himself as a war hero. Recent history is unspeakable. It is easier to remember the atrocities of the settlers who 'killed and scalped and gutted like fish'.[44] But Bell refuses the allure of turning recent history into myth, and although Chigurh reads like something from the apocalypse, he is still a human killer, not a ghost.[45]

McCarthy's plainly delivered apocalyptic tale of America's contemporary frontier is a rival to the golden haze settling across the frontier-horizon of earlier writers such as Conrad Richter. Richter's 1936 *Sea of Grass* blithely indulges in notions of 'lusty pioneer blood … broken and gelded like a wild horse'. This 'tamed' animal is a quite different creature from McCarthy's pioneer-killer. Richter's pioneer emerges from a Golden Age of American history; a prehistory in which men rode lathered horses across a shaggy range and stood like glorious cowboy-conquistadores in whose 'blazing eyes' there burns an 'empire of grass and cattle'.[46] His frontier is a wash of emotion, an unabated fictionalising of western heroism that dips and blurs into the majestic forms of the sandy hills and rolling skies of Kansas. Man and landscape unfurl together across a billowing canvas of myth and legend. Richter's stories are biblically charged, predestined and fateful; as 'immutable and fixed' a cultural lore as the Judaeo-Christian stories of the Bible. His West is a Promised Land.

Rough Crossings

As for Wyeth's young Christina, there are painful crossings to be made between myth and history, past and present, now and then. There are layers of story to be peeled back, and like Sheriff Bell's narrative, it is a process at times uncomfortably confessional but boldly undertaken. Bell 'fronts' not only his personal history – his career and the institution of

law enforcement he represents – but also the history he shares with his fellow Americans. At the heart of this revisionary glance is a confession of dependency upon the throbbing heart of a home life, the essential point of heroic departure.

No Country for Old Men is a narrative of an inner life trying to make sense of a decimated outer world. McCarthy's story crosses between inner and outer horizons, between the landscape of a personal history marked by the usual amount of sorrowful landmarks, and that of contemporary history, whose outline is filled with forms of horror: narcotics and serial killers. Bell's narrative is rough and rocky, gaping with unanswered questions. He moves through a cloud of unknowing – the blood-red scudding clouds seem to line the horizon of every McCarthy novel – in which questions hover, dramatically and portentously, awaiting transcendence. But inner and outer lives remain unreconciled. The crossing between the mind of the western man and his environment is never quite bridged. Always, there are borders whose rocky ridges betray lines of tension, splits and rifts.

McCarthy's men seek transcendence through repeated, often miscalculated journeys across a rebutting and scornful Nature. His men travel all day and all night, riding towards a forever shifting horizon. The journey into transcendence is one of self-transport, Emersonian self-sufficiency; but McCarthy's men are under threat of being undone and outdone by the vastness of the mountains and valleys they cross. In the tradition of the transcendentalists, these men seek height and elevation, a distinct place in the universe. They long for the horizon, for sublime transport – renewal, a new tract of land – but they must first learn how to manage its size; how to view Nature proportionately from the threshold of the mind.

Following the death of his father, John Grady Cole of *All the Pretty Horses* (1992), the first part of McCarthy's Border Trilogy, leaves home in search of a new homeland. He rides southwest towards Mexico, following the tracks of history: an 'ancient road' shaped with the 'dream of the past', along which the ghosts of a 'lost nation' of Native Americans pursue him.[47] Grady crosses the threshold of his ranch home and all of its history to track new ghosts, ones that 'glide through nature'. He goes in search of individuation; a new place to settle.[48] Riding out into the wide open spaces of the Mexican desert, he pursues a new form of self-accomplishment.

Etymologically speaking, the sublime is the threshold between what is known and what remains unknown; the 'limen' or running seam between the viewer and the untold horizon ahead of him. The sublime resists cognition. It resents being known. It temporarily suspends thought and belief.[49] In the tradition of the American sublime, the individual is enlarged by that which estranges him, and so he looks towards the horizon with an eye forever seeking strangeness. He pushes himself towards larger and broader experiences. This is what Emerson meant when he wrote of man's desire to lose his 'sempiternal memory', to forge new and foreign links with himself, to be subsumed by inexplicable acts and places.[50] It is the most sublime of experiences not to know why.

As Thoreau suggests in *Walking*:

> climate does react on man, – as there is something in the mountain-air that feeds the spirit and inspires … [and] I trust that we shall be more imaginative, that our thoughts will be clearer, fresher, and more ethereal, as our sky, – our understanding more comprehensive and broader, like our plains, – our intellect generally on a grander scale … like our rivers and mountains and forests.[51]

The mind is enlarged by Nature's dimensions, whose 'great-enough' both 'accept[s] and subdue[s] what already exists'.[52] In other words, the confrontation with Nature both ratifies and challenges the mind-space; in the face of the sublime, the mind expands and contracts. The essential doubleness or split in this equation can only be overturned by bringing the mind back into the body, into the physical frame. And so in the tradition of the frontiersman, man turns hunter and pursues prey, those found objects he gathers up as part of the effort of self-reclamation. He moves away from his submerged and overwhelmed mind and turns back towards a sense of himself as framed and formed. He turns further away from the horizon, maintaining distance and perspective between himself and the larger form he seeks. He turns his attention once again to basic acts of survival.

This is precisely the narrative of McCarthy's *The Crossing* (1994), part two of his Border Trilogy. Billy Parham leaves the security of his prairie home to repatriate a wolf he has captured. The repatriation of the animal is also a repatriation of a savage past, and like John Grady, Billy rides into a frontier consciousness of a 'secular and transitory and violent' nature.[53]

Billy returns to the primary experience of the hunter and hunted, the pursuer and pursued – tracks closer to the ground and easier to follow than the wandering tracks of his mind. Clearly, the limited circuit of the hunter is a more immediate and easily recorded experience than the unenclosed, circumferenceless space of Emersonian transcendence.[54]

Dickinson's lauded 'My Life had stood – a Loaded Gun' records the pure experience of self as object: that is, the speaking subject as a gun loaded with singular intent. The self as pure reflex – 'me' rather than 'I', effect rather than cause – draws away from the responsibility of viewing anything larger than the limited intent of the instrument: 'to kill'. The gun knows only what it can do; knows itself only as pure effect. There can be no room for not knowing, for the transcendentalist's process of self-expansion. For that, there must be the endless space of Whitman's roaming poetic 'I', and in Dickinson's gun-shooting Wild West, there is no sense of time or place, no majestic sweep of history, no apocalyptic end-of-the-line revelation. Her gun-hunter has her 'yellow eye' only on the action.

Dickinson's poem renders the frontier experience a subjectless space. Identity is passed over to an instrument, and the idea of a nation having formed from a heroic group of gunfighters is undone by the instrument itself. In Dickinson's poem, the only speaking subject is the gun; there are no other heroes. History has been replaced by mythology: 'And now we roam in Sovereign Woods – / And now we hunt the Doe'.[55] The teleology of the frontier has folded into a single instrument, a sole and rather lonely action.

Dickinson's West is a role-play; a piece of mythological cabaret. Outside of time and space, her version of the West is exorbitant and deeply personal. Her rendition shares some of the mythological constructions of Thoreau's essay, *Walking*. Here, America is a 'Holy Land', whose westward trajectory is part of a body of European myth unfurling from personal thoughts had out walking.[56] Thoreau 'saunters' westward, towards 'absolute freedom and wildness'. He strolls out, 'crusading' his way through a spacious form of self-expression, expanding his disquisition, American style.[57]

The transcendentalist sought freedom of movement outside of space and time. Cormac McCarthy's post-apocalyptic tale of American self-extinction, *The Road* (2006), is the transcendentalist myth-turned-horror show. In the days and weeks following a nuclear war, a man and his son

walk the scorched and tarry remains of the American landscape. Thoreau's sauntering is here converted into full-scale scavenging, military style; walking is for the pre-apocalyptic dandy. This is a tale of survival running out.

The Road presents the experience of timelessness and a space devoid of geography. The land has been stripped of any sense of itself; instead, we have retreated into the tectonics of the earth, geologic structures where the deep scar tissue of history is barely discernible. The novel opens with a Jurassic image – a dark cave – the tragic proscenium from which father and son emerge, 'deep stone flues from where the water dripped and sang'. Prehistoric, McCarthy's characters are creatures moving across 'the inward parts of some granitic beast'.[58] The landscape is certainly sublime in the Burkean sense: a sight so filled with horror that the mind is suspended by a state of horrific astonishment.[59] The pretty proportions of the picturesque have been wiped out by much larger and more ferocious dimensions of activity.

America's relationship to its nature has always been that of a heroine to her hero. The iconographic landscape art of the nineteenth-century landscape artists Frederic Church, Thomas Cole, Albert Bierstadt and Fitz Hugh Lane muster up grand representations of manifest destiny in the majestic lines of Niagara Falls in the East; the Grand Canyon, the Rocky Mountains and the Yellow and Yosemite valleys of the West. Such images embodied dreams of grandeur and hope; the power and resolution to go on. Manifest destiny erupted from the aerobic production of Nature, filling lungs, hearts and minds. And from the inspiration of Nature, the Protestant workforce was born. The pioneering project was one of direct conquest.[60] As salesman Charlie tells Willie Loman's son Biff, it is the American scenery the salesman drives through that spurs him on to more sales.[61] The immanent force of Nature is transferred into direct action, stirring up a kinetic energy that spurs on progress. The torrent of water charging over the rocky face at Niagara Falls is a manifestation of the charged resources of its citizens – Willy Loman cruising 'way out there in the blue'.[62] Sublime or heroic nature provides visual stimulation, a spectacle, but it also enlivens the aural, tactile and olfactory senses.[63] It is all encompassing and potentially radically altering. Charles Dickens, describing his first visit to Niagara Falls in 1842, declared, 'I had no idea of shape, or situation, or anything but vague immensity.' Here was pure nature, and as Thoreau advised, in relation

to 'the fresh and natural surface of the planet Earth ... Man was not to be associated with it'.[64]

Sublime nature blows the mind away. In the presence of symbolic nature, the American citizen can experience a return to the natural man of Walt Whitman's creed.[65] For geological sculptor Robert Smithson, the overwhelming force of nature subsumes any form of 'concepts', 'systems', 'structures' or 'abstractions'. Thought itself was wiped out by the quaking force of nature, Smithson's own thoughts on the effect of his most famous sculpture, *Spiral Jetty* (1970) on Lake Utah. His earthwork is a talismanic form in basalt rock that appears, disappears and reappears depending upon the rise and fall in the level of water – a reminder of the 'astonishing' nature of the sublime. The sculpture, spiralling like a shepherd's crook into an often invisible centre, rotates from the centre outwards, a gigantic whorl of energy spinning off towards unfathomable, unimaginable horizons. Smithson's own description of *Spiral Jetty* is filled with a language of limited viewing, unforeseeable horizons: 'As I looked at the site, it reverberated out to the horizons only to suggest an immobile cyclone ...'.[66] Here, in rock formation, is a sense of sublime transportation; a cyclonic black mass of basalt 'terror'. With no specific meaning attached to the form, *Spiral Jetty* renders the viewer speechless. We can apprehend its form – that is, take in a certain visual field, a certain scope. Our imagination will compensate for what our eyes cannot see. But we cannot necessarily comprehend the entirety of it form. We cannot determine its magnitude; we cannot perceive its totality.[67]

Visibility is an early and key figure of McCarthy's *The Road*, the view of the world and its limits now hanging in an ashen blanket of death and destruction, a grey wasteland of 'cold glaucoma dimming away the world'. Contemporary history has been wiped out. A creature on the edge of an ancient lake marks the modern world, a return to primeval life-forms.[68] As with Smithson's earthwork, temporality is a ghost that shivers on the edge of the world, barely conscious. And what Nature there is, is unrecognisable, because its forms are prehistoric, even atavistic.

Spiral Jetty makes the presumption that Nature has a life of its own, beyond human comprehension, and in the face of that life-force, nothing can hold itself together – certainly not human cognition. As Smithson himself noted, moving through the spiral form we return to our 'origins', to the ectoplasmic beginnings of organic life. Reduced to the red algae of Lake Utah, the blood-red composition of 'primordial seas' – McCarthy's

ancient lake – we are forced to admit to the meaninglessness of contemporary history, the obsolescence of contemporary forms.[69] Smithson's own visual account of *Spiral Jetty* is awash with the colour and language of the apocalypse, crimson red suns setting across the lids of his eyes: 'I closed my eyes, and the sun burned crimson through the lids. I opened them, and the Great Salt Lake was bleeding scarlet streaks. My sight was saturated by the color of red algae circulating in the heart of the lake …'. Smithson's account tells of the end of seeing: 'My sight was saturated …'. Suspended above his creation in a helicopter, he describes the corollary experience, the end of being: 'All existence seemed tentative and stagnant … Was I but a shadow in a plastic bubble hovering in a place outside mind and body?'[70] The end of seeing is also the end of being.

Smithson's account is the experience of entropy, of matter 'tentative and stagnant', untransformed. In *Spiral Jetty*, the artist experiments with the notion of time suspended by place – time arrested by a particular place; a site of time.[71] As is the case in McCarthy's desecrated world, in the place of *Spiral Jetty* – Rozel Point, Lake Utah – time has little meaning; entropic disintegration has led to all matter falling apart. At Rozel Point, Smithson has created a sense of an ultimate ending. In another version of the same ending, McCarthy's father and son haul themselves between one site of waste and another, desperate for something known, some material matter: forms of life. McCarthy's dystopic version of the American wilderness has no roads and no states. And in a state of chronic cultural regression the country has lost its chief emblem – life on the road, trucks and cars crawling across highways; matter on the move. Like Tyrannosaurus Rex, the American automobile is now extinct, and with it, all hope of progression.

Inner Horizons

Moving matter, the journey between one state and the next, the black lines of roads marked on the map – all the signifiers of movement and progress are reduced to entropic disintegration. With no clear routes to follow, father and son cannot work out how to cross the land before them. There is no heroic progression, no archetypal cowboy wandering from

one small-town site to another. This is no John Wayne movie, no Sunday matinee plot of Technicolor dispossession. McCarthy's sorry pair are the disinherited of the earth.

Like *Spiral Jetty*, *The Road* is a study of collapsed matter, the aftermath of the sublime encounter. In the same way that the sublime at some point arrests cognition, delimits the imagination, McCarthy's post-apocalyptic scenario is imaginable only up to a point. To the contemporary American reader it is just another piece of dystopian fiction that imagines the worst – the unimaginable worst. But it is difficult not to read it as a grim undoing of the archetypal American journey, the mobility and migrancy of the displaced, rootless cowboy-gangster who rids the world of 'evil doers'. McCarthy's scarred earth has little time for wandering heroes; the whole point is that time is running out for life on earth. The over-extended and collapsed plot of the outward journey must turn back inwards. The only hope for McCarthy's sole survivors is that they can still dream.

Gary Wills has noted that American life begins 'when the enclosure is escaped. One becomes American by going out.'[72] But one can only go so far with 'going out', with chasing down new 'Beyond[s]' as Dickinson reminds us. Her confessional, 'I saw no Way – The Heavens were stitched' is an admittance of mental limits; the sublime frontier. Pushing towards the edge of the 'Universe', Dickinson's speaker can go no further; she slides back and finds herself 'alone', spurned by a universe that permits her no further self-expansion. Her mind folds back upon itself, and she retreats into a relationship in which she is rendered, in the poetic scheme of things – immortal. And yet her capacities for figurative imagining, for frontier consciousness, fail her. Figuratively speaking, in terms of her own ability to conceive, to reach for a conceit, she is nothing more than a 'speck' upon a distant horizon. Self-transcendence retains a sublime form: unachievable, still unreached. Her speaker must admit that transcendence is a process kept within imaginable limits, as far as the inner eye can see, within the 'Circumference' of the possible. Apparently, the journey towards the unforeseeable horizon never ends, as long as there is life.[73]

At the end of the road with the outer journey, recent American fiction resorts to the journey inwards. Beneath inner skies there is always more room for expansion. Paul Auster's *Moon Palace* (1989) marks the end of a decade of Reaganist frontiersmanship with a tale of inner progression traced through outer geographies. Marco Stanley Fogg retreats into a minor inner apocalypse of his own making. His mental regression takes

him into the heart of New York City, Central Park, where he undergoes a sort of Thoreauvian wilderness retreat, his identity 'blending' into the natural environment in which he camps out. Embedded in the park's foliage, Fogg feels secure, able to reconfigure the relations of his inner and outer worlds. He clambers inside a 'nowhere', and leaves geography behind, the compulsions of time and space. Like Dickinson, he wishes to avoid becoming a speck on the broad and trailing horizon of humanity. He desires the distinct identity of Whitman's privileged and loafing dandy-soul, a 'democratic' and equal share in nature, a co-operation or 'equilibrium' between inner and outer.[74] Along with Whitman's soul-speaker, he longs to 'lean' easily and causally, perhaps somewhat presumptuously, into a relationship with Nature.[75]

Fogg's existential crisis is figured in a language of thresholds and boundaries: who or what he will take into his inner life, the index of his soul. He craves a secure identity, until now left wide open and gaping. And so he creates an enclosure and builds a dwelling for his vagrant identity; pitches an identity crisis in the middle of Central Park and calls upon the tradition of the American transcendentalist to save him.

Fogg retreats into basic acts of survival as a means of smoothing his raging mental life. He wanders around the park enjoying its man-made 'natural' sites as a sort of theme-park version of America from which he scrounges food and shelter. Unable to manage the size and variety of 'real' America, the park becomes a simulacrum of the nation's manifold terrain. Indeed, the 'real' America is the source of persecution from which he beats a retreat. American geography has pursued him since the novel's opening, in the postcards he receives from his Uncle Victor: 'full-color tourist items', 'Rocky Mountain sunsets, publicity shots of roadside motels, cactus plants and rodeos, dude ranches, ghost towns, desert panoramas'. When his Uncle Victor goes missing in Boise, Idaho, Fogg has to consider crossing the States, that 'vast danger zone' of the American continent, to retrieve his uncle. But his uncle is found dead and soon after, Fogg, borrowing the conceit of his uncle's western voyage, departs on his figurative trip out west.[76]

Fogg's journey becomes one of pure space, empty mental space. Indeed, the mind space functions increasingly as a substitute for real time and space, a simulacrum of the coordinates of here and now. Fogg is captivated by the idea of simulate reality, hovering around the figure of the telephone as a 'simulacrum of ourselves', constructing voice-overs for

the real thing.[77] *Moon Palace*, begun in 1968 and completed in the mid- to late 1980s, is a novel literally stretched out. It thus exhausts two decades and the longevity of its writing process is reflected in the stretched nature of its narrative – across three generations and two coasts. Passing from east coast to west, New York to Laguna Beach, California, Fogg's narrative shifts between two additional pairs of hands – those of Thomas Effing and Solomon Barber – both possible 'voice-overs' for Fogg's father. An alluring range of simulacra is the novel's major conceit, smoothly edited more civil personal narrations of history struggling against the shrieks and squawks of its unedited, feral counterpart. Fogg roams from site to site, from place to place, hoping for a better edition of events, a more polished version of himself. Concerned with modes of representation, the novel draws attention to the artifice of art and to the allure of revising reality in art. The narrative of Thomas Effing is that of an artist enticed by the allure of the mystical landscape of the Great Salt Desert – something of an artistic cliché. Effing's identity crisis in the desert – a process by which he abandons himself to any conventional markings of time and place – is another narrative simulacra to which Fogg attaches himself. Just as Effing longs to be 'swallowed up' by the immensity of the southwestern landscape, so Fogg seeks out alternative narratives that will enshroud and enclose his own – defer the messy denouement of real living. His narrative boundaries are as arbitrarily selected as his picaresque encounters; roaming from one rescue site to another, he seeks out the rehabilitation of his fearful and trembling sense of self in the stories of other lost souls. Each locale provides him with a rarefied sense of place, a setting to match his efforts at self-identification. He moves from Central Park to Zimmer's apartment, then, vicariously, to Effing's cave-narrative, where the artist camps out with his soul and the landscape – mirroring Fogg's own Central Park camp-out. Finally, the narrative moves to Westlawn Cemetery, Chicago, where the third father-substitute – another artist, Solomon Barber – turns out to be the real thing.

Just as Fogg's narratives of paternal hunting are rather randomly acquired, and loop back upon themselves (Barber, it turns out, could also be Thomas Effing's son, as Barber eventually turns out to be Fogg's father), so the sites of narrative time and space become a series of involuted whorls, whirling out of real time and space like Smithson's spiralling jetty. Auster's novel is as much concerned with its own process of story-telling, its own swirling and whirling devices, as it is in telling a

particular story. Fogg's originary tale is neither here nor there in the much wider scope of interest: the inclusion or exclusion of particular details, the construction of fiction through an arbitrary selection of facts – and the interaction between the two.

Exclusionary Practices

Moon Palace explores the construction of the alternative reality of art – in this case, story-telling – the inevitable inaccuracy of mimetic reconstruction. Diegesis – one character's telling of a story – is inevitably corrupted by the attempt at imitating that voice, that story retold in another medium. Fogg's restless travel across his inner landscape is mirrored in his geographical wanderings. Hovering around the edges of that inner journey, a particular search for self, is the larger journey into a cultural identity, and what it means to be American. Fogg's own efforts at writing – 'short bursts at prose' on 'far flung and abstract topics' – are always, self-admittedly, self-reflexive. He cannot wander too far from himself before he admits to straying into a 'foreign country'.[78]

A text that explores American identity will inevitably produce conceits of geographic and spatial exploration – territories. Auster's novel is as much about the hesitancy of modern American identity as it is about the story of Marcos Stanley Fogg. What Fogg pursues is what America has always pursued – a successful, personally tailored constitution, an identity rubric with a Fifth Amendment right to remain silent on certain aspects of its origins. Fogg's creation story is a clumsy process of demarcation, the marks and measures of an exclusionary practice – the inevitable starting and end-point of those who draft constitutions.

Unsurprisingly, recent American films have also debated drafted versions of American identity. Film director Lars von Trier's *Dogville* (2003) takes as its subject the moral terrain of small-town Depression-era America and its attempts to draw up a moral constitution of its own – what proves to be a rather treacherous affair. Dogville exists as an arbitrary model of American moral identity, a small slice of its inner horizon. Grace (Nicole Kidman) arrives in town as a fugitive in flight from a mob of gangsters and throws herself upon the mercy of the town's

inhabitants. The 'good people' of Dogville take her into their bosom. An infinitely darker version of Thornton Wilder's 1938 *Our Town*, von Trier's vision is a Christian allegory of back-yard America flung across a harsh Brechtian setting. Denuded of filmic saccharine, not at all easy on the eye, *Dogville* is cruelly anti-American in both its aesthetic and its politics. A series of painted white lines mark out the precincts of the town and its houses, and most of the action of the film-play takes place along these lines of inclusion and exclusion. Throwing herself upon the mercy of the townsfolk, Grace is eventually incorporated into the town's membership – the township, as Tocqueville noted, being the first order of democracy in America.[79] Tocqueville's model of decentralised local government is the grass-roots level of American democracy. By crossing inside township boundaries, Grace signs up for a particular local constitutional model. She joins in and so becomes bound in, part of an exclusionary practice.

In the words of Benedict Anderson, Dogville is an 'imagined community', enjoying a 'horizontal comradeship' which is both 'inherently limited and sovereign'. It conceives of and perceives itself as autonomous and omniscient, founded upon self-determined constitutional principles. Yet, despite this, it is unable to know itself fully because its members will never all know one another.[80] And because of this, there will always be gaps in the community's self-knowledge, its constituents. With the American principle of individual self-interest at its core, there will always be room for constitutional violations.

A simulated space, Dogville is indicative of the end of America's spatial exploration. Dogville is not a space converted into a place. Rather, it is an imagined territory, as involuted as Smithson's *Spiral Jetty*; an imagined township whose predicaments of self-government make it universally American: simultaneously everywhere but also nowhere in particular. The film's ironic jab at a sense of place – chalk markings of arbitrarily selected street names ('Elm Street', for example, although we are told that no elms grow in Dogville) – cruelly underwrites the Beckettian 'nowhere' nature of its setting. The camera hovers, superciliously, over the town's inhabitants, sneering at its attempts at self-control. Eloigned shots of the main street distance the viewer from the setting, intimating unfamiliar and uncanny relations between the inhabitants and their town. As Grace finds out, being at home in Dogville is not easy. John Hurt's narrative voice-over increases the sense of unhomeliness: another contribution to

the general tone of superciliousness that dooms all present actions to an ineluctable past historic. In the mouth and eyes of its directors, Dogville's dire history has already been written.

Grace moves in and out of contractual domestic labour until, eventually, she is blackmailed by Chuck (Stellan Skarsgaard), an apple farmer, who holds her to ransom as his sex toy. Shot through the transparent space of the open-plan 'buildings', the rape proceeds while the townsfolk go blithely about their business. 'Leased out' for the sexual pleasure of several male inhabitants, Grace is incorporated into the town's repressed libidinal economy. Suddenly, the grid lines of the streets begin to mean more than stabs at democratic conventions. Dogville's constitution appears to be failing the rights of its citizens. A blaring critique of American values, *Dogville* is an indictment of the failure of the town's constitution to protect its citizens. A dark parody of Tocqueville's vision of local self-government, the venality of its citizens runs amok over any higher pursuit. In Dogville, the bounds of self-interest – the very principle Tocqueville relied upon for American democracy to work – go dangerously and inhumanely unchecked.

And yet Dogville is 'somewhere'. Elm Street was the street upon which JFK was shot. And this is Depression-era America in the Rocky mountains, and the last word in the action is had by outsiders: the gangsters Grace first fled from. Calling upon her gangster-father and his mob to retrieve her, Grace is handed back to her violent and patriarchal origins. But not before she delivers her final edict upon Dogville: 'Shoot all the people here and then burn it down.' The order could only have come from an outsider – a fact reflected in von Trier's own outsider status to America – who thought nothing of creating a filmic representation of a nation (albeit a highly theatrical, denaturalised one), about a country he had never visited. The film ends with David Bowie's 'Young Americans' playing to photographic stills of scenes from a poverty-stricken America. The real America thus steals the show. Moving from a simulacrum of American place, von Trier makes it explicit that this is a version of historic America.

Clearly, Grace is a rather forced symbol for America's violent origins: her gangster past. Retreating from the failed, now razed constitution of Dogville, she passes back into the hands of a bunch of murdering cowboys. She is once again on the run, her constitutional aims unsettled and unbounded. Dogville becomes a failed experiment in living, a unit of

place and time that is handed back to the ravages of the wilderness, the uncivilised – the cruel and petty acts of the criminal.

Dogville is a study of civic spillage: of uncontained and unresolved civic disputes; of weak and ineffective political boundaries; of shoddy jurisprudence. Finally, Dogville is consumed by its own outlawry, its inability to settle upon and implement an effective polity. It is a microcosm of a failed nation-space whose history finally implodes. A failed model of American locality, Dogville is an experimental space that fails to convert into any enduring sense of place.

America has always existed as an imagined space: a space created in the minds of the first European settlers. Constructed against a European past, it is a nation both 'nowhere' and also without a past.[81] The space of America had to be translated into a series of local places: lived and inhabited; zoned. Von Trier's film deals with the American penchant for zones, as does Don DeLillo's novel *White Noise* (1985), where the zones of American living are jeopardised by a toxic disaster. And so the precincts of middle-class, college town America become dangerously leaky. A place of refuge and a counterpoint to the larger chemical leakage is the local supermarket, where chemicals are safely contained within zipped and sealed packages and products. The supermarket locale exudes white noise: 'a dull and unlocatable roar', an unknowable, indiscernible form of life, 'just outside the range of human apprehension'.[82] Here is a zone of sensory implosion; of alluring and shiny surfaces. Shopping is the experience of too many competing surfaces, a galaxy of reflective surfaces that deflect the image of the consumer back upon himself: 'I kept seeing myself unexpectedly in some reflecting surface', says family man and college professor, Jack Gladney. Shopping is about the encounter with competing surfaces, surfaces that throw up little opportunity for real self-reflection despite creating the sensory illusion of such: a simulacra of reflective activity. Shopping simulates the consumer's equivalent of Whitmanesque self-expansion:

> I filled myself out, found new aspects of myself, located a person I'd forgotten existed. Brightness settled around me … I traded money for goods … I was bigger than these sums … These sums in fact came back to me in terms of existential credit. I felt expansive, inclined to be sweepingly generous.

Modern America, DeLillo implies, is organised around a binary of overloaded sensory zones and zones of retreat. Extracting themselves from the mall-emporium, Jack and his family 'drive home in silence', where the members of the family retreat separately into their 'respective rooms, wishing to be alone'.[83] The family fridge is another place of retreat, stuffed full of more white noise: synthetic, preserved life-forms of life crackling: 'A sound like some element breaking down, resolving itself into Freon vapors. An eerie static, insistent but near subliminal, that made me think of wintering souls, some form of dormant life approaching the threshold of perception.'[84]

The conceit of the zone dominates the novel: from supermarkets and fridges to an iterative and rather empty disquisition on the zone of a room and its particularised code of behaviour. The novel's energy is concentrated around the humming mental threshold between inside and outside the mind, the 'threshold of perception' identified in the static, low freeze-hum of the fridge and the supermarket freezer. Considering the toxic waste seeping across Gladney's home town, the strict maintenance of tight, zip-locked zones is a natural preservative for all forms of life. In a novel about toxic spillage, spaces become highly regulated. Rooms are zones one crosses into from outside. To enter a room is to enter into a certain mode of behaviour, an unwritten constitution between the person entering the room and its proprietor.[85]

White Noise says something specific about the way in which Americans experience lived space or place as a series of contractual zones. According to DeLillo, the difference between outside and inside space is marked by a difference in behaviour. The cluttered indoor spaces of modern America – the mall, the supermarket and the front room where the TV drones on – force a cracked surface attention. A mind humming with competing sights and sounds creates a kind of auditory and visual scrapbook, a scattered and poorly collaged synaesthetic record of the world. In the turbulent mind of the consumer, objects are flying saucers that come out of nowhere with no clear flight path. The result is a fraught relationship between the sentient subject and the distracting surfaces of the objects on view. There is just too much to choose from. The novel waits for some clear apocryphal symbol to edge its way over the horizon; a prophetic image that will jettison all competing sights and sounds. At the end of the novel, the image of the chemical-induced sunset emerges across the town's horizon, and viewed from an overpass off the highway, the Gladney

family revel in a 'postmodern' version of Dickinson's sublime sunset. Here is the final 'gathering storm', the grand visual finale:

> The edge of the sun trembled in a darkish haze. Upon it lay the sun, going down like a burning sea … why try to describe it? It's enough to say that everything in our field of vision seemed to exist in order to gather the light of this event.[86]

The approach to this ultimate spectacle, visual by-product of the toxic waste, is a view of the West: a running stream of cars 'coming from the west, from out of the towering light'. The cars are the final commodity-carrier for the subliminal message the sunset ultimately delivers; the literal and metaphorical vehicle for the sublime: 'we watch them as if they carry on their painted surfaces some residue of the sunset, a barely detectable luster or film of telltale dust'.[87]

Cars deliver semantic epiphanies. Earlier on in the novel, Jack's daughter utters the name of a car brand in her sleep: 'Toyota Celica', words 'gold-shot with looming wonder', a 'moment of splendid transcendence'.[88] A flow of traffic running along the highway delivers a surface reflection of 'something golden', something over the mental horizon. DeLillo's novel ends with a field of vision flooded with an unnatural equivalent of the natural sublime: a chemically induced sunset. Here, literally, is Sunset Boulevard: a place where visuals are considered more effective than words – an opinion shared by Norma Desmond, the eclipsed silent-screen star of Billy Wilder's classic film *Sunset Blvd.* (1950). DeLillo's sunset is a simulacra, a chemically induced substitute of a traditional visionary moment.

And in America, the search for such moments can go very large. Earthwork artist James Turrell's hunt for a fixed visionary moment, the splendour of transcendence, has created the Roden Crater project in Painted Desert, California, perhaps the most ambitious piece of earthwork art yet attempted on American soil. His vision: to create a bowl-shaped oculus pressing into the sky, thereby rearranging the view of the sky; to limit the effect of the horizon and to capture a sense of eternally stored starlight. Turrell's designs for the crater – a series of chambered spaces open to the sky – rely upon an interplay with the crater's rim, a simulacrum of the actual horizon. Looking outwards from the observatory rim, viewers will be forced into a close encounter with the heavens.

Turrell is a hunter-gatherer of ancient light. His extraordinarily over-exalted vision is an attempt to scoop up light from outside the planetary universe; from galactic planes. Excavating light from the oldest of skies – light lying outside the Milky Way, three and a half billion years old – Turrell poses as a cocktail artist of light, mixing newer sources of light from the sun with more ancient reserves. Against dark desert skies the effect is a potent cross-blend of ripe, red, older light with the more thinly diluted, white light of the sun and the moon.[89] A con-artist of light and space, Turrell plans to simulate a new version of the horizon, interrupting and dispersing the relations between universal light and space. His ambition is to alter the context of the sky by masterminding an extraordinary ocular arrangement; to alter our view of the universe and ourselves within it. By creating architecture from natural phenomena, his viewing chambers and bronze staircase leading towards the sky, Turrell pulls off a similar *trompe-l'oeil* chicanery to the Amherst poet in her chamber. Dickinson's 'impregnable eye' suggests the solid security of internal views; views of the inside, self-reflexive and self-haunting. And yet, just like Turrell's grandiloquent volcano, her poetry promises radical new perspectives: an 'everlasting roof' in 'the gambrels of the sky'.[90] From inviolable interiors, both bequeath a radical revision of the American horizon; both promise to gather up the sunset in a cup: the ultimate sublime commodity.[91]

Conclusion: Home and Horizon

Dickinson dreams of taking a sublime souvenir home: a sunset in a cup. What she wants is a portable image of sublime America, proof of its manifest self; sublimity in miniature. But not everything in America is flagrantly obvious; there are also small as well as large things that remain hidden, as Dickinson, a devotee of the small and the hidden (her body of poetic fascicles stored within a rosewood chest), attests to. For Dickinson, the world of home was synonymous with the world of her poetry; both offered domestic interiors that she could imaginatively 'do up': places of self-display as well as retreat; nooks and corners. Hovering among the small and well-matched details of the picturesque home life, Dickinson zooms out, often extravagantly, towards the wider world. But like Thoreau, tucked away in his wooded idyll, she is quite aware just how far from herself the horizon lay. The space between self and horizon, home and the furthest point away that the eye can see, is difficult to measure: approximate. As Thoreau put it, 'Our horizon is never quite at our elbows,'[1] or as the American poet Frederick Seidel bluntly stated: 'It I feel close to, it cannot come near.'[2] In other words, the horizon is a far-off abstraction, and so an easy target for the limitless projection of individual hopes, fears and dreams, continually and comfortably receding into an ever-extendable ideological distance.

Since the arrival of the American highway in 1956, the natural horizon has competed for attention against an ever-increasing thicket of glittery signs – its arteries blocked with the toxins of consumer culture. The Federal Aid Highway Act precipitated the opening up of the suburbs connecting suburban dwellers to urban centres; and so the suburbs began their rapid crawl along the length of highways, rupturing the landscape with oversized shopping malls and cinema complexes.[3] Stretched out

along the highway, a cornucopia of businesses and accommodations grab the attention of the tired and flagging motorist, mesmerised by the lights and spangle of America's alternative horizon.[4]

Seidel reminds us of how America continues to take pleasure in its own consumption. His tropes of the material life compress and crunch the nation into consumer-friendly zones, packaged parts of experience in which the 'cell' of the 'house lot' 'links up' to become 'house/ Shade, tree and lawn'; a zip-locked disposal package of metonymic spaces lined up for the citizen-consumer to swipe at as he dashes by, and then discard like 'plastic wrap refuse in the bare trees'.[5] Seidel's cultural zones, like his conceits, are littered and must always breed more of themselves; there is never enough room to feed the demand, the consumer appetite: 'the frontier hypoblast / Of frontier capitalism develops streets in minutes / Like a Polaroid.'[6] His cultural horizon is a 'bulging' golden Christ with 'too much honey' in his 'spoon'; over-endowed with value and meaning, it refuses the diurnal eclipse of the moon. In Seidel's America, the sunrise is always flushed, full and ready to compete. Nothing ever wanes, hope is remorseless and the frontier is a superfluous conceit.

But away from the horizon, America has always advertised itself at home. In the nineteenth century, the American parlour, as Huck Finn quickly realised, was not just a place to kip for the night, but an advertising space for the imagos of American identity. In the front parlour, homeowners could announce, along with their visitors, a heraldic display of the wealth of a nation, what Edgar Allan Poe described as the 'crimson tints' of the nouveaux riches.[7] Like the highway, the parlour was another easy-access showcase of consumer culture; a space where the accumulations of the domestic life lifted an opulent veil against the outdoor life.

And yet, as a conceit of self-progression, the American sense of manifest destiny has always relied upon an infinite and ensuing amount of space, an interminable stretch between home and horizon. Beyond the culture of things, the nation continues to produce ramblers and roamers, those with a taste for the road. For legendary folk singer Bob Dylan, America is an active space, a rambling and a roaming across territories; a continuous unfolding.[8] And for Dylan's gambling outlaw, Will O'Conley of 'Rambling, Gambling Willie', geographical progression is synonymous with the 'rolling' movement of his dice, in which a quick trip up the Mississippi is as good as a night playing hard up in the Rocky mountains. The horizon follows Willie, and to return to Thoreau's formula, is

never quite at his elbow: always as far away as the next game. Willie is happy as long as he is on the move; and the conspicuous consumption of geography is all part of the thrill of a gambler's quick and cunning moves; his gaining ground. Space and time are relative measures for the outlaw who can win a steamboat in a game. Home is wherever the game of outlawry takes him, and for the successful gambler, things can always be acquired along the way.

Andrew Dominik's 2007 film *The Assassination of Jesse James by the Coward Robert Ford*[9] lays open, in cinematographic terms, the relationship between the American home and the big outdoors, in which some conquests, but chiefly the losses of the roaming outlaw, are laid bare. This is a film that fêtes and foregrounds the heroism of the Missouri plains, territories through which Jesse James and his band of not-so-merry men roam like homeless beasts. The cinematography of Roger Deakins sets up a startlingly bleak opposition between inner and outer worlds, operating, in the tradition of John Ford's western, as a messianic call and response between James's 'guerrilla' fighters and the landscape they roam. Like McCarthy's western campaigners, James's men are as much or as little as the landscape permits them to be.

As the film progresses, the distance between the rude domestic life of nineteenth-century Midwestern America and the surrounding plains, collapses. Relations between the two become increasingly contingent and conjugal. Women and children appear around the edges of the screen, tattered signs of the flimsy home life remaining to outlaws. As James declines into a stricken dotage, his glorious sheen fades as he and his men shuffle like damaged creatures between wintry plains or sun-blazed trails and darker interiors. As viewers, we are also on the run, our retinas forced into a brutally rapid expansion and contraction as, suddenly, we are thrown out of doors again or hustled rapidly into the darker cubby holes of a collapsing domestic world.

In the opening sequence, James's men are seated out in the Missouri woods. Deakins' nifty camera work makes early connections between indoor and outdoor spaces: the men sit in small, enclosed huddles, inhabiting the spaces between the trees as they would rooms. The young Robert Ford, later to be James's assassin, moves shiftily between the wooded gaps looking for a place to settle into conversation, a comfy seat, a way into the illusory camaraderie of outlawry. James's men occupy their wooded camp near Blue-Cut Mountain with a Thoreauvian degree of comfort; a

guarded interval between host and guest, one body and another. But in the company of outlaws there is no room for hospitality, only a rigorously guarded distance over one's life; to lose this distance almost certainly guarantees sudden death.

This is a film that explores distance: the distance between one's self and the all-pervasive, ever-ready enemy; the distance between the loyal guest and the treacherous visitor; the mysterious interval between concealment and detection; the undetermined lag between the roaming outlaw and the pursuing law. As a means of closing off distance, James and his bunch of footloose guerrillas take refuge in several shambolic forms of home life, relying as much on the rickety homestead for their bumbling shoot-outs as they do the grander frames of the plains. James has a home, but it is one in constant motion, his household ground permanently shifting and moving.

Outlaws are meant to inhabit the big outdoors, to disavow domestic comfort and familial relations. But Dominik's Jesse James is also a family man and his men are all, in their own way, tied to the domestic hip. As the film moves increasingly indoors, the action shifts towards James's scattered home life and those of his associates, whose migrant homes play host to a sequence of familial shoot-outs. And so we watch as James's alternative family – his 'brothers in arms' – begins to undo the traditional pattern of family life that is its accepting and welcoming host. Suddenly a violent underworld of threats and betrayals launches itself across the dinner table, and scattered around the home are images of men slumped against door jambs, dying, while the women of the house prepare dinner downstairs. Some of these threats are followed up; some of these bodies are found on the floor, but what is more terrifying is not the actual body count but the constant threat of a gun going off at home.

James's boys come and go against sparse interiors, framed by the still outlines of domestic objects: a rocking chair, a woman kneading dough in the kitchen, a daguerreotype on the parlour wall; objects overlooking windows that look out upon a wilder, more frenzied existence. But Dominik's film distinctly captures the sinking West and all of the violent mischief carried out beneath its glorious skies. The film's narrative arc is a dipping sunset farewell to the West of legends. Jesse James was never meant to be seen sitting in an armchair at home, rocking himself to sleep, or caught adjusting a painting in his living room while his assassin stands behind him, preparing to bring the great legend to an end. In the end,

James's death is a parlour visit gone badly wrong; the twee reduction of a great legend. Gone is the 'prairie optimism' that Chip Lambert recognises in his familial front room; the 'opulent' proportions of the settler's imagination captured in his parents' Midwestern furnishings.[10] The western renegade is now just part of the furniture.

Prairie Optimism

What Dominik's film does is domesticate the Old West; shrink and reduce it down to size. The vast Missouri plains overhung with sublimely scudding clouds are folded away behind doors and pushed into cupboards. James's outlaws are frequently caught hopping into a cupboard, crouching behind a door jamb or lying in bed with bullet wounds. They are men suffering arrested development, the progression of their bandit plots now less than majestic.

The 'prairie optimism' that Chip Lambert reads into the Lambert décor is a sort of faith in the heroic expansiveness of the settler imagination, now shrinking in James and his men. Dominik's film is loyal to the notion of the American hero tracking his way across a wilderness, and he collapses the image of the outlaw into this heroic frame. But he is careful to expose the dwindling prospects of the outmoded outlaw with his arrogant commitment to self-sufficiency. James is also a man with a diminishing sense of mission. Like McCarthy's Sheriff Bell, these are men crying out for home lives, their dependency reflected in the iterated image of man and horse crossing between homestead and plain and back again.

The 'wildness and entitlement' of prairie optimism is a brand of national imagining that has sent America along its positive and progressive way. Built upon a rhetoric of faith in the common man and ideals of human progress, 'progression' in America is a term loaded with moral import.[11] The outlawry of Jesse James is a far cry from any such thing, but 'progress' has always been a vital American verb, carrying with it national hopes of social and cultural betterment. 'Progress' is also peculiarly attached to the historical experience of settlement which involved crossing vast tracts of land. It is a means of replaying what Chip Lambert terms 'memories of an unfenced world', the propulsion of those

first nation-builders crossing the wilderness. The legend of Jesse James is a rather crooked way back to the image of man fronting nature, the promotion of an Emersonian self-sufficiency sizzling across the screen in the opening iconic shots of James (played by a ruggedly Apollonian Brad Pitt). Golden sunlight lights up prairie grass and cheekbones alike, and Deakins' opening visual gambit is a Marlboro man advertisement to western individuality. The horizon gently dipping down across the back of the screen suggests a mesmerisingly indeterminate but romantic hued view of the future, the broad and hopeful outline of American progress – the view preferred by the transcendentalist philosopher and poet.

'Size circumscribes', Dickinson boldly declares, 'it has no room for petty furniture.'[12] Grandeur is essential fuel to prairie optimism, providing its most vital conceit. The grand proportions of the prairies are the mythological substance behind Laura Ingalls Wilder's classic paean to prairie vistas. *Little House on the Prairie* (1935) is the substantive all-American rendering of unconquered, heroic proportions, the jutting sky and wildness of the pioneer folded into the petite dimensions of the homestead. Indeed, in Dickinson's words it is the 'intrinsic size' of the homestead that circumscribes the depth and breadth of the surrounding landscape. Moist with the language of domestic sweetness, the prairie is just as 'wide and sweet and clean' as the young Laura Ingalls Wilder's newly built hearth.[13] Prairie optimism is distilled into the 'sweet', infant proportions of the home and the central emblem of that place: the hearth. Wilder's settler imagination conjures a Disneyesque hearth garlanded by *Fantasia*-style birds, whistling sweet nothings around a pretty porch. The building of the hearth heralds a chorus of little 'dickie' birds, the aesthetic, one of Sylvanian family animals: all cutesy and diminutive. Everything is 'snug'; the opulent proportions left to the surrounding 'big and splendid' earth and sky, framed through the modest window panes. Wilder's cosy prairie home is in service to the greater majesty of a land whose end you cannot see. Every sentence lauds the interminable, unreckoned force of the 'enormous' western sky. Dinner is taken by the western window in homage to western optimism, and every chapter brims with hopeful intent. Indeed, there is so much hopeful promise, it is surprising that anyone sleeps. The relations between inner and outer worlds are as pellucid as the ideals that support them: the far-reaching prairies overrun with gusty winds remind Laura and her family of their divinely sanctioned onward progress.[14]

Wilder's stories of settler life narrate a version of America's past – its westward migration – that has now become part of how America reads itself. Her books explain to their young readers what the 'olden days' were really like and the significance of the pioneers' journey; indeed, in and through the character of young Laura, America grows into itself. These are books about a family settling into a sense of itself, of a nation growing up and learning a socioeconomic identity. And progress is directly related to homebuilding, as the family discusses building materials as signs of economic progress: 'Glass windows would be nice if we could afford them', Ma comments; 'You can't beat a good puncheon floor', declares Pa.[15] Material progress literally means improved resources for construction; a more sophisticated and better-built home.

Wilder's childishly enthusiastic narrator endorses a way of living that is forever new and always original. The Kansas plains viewed for the first time reflect a virgin America unfolding through the awe-filled, wondrous gaze of a young girl. Indeed, it is Laura's perception that births this myth of nation, unpeopled and as yet unfigured; her eyes that perpetuate the 'endless' stretch of 'empty land' ripe with possibility. According to Laura, America is a place where 'not even the faintest trace of wheels or of a rider's passing' can be seen anywhere; where possibilities for new beginnings are as endless as the horizon.[16] Wilder's story, after all, is an American creation myth.

But, as with all settlers, the Ingalls family are in the business of leaving their mark on the land. The building of the log cabin is the first step in marking out their territory, square inch by square inch, fencing off a small corner of the prairie world that is theirs. Pa's fitting of one log to another reassures the family of their arrival, demonstrates the snug shape of ownership. This is the ceremonial rite of arrival, the ritual of taking possession; the inscribing of marks and trails across virgin land, the first signs of settling in.[17]

America's folk architecture – the backwoods log cabins of Missouri and Oklahoma, built by settlers spreading from the Middle Colonies, particularly Pennsylvania – was built around the 'double log house' or 'double-pen' design: two penned-in square rooms with a passageway running between.[18] This is style of home built by Laura's Pa, whose simple design carries with it all the hopes of the frontiersman-in-training with his dreams of self-extension. And so property becomes a means of measuring growth, the ownership of land commensurate with self-development. As

Wallace Stegner aptly notes, the building of an exclusive place of settlement is the 'root-cause' of America's pioneering cult of progress.[19] Laura's Pa surely would agree.

Spatial Cramps

In contemporary domestic literature, space still speaks for a sense of progress or stagnation. In the suburban America of John Updike, Richard Yates, Richard Ford, Jonathan Franzen and Don DeLillo, the fenced-in space of the front lawn or back yard is the measure of a man's worth, the picket fence the suburban equivalent of the democratic vistas of which Whitman sang in so hale and hearty a manner. The individualism of the frontiersman living on his wit and instinct is translated into a rather pettier version in the suburbs. Here, the lawn is the extent of frontier consciousness and it is on the edge of a narrow strip of green that John Updike's Harry Angstrom, former high-school basketball star, is converted from a tall and rangy athlete into something resembling a garden gnome. The only call upon his manhood is his weekly struggle with the gas-driven lawnmower, a poor substitute for the automobile. Harry is a large man caught up in small spaces: the township of Mt Judge that holds him captive. He is a giant in a cemented toy town. In Harry's neighbourhood, space is eked out, along with the number of doors and windows. Homes suffer the warped dimensions of cheap suburban development, crouching like cowering and caged animals upon packed hillsides. In Mt Judge, signs of the 'wild' entitlement of prairie optimism are lacking, and Updike's *Rabbit* tetralogy is filled with oppressive shadows, the stuffy interiors of overpopulated homes annexed by disintegrating marriages and undesired children and relatives.

Harry's issue is that he never manages to leave home. He is forever bound to the diminishing proportions of his childhood home, snapshots of a childhood album in which his adult plot is entirely controlled by parental forces. For Harry or 'Rabbit' there is no self-extension except through the legacy of his parents – the original settlers. The frame houses of his neighbourhood only remind him of his trapped animal status. Designed around the rather more prosperous English yeoman's house,

the original two-storey wooden-frame house is a throwback to a colonial legacy. In Virginia, framed houses came with the first English settlers – Thomas Dale and his company – and boasted of pioneering achievements. The first frame houses were homes of local dignitaries and spoke of historical purpose. Size was everything: and a 'great frame' was equal to a 'great house'.[20]

But in postwar America, the frame home translates into a rather more squalid structure, mass-produced and anonymous, the 'wildness and entitlement' of its original timbered structure, shrunken and reduced to 'scabby clapboards'. Rabbit exists at home with his son Nelson and wife Janice like a kept pet, his home, a dark and narrow cubby hole, a warren of cheap, synthetic surfaces.

The word 'narrow' seems to follow Rabbit around, and like Jesse James and his men, his existence is measured by the distance between himself and his adversaries. In Rabbit's case, it is the petty intervals between essential household objects: the space between the closet door in the living room that only opens half way and the television parked in front of it. These are the meagre measurements of blue-collar living, the cramped geometry of lives scrambling for a living. Working for his father-in-law, Rabbit lives in complete dependency. He is not his own man, and none of the tracks he moves across were made by him. Over the course of the tetralogy, he shifts from one abode to another, restlessly pursuing domestic alternatives, but always returning to a state of dependency, until finally, in *Rabbit is Rich*, he returns with his wife Janice to burrow down with his in-laws.

The town of Mt Judge is hemmed in on one side by the mountain that is its namesake, and on the other, by the highway. In this sense, it adheres to the classic definition of suburbia as a borderland between the urban and the rural.[21] The mountain and the highway constitute Rabbit's geographic borders, dark forms that repeatedly rear their heads: a reminder of a more ancient landscape crossed by his forefathers. As the sun sets over Mt Judge, the whole socioeconomic gamut of the suburbs is exposed by its rays. Through the large picture windows of ranch houses, designed, as Frank Lloyd Wright would have it, to bring the outside in, the sun reflects back the east-to-west trajectory of America in miniature: between Mt Judge on the east side and the city of Brewer where his parents live on the western slope.

Picture windows are common motifs in the *Rabbit* tetralogy, emblems of a postwar familial 'togetherness'.[22] But their large frames also bring together views of inside and out, and scenes are repeatedly played out in front of their widening exposures; like a series of overblown family snapshots, they exaggerate all the darker and grainy areas of Rabbit's life. Picture windows over-expose, and when, in *Rabbit Redux*, a black youth named Skeeter moves in with a young white woman and they practise sexual relations in Rabbit's front-room, few details are kept from the neighbours. Picture windows support transparency, indoor lives led as though they were projected outdoors with the neighbourly bonhomie of Pleasantville. They support sunshine and happiness, suburban lives led as a continually projecting home movie. Producing more space, they bring the outside in, whether invited or not.

In suburban homes, space is a premium; there is little opportunity for spilling over into public spaces, for mixing with others. Socialising occurs through invitation only, and the maintenance of one's lawn is also the essential maintenance of one's perimeters. As nineteenth-century landscape artist Frederick Law Olmsted concluded, any suburban dweller who does not maintain the borders of his home cannot be in a healthy state of mind.[23] Suburban living requires knowing one's own boundaries and being prepared to live well within them. And as Rabbit discovers, it is difficult to leave the suburbs; one needs a car to go in or out, and a plethora of home entertainment facilities makes it more tempting to stay put. And anyway, there is always something that needs fixing; there are lawns to be cut and driveways to clear of weeds.

In the suburbs, men are tamed and then unleash their fury in the backyard – the suburban equivalent of the wilderness-in-miniature. Jonathan Franzen's frustrated and inebriated Gary Lambert spends quite a bit of time storming out of the house and trampling across the back yard, where he performs a drunken parody of the frontiersman cutting back trees. However, his particular version of fronting leads him into a dangerous dance with an electric clipper:

> In the garage he took the eight-foot stepladder down from its brackets and danced and spun with it, nearly knocking out the windshield of the Stomper before he got control ... To keep the dirty cord from contact with his expensive linen shirt ... he let the cord drag behind him and get destructively

tangled up in flowers … he should have turned off the clipper and come down and moved the ladder closer …[24]

Gary's efforts at clipping are a more dangerous version of Humbert Humbert out front upon the lawn of 342 Lawn Street, a delightful parody of the frontiersman with his 'civilising' instrument of modernity. But his efforts to tame the back-yard wilderness become increasingly ludicrous. Having harmed himself, his role-play reverts to a grotesque version of the 'caught' and 'wounded' native following the trail of his own blood back into the house, his efforts to tame the 'wilderness' coming to a sorry end. Inside the house the absurd role-play continues: reduced to a domestic fugitive, his home suddenly transforms into a series of territories he must cross without detection. He continues as a ridiculous version of the native terrified of crossing the hallway:

> A trail of blood receded up the central hall toward the front door. Crouching and moving sideways in crab fashion, with his injured hand pressed to his belly, Gary swabbed up the blood with the guest towel. Further blood was spattered on the gray wooden floor of the front porch. Gary walked on the sides of his feet for quiet.[25]

Like Gary, Rabbit Angstrom trails the suburbs looking for a new set of marks, a new road map through his life. Updike is clear about his confinement to what he calls the 'continual criss-crossing mess' of domesticity. Repeatedly running from the family warren, he drives through the suburbs, wandering like an aimless animal, a runaway horse. But bound in by domestic proportions, even a drive is linked to a household errand: a trip to his in-laws to collect his son Nelson, another reminder of his dependency. Going home is something to avoid, and so he spins the suburban streets looking for an alternative geography.

In the suburbs, relations between indoors and out are carefully demarcated, carefully patrolled. Suburban spaces are highly specialised and regulated. But Updike reveals Rabbit's pioneer's desire to live more out of doors; to draw lines of equanimity between inside and out. He craves a relationship with the 'texture' of outdoors, a 'small answer' from the 'bark of a tree' or the 'dry twigs of a hedge', a way back to memories of the 'unfenced' world of the settler. Rabbit would dissolve the thresholds of space and time and return to the more finely textured landscapes of his

childhood where trees were for climbing in, not for pruning. Brought up upon the recreational view of nature – a national park system designed to provide 'mass recreation' for the motoring middle classes[26] – Rabbit's desire to move outdoors and engage with natural textures is a bid to return to an unregulated experience of nature; to something more sensorily rounded. Rather than viewing his environment through the framed matrix of his picture windows, rather than inhabiting his home as a static space filled with regulated objects and forms – the square lawn, the length of the driveway – Rabbit longs to join the immediate flux of embodied nature. He craves an intimate discovery of the living, breathing body of his American outdoors.

In Retirement

For the young Rabbit, outdoors had always meant, in his youth, basketball, and then, later, baseball – the nation's favourite sports, designed to transfer easily into urban living. *Rabbit at Rest* closes the tetralogy with a retired Rabbit at the basketball hoop again. Frustrated with sitting at home alone with his furniture in his retirement condominium in Florida, Rabbit drives to the recreation ground on the edge of town to shoot some hoops. The scene is the suburban equivalent of Dominik's filmic eclipse of the Wild West, in which the sun, dipping down behind a row of frame houses around which a 'grassy wind blows', frames Rabbit, the retiring basketball hero now sinking lower and lower into cosy condominium comfort. The suburban scene is frozen, motionless, the houses 'silent and remote' with no traffic in or out. He joins a young man in shooting some hoops, but his actions on the basketball court are an older man's failed efforts to mix with the palette and composition of youth. On this suburban basketball court he makes noble (heroic) efforts to reconjure the proportions of earth to sky that are the sublimely remembered history of youthful action; of a life led out of doors. But when he attempts to replicate the 'herky-jerky' moves of the young man opposite him, he finds himself as 'alone on court as the sun in the sky': flat out upon pink tarmac, fallen.[27]

Rabbit's final phase of condominium living is a stake in the American fad for zoned existences, gated communities that keep all the faded imperfections and wrinkles of ageing sealed away in zip-locked 'villages'. A satirised subject of the recent Disney animation *Up* (2009),[28] America's corporate retirement communities testify to the nation's incipient fear of ageing, a fear managed by a prescriptive lifestyle of golf, bingo nights and trips to Wal-Mart – something *Up*'s Mr Fredrickson would rather avoid. It is safer to launch a mobile balloon home than hand one's self over to the retirement home folks: to go 'up' rather than down into a simulated hell.

A simulated version of 'hometown', the retirement village offers banal elevator music and outdoor green carpeting between buildings to enable slipper wearing inside and out. Simulated neighbourhood clubs offer bar snacks in china bowls monogrammed with the village logo, and like the pretzels served at the bar, the whole atmosphere is brittle with poor circulation and the dry breath of death.[29] It is a place for people frightened by difference and change, which, fortunately for the developers, holds captive the easily won majority of the elderly. America's retirement villages are colonies of knee-jerk capitalism where the community trails are safely predictable and easily followed, like Dorothy's yellow brick road; 'you leave the clubs with the pro shops and shoes', explains Rabbit, and move across a parking lot and 'a striped piece of driveway', across a neat traffic island, back to the safety of the numbered buildings.[30]

Retirement communities are a clear indication of the national preference for specialised spaces. Retirement in America means receding into the domestic distance – over the horizon of working life and into a sluggish rhythm of slow, unwinding leisure. In Rabbit's case this means relocating to the absurdly named retirement development of 'Valhalla Village'. His Florida condominium offers a simulacrum of 'home base', but with a touch of the cheap hotel or luxury caravan. On the fourth floor, the two-bedroom condominium sits suspended in space and time, a deliberate turning of the cheek against the ranch house of their unhappy suburban past. His Florida home is a den all of his own, a place he finally retreats to, in shame, when his wife discovers he has had sexual relations with their daughter-in-law. And so the condominium becomes an extended version of his den; a sort of basement retreat. Here, the retired male can create his own arbitrary matrix. Unwatched, unchecked, he can retreat into full-scale perversion – and an equal amount of fear.

And Down in the Basement

Like Alfred Lambert, the retired Rabbit disappears into a basement existence; a domestic black hole. Windowless and untransparent, the American basement is a site of suspected retrograde activity; a tight and airless box. Its existence violates Frank Lloyd Wright's transparent aesthetic, heeding Thoreau's generous and gleeful plans for hosting, with the entire house read as a single room; an open-armed, cruciform design with the kernel of the home opening up from the hearth, as it did to the fatigued Puritans of the seventeenth century.[31] In the basement, there is no scenery, none of the apprehensions of the outer world Dickinson laid claim to from her homestead windows; no sea of pines by which to trace news from the universe.[32] As Diana Fuss has noted, the view from Dickinson's bedroom desk positioned her between south and west, between the afternoon sunlight and the early evening sunset, faced the Holyoke mountains to the south and the Evergreens to the west. Her view included in its scope the home of her beloved sister-in-law, and from her bedroom window, Dickinson could watch the sun set over Sue. From her bed, her sight lines moved out towards the sights and sounds of the street below. Stationed in the inner world of her bedroom, Dickinson nonetheless trafficked with the commerce of the public world, reaping its sights and sounds for her poetic benefit.[33]

Scenery generates perspective, and so depth. Basement consciousness renders the larger world null and void. It is the womb or tomb of a home, its beginning or its end. For the Friedman family of Andrew Jarecki's unpropitious documentary *Capturing the Friedmans* (2003),[34] the basement is the site of familial entombment. Jarecki's film is a study of suspected basement perversion – the sort crystallised by the case of murdered child beauty queen JonBenet Ramsay, whose inflammatory saga became a long-running national sore over American family narratives. JonBenet's body, found by her father stuffed into an unused storage space in the basement of the family home, in December 1996, was an indictment of the presumed innocence of middle-class family life. And the basement was the dark space that betrayed this family myth.

At its core, Jarecki's film is a study of the slippery nature of truth; the impossibility of ever grasping, as Don DeLillo suggests in *White Noise*, any sort of reliable information from within the family den. Families are

the 'cradle of the world's misinformation … Not to know is a weapon of survival.'[35] In the subterranean world of the 'rec' room, the facts about what actually went on remain murky. The putative facts are that Arnold Friedman is an award-winning local schoolteacher in Great Neck, Long Island, leading after-school computer classes in his basement. There is nothing sinister about this choice of extracurricular activity; Arnold is a community man who gives back. But Jarecki's film unnerves our surety, our need to believe in familial health and comity. There is something darkly outmoded about the basement lined with defunct Eighties models of PCs; something amphibious and dangerously retrograde about their forms: a tribe of alligators sitting around in the dark waiting to bite back and tell all. Jarecki's camera technique is stifling, claustrophobic and deliberately abortive; a scrapbook of family opinion dragged up from a dank basement corner with several pages missing. Truth is kept at half mast, and the male opinion on the events from the two confessing sons (one remains notably silent) are directed back to 'mom', whose sexual frigidity is surely the reason for Arnold Friedman's deviance. This is the stuff of Freudian myth and legend where facts are always scarce. Jarecki relies upon the surface cliché of the suburban neighbourhood – dewy sprinklers turning on the back lawn – to play off against the more sinister and more opaque surfaces of the tenebrous, wood-panelled 'rec room', part of Arnold's 'inner sanctum' according to the photograph album of the film website.[36] The point is that there are no clear points of reference within 'Arnie's' inner sanctum. His basement den is all mind and mystery; we are confounded by the impenetrable psychic games of a man who spends time alone, Descartes-style. Arnold Friedman retreats into the basement precisely because he doesn't want to be interfered with. But as viewers we are expected to figure him out. It is too much to ask.

The basement is the vanishing nadir of the home space, a place to disappear into, as does Esther Greenwood in Sylvia Plath's suburban *Bildungsroman*, *The Bell Jar* (1961). Esther's descent into the crawl space – the basement equivalent beneath her mother's Massachusetts home – is the literal rendering of the 'going under' that is her suicide attempt. The crawl space is the narrow underbelly providing access to plumbing and wiring; domestic riggings. Esther descends into the 'secret, earth-bottomed crevice' because she feels she has become unwired, emotionally unrigged.[37] Flickering with light and mirror imagery, Plath's novel is an extended hangover, a morning after spent peering in the mirror.

Ontologically speaking, nothing seems to work any more. The crawl space is where she takes her 'sick Indian' self, so she thinks, for good. In this dark and cramped space she crawls toward the 'thick as velvet' place that is death.[38]

As this is a Cold War novel (it begins with a brusque announcement of the imminent electrocution of the Rosenberg spies), Esther's crawl space is also a model site for the home fall-out shelter. Spectres of the Cold War hum around Esther's breakdown narrative, feeding her psychic disorder with a train of disembodied forms: the electrocuted Rosenbergs, the foetal form of Eisenhower floating to the surface of a medical laboratory, the white walls of the office of Dr Gordon, psychiatrist, which resembles an interrogation room. In Esther's paranoiac world there are traitors in every corner. Culturally speaking, her descent into the crawl space is a version of America descending further into isolation, an American security plan against the Russian enemy-other. Her rape by the predatory Russian, Constantin, is the ultimate rent in this policy: sexual penetration here a cheapened gloss on a failing domestic policy. Esther's retreat into the dark hole in the ground is symptomatic of a nation living out a 'duck and cover' self-protectionism.[39]

The Cold War was the ultimate ideological cleansing of thresholds; America had never worked harder at keeping its doorstep clean of pollutants. The perceived threat to domestic borders meant that family 'togetherness' translated into a resolute solidarity in the face of the communist 'threat'; the home life was to be protected against the toxic leak both of chemicals and of Stalinist ideas. The home was a 'psychological fortress' against the uncertainties of the nuclear age, the containing space for a nation's fears.[40] And the fall-out shelter in the basement or back garden was the ultimate Do-It-Yourself project of family 'togetherness'. Couples were encouraged to build shelters as part of a leisurely weekend project; 'everyone is talking about shelters', *Life* magazine declared in January 1962, the year before *The Bell Jar* was published. Building a home-shelter in the basement was a way of sharing 'together' time; a date plotting home security.[41]

So the basement is a locus of fear and retreat. It is a place of security but it is also a storage site of secrets and perversions removed from the normative roles of the household. In Sam Mendes' *American Beauty* (1999) it is in his basement gym that Lester Burnham pumps iron and fantasises about his teenage daughter's gorgeous friend, played by actress Mena

Suvari. In the basement a 42-year-old advertising agent reinvents himself as a subject for a teenage girl's sexual fantasies. He pumps iron and returns to his adolescence. The basement, then, also supports regression.

But the American basement has also handled some of the nation's most significant experimental sounds; it has raised enquiries. Bob Dylan and The Band's *The Basement Tapes*, of which Dylan's contributions were recorded in 1967 in the basement of 'Big Pink', New York, the home shared by three members of the band, and then in Dylan's home in Woodstock, did not surface until their commercial release in 1975. The album sounds like a bit of monkeying around; a rehabilitation project: the album the by-product of a marooned Dylan recovering from a motorbike accident.

The delay in their release and the fact that several of the tracks were bootlegged has incited a great deal of mythological projection about the lost basement songs – more even than the myth consuming Dylan can perhaps stomach. Dylan-projection, after all, is a fundamental part of his cultural mythos, and *The Basement Tapes* fuel this more than any of his recordings because premature, frayed around the edges, too casual and insouciant for release, they seem to invite vagrant projection. But this is also their draw: the fact that we cannot quite see through their history, as we can never quite see through to the epistemological end of a Dylan lyric. They give us room to play; to make associations, to imaginatively project things that are, as director Todd Haynes' recent Dylan biopic framed it, simply 'not there'. In many ways, *The Basement Tapes*, like much of Dylan's lyrical corpus, are all about missing parts. The Houdini of folk music, Dylan manages to wriggle out of any definite form, any narrative commitment. By the time we get to the end of a line, he has disappeared elsewhere. The lights in the basement are not on; we fumble around in the dark for things we think we recognise, but in the process, we run into walls.

The whole album sides with obscurity and inference; dark corners. Stuffed with snatches and snippets of folk songs of the twenties and thirties taken from Harry Smith's *Anthology of American Folk Music* that appeared in 1952, Dylan's basement recordings are a hoard of piecemeal antecedents of folk culture.[42] Blurry and incomplete, they translate, in some cryptic way, into the sketchy and opaque outlines of a private self; a self disappearing into the basement; a self in recreational mood. In 'Don't Ya Tell Henry' the singing voice wanders off for a lyrical mooch around

the corners of itself, through local and domestic territories: the 'beanery' at 'half past twelve'; someone's 'house at night'. There is no clear purpose to this lyrical hanging about: only to 'look around' and remain 'out of sight'.[43] Dylan's singer has no clear sense of direction, only to remain invisible to the public eye; to enshroud himself in cryptic mystery. We follow him on his gnomic trails, tailing behind, hoping that someone will tell us where it is we are going.

As music critic Greil Marcus has noted, the 'basement theatre', the antics that produced these recordings, was a place where 'nothing was exactly clear and nothing was obviously wide open'.[44] And yet, Dylan *did* sing of opening doors; he sang of preserving memories, the American past; and he sang, obliquely, of revisioning America. His track 'Open the Door, Homer' is a call for fresh air, new associations, broader and better views of life and of the nation. It calls for a new muse, to 'flush out' the old cultural storehouse and bring about some psychic cleansing; a better way of storing memories so that the past doesn't turn ugly. Dylan's basement songs warn against old habits dying hard, the sickly and melancholic forms induced by roosting for too long in old haunts: 'There's a certain way / that a man must swim / if he expects to live off / of the fat of the land'. Thoreauvian self-sufficiency is a surer bet for living than chasing down 'better' and best.[45] But there is always the road trip to sort you out, the contemporary version of Walden Pond: the mobile retreat for a more restless age. And Dylan's crew are restless; 'Goin' to Acapulco' promises new scenery and a new plot; 'a big place' in which to 'have some fun'. *The Basement Tapes* produce moments of folkish wisdom, but on the whole, they are more about the grass-roots sounds of young appetites hungry for adventure, men who dream of the road in their spare time, hoarded up, underground, making 'basement noise'.[46]

The album is a hothouse of emotion filled with the crooning moodiness of the young and the homebound. The singer of 'Orange Juice Blues' can't wake up in the mornings; he is tired of 'walking round the block' and threatens to 'slide on out the door'. 'I can't stay here anymore', complains the high-pitched Robbie Robertson in 'Yazoo Street Scandal'. The helium spirits of a 'tonic man' are not so high the morning after; these are also the sounds of a man sick with too much hobo laissez-faire; too many late nights wandering the apocalyptic terrors of a whore house; a young man with no proper place to go.

But the terrors of *The Basement Tapes* are also invented just for fun. The sound of articulated nonsense pumps up many of the lyrics: these are bored young men high on helium, in an underground room dreaming of more. Several of the songs lead to the road: somewhere to get out of the nowhere. 'Million Dollar Bash' anticipates an out-of-town party. The refrain of 'Ooh baby, ooh-ee' is the sound of a midnight carousal in a car through cold air, but it is also the sound of restless men beginning to act silly; men short of air. As Marcus notes, the America of *The Basement Tapes* is an 'old free America', an America hovering outside of any historical accountability or actuality; a nation wailing for an idealised past. It is a little country all of its own, an imagined nation invisible to the outside world; an America of the mind and in retreat.[47] But it is also a private and unprepared Dylan; a Dylan who refuses to meet with a public or his nation, a Dylan who is just 'not there': unrecorded, unreleased, and who, as he extravagantly pleads in 'Please, Mrs Henry', would rather not be crowded. In the wavering sounds of *The Basement Tapes* we hear the Dylan who wants to be left alone just to mess around.

And for the retired male in recreational mode, this is precisely what the basement offers: a space in which to tinker. Sadly, for Alfred Lambert, the basement is a descent into mental dysfunction and personal stasis. In his basement things don't work properly and Alfred is just another piece of unwanted furniture, out of sight and going out of his mind: 'Alfred's red sweater hung on him in skewed folds and bulges, as if he were a log or a chair.'[48] Like the Christmas lights he wrestles to fix, his mental circuitry has been rendered faulty and hazardous by Parkinson's disease. Down in the basement, Alfred appears ridiculous, even to himself. Struggling to fit himself with a plastic enema, he loses his dignity and privacy when his daughter, Denise, walks in on him. For Alfred, the basic tenet of the home life is privacy. Without privacy he is not-at-home: 'without privacy there is no point in being an individual'; there is no point in being American.[49] His basement hide-out is the only place Alfred feels truly American, truly at home.

Home to Stay?

As Dorothy wanted to believe, every road leads back to Kansas. Every path or road presupposes a destination, typically a home. 'The true function of every road is to take us home', argues John Brinckerhoff Jackson. Home provides a sense of place and time;[50] in Franzen's novel, the family Thanksgiving is *the* event: of the American calendar, and of the home.

Home then, is also constituted by events; it functions as a sort of dominion, a kingdom with its own presiding rules and rulers.[51] The road that leads home leads back to a particular order: a certain way of doing things. Frank Wheeler of Richard Yates's 1961 novel *Revolutionary Road* surveys the layout of his first suburban home and notes that the 'symmetry of the place' encouraged a 'sorting out' of the mess of his current domestic life. The open-plan design elicits renewed courage, reflects honesty and integrity – the organic, wholesome value system of the picturesque home.[52] Coming home helps make sense of things. It keeps at bay the murky and troublesome ghosts of the gothic imagination: the devilry of Arthur Miller's *The Crucible*, in which the hocus-pocus of ungodly business in the woods threatens the stability and order of the god-given home life.

The threshold of the home needs careful monitoring lest, as Dickinson explained, the uncanny intruder, or 'booger', disturb the sacred order of things. And yet, one need not leave home to experience the uncanny; feeling strange at home was a familiar experience to Emily Dickinson, and her conceits of home life are partly bred upon the increasing atomisation of nineteenth-century domesticity. Her poem, 'One need not be a chamber to be haunted' explores the allocation of home space whose 'Host' is 'cooler' because he is estranged from himself. He is both ontologically and spatially divided. External structures are brought inside and get in the way: the stones of an abbey, unwinding corridors and obstructive doors alienate the speaker from a clear view of her home. Externality ousts internality and the prospect of peaceful settlement. In Dickinson's haunted house, too much of the outside lurks within. Hers is a conceit of gothic threat in which the 'ghost' of external fears is brought home to roost.[53]

And so the chamber space – that nineteenth-century retreat for the private self tucked at the back of the house[54] – is annexed by the demands of formal hospitality at the front: the duties of the host. Locked into duty,

the Thoreauvian host becomes an assassin figure armed with a gun, an intruder turned against the home and its sacred properties. Threatening his guests with the most indecorous and unhomely of instruments – a gun – the host-assassin also turns upon himself. He guns down the inviolable right to privacy and polite hospitality that is the cornerstone of American life.

Under threat of such violent intrusion, what is the solution? Dickinson's answer is to keep her doors ajar; indeed, the state of being 'ajar'[55] to another, to the world, is inveterately Dickinson at-home. Doors kept ajar allow for a certain distance between 'you' and 'I': no overlap of subject positions, and no compromise of personal space. And in between, there is enough room for the projection of fantasy. Doors left ajar create angles, new sight lines, new corridors of seeing, new and perhaps safer 'slants'[56] upon the world and others. Through a partly open door a viewer can enjoy a personal geometry, a 'take' or assessment between what stands on one side of the door – one's self – and what lies on the other. Lines are broken and discontinued, views aborted and partly obliterated, but this is how the poet would rather come to know something or someone. She would rather remain partial. In Dickinson's mansion-universe, there is freedom in not being able to see everything at once; one can invent, project and imagine. One can fill in the gaps.

Like Dickinson, Dylan also had an eye for doors and windows left ajar; a regard for territorial inclusion and exclusion. For Dylan, interior space offers the promise of a good arrangement; a melody, a line through to a song, and passage after passage of his *Chronicles* sees the singer fixing up a relationship with objects in a room, scanning his environment and rearranging himself in order to enjoy things 'in plain sight'.[57] Despite the evidence of his lyrics, he is skeptical of the hidden and the shrouded – the way of legends, and like Thoreau, he would prefer everything out in the open. He is something of a feng shui artist and his mantra for living is a clear sense of 'hospitality'.

Home is family for Dylan, but it is also hospitality, a place where strange things are made more familiar, and in 1968, following on from his motorcycle accident and *The Basement Tapes* sessions, he moves out of his home in Woodstock, in flight from the 'rat race' of celebrity and fame, the marauding eyes of his public. Rejecting the projected legend of the American public, he goes in search of privacy; a more authentic living arrangement; somewhere more hospitable. But he realises that 'no place

is far enough away', and that Thoreau's dream for open-plan living is just not feasible in modern America where celebrity breeds like Frankenstein's monster; once created, it cannot be demolished. Regarding his domestic imagination, Dylan is no different from the rest: he dreams of his white picket fence, his enclosed plot of sanctuary out of 'plain sight'. But instead of building upon his plot of land, he is forced to pack up home and carry it with him; to become Thoreau's 'weary traveller'.[58] From 1968, Dylan's trajectory is one of flight from any stable base; he goes on the run and takes up the highway as a permanently mobile home.[59] Home is an imagined world lived out in exile; the sound and substance of a familiar America made strange. It is his version of folk.[60]

Like Dickinson, Dylan is aware of the precariousness of life at home, and so his version of the door ajar, the circumspect consciousness of the unsettled and restless American, is to run, ramble and roam; to cross thresholds, to keep moving. And like the Amherst poet, his principal dynamic is the spontaneous 'stretch'[61] of consciousness that sends him away from home whilst also perpetually calling him back. Both acknowledge the imaginative impossibility of the declarative that opens Marilynne Robinson's recent novel, *Home* (2008): 'Home to stay … Yes!' But the statement is quickly amended. Robinson's ageing father figure realises that his daughter can only stay – must only stay – 'for a while'.[62] To be held hostage to one's childhood home is the most damning of fates. It is to be ransomed to the past in the present as well as the future. And it is to make home the bitter gall of progress. In the American imagination, to be at home is to dwell perpetually in the possibility of leaving.

Notes

INTRODUCTION

1. Emily Dickinson, *The Complete Poems*, ed. Thomas H. Johnson (London: Faber & Faber, 1976), no. 657. Hereafter cited as *The Complete Poems* followed by the number of the poem only.
2. Ibid., no. 836.
3. Ibid., no. 378.
4. Charles Olson, *Call Me Ishmael* (San Francisco, CA: City Lights, 1947), 11.
5. 'Certaine Articles/An Admonition to the Parliament' in W. H. Frere and C. E. Douglas, eds, *Puritan Manifestos* (London: Church History Society, 1954), 143.
6. *The Letters of Emily Dickinson*, ed. Thomas H. Johnson (Cambridge, MA: Belknap Press, 1986), no. 59. Hereafter cited as *Letters* followed by the number of the letter only.
7. Mary Douglas, 'The Idea of a Home' in Barbara Miller Lane, ed., *Housing and Dwelling: Perspectives on Modern Domestic Architecture* (London: Routledge, 2007), 62.
8. Yi-Fu Tuan, *Space and Place: The Perspective of Experience* (London/Minnesota, MN: University of Minnesota Press, 2001), 123–4. Hereafter cited as *Space and Place*.
9. *The Complete Poems*, no. 821.
10. Ibid., no. 719.
11. Georges Perec, *Species of Space and other Pieces* (London: Penguin Classics, 2008). Hereafter cited as *Species of Space*.
12. *The Complete Poems*, no. 289.
13. *Oxford English Dictionary*, www.oed.com (accessed 12 December 2008).
14. Lionel Trilling, 'The Sense of the Past' in *The Liberal Imagination: Essays on Literature and Society* (London: Penguin, 1971), 191. Hereafter cited as *The Liberal Imagination*.
15. *Letters*, 103.
16. See, for example, 'Bring me the sunset in a cup', *The Complete Poems*, 128.
17. *The Complete Poems*, no. 657.

18 *Letters*, no. 85.
19 *Coleridge's Miscellaneous Criticism*, ed. Thomas Middleton Raysor (Cambridge: Cambridge University Press, 1936), 387.
20 The American War of Independence was fought from 1775 to 1783.
21 David Reynolds, *America: Empire of Liberty: A New History* (London: Allen Lane, 2009), 100–4. Hereafter cited as *America: Empire of Liberty*.
22 David Foster Wallace, *A Supposedly Funny Thing I'll Never Do Again* (London: Abacus, 1997), 3.
23 Wallace Stegner, *Wolf Willow: A History, a Story and a Memory of the Last Plains Frontier* (London: Penguin, 1990), 6–7. Hereafter cited as *Wolf Willow*.
24 *Dogville* (2003), dir. Lars von Trier.
25 Frederick Jackson Turner, *The Frontier in American History* (1920) (New York: Dover Publications, 1996), 3. Hereafter cited as *The Frontier in American History*.
26 Edward T. Price, *Dividing the Land: Early American Beginnings of our Private Property Mosaic* (Chicago, IL: University of Chicago Press, 1995), 3–4.
27 *America: Empire of Liberty*, 101.
28 David P. Handlin, *The American Home: Architecture and Society, 1815–1930* (Boston, MA: Little, Brown, 1979), 90–7. Hereafter cited as *The American Home*.
29 Yi Fu Tuan, *Passing Strange and Wonderful: Aesthetics, Nature and Culture* (New York/Tokyo/London: Kodansha International, 1995), 148.
30 Ibid., 150.
31 Ibid.
32 Ibid., 141–9.
33 Paul Auster, *The City of Glass* (London: Faber & Faber, 1985), 91.
34 David L. Lewis & Laurence Goldstein, eds, *The Automobile and American Culture* (Ann Arbor, MI: University of Michigan, 1983), 37–8.
35 Alberto Lena, 'The Seducer's Stratagems: The Great Gatsby and the Early Twenties', *Forum for Modern Language Studies*, vol. 34, no. 4 (1998), 309–10.
36 *Letters*, 281.
37 *The Liberal Imagination*, 191.
38 Deborah Nelson, *Pursuing Privacy in Cold War America* (New York: Columbia University Press, 2002), 89–90.
39 *Oxford English Dictionary*, www.oed.com (accessed 13 October 2009).
40 Amy Kaplan, 'Homeland Insecurities: Reflections on Language and Space', *Radical History Review* (Winter 2003), 82–93.
41 Frederika Bremer, *The Homes of the New World* trans. Mary Howitt, 2 vols (New York: Harper & Brothers, 1854), vol. 1, 53.
42 Payne's song dates from 1824.
43 *The American Home*, 1–15.
44 *The Complete Poems*, no. 324.
45 *Oxford English Dictionary*, www.oed.com (accessed 4 October 2009).

46 *The Complete Poems*, no. 324.
47 *The Complete Poems*, no. 944.
48 Diana Fuss, 'Interior Chambers: The Emily Dickinson Homestead', *Differences: A Journal of Feminist Cultural Studies*, vol. 10, no. 3 (1998), 7. Hereafter cited as 'Interior Chambers'.
49 Jed Deppmann, 'Trying to Think with Emily Dickinson', *The Emily Dickinson Journal*, vol. 14, no. 1 (2004), 84–103: 91.
50 Lyndall Gordon, *Lives Like Loaded Guns: Emily Dickinson and Her Family's Feuds* (London: Virago, 2010), 50–1. Hereafter cited as *Lives Like Loaded Guns*.
51 Ibid., 51, 171.
52 Henry David Thoreau, *Walden*, ed. Stephen Fender (Oxford: Oxford University Press, 1997), 84. Hereafter cited as *Walden*.
53 Ibid., 79.
54 Francis J. Bremer and Tom Webster, eds, *Puritans and Puritanism in Europe and America: A Comprehensive Encyclopaedia*, vol. 2 (Santa Barbara, CA: ABC-CLIO, 2005), 362.
55 Witold Rybczynski, *Home* (London: Pocket Books, 2001), 178. Hereafter cited as *Home*.
56 'Interior Chambers', 4.
57 William Barksdale Maynard, 'Thoreau's House at Walden' (1999) in Barbara Miller Lane, ed., *Housing and Dwelling* (Oxford/New York: Routledge, 2007), 200.
58 Diana Fuss, *The Sense of an Interior: Four Writers and the Rooms that Shaped Them* (New York: Routledge, 2004), 31–2. Hereafter cited as *The Sense of an Interior*.
59 Ibid., 202.
60 Andrew Jackson Downing, *Victorian Cottage Residences* (1842) (New York: Dover Publications, 1981), 15.
61 *Letters*, 432.
62 *Home*, 191.
63 *Walden*, 78.
64 Neil Levine, *The Prairie School: Frank Lloyd Wright and His Midwest Contemporaries* (New York: Norton, 1974), 17.
65 Frank Lloyd Wright, 'Building the New House' in Barbara Miller Lane, ed., *Housing and Dwelling: Perspectives on Modern Domestic Architecture* (London: Routledge, 2007), 23–4.
66 *Walden*, 234.
67 *Walden*, 218–19.
68 Bob Dylan, *Chronicles: Volume One* (London: Pocket Books, 2005), 58. Hereafter cited as *Chronicles*.
69 *The Complete Poems*, no. 1055.
70 *Oxford English Dictionary*, www.oed.com (accessed 24 January 2009).
71 *Letters*, 107.

72 *Chronicles*, 25.
73 R. B. Browne and Pat Browne, eds, *A Guide to United States Popular Culture* (Madison, WI: University of Wisconsin Press, 2001), 246.
74 Sigmund Freud, 'The Uncanny' in *The Standard Edition of the Complete Psychological Works of Sigmund Freud*, vol. XVII, ed. and trans. James Strachey (London: Hogarth, 1953), 219–52.
75 *The Complete Poems*, no. 289.
76 *Walden*, 83.
77 Ralph Waldo Emerson, 'Nature' in *Essays and Lectures*, ed. Joel Porte (New York: Library of America, 1983), 10.
78 Laura Ingalls Wilder, *The Little House on the Prairie* (London: Egmont, 2000), 46.
79 *Space and Place*, 124.
80 *The Little House on the Prairie*, 48.

CHAPTER ONE

1 *Lives Like Loaded Guns*, 86.
2 Ibid., 197–203.
3 *Letters*, 59.
4 Andrew Jackson Downing, *The Architecture of Country Houses* (1850) (New York: Dover Publications, 1969), 10–17. Hereafter cited as *The Architecture of Country Houses*.
5 Sandy Isenstadt, *The Modern American House: Spaciousness and Middle-Class Identity* (Cambridge: Cambridge University Press), 1–10. Hereafter cited as *The Modern American House*.
6 *Letters*, 77.
7 Gaston Bachelard, *The Poetics of Space* (Boston, MA: Beacon Press, 1994), 222. Hereafter cited as *The Poetics of Space*.
8 *The Complete Poems*, no. 475.
9 Susan Fenimore Cooper, 'A Dissolving View', in *The Home Book of the Picturesque: Or American Scenery, Art and Literature Comprising a Series of Essays by Washington Irving, W. C. Bryant, Fenimore Cooper, And Others.* (Gainsville, FL: Scholars' Facsimiles and Reprints, 1967), 79–94. Hereafter cited as 'A Dissolving View'.
10 *Oxford English Dictionary*, www.oed.com (accessed 24 October 2009).
11 Thad Logan, *The Victorian Parlour: A Cultural Study* (Cambridge University Press, 2001), 9–11. Hereafter cited as *The Victorian Parlour*.
12 Ibid.
13 *The Poetics of Space*, 13.
14 John Conron, *American Picturesque* (University Park, PA: Pennsylvania University Press, 2000), 232. Hereafter cited as *American Picturesque*.

15 John White Alexander, 'Repose', oil on canvas, 52¼" × 63⅝", Metropolitan Museum of Art, Anonymous Gift, 1980.
16 Gaston Bachelard, *The Poetics of Reverie* (Boston, MA: Beacon Press, 1971), 29. Hereafter cited as *The Poetics of Reverie*.
17 Gervase Wheeler, *Homes for the People in Suburb and Country* (New York: Charles Scribner, 1855), 192.
18 *Lives Like Loaded Guns*, 81–2.
19 *The Victorian Parlour*, xiii.
20 *Lives Like Loaded Guns*, 87.
21 Suzanne M. Spencer-Wood, 'The World Their Household: Changing Meanings of the Domestic Sphere in the Nineteenth Century', in Barbara Miller Lane, ed., *Housing and Dwelling: Perspectives on Modern Domestic Architecture* (London: Routledge, 2007), 172–4.
22 *American Picturesque*, 232.
23 *The Architecture of Country Houses*, iv.
24 Catherine Esther Beecher and Harriet Beecher Stowe, *The American Woman's Home*, ed. Nicole Tonkovich (New Brunswick, NJ: Rutgers University Press, 2002), 31–4.
25 *The Architecture of Country Houses*, 1–38.
26 Ibid., 262–3.
27 *Walden*, 45–6.
28 Andrew Jackson Downing, 'Moral Influence of Good Houses' (1848), in Don Gifford, ed., *The Evolution of Architectural Influence and Practice in Nineteenth Century America* (New York: Dutton, 1966), 233–5.
29 *The Architecture of Country Houses*, 84; vi.
30 Ibid., 20.
31 'Gingerbread work' was wooden scrollwork, following the line of the eaves, a fashionable ornament to mid- to late Victorian American houses. *Walden*, 234.
32 *The Poetics of Reverie*, 175.
33 *The Complete Poems*, no. 1743.
34 Katherine Grier, *Culture and Comfort: Parlor-Making and Middle-Class Identity, 1850–1930* (Washington, DC: Smithsonian Institution Press, 1997).
35 Harriet Beecher Stowe, *The Minister's Wooing* (Harmondsworth, Middlesex: Penguin Classics, 1999), 3. Hereafter cited as *The Minister's Wooing*.
36 Ibid., 13.
37 Ibid.
38 Joan Hedrick, 'Parlor Literature: Harriet Beecher Stowe and the Question of "Great Women Artists"', *Signs: Journal of Women in Culture and Society* (1992), vol. 17, no. 2, 278–81.
39 Ibid., 286–7.

40 Karen Halttunen, *Confidence Men and Painted Women: A Study of Middle-Class Culture in America, 1830–1870* (New York/London: Yale University Press, 1983), 184–6.

41 Joan Hedrick, *Harriet Beecher Stowe: A Life* (Oxford: Oxford University Press, 1994), 123.

42 Ibid., 124–5.

43 'timely; seasonable; opportune; in season': *Oxford English Dictionary*, www.oed.com (accessed 25 March 2008).

44 Oil on canvas, 21½" × 28½", Private Collection, Photograph, Schweitzer Gallery.

45 John Whiteman, 'On Hegel's Definition of Architecture', *Assemblage*, no. 2 (February 1987), 6–17: 10.

46 Anthony Vidler, *The Architectural Uncanny: Essays in the Modern Unhomely* (Cambridge, MA: MIT Press, 1992), 42–3.

47 Oil on paperboard, 13¼" × 22¾", private collection.

48 *The Minister's Wooing*, 12.

49 Bill Brown, 'The Tyranny of Things: Trivia in Karl Marx and Mark Twain', *Critical Inquiry*, vol. 28, no. 2 (Winter 2002), 442–469: 445.

50 Mark Twain, *The Adventures of Huckleberry Finn* (London: Penguin Classics, 1985), 163.

51 Richard L. Bushman, *The Refinement of America: Persons, Houses, Cities* (New York: Alfred A. Knopf, 1992), xvi (hereafter cited as *The Refinement of America*); *The American Home*, 18–19.

52 Ibid.

53 Bill Brown, *A Sense of Things: The Object Matter of American Literature* (Chicago, IL/London: University of Chicago Press, 2003), 24.

54 *The Refinement of America*, 121.

55 *The Poetics of Space*, 8.

56 Martha Dickinson Bianchi, *Emily Dickinson Face to Face: Unpublished Letters with Notes and Reminiscences* (Boston, MA/New York: Houghton Mifflin, 1932), 34.

57 George William Curtis, *Homes of American Authors comprising Anecdotal, Personal and Prescriptive Sketches by Various Writers* (New York: G. P. Putnam and Co., 1853), 197–236. Hereafter cited as *Homes of American Authors*.

58 Ibid.

59 *The Complete Poems*, no. 628.

60 The Grand Tour refers to the tradition of European travel undertaken mainly by upper-class young men of means. The tradition dates from c. 1660. See Geoffrey Trease, *The Grand Tour* (New Haven, CT: Yale University Press, 1991).

61 Millicent T. Bingham, *Ancestor's Brocades: The Literary Debut of Emily Dickinson* (New York/London: Harper & Brothers, 1945), 3.

62 Ibid., 3–4.

63 *Lives Like Loaded Guns*, 170.

64 Maurice Charney, 'Hawthorne and the Gothic Style', *New England Quarterly*, vol. 34, no. 1 (1961), 37.
65 Sacvan Bercovitch, *The American Puritan Imagination* (New York: Cambridge University Press, 1974), 5.
66 Edgar Allan Poe, *The Complete Tales and Poems* (New York: Modern Library, 1938), 231.
67 Nathaniel Hawthorne, *The House of the Seven Gables* (London: Walter Scott, c. 1890), 168–71.
68 *Homes of American Authors*, 302.
69 *Lives Like Loaded Guns*, 163.
70 Henry James, 'The Jolly Corner' in *Selected Tales* (London/Melbourne/Toronto: Dent, 1982), 361–3.
71 Doreen Massey, *For Space* (London: Sage Publications, 2007), 130. Hereafter cited as *For Space*.
72 Nathaniel Hawthorne, *The English Notebooks*, ed. Randall Stewart (New York: Modern Language Association of America, 1941), 149.
73 Ibid., 372.
74 *The Complete Poems*, no. 303.
75 Judith Fryer, *Felicitous Space: The Imaginative Structures of Edith Wharton and Willa Cather* (Chapel Hill, NC/London: University of North Carolina Press, 1986), 65.
76 *Letters of Mark Twain*, ed. Albert Bigelow Paine, 2 vols (New York: Harper & Bros, 1917), 416.
77 *Walden*, 219–20.
78 *The Refinement of America*, 123.
79 *Space and Place*, 6.
80 Edith Wharton and Ogden Codman, Jr, *The Decoration of Houses* (1897) (New York: W. W. Norton, 1997), 23–5. Hereafter cited as *The Decoration of Houses*.
81 Henry James, *The American Scene* (London: Chapman and Hall, 1907), 124. Hereafter cited as *The American Scene*.
82 *The Poetics of Space*, 7.
83 *The American Scene*, 166–9.
84 Ibid., 167–8.
85 Henry James, *The Europeans* (New York: Library of America, 1983), 888.
86 Ibid., 888–90.
87 *The Poetics of Space*, 6.
88 Willa Cather, *The Professor's House* (London: Virago, 1981), 26. Hereafter cited as *The Professor's House*.
89 Ibid., 161.
90 *The Poetics of Space*, xxxv–xxxvi.

91 Clifford Edward Clark, Jr, *The American Family Home, 1800–1960* (Chapel Hill, NC: University of North Carolina Press, 1986), 38–9. Hereafter cited as *The American Family Home*.
92 *For Space*, 139–41.
93 *The Professor's House*, 125.
94 *The American Family Home*, 153.
95 Ibid., 161.
96 *The Modern American House*, 4.
97 Tom Martinson, *American Dreamscape: The Pursuit of Happiness in Postwar Suburbia* (New York: Carroll & Graf, 2000), 18–19.
98 Richard Harris, 'Chicago's Other Suburbs', *Geographical Review*, vol. 4, no. 4 (October 1994), 394–410: 394.
99 Robert Breugmann, *Sprawl: A Compact History* (Chicago, IL: University of Chicago Press, 2006), 39–40.
100 Theano S. Terkenli, 'Home as Region', *Geographical Review*, vol. 85, no. 3 (July 1995), 325.
101 *For Space*, 141.
102 Laura J. Miller, 'Family Togetherness and the Suburban Ideal', *Sociological Forum*, vol. 10, no. 3 (1995), 396–8.
103 *The American Family Home*, 195–8.
104 Margaret Marsh, *Suburban Lives* (New Brunswick, NJ/London: Rutgers University Press, 2000), 84. Hereafter cited as *Suburban Lives*.
105 Dave Eggers, *A Heartbreaking Work of Staggering Genius* (New York: Simon & Schuster, 2000), 6.
106 *Suburban Lives*, 84.
107 J. Hector St John de Crèvecoeur, *Letters from an American Farmer* (1782) (Oxford: Oxford University Press, 1998). Here after *Letters from an American Farmer*.
108 *A Heartbreaking Work of Staggering Genius*, 56.
109 Ibid., 64.
110 Gwendolyn Wright, *USA: Modern Architecture in History* (London: Reaktion Books, 2008), 168–71.
111 Ibid., 168.
112 *Walden*, 235.
113 *A Heartbreaking Work of Staggering Genius*, 72; 180.
114 Gertrude Stein, 'The Gradual Making of the Making of Americans' (1935) in *Lectures in America* (New York: Random House, 1935), 161. Hereafter cited as 'The Gradual Making of the Making of Americans'.
115 Wallace Stegner, *Here the Bluebird Sings to the Lemonade Springs: Living and Writing in the West* (London/New York: Penguin, 1992), 72; 110.
116 Jonathan Franzen, *The Corrections* (London: Fourth Estate, 2002), 307. Hereafter cited as *The Corrections*.

117 Elaine Tyler May, 'Cold War–Warm Hearth: Politics and the Family in Postwar America' in Steve Fraser and Gary Gerstle, eds, *The Rise and Fall of the New Deal Order* (Princeton, NJ: Princeton University Press, 1990), 158.
118 David L. Ames, 'Interpreting Post-War II Suburban Landscapes as Historic Resources', www.nps.gov/history/nr/publications/bulletins/suburbs/Ames.pdf (accessed 20 April 2008).
119 *The Corrections*, 622.
120 *Letters from an American Farmer*.
121 Lucy Hazard, *The Frontier in American Literature* (New York: Thomas Y. Crowell, 1927), 152.
122 Ibid., 531–3.
123 Ibid., 550.
124 *Walden*, 102–7.
125 Ibid., 547.
126 *For Space*, 141; 120.
127 Marilynne Robinson, *Housekeeping* (New York: Picador, 1980), 47–8. Hereafter cited as *Housekeeping*.
128 Ibid., 49–51.
129 Ibid., 68.
130 Anne Bradsheet, *To My Husband and Other Poems* (New York: Dover Thrift Editions, 2000), 14.
131 Gertrude Stein, *The Making of Americans* (Normal, IL: Dalkey Archive, 1995), 191.
132 *Housekeeping*, 44.
133 *The Decoration of Houses*, 120.
134 Ibid., 61.
135 Perry Miller, *Errand into the Wilderness* (Cambridge, MA: Belknap Press of Harvard University Press, 1956), 217.
136 *To My Husband and Other Poems*, 46.
137 *The Adventures of Huckleberry Finn*, 369.
138 Frank Lloyd Wright, 'In the Cause of Architecture' (1908), in *The Work of Frank Lloyd Wright* (New York: Horizon Press, 1965), 15.
139 *Housekeeping*, 89.
140 'Wide Open Spaces', The Dixie Chicks, Epic, 1998.
141 *The Corrections*, 306.
142 *The Complete Poems*, no. 821.

CHAPTER TWO

1 *The Corrections*, 531.
2 *The Poetics of Space*, 212.

3 J. Winthrop, 'A Model of Christian Charity' (1630) in N. Baym, R. Gottesman and L. B. Holland, eds, *The Norton Anthology of American Literature*, vol. 2 (New York: W. W. Norton, 1989), 31–42.
4 Alexis de Tocqueville, *Democracy in America*, trans. George Lawrence, ed. Mortimer J. Adler, 2 vols (Chicago, IL: University of Chicago Press, 1990), vol. 1, p. 289. Hereafter cited as *Democracy in America*.
5 *Letters*, 52.
6 *Letters*, 330.
7 *Species of Space*, 38.
8 Peter Kohane and Michael Hill, 'The Decorum of Doors and Windows, from the Fifteenth to the Eighteenth Century', *Architectural Review Quarterly*, vol. 10, no. 2 (2006), 141–3.
9 *Lives Like Loaded Guns*, 93.
10 Ibid., 142.
11 *Letters*, 187.
12 *Letters*, 238.
13 Siri Hustvedt, 'Yonder' in *A Plea for Eros* (London: Hodder & Stoughton, 2006), 1.
14 *Letters*, 337.
15 Ibid.
16 Ibid., 316.
17 Wallace Jackson, '*To Look*: The Scene of the Seen in Edward Hopper', *South Atlantic Quarterly*, vol. 103, no. 1 (Winter 2004), 133–148: 144.
18 Henri Lefebvre, *The Production of Space*, trans. D. Nicholson Smith (Oxford: Blackwell, 1991), 42. Hereafter cited as *The Production of Space*.
19 Ibid., 33.
20 Frank Lloyd Wright, *An American Architecture* (New York: Bramhall House, 1955), 80. Hereafter cited as *An American Architecture*.
21 Richard G. Wilson, Dianne H. Pilgrim and R. N. Murray, *American Renaissance, 1876–1917* (exhibition catalogue) (New York: Brooklyn Museum, 1979), 11.
22 *An American Architecture*, 75.
23 Ibid., 78–80.
24 Frank Lloyd Wright's 'Prairie Concept', www.westcotthouse.org/prairie_concept.html (accessed 31 October 2009).
25 'Two on the Aisle', 1927, 'Girlie Show', 1941, 'First Row Orchestra', 1951, and 'Intermission', 1963, are obvious examples.
26 *The Wizard of Oz* (1939), dir. Victor Fleming.
27 *The Complete Poems*, no. 1158.
28 Gail Levin, *Edward Hopper* (New York: Alfred A. Knopf, 1995), 518.
29 *A Heartbreaking Work of Staggering Genius*, 1.
30 Ibid., 5.
31 Ibid., 258.

32 *Rear Window* (1954), dir. Alfred Hitchcock.
33 Martin Heidegger, *Poetry, Language, Thought* (New York: Harper & Row, 1971), 149.
34 Ibid., 154–5.
35 Edward Relph, *Place and Placelessness* (London: Pion, 1976).
36 T. Thiis-Evensen, *Archetypes in Architecture* (Oslo: Norwegian University Press), 251–9.
37 *Housekeeping*, 154.
38 *Letters*, 85.
39 Christopher Alexander, S. Ishikawa and M. Silverstein, *A Pattern Language* (New York: Oxford University Press, 1977), 834; 837.
40 *The Corrections*, 621.
41 Ibid., 549.
42 William Gass, 'In the Heart of the Country' in Richard Ford, ed., *The Granta Book of the American Short Story* (London: Granta Books, 1998), 319–20.
43 *The Complete Poems*, no. 1206.
44 *Letters*, 381.
45 Elizabeth Blackmar, 'The Social Meanings of Housing, 1800–1840', in *Manhattan for Rent, 1785–1850* (Ithaca, NY/London: Cornell University Press, 1989), 126–38.
46 *Letters*, 432.
47 'The Hissing of Summer Lawns', *The Hissing of Summer Lawns* (Asylum, 1975).
48 Deborah Tall, 'Dwelling: Making Peace with Space and Place' in *Rooted in the Land: Essays on Community and Place*, ed. Wes Jackson and William Vitek (Yale University Press, 1996), 104–12.
49 *The Production of Space*, 38, 46.
50 Ralph Waldo Emerson, *Essays and Lectures*, ed. Joel Porte (New York: Library of America, 1983), 403.
51 A. M. Homes, *Music for Torching* (London: Doubleday, 1999), 321.
52 Michel de Certeau, *The Practice of Everyday Life*, trans. Steven Rendall (Berkeley, CA: University of California Press, 2002).
53 Sylvia Plath, 'Lesbos' in *The Collected Poems* (New York: Harper & Perennial, 1992), 227–8.
54 Ibid.
55 Eugene Walter, *Milking the Moon: A Southerner's Story of Life on This Planet* (New York: Crown, 2001), 19.
56 John Bennett, 'A Note on Middle Mississippi Architecture', *American Antiquity*, vol. 9, no. 3 (January 1944), 334.
57 Susan Bridwell Beckham, 'The American Front Porch: Women's Luminal Space' in Barbara Miller Lane, ed., *Housing and Dwelling: Perspectives on Modern Domestic Architecture* (London: Routledge, 2007), 86.

58 John Michael Vlach, *The Afro-American Tradition in Decorative Arts* (Cleveland, OH: Cleveland Museum of Art, 1978), 136–8.
59 Charles E. Peterson, 'The American Porch', *Journal of the Society of Architectural Historians*, vol. 10, no. 2 (May 1951), 20.
60 Renee Kahn and Ellen Meagher, *Preserving Porches* (New York: Henry Hold, 1990), 23.
61 *The American Home*, 350.
62 Tennessee Williams, *Cat on a Hot Tin Roof and Other Plays* (London: Penguin, 1986), 87. Hereafter cited as *Cat on a Hot Tin Roof*.
63 Ibid., 96.
64 E. Martin Browne, 'Editorial Note' in Tennessee Williams, *Cat on a Hot Tin Roof*.
65 Carson McCullers, *The Ballad of the Sad Café* (New York: First Mariner Books/Houghton Mifflin, 2005), 7. Hereafter cited as *The Ballad of the Sad Café*.
66 Ibid., 18.
67 *Space and Place*, 6, 136.
68 *Cat on a Hot Tin Roof*, 76.
69 *The Ballad of the Sad Café*, 22.
70 *Democracy in America*, 2: 274.
71 Carson McCullers, *The Heart is a Lonely Hunter* (London: Penguin, 1961), 276. Hereafter cited as *The Heart is a Lonely Hunter*.
72 Michael Dolan, *The American Porch: An Informal History of an Informal Place* (Guilford, DE: Lyons Press, 2002), www.curledup.com/porch.htm (accessed 30 April 2010).
73 Victor Turner, *Dramas, Fields and Metaphors: Symbolic Action in Human Society* (Ithaca, NY: Cornell University Press, 1974).
74 *The Heart is a Lonely Hunter*, 94.
75 *Space and Place*, 118–21.
76 Maria Tai Wolff, 'Listening and Living: Reading and Experience in Their Eyes Were Watching God', in Henry Louis Gates, Jr and K. A. Appiah, eds, *Zora Neale Hurston: Critical Perspective in Their Eyes Were Watching God* (New York: Amistad Press, 1993), 226.
77 www.metrolyrics.com/front-porch-song-lyrics-robert-earl-keen.html (accessed 29 October 2008).
78 http://widespread-panic-porch-song-lyrics-mp3.kohit.net/_/93808 (accessed 29 October 2008).
79 'The Gradual Making of the Making of Americans', 161.
80 Annie Dillard, *An American Childhood* (London: Picador, 1989), 44. Hereafter cited as *An American Childhood*.
81 Yi-Fu Tuan, *Dominance and Affection: The Making of Pets* (New Haven, CT: Yale University Press, 1984), 19.

82 Virginia Scott Jenkins, *The Lawn: A History of an American Obsession* (Washington, DC: Smithsonian Institution, 1994), 4. Hereafter cited as *The Lawn*.
83 Frank J. Scott, *The Art of Beautifying Suburban Home Grounds* (1870) cited in Michael Pollan, 'A Brief History of the American Lawn', *Biolore*, vol. 16, nos 1–2 (2000), 60.
84 Ibid.
85 *The Architecture of Country Houses*, v.
86 Ibid., 184.
87 F. Scott Fitzgerald, *The Great Gatsby* (London: Penguin Popular Classics, 1994), 13; 47.
88 *An American Childhood*, 44.
89 *The Lawn*, 185.
90 Vladimir Nabokov, *Lolita* (London: Penguin Classics, 2000), 73.
91 *The Complete Poems*, no. 258.
92 *Lolita*, 39.
93 Ibid., 95.
94 *The Virgin Suicides* (1999), dir. Sofia Coppola.
95 Jeffrey Eugenides, *The Virgin Suicides* (London: Bloomsbury, 2002), 233.
96 Sara Lowen, 'The Tyranny of the Lawn', www.americanheritage.com/articles/magazine/ah/1991/5/1991_5_44.shtml (accessed 11 June 2008).
97 *Blue Velvet* (1986), dir. David Lynch.
98 Peter Keough, 'Blue Movie: David Lynch's Velvet Revolution', http://thephoenix.com/Boston/Movies/15021-BLUE-VELVET/ (accessed 13 June 2008).
99 *The Straight Story* (2000), dir. David Lynch.
100 Tim Kreider, 'The Straight Story', *Film Quarterly* (Fall 2000), www.davidlynch.de/qaurterstraight.html (accessed 13 June 2008).
101 *The American Family Home*, 228.
102 Arthur Miller, *All My Sons* (Oxford: Heinemann, 1971), 3.
103 Ibid., 4.
104 *An American Childhood*, 31.
105 Don DeLillo, *White Noise* (London: Picador, 1999), 81–2. Hereafter cited as *White Noise*.
106 *Lives Like Loaded Guns*, 205.
107 www.brainyquote.com/quotes/quotes/a/annieleibo344659.html (accessed 30 October 2008).
108 Deborah Nelson, 'Penetrating Privacy: Confessional Poetry and the Surveillance Society' in Catherine Wiley and Fiona R. Barnes, eds, *Homemaking: Women Writers and the Politics and Poetics of the Home* (New York: Garland, 1996), xv.
109 Ray Bradbury, *Dandelion Wine* (London: Rupert Hart Davis, 1957), 22.
110 Richard Reep, *Urban Morphology Research Group Bulletin*, no. 7 (June 1997), www.gees.bham.ac.uk/documents/Miscellaneous/umrg_bulletin7.htm (accessed 23 November 2008).

111 *American Beauty* (1999), dir. Sam Mendes.
112 *Gone With the Wind* (1939), dir. Victor Fleming.
113 *The American Family Home*, 228.
114 Ibid., 229.
115 Arthur Miller, *Death of a Salesman* in *Plays: One* (London: Methuen, 1988), 131. Hereafter cited as *Death of a Salesman*.
116 Witold Rybczynski, 'America's Growing Obsession with Bathrooms', *Slate*, www.slate.com/id/2157288/slideshow/2157334/entry/2157336/fs/0// (accessed 31 October 2009).

CHAPTER THREE

1 W. H. Auden, 'Thanksgiving for a Habitat' in *Collected Poems* (London: Faber & Faber, 1991), 688–91.
2 Ibid., 700–3.
3 *The Shining* (1980), dir. Stanley Kubrick.
4 'History of Plumbing in America', *Plumbing and Mechanical* (July 1987), www.theplumber.com/usa.html (accessed 29 April 2010).
5 Amos Rapoport, 'The Nature and Definition of the Field', in Barbara Miller Lane, ed., *Housing and Dwelling: Perspectives on Modern Domestic Architecture* (London: Routledge, 2007), 30.
6 Jefferson Williamson, *The American Hotel* (New York: Alfred Knopf, 1930), 55–60.
7 Witold Rybczynski, 'Flushed with Pride: How the Bathroom Became America's Latest Status Symbol', www.slate.com/id/2157288 (accessed 1 November 2009).
8 Ibid., 16; 25.
9 *Silkwood* (1983), dir. Mike Nichols.
10 *In the Company of Men* (1997), dir. Neil LaBute.
11 Patricia Cooper and Ruth Oldenziel, 'Bathrooms and the Construction of Gender/Race on the Pennsylvania Railroad During World War II', *Feminist Studies*, vol. 25, no. 1 (Spring 1999), 15.
12 John Updike, *Couples* (London: Penguin, 1968), 140.
13 *Marnie* (1963), dir. Alfred Hitchcock.
14 Winston Graham, *Marnie, Greek Fire, The Forgotten Story* (London: Chapman, 1992), 321–2.
15 Sylvia Plath, *The Bell Jar* (London: Faber & Faber, 1966), 19.
16 *Space and Place*, 47.
17 Philip Roth, *Portnoy's Complaint* (London: Penguin 1986), 20–6.
18 Philip Roth, *Sabbath's Theatre* (London: Vintage, 1995), 149–50.
19 *Species of Space*, 45.
20 J. D. Salinger, *Franny and Zooey* (London: Penguin, 1994), 35–81.

21. *Rear Window* (1954), dir. Alfred Hitchcock.
22. Elizabeth C. Cromley, *Alone Together: A History of New York's Early Apartments* (Ithaca, NY: Cornell University Press, 1990), 1. Hereafter cited as *Alone Together*.
23. Dorothy Parker, *The Portable Dorothy Parker* (London: Penguin, 1973), 170–81. Hereafter cited as *The Portable Dorothy Parker*.
24. Henry James, *The American Scene* (London: Chapman & Hall, 1907), 406.
25. Ibid., 104–5.
26. Henry James, *The Portrait of a Lady* (Oxford: Oxford University Press, 1995), 115. Hereafter cited as *The Portrait of a Lady*.
27. Andrew Sandoval-Strauz, *Hotel: An American History* (New Haven, CT: Yale University Press, 2007), 263–4. Hereafter cited as *Hotel: An American History*.
28. Theodore Dreiser, *Sister Carrie* (Philadelphia, PA: University of Pennsylvania Press, 1981), 81.
29. *Alone Together*, 3–4.
30. Andrew Alpern, *Luxury Apartment Houses of Manhattan: An Illustrated History* (New York: Dover Publications, 1993), 6.
31. *Hotel: An American History*, 274–5.
32. Ibid., 277.
33. *Alone Together*, 111.
34. Ibid., 107.
35. Dorothy Parker, *Ladies of the Corridor* (London: Penguin Classics, 2008), 26.
36. Ibid., 28.
37. Ibid., 29.
38. *The Portable Dorothy Parker*, 273–83.
39. *Chronicles*, 31.
40. Ibid., 25.
41. Ibid.
42. Bob Dylan, 'Corner Flat', *The Drawn Blank Series* (London: Halcyon Gallery, 2008), 42.1–42.3.
43. *Species of Space*, 90.
44. *Chronicles*, 31.
45. *The Portrait of a Lady*, 238.
46. *Hotel: An American History*, 166.
47. Olive Higgins Prouty, *Stella Dallas* (London: Virago, 1990), 11–12. Hereafter cited as *Stella Dallas*.
48. *Hotel: An American History*, 179.
49. *Stella Dallas*, 23–4.
50. Ibid., 37–8.
51. *The American Scene*, 11.
52. *Stella Dallas*, 104.

53 John Margolies, *Home Away From Home: Motels in America* (New York: Little, Brown, 1995).
54 Warren James Belasco, *Americans on the Road: From Autocamp to Motel, 1910–1945* (Baltimore, MD/London: Johns Hopkins University Press, 1979), 132–3.
55 John A. Jakle, Keith A. Sculle and Jefferson S. Rogers, *The Motel in America* (Baltimore, MA/London: Johns Hopkins University Press, 1996), 327. Hereafter cited as *The Motel in America*.
56 *Memento* (2001), dir. Christopher Nolan.
57 *The Motel in America*, 327.
58 *Tape* (2001), dir. Richard Linklater.
59 *Lolita*, 168.
60 Ibid., 145.
61 Ibid., 154.
62 Michael Karl Witzel, *The American Motel* (Osceola, WI: MBI Publishing Co., 2000), 117.
63 *The Motel* (2005), dir. Michael Kang.
64 Abraham Ferrer, 'Checking into the Motel', interview with Michael Kang, www.vconline.org/screenings/kang2.html (accessed 17 July 2008).
65 *Lolita*, 145–7.
66 Sam Shepard, *Fool for Love* (London: Faber & Faber, 1983), 43.
67 Bonnie Marranca, 'Alphabetical Shepard: The Play of Words' in Bonnie Marranca, ed., *American Dreams: The Imagination of Sam Shepard* (New York: Performing Arts Journal Publications, 1981), 32–3.
68 Sam Shepard, *Motel Chronicles and Hawk Moon* (Boston, MA/London: Faber & Faber, 1985), 31.
69 Ibid., 24.
70 Ibid., 15.
71 *Wild at Heart* (1990), dir. David Lynch.
72 *The Complete Poems*, no. 1664.
73 Michael Cunningham, *The Hours* (1998) (London: Fourth Estate, 2003), 146.
74 Sam Shepard, *La Turista*, in *Plays*, vol. 2 (London: Faber & Faber, 1997), 255.
75 Laura Ingalls Wilder, *By the Shores of Silver Lake* (London: Puffin, 1977), 131–2.
76 *Wolf Willow*, 267–9.

CHAPTER FOUR

1 *The Complete Poems*, no. 821.
2 Sacvan Bercovitch, *The Puritan Origins of the American Self* (New Haven, CT: Yale University Press, 1975), 143.

3. Adrienne Rich, 'Notes Towards a Politics of Location' in *Blood, Bread and Poetry. Selected Prose 1979–1985.* (New York: W. W. Norton, 1986), 27.
4. *The Frontier in American History*, 36.
5. David Wrobel, *The End of American Exceptionalism: Frontier Anxiety from the Old West to the New Deal* (Lawrence, KS: University of Kansas Press, 1993), 136.
6. www.internationalschoolhistory.net/coldwar_documentary/14-red_spring.htm (accessed 30 April 2010).
7. Cited in Catherine Gouge, 'The American Frontier: History, Rhetoric, Concept', *Americana: The Journal of American Popular Culture 1900–Present Day*, vol. 6, no. 1 (Spring 2007): www.americanpopularculture.com/journal/articles/spring_2007/gouge.htm (accessed 30 April 2010).
8. Robert V. Hine and John Mack Faragher, *Frontiers: A Short History of the American West* (New Haven, CT/London: Yale University Press, 2007), 204–5.
9. José Salvidar David, *Border Matters: Remapping American Cultural Studies* (Berkeley, CA: University of California Press, 1997), x.
10. *The Frontier in American History*, 300.
11. Lynda H. Schneekloth, 'The Frontier is our Home', *Journal of Architectural Education*, vol. 49, no. 4 (May 1996), 210. Hereafter cited as 'The Frontier is our Home'.
12. Annette Kodolny, *The Land Before Her: Fantasy and Experience of the American Frontiers 1630–1860* (Chapel Hill, NC/London: University of North Carolina Press, 1984), 3. Hereafter cited as *The Land Before Her*.
13. Ibid., 4.
14. Annette Kolodny, *The Lay of the Land: Metaphor as Experience and History in American Life and Letters* (London/Chapel Hill, NC: University of North Carolina Press, 1975), 138.
15. 'A ranch house on the hill' comes from Mitchell's lyrics to 'The Hissing of Summer Lawns', the title track of her 1975 album of the same name.
16. Fred E. H. Schroder, 'Andrew Wyeth & the Transcendental Tradition', *American Quarterly*, vol. 17, no. 3 (Autumn 1965), 558–567: 563.
17. *Wolf Willow*, 268–9.
18. John Wylie, *Landscape* (Oxford/New York: Routledge, 2007), 59.
19. Henry David Thoreau, *Writings* (Boston, MA/New York: Houghton & Mifflin, 1906), vol. 2, 100–1.
20. 'The Frontier is our Home', 210.
21. *The Complete Poems*, no. 802.
22. Cited in *The Land Before Her*, 29.
23. Howard Mumford Jones, *O Strange New World*: *American Culture, the Formative Years* (London: Chatto & Windus, 1965), 352.
24. *The Complete Poems*, nos 656, 657, 326, 327.
25. *The Complete Poems*, no. 228.

26 Cormac McCarthy, *Blood Meridian or The Evening Redness in the West* (London: Picador, 1990), 15.
27 Ibid., 21.
28 'A Dissolving View', 79–94.
29 Thomas Jefferson, *Notes on the State of Virginia*, ed. William Peden (Chapel Hill, NC: University of North Carolina Press, 1954, reprinted New York: Norton, 1972), 19.
30 Lou Cannon, *President Reagan: The Role of a Lifetime* (New York/London: Simon & Schuster, 1992), 793–4.
31 *Death of a Salesman*, 222.
32 Robert V. Hine and John Mack Faragher, *The American West: A New Interpretative History* (New Haven, CT/London: Yale University Press, 2000), 526. Hereafter cited as *The American West*.
33 Michael Rogin, 'Kiss Me Deadly: Communism, Motherhood and Cold War Movies' in *Ronald Reagan, the Movie and Other Episodes in Political Demonology* (Berkeley, CA: University of California Press, 1987), 258.
34 *The American West*, 531.
35 Cited in Tim Raphael, 'The King is the Thing: Bodies of Memory in the Age of Reagan', *The Drama Review*, vol. 43, no. 1 (Spring 1999), 52–3.
36 *She Wore A Yellow Ribbon* (1949), dir. John Ford.
37 Tag Gallagher, *John Ford: The Man and his Films* (London/Berkeley, CA: University of California Press, 1986), 257–8.
38 *Kill Bill* part 1 (2003); *Kill Bill* part 2 (2004), dir. Quentin Tarantino.
39 *Seven Men From Now* (1956), dir. Budd Boetticher.
40 Dave Kehr, 'Charting the Tarantino Universe', *The New York Times*, Saturday 9 August 2008, http://query.nytimes.com/gst/fullpage.html (accessed 9 August 2008).
41 Richard Slotkin, *Gunfighter Nation: The Myth of the Frontier in Twentieth-Century America* (New York: Atheneum, 1992). Hereafter cited as *Gunfighter Nation*.
42 *No Country For Old Men* (2007), dir. Joel and Ethan Coen.
43 *Gunfighter Nation*, 159.
44 Ibid., 195.
45 Ibid., 248.
46 Conrad Richter, *The Sea of Grass* (London/New York: White Lion, 1936), 3.
47 Cormac McCarthy, 'All the Pretty Horses' in *The Border Trilogy* (London: Picador, 2002), 5. Hereafter cited as 'All the Pretty Horses'.
48 Ralph Waldo Emerson, 'Experience' in *Complete Works*, 12 vols (Boston, MA: Houghton Mifflin, 1904), 3: 198.
49 In what Kant terms the 'dynamic sublime', the mind falls into abeyance in the face of something larger than itself. It resorts to reason as a means of compensating for its inability to imaginatively process what it has encountered. Reason thus bridges the gap between the sublime form and the impaired imagination. Mary Arensburg, *The American Sublime* (Albany: University of New York Press, 1986), 5–6.

50. Ralph Waldo Emerson, 'Circles' in *Emerson's Prose and Poetry*, ed. Joel Porte and Saundra Morris (New York: Norton, 2001), 181. Hereafter cited as 'Circles'.
51. Henry David Thoreau, *Walking* (Rockville, MD: Arc Manor Classics, 2007), 24–5. Hereafter cited as *Walking*.
52. Robinson Jeffers, 'Phenomena' in *The Wild God of the World: An Anthology of Robinson Jeffers*, ed. Albert Gelpi (Stanford, CA: Stanford University Press, 2003), 40.
53. 'All the Pretty Horses', 5.
54. 'Circles', 175.
55. *The Complete Poems*, no. 754.
56. *Walking*, 7.
57. Ibid., 8.
58. Cormac McCarthy, *The Road* (London: Picador, 2006), 1.
59. Paul Crowther, *Critical Aesthetics and Postmodernism* (Oxford: Oxford University Press, 1996), 118.
60. Leo Marx, *The Machine in the Garden: Technology and the Pastoral Ideal in America* (London/New York: Oxford University Press, 1964), 155; 159.
61. *Death of a Salesman*, 222.
62. Ibid, 222.
63. John A. Agnew and Jonathan M. Smith, eds, *American Space/American Place: Geographies of the Contemporary United States* (Edinburgh: Edinburgh University Press, 2002), 22. Hereafter cited as *American Space/American Place*.
64. Charles Dickens, *American Notes* (New York: St Martin's, 1985), 182; Henry David Thoreau, 'The Maine Woods' in *The Writings of Henry David Thoreau*, 3: 71, 78.
65. *American Space/American Place*, 39.
66. *The Writings of Robert Smithson*, ed. Nancy Holt (New York: New York University Press, 1979), 111. Hereafter cited as *The Writings of Robert Smithson*.
67. Immanuel Kant, *Critique of Judgment*, trans. J. H. Bernard (London: Hafner Pub. Co., 1951), 90, 26.
68. Ibid.
69. *The Writings of Robert Smithson*, 113.
70. Ibid., 113.
71. Ibid., 85–6.
72. Gary Wills, *John Wayne's America* (New York: Simon and Schuster, 1997), 302–3.
73. *The Complete Poems*, no. 378.
74. Paul Auster, *Moon Palace* (London: Faber & Faber, 1989), 54–6.
75. Walt Whitman, *Leaves of Grass*, ed. Harold W. Blodgett and Sculley Bradley (London: University of London, 1965), 28.
76. Ibid., 14; 17; 21.
77. Ibid., 24.
78. Ibid., 226–7.
79. *Democracy in America*, vol. 2, 61.

80 Benedict Anderson, *Imagined Communities: Reflections on the Origin and Spread of Nationalism*, revised edition (London/New York: Verso, 1991), 5–7.
81 *American Space/American Place*, 82–3.
82 *White Noise*, 36.
83 Ibid., 84–5.
84 Ibid., 258.
85 Ibid., 306.
86 Ibid., 226–7.
87 Ibid., 325.
88 Ibid., 155.
89 Interview with James Turrell, www.pbs.org/art21/artists/turrell/clip1.html (accessed 3 September 2008).
90 *The Complete Poems*, no. 657.
91 *The Complete Poems*, no. 128.

CONCLUSION

1 *Walden*, 126.
2 Frederick Seidel, *Sunrise* (New York: Viking, 1980), 5. Hereafter cited as *Sunrise*.
3 Stacy Carlson and Daniel Kroop, 'On the Road (to the Suburbs)', *Harvard Political Review*, Friday 16 November 2007, http://hprsite.squarespace.com/on-the-road-112007 (accessed 17 January 2009).
4 William Kaszynski, *The American Highway: The History and Culture of Roads in the United States* (Jefferson, NC: McFarland, 2000), 176.
5 *Sunrise*, 12–13.
6 Ibid., 13.
7 Wayne Craven, *American Art: History and Culture* (New York: Harry N. Abrams, 1994), 190.
8 Bob Dylan, 'Ramblin' and Gamblin' Willie', *The Bootleg Series Volumes 1–3 (Rare & Unreleased, 1961–1991)*.
9 *The Assassination of Jesse James by the Coward Robert Ford* (2007), dir. Andrew Dominik.
10 *The Corrections*, 621.
11 Malcolm Magee, 'Speaking of Progress: The Rhetoric of Reform in the Progressive Era', *Journal of the Gilded Age and Progressive Era*, vol. 3, no. 1 (January 2004), www.historycooperative.org/journals/jga/3.1/br_1.html (accessed 10 September 2008).
12 *The Complete Poems*, no. 641.
13 *The Little House on the Prairie*, 70.
14 Ibid., 46, 67, 74.
15 Ibid., 83.

16 Ibid., 16.
17 *Wolf Willow*, 272.
18 Terry G. Jordan and Matti Kraups, *The American Backwoods Frontier* (Baltimore, MD/London: Johns Hopkins University Press, 1989), 179–82.
19 *Wolf Willow*, 272.
20 Fiske Kimball, *Domestic Architecture of the American Colonies and the Early Republic* (1922) (New York: Courier Dover Publications, 2001), 9–10.
21 John R. Stillgoe, *Borderland: Origins of the American Suburb, 1820–1939* (New Haven, CT: Yale University Press, 1988).
22 Betty Friedan, *The Feminine Mystique* (New York: Gollancz, 1963), 48.
23 Robert Fishman, *Bourgeois Utopias: The Rise and Fall of Suburbia* (New York: Basic Books, 1987), 130.
24 *The Corrections*, 264.
25 Ibid., 266.
26 'History of the National Park Service', www.nps.gov/archive/wrst/npshistory.htm (accessed 21 September 2008).
27 John Updike, *Rabbit at Rest* (London: Penguin, 2006), 446–8. Hereafter cited as *Rabbit at Rest*.
28 *Up* (2009), dir. Pete Docter and Bob Petersen.
29 *Rabbit at Rest*, 62–3.
30 Ibid., 65.
31 Siegfried Giedion, *Space, Time and Architecture* (Boston, MA: Harvard University Press, 1967), 400.
32 *The Complete Poems*, no. 797.
33 *The Sense of an Interior*, 58.
34 *Capturing the Friedmans* (2003), dir. Andrew Jarecki.
35 *White Noise*, 84.
36 www.capturingthefriedmans.com/main.html (accessed 23 September 2008).
37 *The Bell Jar*, 163.
38 Ibid., 108, 163.
39 Sarah A. Lichtman, 'Do-It-Yourself Security: Safety, Gender and the Home Fallout Shelter in Cold War America', *Journal of Design History*, vol. 19, no. 1 (2006), 40. Hereafter cited as 'Do-It-Yourself Security'.
40 Elaine Tyler May, *Homeward Bound: American Families in the Cold War Era* (New York: Basic Books, 1988), 11.
41 'Do-It-Yourself Security', 41–2.
42 Greil Marcus, *Invisible Republic: Bob Dylan's Basement Tapes* (London: Picador, 1997), 87–8. Hereafter cited as *Invisible Republic*.
43 Bob Dylan and the Band, 'Open the Door, Homer'; 'Nothing was Delivered', *The Basement Tapes*, Columbia Records, 1975.
44 *Invisible Republic*, 70.

45 Bob Dylan and the Band, 'Open the Door, Homer'; 'Nothing was Delivered', *The Basement Tapes*, Columbia Records, 1975.
46 'Ain't Going Nowhere', *The Genuine Basement Tapes*, vol. 4, June–October 1967.
47 *Invisible Republic*, 89–91.
48 *The Corrections*, 531.
49 *The Corrections*, 537.
50 John Brinckerhoff Jackson, *A Sense of Place, A Sense of Time* (New Haven, CT/London: Yale University Press, 1994), 159, 189.
51 Ibid.
52 Richard Yates, *Revolutionary Road* (London: Methuen, 2001), 30.
53 Domhnall Mitchell, *Emily Dickinson: Monarch of Perception* (Amherst, MA: University of Massachusetts Press, 1999), 45–50.
54 Ibid.
55 *The Complete Poems*, no. 640.
56 *The Complete Poems*, no. 82.
57 *Chronicles*, 58.
58 *Walden*, 234.
59 Ibid., 116–20.
60 *Invisible Republic*, 91–5.
61 *Chronicles*, 73.
62 Marilynne Robinson, *Home* (New York: Farrar, Strauss & Giroux, 2008), 3.

Bibliography

Primary Texts

W. H. Auden, *Collected Poems* (London: Faber & Faber, 1991).
Paul Auster, *The City of Glass* (London: Faber & Faber, 1985).
——, *Moon Palace* (London: Faber & Faber, 1989).
Harriet Beecher Stowe, *The Minister's Wooing* (Harmondsworth, Middlesex: Penguin Classics, 1999).
Ray Bradbury, *Dandelion Wine* (London: Rupert Hart Davis, 1957).
Anne Bradsheet, *To My Husband and Other Poems* (New York: Dover Thrift Editions, 2000).
Frederika Bremer, *The Homes of the New World*, trans. Mary Howitt, 2 vols (New York: Harper & Brothers, 1854).
Willa Cather, *The Professor's House* (London: Virago, 1981).
Raymond Chandler, *From Where I'm Calling: New and Selected Stories* (New York: Atlantic Monthly Press, 1988).
Samuel Taylor Coleridge, *Coleridge's Miscellaneous Criticism*, ed. Thomas Middleton Raysor (Cambridge: Cambridge University Press, 1936).
Susan Fenimore Cooper, 'A Dissolving View' in *The Home Book of the Picturesque: Or American Scenery, Art and Literature Comprising a Series of Essays by Washington Irving, W. C. Bryant, Fenimore Cooper, And Others* (Gainsville, FL: Scholars' Facsimiles and Reprints, 1967).
Michael Cunningham, *The Hours* (1998) (London: Fourth Estate, 2003).
Don DeLillo, *White Noise* (London: Picador, 1999).
Charles Dickens, *American Notes* (New York: St Martin's, 1985).
Emily Dickinson, *The Complete Poems*, ed. Thomas H. Johnson (London: Faber & Faber, 1976).
The Letters of Emily Dickinson, ed. Thomas H. Johnson (Cambridge, MA: Belknap Press, 1986).

Theodore Dreiser, *Sister Carrie* (Philadelphia, PA: University of Pennsylvania Press, 1981).
Bob Dylan, *Chronicles: Volume One* (London: Pocket Books, 2005).
Dave Eggers, *A Heartbreaking Work of Staggering Genius* (New York: Simon & Schuster, 2000).
Ralph Waldo Emerson, *Essays and Lectures*, ed. Joel Porte (New York: Library of America, 1983).
——, *Emerson's Prose and Poetry*, ed. Joel Porte and Saundra Morris (New York: Norton, 2001).
Jeffrey Eugenides, *The Virgin Suicides* (London: Bloomsbury, 2002).
F. Scott Fitzgerald, *The Great Gatsby* (London: Penguin Popular Classics, 1994).
Richard Ford, ed., *The Granta Book of the American Short Story* (London: Granta Books, 1998).
Jonathan Franzen, *The Corrections* (London: Fourth Estate, 2002).
W. H. Frere and C. E. Douglas, eds, *Puritan Manifestos* (London: Church History Society, 1954).
Sigmund Freud, 'The Uncanny' in *The Standard Edition of the Complete Psychological Works of Sigmund Freud*, vol. XVII, ed. and trans. James Strachey (London: Hogarth, 1953).
Betty Friedan, *The Feminine Mystique* (New York: Gollancz, 1963).
William Gass, 'In the Heart of the Country' in Richard Ford, ed., *The Granta Book of the American Short Story* (London: Granta Books, 1998), 319–20.
Nathaniel Hawthorne, *The House of the Seven Gables* (London: Walter Scott Limited, c. 1890).
——, *The English Notebooks*, ed. Randall Stewart (New York: Modern Language Association of America, 1941).
Olive Higgins Prouty, *Stella Dallas* (London: Virago, 1990).
A. M. Homes, *Music for Torching* (London: Doubleday, 1999).
Zora Neale Hurston, *Their Eyes Were Watching God* (1937) (London: Virago, 1986).
Henry James, *The American Scene* (London: Chapman and Hall, 1907).
——, *Selected Tales* (London/Melbourne/Toronto: Dent, 1982).
——, *The Europeans* (New York: Library of America, 1983).
——, *The Portrait of a Lady* (Oxford: Oxford University Press, 1995).
Robinson Jeffers, *The Wild God of the World: An Anthology of Robinson Jeffers*, ed. Albert Gelpi (Stanford, CA: Stanford University Press, 2003).
Immanuel Kant, *Critique of Judgment*, trans. J. H. Bernard (London: Hafner Pub. Co., 1951).
Henry Wadsworth Longfellow, *The Poems of Longfellow* (New York: Modern Library of New York, 1949).
Cormac McCarthy, *Blood Meridian or The Evening Redness in the West* (London: Picador, 1990).

——, *The Border Trilogy* (London: Picador, 2002).
——, *The Road* (London: Picador, 2006).
Carson McCullers, *The Heart is a Lonely Hunter* (London: Penguin, 1961).
——, *The Ballad of the Sad Café* (New York: First Mariner Books/Houghton Mifflin, 2005).
James Merrill, *Collected Poems*, ed. J. D. McClatchy and Stephen Yenser (New York: Alfred Knopf, 2002).
Arthur Miller, *All My Sons* (Oxford: Heinemann, 1971).
——, *Death of a Salesman* in *Plays: One* (London: Methuen, 1988).
Vladimir Nabokov, *Lolita* (London: Penguin Classics, 2000).
Charles Olson, *Call Me Ishmael* (San Francisco, CA: City Lights, 1947).
Dorothy Parker, *The Portable Dorothy Parker* (London: Penguin, 1973).
——, *Ladies of the Corridor* (London: Penguin Classics, 2008).
Sylvia Plath, *The Bell Jar* (London: Faber & Faber, 1966).
——, *The Collected Poems* (New York: Harper & Perennial, 1992).
Edgar Allan Poe, *The Complete Tales and Poems* (New York: Modern Library, 1938).
Conrad Richter, *The Sea of Grass* (London/New York: White Lion, 1936).
Marilynne Robinson, *Housekeeping* (New York: Picador, 1980).
——, *Home* (New York: Farrar, Strauss & Giroux, 2008).
Philip Roth, *Portnoy's Complaint* (London: Penguin 1986).
——, *Sabbath's Theatre* (London: Vintage, 1995).
J. D. Salinger, *Franny and Zooey* (London: Penguin, 1994).
Frederick Seidel, *Sunrise* (New York: Viking Press, 1980).
Anne Sexton, *The Complete Poems* (Boston, MA: Houghton Mifflin, 1981).
Sam Shepard, *Fool for Love* (London: Faber & Faber, 1983).
——, *Motel Chronicles and Hawk Moon* (Boston, MA/London: Faber & Faber, 1985).
——, *La Turista*, in *Plays*, vol. 2 (London: Faber & Faber, 1997).
Gertrude Stein, 'The Gradual Making of the Making of Americans', in *Lectures in America* (New York: Random House, 1935).
——, *The Making of Americans* (Normal, IL: Dalkey Archive, 1995).
Henry David Thoreau, *The Writings of Henry David Thoreau*, 11 vols (Boston, MA/New York: Houghton & Mifflin, 1906).
——, *Walden*, ed. Stephen Fender (Oxford: Oxford University Press, 1997).
Alexis de Tocqueville, *Democracy in America*, trans. George Lawrence, ed. Mortimer J. Adler, 2 vols (Chicago, IL: University of Chicago Press, 1990).
Mark Twain, *Letters of Mark Twain*, ed. Albert Bigelow Paine, 2 vols (New York: Harper & Bros, 1917).
——, *The Adventures of Huckleberry Finn* (London: Penguin Classics, 1985).
John Updike, *Couples* (London: Penguin, 1968).
——, *Rabbit Omnibus* (London: Penguin, 2001).
——, *Rabbit at Rest* (London: Penguin, 2006).

David Foster Wallace, *A Supposedly Funny Thing I'll Never Do Again* (London: Abacus, 1997).
Walt Whitman, *Leaves of Grass*, ed. Harold W. Blodgett and Sculley Bradley (London: University of London, 1965).
Laura Ingalls Wilder, *By the Shores of Silver Lake* (London: Puffin, 1977).
——, *The Little House on the Prairie* (London: Egmont, 2000).
Tennessee Williams, *Cat on a Hot Tin Roof and Other Plays* (London: Penguin, 1986).
J. Winthrop, 'A Model of Christian Charity' (1630), in N. Baym, R. Gottesman and L. B. Holland, eds, *The Norton Anthology of American Literature*, vol. 2 (New York: W. W. Norton, 1989), 31–42.
Richard Yates, *Revolutionary Road* (London: Methuen, 2001).

Secondary Texts

THE AMERICAN HOME

Christopher Alexander, S. Ishikawa and M. Silverstein, *A Pattern Language* (New York: Oxford University Press, 1977).
Susan Bridwell Beckham, 'The American Front Porch: Women's Luminal Space' in Barbara Miller Lane, ed., *Housing and Dwelling: Perspectives on Modern Domestic Architecture* (London: Routledge, 2007).
Catherine Esther Beecher and Harriet Beecher Stowe, *The American Woman's Home*, ed. Nicole Tonkovich (New Brunswick, NJ: Rutgers University Press, 2002).
John Bennett, 'A Note on Middle Mississippi Architecture', *American Antiquity*, vol. 9, no. 3 (January 1944), 333–4.
Vincent J. Bertoloni, 'Fireside Chastity: The Erotics of Sentimental Bachelorhood in the 1850s', *American Literature*, vol. 68, no. 4, 707–37.
Elizabeth Blackmar, 'The Social Meanings of Housing, 1800–1840', in *Manhattan for Rent, 1785–1850* (Ithaca, NY/London: Cornell University Press, 1989).
Edward J. Blakely and Mary Gail Snyder, *Fortress America: Gated Communities in the United States* (Washington, DC: The Brookings Institution Press, 1997).
Edith Borroff, 'An American Parlor at the Turn of the Century', *American Music*, vol. 4, no. 3 (Autumn 1986), 302–8.
Bill Brown, 'The Tyranny of Things: Trivia in Karl Marx and Mark Twain', *Critical Inquiry*, vol. 28, no. 2 (Winter 2002), 442–69.
——, *A Sense of Things: The Object Matter of American Literature* (Chicago, IL/London: University of Chicago Press, 2003).

Bibliography

Akiko Busch, *Geography of Home: Writings on Where We Live* (Princeton: Princeton Architectural Press, 2004).

Richard L. Bushman, *The Refinement of America: Persons, Houses, Cities* (New York: Alfred A. Knopf, 1992).

Michel de Certeau, *The Practice of Everyday Life*, trans. Steven Rendall (Berkeley, CA: University of California Press, 2002).

Maurice Charney, 'Hawthorne and the Gothic Style', *New England Quarterly*, vol. 34, no. 1 (1961), 36–49.

Irene Cieraad, ed., *At Home: An Anthropology of Domestic Space* (new edition, Syracuse, New York: Syracuse University Press, 2006).

Clifford Edward Clark, Jr, *The American Family Home, 1800–1960* (Chapel Hill, NC: University of North Carolina Press, 1986).

John Conron, *American Picturesque* (University Park, PA: Pennsylvania University Press, 2000).

Clare Cooper Marcus, *House as a Mirror of Self: Exploring the Deeper Meaning of Home* (Hays: Nicolas, 2007).

George William Curtis, *Homes of American Authors comprising Anecdotal, Personal and Prescriptive Sketches by Various Writers* (New York: G. P. Putnam & Co., 1853).

Annie Dillard, *An American Childhood* (London: Picador, 1989).

Michael Dolan, *The American Porch: An Informal History of an Informal Place* (Guilford, DE: Lyons Press, 2002), www.curledup.com/porch.htm (accessed 30 April 2010).

Mary Douglas, 'The Idea of a Home' in Barbara Miller Lane, ed., *Housing and Dwelling: Perspectives on Modern Domestic Architecture* (London: Routledge, 2007).

Andrew Jackson Downing, *Victorian Cottage Residences* (1842) New York: Dover Publications, 1981).

——, *The Architecture of Country Houses* (1850) (New York: Dover Publications, 1969).

Judith Fryer, *Felicitous Space: The Imaginative Structures of Edith Wharton and Willa Cather* (Chapel Hill, NC/London: University of North Carolina Press, 1986).

Winnifred Gallagher, *The Power of Place: How Our Surroundings Shape Our Thoughts, Emotions, and Actions* (New York: Harper Perennial, 2007).

Don Gifford, ed., *The Evolution of Architectural Influence and Practice in Nineteenth Century America* (New York: Dutton, 1966).

Katherine Grier, *Culture and Comfort: Parlor-Making and Middle-Class Identity, 1850–1930* (Washington, DC: Smithsonian Institution Press, 1997).

David P. Handlin, *The American Home: Architecture and Society, 1815–1915* (Boston, MA: Little, Brown, 1979).

Joan Hedrick, 'Parlor Literature: Harriet Beecher Stowe and the Question of "Great Women Artists"', *Signs: Journal of Women in Culture and Society*, vol. 17, no. 2 (1992), 278–81.

——, *Harriet Beecher Stowe: A Life* (Oxford: Oxford University Press, 1994).

Sandy Isenstadt, *The Modern American Home: Spaciousness and Middle Class Identity* (Cambridge: Cambridge University Press, 2006).

Andrew Jackson Downing, 'Moral Influence of Good Houses' (1848) in Don Gifford, ed., *The Evolution of Architectural Influence and Practice in Nineteenth Century America* (New York: Dutton, 1966), 233–5.

Renee Kahn and Ellen Meagher, *Preserving Porches* (New York: Henry Hold & Co., 1990).

Peter Keough, 'Blue Movie: David Lynch's Velvet Revolution', http://thephoenix.com/Boston/Movies/15021-BLUE-VELVET/ (accessed 13 June 2008).

Fiske Kimball, *Domestic Architecture of the American Colonies and the Early Republic* (1922) (New York: Courier Dover Publications, 2001).

Peter Kohane and Michael Hill, 'The Decorum of Doors and Windows, from the Fifteenth to the Eighteenth Century', *Architectural Review Quarterly*, vol. 10, no. 2 (2006), 141–3.

Tim Kreider, 'The Straight Story', *Film Quarterly* (Fall 2000), www.davidlynch.de/qaurterstraight.html (accessed 13 June 2008).

Neil Levine, *The Prairie School: Frank Lloyd Wright and His Midwest Contemporaries* (New York: Norton, 1974).

Thad Logan, *The Victorian Parlour: A Cultural Study* (Cambridge: Cambridge University Press, 2001).

Sara Lowen, 'The Tyranny of the Lawn', www.americanheritage.com/articles/magazine/ah/1991/5/1991_5_44.shtml (accessed 11 June 2008).

Susie McKellar and Penny Sparke, eds, *Interior Design and Identity* (Manchester: Manchester University Press, 2004).

Sally McMurray, 'City Parlor, Country Sitting Room: Rural Vernacular Design and the American Parlor, 1840–1900', *Winterthur Portfolio*, vol. 20, no. 4 (Winter 1985), 261–80.

Margaret Marsh, *Suburban Lives* (New Brunswick, NJ/London: Rutgers University Press, 2000).

Tom Martinson, *American Dreamscape: The Pursuit of Happiness in Postwar Suburbia* (New York: Carroll & Graf, 2000).

Daniel Miller, ed., *Home Possessions: Material Culture Behind Closed Doors* (Oxford: Berg, 2001).

Laura J. Miller, 'Family Togetherness and the Suburban Ideal', *Sociological Forum*, vol. 10, no. 3 (1995), 393–418.

Barbara Miller Lane, ed., *Housing and Dwelling: Perspectives on Modern Domestic Architecture* (London: Routledge, 2007).

Deborah Nelson, 'Penetrating Privacy: Confessional Poetry and the Surveillance Society' in Catherine Wiley and Fiona R. Barnes, eds, *Homemaking: Women Writers and the Politics and Poetics of the Home* (New York: Garland, 1996).

Charles E. Peterson, 'The American Porch', *Journal of the Society of Architectural Historians*, vol. 10, no. 2 (May 1951), 19–20.

Sarah Pink, *Home Truths: Gender, Domestic Objects and Everyday Life* (Oxford: Berg, 2004).

Amos Rapoport, 'The Nature and Definition of the Field' in Barbara Miller Lane, ed., *Housing and Dwelling: Perspectives on Modern Domestic Architecture* (London: Routledge, 2007).

Witold Rybczynski, *Home* (London: Pocket Books, 2001).

Virginia Scott Jenkins, *The Lawn: A History of an American Obsession* (Washington, DC: Smithsonian Institution, 1994).

Suzanne M. Spencer-Wood, 'The World Their Household: Changing Meanings of the Domestic Sphere in the Nineteenth Century', in Barbara Miller Lane, ed., *Housing and Dwelling: Perspectives on Modern Domestic Architecture* (London: Routledge, 2007).

Wallace Stegner, *Wolf Willow: A History, a Story and a Memory of the Last Plains Frontier* (London: Penguin, 1990).

—, *Here the Bluebird Sings to the Lemonade Springs: Living and Writing in the West* (London/New York: Penguin, 1992).

Deborah Tall, 'Dwelling: Making Peace with Space and Place', in Wes Jackson and William Vitek, eds, *Rooted in the Land: Essays on Community and Place* (New Haven, CT: Yale University Press, 1996).

T. Thiis-Evensen, *Archetypes in Architecture* (Oslo: Norwegian University Press).

Yi-Fu Tuan, *Dominance and Affection: The Making of Pets* (New Haven, CT: Yale University Press, 1984).

Anthony Vidler, *The Architectural Uncanny: Essays in the Modern Unhomely* (Cambridge, MA: MIT Press, 1992).

John Michael Vlach, *The Afro-American Tradition in Decorative Arts* (Cleveland, OH: Cleveland Museum of Art, 1978).

Edith Wharton and Ogden Codman, Jr, *The Decoration of Houses* (1897) (New York: W. W. Norton, 1997).

Gervase Wheeler, *Homes for the People in Suburb and Country* (New York: Charles Scribner, 1855).

John Whiteman, 'On Hegel's Definition of Architecture', *Assemblage*, no. 2 (February 1987), 6–17.

Maria Tai Wolff, 'Listening and Living: Reading and Experience in Their Eyes Were Watching God', in Henry Louis Gates, Jr and K. A. Appiah, eds, *Zora Neale Hurston: Critical Perspective in Their Eyes Were Watching God* (New York: Amistad Press, 1993).

Frank Lloyd Wright, *An American Architecture*, ed. Edgar Kaufman (New York: Bramhall House, 1955).

——, 'In the Cause of Architecture' (1908) in *The Work of Frank Lloyd Wright* (New York: Horizon Press, 1965).
——, 'Building the New House' in Barbara Miller Lane, ed., *Housing and Dwelling: Perspectives on Modern Domestic Architecture* (London: Routledge, 2007).
——, 'Prairie Concept', www.westcotthouse.org/prairie_concept.html (accessed 31 October 2009).
Gwendolyn Wright, *USA: Modern Architecture in History* (London: Reaktion Books, 2008).

EMILY DICKINSON AND DOMESTICITY

Millicent T. Bingham, *Ancestor's Brocades: The Literary Debut of Emily Dickinson* (New York/London: Harper & Brothers, 1945).
Jed Deppmann, 'Trying to Think with Emily Dickinson', *The Emily Dickinson Journal*, vol. 14, no. 1 (Spring 2004), 84–103.
Martha Dickinson Bianchi, *Emily Dickinson Face to Face: Unpublished Letters with Notes and Reminiscences* (Boston, MA/New York: Houghton Mifflin, 1932).
Diana Fuss, 'Interior Chambers: The Emily Dickinson Homestead', *Differences: A Journal of Feminist Cultural Studies*, vol. 10, no. 3 (1998), 1–46.
——, *The Sense of an Interior: Four Writers and the Rooms that Shaped Them* (New York: Routledge, 2004).
Lyndall Gordon, *Lives Like Loaded Guns: Emily Dickinson and Her Family's Feuds* (London: Virago, 2010).
Jennifer Leader, 'Fitting In: Emily Dickinson Among Others', *The Emily Dickinson Journal*, vol. 15, no. 1 (Spring 2006), 83–94.
Domhnall Mitchell, *Emily Dickinson: Monarch of Perception* (Amherst, MA: University of Massachusetts Press, 1999).
Aife Murray, 'Kitchen Table Poetics: Maid Margaret Maher and Her Poet Emily Dickinson', *The Emily Dickinson Journal*, vol. 5, no. 2 (Fall 1996), 285–96.

BOB DYLAN

R. B. Browne and Pat Browne, eds, *A Guide to United States Popular Culture* (Madison, WI: University of Wisconsin Press, 2001).
Bob Dylan, *Chronicles: Volume One* (London: Pocket Books, 2005).
Michael Gray, *Song and Dance Man: The Art of Bob Dylan* (London/New York: Continuum, 2002).
Greil Marcus, *Invisible Republic: Bob Dylan's Basement Tapes* (London: Picador, 1997).

——, *Rolling Stone: Bob Dylan at the Crossroads* (New York: Public Affairs, 2005).
Christopher Ricks, *Dylan's Visions of Sin* (London: Ecco, 2004).
Anthony Varesi, *The Bob Dylan Albums: A Critical Study* (Toronto: Guernica Editions, 2002).

SPACE AND PLACE

John A. Agnew and Jonathan M. Smith, eds, *American Space/American Place: Geographies of the Contemporary United States* (Edinburgh: Edinburgh University Press, 2002).
Benedict Anderson, *Imagined Communities: Reflections on the Origin and Spread of Nationalism*, revised edition (London/New York: Verso, 1991).
Mary Arensburg, *The American Sublime* (Albany: University of New York Press, 1986).
Gaston Bachelard, *The Poetics of Reverie* (Boston, MA: Beacon Press, 1971).
——, *The Poetics of Space* (Boston, MA: Beacon Press, 1994).
William Barksdale Maynard, 'Thoreau's House at Walden' (1999) in Barbara Miller Lane, ed., *Housing and Dwelling: Perspectives on Modern Domestic Architecture* (London: Routledge, 2007).
Francis J. Bremer and Tom Webster, eds, *Puritans and Puritanism in Europe and America: A Comprehensive Encyclopaedia*, 2 vols (Santa Barbara, CA: ABC-CLIO, 2005).
John Brinckerhoff Jackson, *A Sense of Place, A Sense of Time* (New Haven, CT/London: Yale University Press, 1994).
Wayne Craven, *American Art: History and Culture* (New York: Harry N. Abrams, 1994).
Paul Crowther, *Critical Aesthetics and Postmodernism* (Oxford: Oxford University Press, 1996).
Judith Fryer, *Felicitous Space: The Imaginative Structures of Edith Wharton and Willa Cather* (Chapel Hill, NC/London: University of North Carolina Press, 1986).
Tag Gallagher, *John Ford: The Man and his Films* (London/Berkeley, CA: University of California Press, 1986).
Siegfried Giedion, *Space, Time and Architecture* (Boston, MA: Harvard University Press, 1967).
Richard Harris, 'Chicago's Other Suburbs', *Geographical Review*, vol. 4, no. 4 (October 1994), 394–410.
Martin Heidegger, *Poetry, Language, Thought* (New York: Harper & Row, 1971).
Siri Hustvedt, 'Yonder', in *A Plea for Eros* (London: Hodder & Stoughton, 2006), 1–43.
Wallace Jackson, '*To Look*: The Scene of the Seen in Edward Hopper', *South Atlantic Quarterly*, vol. 103, no. 1 (Winter 2004), 133–48.
Terry G. Jordan and Matti Kraups, *The American Backwoods Frontier* (Baltimore, MD/London: Johns Hopkins University Press, 1989).

Amy Kaplan, 'Homeland Insecurities: Reflections on Language and Space', *Radical History Review* (Winter 2003), 82–93.
Dave Kehr, 'Charting the Tarantino Universe', *The New York Times*, Saturday 9 August 2008, http://query.nytimes.com/gst/fullpage.html (accessed 9 August 2008).
Annette Kolodny, *The Lay of the Land: Metaphor as Experience and History in American Life and Letters* (London/Chapel Hill, NC: University of North Carolina Press, 1975).
Henri Lefebvre, *The Production of Space*, trans. D. Nicholson Smith (Oxford: Blackwell, 1991).
Alberto Lena, 'The Seducer's Stratagems: The Great Gatsby and the Early Twenties', *Forum for Modern Language Studies*, vol. 34, no. 4 (1998), 309–10.
Gail Levin, *Edward Hopper* (New York: Alfred A. Knopf, 1995).
Doreen Massey, *For Space* (London: Sage, 2007).
Georges Perec, *Species of Space and Other Pieces* (London: Penguin Classics, 2008).
Michael Pollan, 'A Brief History of the American Lawn', *Biolore*, vol. 16, nos 1–2 (2000).
Richard Reep, *Urban Morphology Research Group Bulletin*, no. 7 (June 1997), www.gees.bham.ac.uk/documents/Miscellaneous/umrg_bulletin7.htm (accessed 23 November 2008).
Edward Relph, *Place and Placelessness* (London: Pion, 1976).
Adrienne Rich, 'Notes Towards a Politics of Location' in *Blood, Bread and Poetry: Selected Prose 1979–1985* (New York: W. W. Norton, 1986).
Fred E. H. Schroder, 'Andrew Wyeth and the Transcendental Tradition', *American Quarterly*, vol. 17, no. 3 (Autumn 1965), 558–67.
The Writings of Robert Smithson, ed. Nancy Holt (New York: New York University Press, 1979).
Theano S. Terkenli, 'Home as Region', *Geographical Review*, vol. 85, no. 3 (July 1995), 324–34.
Henry David Thoreau, *Walking* (Rockville, MD: Arc Manor Classics, 2007).
Yi-Fu Tuan, *Passing Strange and Wonderful: Aesthetics, Nature and Culture* (New York/Tokyo/London: Kodansha International, 1995).
——, *Space and Place: The Perspective of Experience* (London/Minneapolis, MN: University of Minnesota Press, 2001).
Eugene Walter, *Milking the Moon: A Southerner's Story of Life on This Planet* (New York: Crown, 2001).
John Wylie, *Landscape* (Oxford/New York: Routledge, 2007).

AMERICAN HOTELS, MOTELS AND BATHROOMS

'History of Plumbing in America', *Plumbing and Mechanical* (July 1987), www.theplumber.com/usa.html (accessed 29 April 2010).

Andrew Alpern, *Luxury Apartment Houses of Manhattan: An Illustrated History* (New York: Dover Publications, 1993).
Warren James Belasco, *Americans on the Road: From Autocamp to Motel, 1910–1945* (Baltimore, MD/London: Johns Hopkins University Press, 1979).
Patricia Cooper and Ruth Oldenziel, 'Bathrooms and the Construction of Gender/Race on the Pennsylvania Railroad during World War II', *Feminist Studies*, vol. 25, no. 1 (Spring 1999), 7–41.
Elizabeth C. Cromley, *Alone Together: A History of New York's Early Apartments* (Ithaca, NY: Cornell University Press, 1990).
John A. Jakle, Keith A. Sculle and Jefferson S. Rogers, *The Motel in America* (Baltimore, MD/London: Johns Hopkins University Press, 1996).
William Kaszynski, *The American Highway: The History and Culture of Roads in the United States* (Jefferson, NC: McFarland, 2000).
John Margolies, *Home Away From Home: Motels in America* (New York: Little, Brown, 1995).
Bonnie Marranca, 'Alphabetical Shepard: The Play of Words', in Bonnie Marranca, ed., *American Dreams: The Imagination of Sam Shepard* (New York: Performing Arts Journal Publications, 1981).
Witold Rybczynski, 'Flushed with Pride: How the Bathroom Became America's Latest Status Symbol', www.slate.com/id/2157288 (accessed 1 November 2009).
—, 'America's Growing Obsession with Bathrooms', *Slate*, www.slate.com/id/2157288/slideshow/2157334/entry/2157336/fs/0// (accessed 31 October 2009).
Andrew Sandoval-Straus, *Hotel: An American History* (New Haven, CT: Yale University Press, 2007).
Jefferson Williamson, *The American Hotel* (New York: Alfred Knopf, 1930).
Michael Karl Witzel, *The American Motel* (Osceola, WI: MBI Publishing Co., 2000).

AMERICAN SETTLEMENT AND THE WEST

Sacvan Bercovitch, *The American Puritan Imagination* (New York: Cambridge University Press, 1974).
—, *The Puritan Origins of the American Self* (New Haven, CT: Yale University Press, 1975).
Robert Breugmann, *Sprawl: A Compact History* (Chicago, IL: University of Chicago Press, 2006).
J. Hector St John de Crèvecoeur, *Letters from an American Farmer* (1782) (Oxford: Oxford University Press, 1998).
José Salvidar David, *Border Matters: Remapping American Cultural Studies* (Berkeley, CA: University of California Press, 1997).

Robert Fishman, *Bourgeois Utopias: The Rise and Fall of Suburbia* (New York: Basic Books, 1987).
Thomas Frank, *What's the Matter with America?* (London: Secker & Warburg, 2004).
Karen Halttunen, *Confidence Men and Painted Women: A Study of Middle-Class Culture in America, 1830–1870* (New York/London: Yale University Press, 1983).
Lucy Hazard, *The Frontier in American Literature* (New York: Thomas Y. Crowell, 1927).
Robert V. Hine and John Mack Faragher, *Frontiers: A Short History of the American West* (New Haven, CT/London: Yale University Press, 2007).
Thomas Jefferson, *Notes on the State of Virginia*, ed. William Peden (Chapel Hill, NC: University of North Carolina Press, 1954, reprinted New York: Norton, 1972).
Howard Mumford Jones, *O Strange New World: American Culture, the Formative Years* (London: Chatto & Windus, 1965).
Annette Kodolny, *The Land Before Her: Fantasy and Experience of the American Frontiers 1630–1860* (Chapel Hill, NC/London: University of North Carolina Press, 1984).
David L. Lewis and Laurence Goldstein, eds, *The Automobile and American Culture* (Ann Arbor: University of Michigan, 1983).
Malcolm Magee, 'Speaking of Progress: The Rhetoric of Reform in the Progressive Era', *Journal of the Gilded Age and Progressive Era*, vol. 3, no. 1 (January 2004), www.historycooperative.org/journals/jga/3.1/br_1.html (accessed 10 September 2008).
Leo Marx, *The Machine in the Garden: Technology and the Pastoral Ideal in America* (London/New York: Oxford University Press, 1964).
Perry Miller, *Errand into the Wilderness* (Cambridge, MA: Belknap Press of Harvard University Press, 1956).
Edward T. Price, *Dividing the Land: Early American Beginnings of our Private Property Mosaic* (Chicago, IL: University of Chicago Press, 1995).
David Reynolds, *America: Empire of Liberty: A New History* (London: Allen Lane, 2009).
Lynda H. Schneekloth, 'The Frontier is our Home', *Journal of Architectural Education*, vol. 49, no. 4 (May 1996), 210–25.
Richard Slotkin, *Gunfighter Nation: The Myth of the Frontier in Twentieth-Century America* (New York: Atheneum, 1992).
John R. Stillgoe, *Borderland: Origins of the American Suburb, 1820–1939* (New Haven, CT: Yale University Press, 1988).
Geoffrey Trease, *The Grand Tour* (New Haven, CT: Yale University Press, 1991).
Lionel Trilling, 'The Sense of the Past' in *The Liberal Imagination: Essays on Literature and Society* (London: Penguin, 1971), 187–201.
Frederick Jackson Turner, *The Frontier in American History* (1920) (New York: Dover Publications, 1996).
Gary Wills, *John Wayne's America* (New York: Simon and Schuster, 1997).

Richard G. Wilson, Dianne H. Pilgrim and R. N. Murray, *American Renaissance, 1876–1917* (exhibition catalogue) (New York: Brooklyn Museum, 1979).

David Wrobel, *The End of American Exceptionalism: Frontier Anxiety from the Old West to the New Deal* (Lawrence, KS: University of Kansas Press, 1993).

REAGANISM AND THE COLD WAR ERA

David L. Ames, 'Interpreting Post-War II Suburban Landscapes as Historic Resources', www.nps.gov/history/nr/publications/bulletins/suburbs/Ames.pdf (accessed 20 April 2008).

Lou Cannon, *President Reagan: The Role of a Lifetime* (New York/London: Simon & Schuster, 1992).

Winston Graham, *Marnie, Greek Fire, The Forgotten Story* (London: Chapman, 1992).

Sarah A. Lichtman, 'Do-It-Yourself Security: Safety, Gender and the Home Fallout Shelter in Cold War America', *Journal of Design History*, vol. 19, no. 1 (2006), 39–55.

Elaine Tyler May, 'Cold War–Warm Hearth: Politics and the Family in Postwar America' in Steve Fraser and Gary Gerstle, eds, *The Rise and Fall of the New Deal Order* (Princeton, NJ: Princeton University Press, 1990).

Deborah Nelson, *Pursuing Privacy in Cold War America* (New York: Columbia University Press, 2002).

Tim Raphael, 'The King is the Thing: Bodies of Memory in the Age of Reagan', *The Drama Review*, vol. 43, no. 1 (Spring 1999), 179–84.

Michael Rogin, 'Kiss Me Deadly: Communism, Motherhood and Cold War Movies', in *Ronald Reagan, the Movie and Other Episodes in Political Demonology* (Berkeley, CA: University of California Press, 1987).

Elaine Tyler May, *Homeward Bound: American Families in the Cold War Era* (New York: Basic Books, 1988).

Index

Ackroyd, Peter 21
Alberti, Leon Battista 62–3
Alcotts 39
Alexander, John White, 'Repose' 26
American Agriculturalist, The 8
American Historical Association 126
American Woman's Home or Principles of Domestic Science, The 27
Anderson, Benedict, *Imagined Communities: Reflections on the Origin and Spread of Nationalism* 147
Anderson Corporation 52
apartment 66, 132, 133, 134–6, 141, 142, 143, 147, 196
 apartment-hotel 136; see also hotel-apartment
Auden, W. H.:
 'Thanksgiving for a Habitat' 91
 'Encomium Balnei' 91
Auster, Paul:
 City of Glass 7–8
 Moon Palace 143–6
automobile 8, 85, 86, 89, 142, 160; see also car

Bachelard, Gaston, *The Poetics of Space* 25, 26, 36, 46, 49, 61
backyard/back-yard 18, 19, 61, 74, 147, 160, 162, 163
 'Bare in the Back Yard' 86–90

Bardem, Javier 135
basement 27, 56, 57, 60, 61, 165, 173
 'And Down in the Basement' 166–71
bathroom(s) 19–20, 42, 68, 89–90
 'Hotels, Motels and Bathrooms' 91–124
Baum, Frank, *Wizard of Oz* 8, 68, 120–1, 165, 172
Beaver knows Best 85
Beckham, Sue Bridwell, 'The American Front Porch: Women's Liminal Space' 75
bedroom(s) 26, 45, 53, 58, 90, 91, 92, 95, 102, 110, 114, 116, 118, 165, 166
Belasco, Warren James, *Americans on the Road: From Autocamp to Motel, 1910–1945* 111
Belber, Stephen, *Tape* 113
Bierstadt, Albert 140
Billy the Kid 123
Bingham, Millicent Todd, *Ancestor's Brocades: The Literary Debut of Emily Dickinson* 38–9
Boetticher, Budd, *Seven Men from Now* 133
Boone, Daniel 20
border(s) 2, 5, 8, 9, 19, 36, 37, 38, 44, 46, 56, 62, 63, 87, 123, 125, 127, 134, 135, 137, 138, 161, 162, 168
 'Border Crossings' 58–60
border-tensions 87

boundary/boundaries 3, 6, 8, 12, 13, 42,
 44, 45, 54, 67, 71, 75, 77, 78, 93, 99,
 102, 129, 144, 145, 147, 149, 162
 boundary-crossers 58
Bowie, David, 'Young Americans' 148
Bradbury, Ray, *Dandelion Wine* 88
Bradstreet, Ann, 'Upon the burning of
 our house, July 10th, 1666'
 58–9
Breeder's Gazette, The 8
Bremer, Frederika, *The Homes of the New
 World* 10
Brontë, Charlotte, *Jane Eyre* 119
Browne, E. Martin, 'Editorial Note' to *Cat
 on a Hot Tin Roof* 77
Bryd, William 92
Burgess, Ernest 51–2; *see also* Park,
 Robert
Bushnell, Horace, *Work and Play* 10–11

Cage, Nicolas 121
Calamity Jane 77
California(n) 5, 54, 85, 121, 122, 132, 133,
 145, 151
capitalism 100, 101, 127, 131, 154, 165
car(s) 8, 84, 89, 100, 104, 106, 118,
 120, 142, 151, 162, 171; *see also*
 automobile
Cather, Willa, *The Professor's House*
 48–50
Chicago 7, 51–2, 145
Christian 10, 11, 12, 13, 28, 29, 147
 Judaeo-Christian 136
church 1, 11, 12, 27, 49, 134
 church life 12
Church, Frederic 140
circumference(s) 1, 3, 20, 71–4, 129, 143
 circumferenceless 139
citizen(ship) 7, 9, 19, 21, 28, 57, 69, 87, 89,
 91, 92, 117, 122, 124, 132, 140, 141,
 148, 154

city/cities 6, 7, 8, 39, 51, 56, 61, 62, 65, 95,
 99, 118, 144, 161
Civil War 6, 51, 76, 82, 126
Coen, Ethan and Joel, *No Country for
 Old Men* 135; *see also* McCarthy,
 Cormac
Cold War 9, 87, 91, 119, 168
Cole, Thomas 140
Coleridge, Samuel Taylor 4
Communism 9, 56, 87, 168
 communist-enemy 132
community/communities 2, 6, 7, 31, 52,
 65, 72, 73, 77, 78, 79, 81, 82, 109,
 111, 147, 165, 167
Congress 132
Conrad, Joseph, *Heart of Darkness* 105
Cooper, James Fenimore 20, 25
Cooper, Susan Fenimore, 'A Dissolving
 View' 25, 131
Coppola, Sofia, *The Virgin Suicides* 84; *see
 also* Eugenides, Jeffrey
cosy/cozy 2, 4, 11, 12, 14, 17, 25, 28, 31, 32,
 33, 78, 79, 105, 124, 158, 164
 uncosy 88
Cunningham, Michael, *The Hours* 122; *see
 also* Hare, David
Curtis, George William, *Homes of
 American Authors compris-
 ing Anecdotal, Personal and
 Prescriptive Sketches by Various
 Writers* 37, 40

daily 1, 4, 17, 20, 29, 30, 88, 89, 120, 130;
 see also everyday
Dale, Thomas 76
Davis, Alexander Jackson 100
Deakins, Roger:
 *Assassination of Jesse James by the
 Coward Robert Ford, The* 155,
 158
 No Country for Old Men 135

de Certeau, Michel, *The Practice of Everyday Life* 74
de Crèvecoeur, J. Hector St John, *Letters from an American Farmer* 54, 57
DeLillo, Don, *White Noise* 87–8, 149–51, 160, 166
Dern, Laura 121
Descartes, René 167
De Tocqueville, Alexis, *Democracy in America* 62, 79, 147, 148
Dickens, Charles, *American Notes* 140–1
Dickinson, Emily 4, 5, 9, 13, 15, 16, 17, 18, 20, 23, 25, 26–7, 31, 35, 37–9, 42, 53, 60, 61, 64, 68, 72, 84, 91, 99, 105, 121, 124, 125, 129, 130–1, 143, 144, 151, 152, 153, 158, 166, 173, 174
 Amherst 3, 4, 11, 12, 62, 64, 152, 174
 church 1, 11–12
 circumference(s) 1, 3, 72, 74, 129, 143
 Dickinson, Austin 13, 23, 27, 62
 Dickinson, Edward 15
 Dickinson, Lavinia Norcross 64
 Dickinson, Susan Gilbert 4, 23, 24, 63, 166
 Dickinson Bianchi, Martha 24–5, 36
 domestic/domestic interiority 1–2, 11–14, 23, 36, 37, 39, 42, 72–3, 153, 172
 Higginson, Colonel T. W. 12, 64, 72
 home 1, 2–4, 11–14, 15, 17–18, 23–5, 26–7, 29, 30, 37, 38, 42, 53, 61, 62–4, 72, 90, 124, 125, 129–30, 130–1, 153, 158, 166, 172, 173, 174
 housewife 17–18, 29–30, 31
 imagination/imagining 2–3, 4, 5, 12, 18, 24, 25, 37–8, 62, 63, 64, 90, 125, 130, 143, 153, 173
 inner/outer 1, 3, 4, 11, 37, 62, 64, 72, 143–4, 166

inside/outside 2, 12, 14, 17, 20, 25, 38, 39, 53, 62, 63, 72, 125, 129–30, 139, 152, 172
Jackson, Helen Hunt 37
letters 23, 63, 64:
 to Colonel T. W. Higginson 64, 72
 to Elizabeth Holland 15
 to Susan Gilbert Dickinson 4, 24
 to Louise and Frances Norcross 64
 to Mabel Todd 87
Loomis Todd family 13
 Todd, David 38
 Todd, Mabel 13, 23, 38, 42
memory 4, 11–12, 25, 36–7
nature 11, 14, 15, 16, 38, 62, 144
picturesque/picturesque home 11, 13, 14, 18, 23–4, 25, 31, 35, 153
play 2, 4, 29, 31, 139
poems:
 'Away from Home' 2–3, 125
 'I learned – at least – what home could be' 11–14
 'My Life had stood – a Loaded Gun' 139
 'One need not be a chamber to be haunted' 172
 'They called me to the Window' 37–9
 No. 657 1, 4, 130, 152
 No. 944 14
 No. 1055 17–18
private/public 1, 2, 9, 11, 13, 14, 15, 25, 31, 42, 72, 166
Puritan 1, 63, 129
threshold(s) 2–4, 9, 12, 17, 23, 25, 29–30, 37, 40, 62, 70, 172–4
universe 1, 3, 25, 143, 166, 173
Dillard, Annie, *An American Childhood* 83, 87
Dire Straits 126
divine 1, 7, 11, 13, 27, 39, 59

Dixie Chicks, The, 'Wide Open Spaces' 60
Dolan, Michael, *The American Porch* 79
domestic(ity) 1, 2, 9, 10–11, 12, 14, 15, 16, 17, 18, 19, 23, 24, 25, 26, 27, 28, 29, 30, 31, 32, 33, 34, 36, 37, 39, 40, 41, 42, 43, 44, 45, 46, 47, 51, 52, 53, 54, 58, 60, 61, 66, 70, 71, 72, 73, 74, 75, 82, 84, 85, 86, 87, 88, 89, 100, 101, 110, 118, 122, 124, 132, 148, 153, 154, 155, 156, 157, 158, 160, 161, 163, 165, 166, 167, 168, 169, 172, 174
 domestic abuse 116
 'Domestic Frontiers' 55–7; see also frontier(s)
 'Domestic Territories' 48–51; see also territory/territories
 undomesticated 12
Dominik, Andrew, *The Assassination of Jesse James by the Coward Robert Ford* 155–7, 164; see also Ford, Robert *and* James, Jesse
door(way) 3, 4, 17, 18, 20, 23, 24, 25, 26, 34, 37, 40, 41, 42, 43, 45, 46, 47, 48, 53, 54, 55, 58, 59, 60, 91–9, 102, 108, 111, 112, 113, 114, 117, 118, 123, 129, 131, 134, 155, 156, 157, 160, 161, 163, 164, 170, 172, 173, 174
 'Doors and Windows' 61–90; see also window(s)
 doorstep 3, 4, 14, 123, 168
Downing, Andrew Jackson 31, 50, 76, 82, 85
 'Moral Influence of Good Houses' 28–9
 The Architecture of Country Houses 14–15, 27–9
 Victorian Cottage Residences 15
dream 31, 35, 48, 65, 81, 84, 85, 86, 121, 124
 'The Picturesque Daydream' 23–9; see also picturesque

'Dreamy Kitchens, Tidy Parlours' 29–37; see also kitchen(s) and parlour(s)
Dreiser, Theodore, *Sister Carrie* 101
Dunst, Kirsten 85
D'Usseau, Arnaud (with Dorothy Parker), *The Ladies of the Corridor* 102–3
Dylan, Bob 17–18, 119, 154, 169–71, 173–4
 album *The Basement Tapes*, with The Band 169–71, 173–4
 'Don't Ya Tell Henry' 169–70
 'Million Dollar Bash' 171
 'Open the Door, Homer' 170
 'Orange Juice Blues' 170
 'Please, Mrs. Henry' 171
 Chronicles 17–18, 105–6, 108, 173
 paintings 105–8
 'Corner Flat' 106–7
 'Dallas Hotel Room' 107
 'Table and Chair near Window' 107–8
 'View from Two Windows' 107
Gooch, Ray 18, 106

Earp, Wyatt 133
East/east 42, 47, 65, 76, 126, 127, 130, 133, 140, 145, 161
Eggers, Dave, *A Heartbreaking Work of Staggering Genius* 52–6, 68–9
Eisenhower, President Dwight D. 168
Emerson, Ralph Waldo 6–7, 12–13, 21, 34, 39, 40, 57, 73, 74, 110, 137, 158
 'Circles' 138–9
 'Experience' 137
 'Nature' 21, 34
entrance(way) 3, 14, 23, 27, 40, 53, 62, 69, 78, 88, 97, 102, 108, 112, 113, 114; see also exit(s)
Eugenides, Jeffrey, *The Virgin Suicides* 84–5; see also Coppola, Sofia
Evenson, Thiis 70

everyday(ness) 1–2, 12, 19, 20, 39, 74, 87, 105, 120
exit(s) 23, 62, 69; *see also* entrance(way)
expansion 1, 3, 5, 8, 10, 15, 19, 20, 21, 38, 45, 52, 53, 55, 62, 81, 93, 118, 127, 129, 139, 143, 149, 155, 157
exterior(s) 14, 46, 62, 65; *see also* interior(s)

familiar(ity) 1, 2, 3, 4, 16, 19, 24, 26, 33, 34, 46, 48, 54, 59, 70, 71, 78, 80, 87, 90, 103, 122, 172, 173, 174
　defamiliarized/defamiliarised 8, 68, 71, 77
　unfamiliar(ity) 3, 20, 69, 103, 147
family/families 12, 19, 22, 23, 25, 26, 28, 30, 31, 34, 35, 36, 39, 44, 48, 49, 50, 51, 52, 53, 54, 55, 56, 59, 61, 69, 70, 71, 76, 77, 78, 79, 80, 82, 83, 85, 86, 87, 88, 89, 96, 97, 98, 99, 105, 111, 128, 150, 151, 156, 157, 158, 159, 162, 163, 166, 167, 168, 172, 173
　family estate 76
　family home(s) 34, 39, 47, 51, 52, 53, 55, 56, 57, 58, 68, 70, 80, 86, 88, 89, 101, 103, 123, 166
　'family hotel' 102; *see also* hotel
　family life 30, 44, 50, 52, 53, 79, 86, 87, 89, 101, 111, 116, 156, 166
　family man 89, 149, 156
　family room 53, 55, 68, 89
　family-run 116
fantasy/fantasies 19, 20, 33, 35, 36, 42, 54, 63, 85, 92, 95, 97, 109, 110, 115, 123, 127, 133, 169, 173
Fantasia 158
Federal Aid Highway Act 153
Fifth Amendment 146
fireplace 14, 31, 33, 36, 43, 106
Fitzgerald, F. Scott, *The Great Gatsby* 8, 16–17, 82–3, 86, 127–8

folk(lore) 2, 17, 31, 80, 154, 159, 165, 169, 170, 174
　townsfolk 6, 147, 148
Ford, John 131, 133, 134, 155
　My Darling Clementine 133
　She Wore a Yellow Ribbon 133
　Searchers, The 133
　Stagecoach 133
Ford, Robert 155–6; *see also* Dominik, Andrew
foreign(ness) 2–3, 10, 25, 46, 60, 80, 87, 103, 124, 138, 146
　foreigner 34, 110
Franzen, Jonathan, *The Corrections* 56–7, 71, 72, 160, 162–3, 172
Freud, Sigmund, 'The Uncanny' 19
　Freudian 97, 98, 167
frontier(s) 1, 3, 5, 13, 77, 102
　frontiersman/frontiersmen 20, 131, 136, 138, 143, 159, 160, 162, 163
　'Domestic Frontiers' 55–7; *see also* domestic(ity)
　'Folding Frontiers and Lost Horizons' 125–52; *see also* horizon(s)
function(s) 6, 7, 12, 15, 16, 24, 26, 27, 30, 31, 42, 46, 47, 51, 52, 53, 65, 69, 84, 94, 115, 119, 133, 144, 172
　dysfunction/dysfunctional 69, 74, 76, 88, 171
　malfunctioning 56, 57
Fuss, Diana:
　'Interior Chambers: The Emily Dickinson Homestead' 14
　Sense of an Interior, The: Four Writers and the Rooms that Shaped Them 166

Gass, William, 'In the Heart of the Heart Country' 71–2
Gilbreth, Lillian, *The Psychology of Management* 16

Gone with the Wind (film) 89
Gordon, Lyndall, *Lives Like Loaded Guns: Emily Dickinson and Her Family's Feuds* 23
Gothic/gothic 9, 20, 27, 37, 39, 40, 41, 42, 73, 74, 92, 172
 Gothic revival 76
Graham, Winston, *Marnie* 95; see also Hitchcock, Alfred
Grier, Katherine, *Culture and Comfort: Parlor-Making and Middle Class Identity, 1850–1930* 30
guest(s) 17, 18, 25, 26, 27, 30, 44, 64, 89, 91, 101, 109, 115, 156, 163, 173; see also host(s)
guest room(s) 42, 53

Handlin, David P., *The American Home* 10
Happy Home and Parlor, The 11
Hare, David, *The Hours* 122; see also Cunningham, Michael
Hawke, Ethan 113
Hawthorne, Nathaniel 37, 39, 40, 42
 English Notebooks, The 41
 House of the Seven Gables, The 39–41
Haynes, Todd 169
hearth(s) 2, 15, 18, 28, 31, 33, 34, 39, 43, 44, 112, 158, 166
Hedrick, Joan, 'Parlor Literature: Harriet Beecher Stowe and the Question of "Great Women Artists"' 31
Hegel, Georg Wilhelm Friedrich 33
Heidegger, Martin, *Poetry, Language, Thought* 69–70
Hicks, Thomas, *No Place Like Home* 32–3
Hicock, Wild Bill 133
Higginson, Colonel Thomas Wentworth 12, 64, 72
highway(s) 19, 87, 111, 115, 119, 121, 142, 150, 151, 153–4, 161, 174; see also Federal Aid Highway Act; road(side) *and* street/street(s)
history/histories 4, 14, 18, 20, 36, 39, 40, 41, 45, 48–9, 50, 53, 59, 80, 101, 103, 104–5, 106, 110, 112, 113, 114, 115, 118, 122, 136, 137, 140–2, 145, 148, 164, 169, 171
 of America 1, 5, 8–10, 20, 22, 35–6, 39–40, 49, 71, 72, 82, 112, 125–6, 127, 130, 133–4, 136, 137, 139, 148–9, 157–8, 161
 of the family 3, 11–12, 13, 34, 53, 56, 58, 88, 98–9, 122
 of/in the home 10, 11–12, 24, 34, 35–6, 40, 41, 48, 58, 77–9, 99, 122
 ahistorical 17
 non-historic 40
Hitchcock, Alfred:
 Marnie 94–6, 97; see also Graham, Winston
 Psycho 19–20
 Rear Window 69, 99
 Suspicion 9
 Vertigo 96
Holly, Henry Hudson 102
home/home life 1, 2, 3, 4, 8, 10–11, 11–12, 13, 14, 15, 17, 18, 19, 21–2, 23, 24, 25, 34, 49, 52, 61, 62, 63, 66, 69, 71, 72, 73, 74, 75, 76, 77, 79, 80, 81, 84, 88, 89, 90, 91, 92, 93, 95, 100, 101, 103, 109, 110, 111, 112, 115, 116, 122, 124, 125, 128, 130–1, 133, 134, 135, 136, 137, 138, 147, 150; see also hotel-homes *and* threshold(s)
 American home 1–2, 6, 7, 9–11, 14–15, 15–16, 18, 19, 24, 25, 27, 29, 56, 59, 61, 71, 75, 76, 87, 91, 112, 124, 132, 135, 154, 155, 161, 168, 171, 172, 174
 'Conclusion: Home and Horizon' 153–74

in relation to family/the familiar 1–2,
 3, 4, 15, 19, 22, 23–4, 25, 28, 34, 39,
 50, 51, 52, 53, 55, 56, 57, 58, 61, 68,
 70–1, 80, 83, 86, 88, 89, 90, 96,
 101, 103, 123, 156, 160, 166, 172,
 173, 174
ideal home 1, 11, 18, 132
 'The Ideal Home' 23–60
homeland 9–10, 71, 123, 125, 137
homeless 102, 155
homemaker/homeowner(s) 16, 24, 122,
 154
homestead 3, 4, 8, 13, 15, 18, 23, 24, 25,
 27, 37, 42, 124, 129, 130, 156, 157,
 158, 166
hometown/home-town 119, 165
unhomely/unhomeliness 19, 33, 39, 58,
 59, 124, 147, 173
in relation to objects 2, 11, 17, 24, 28,
 29, 34, 35–6, 43, 47, 48, 53, 101,
 103, 164
in relation to place(s) 1–2, 3, 4, 10–11,
 11–12, 13, 14, 15, 17, 18, 19, 21, 24,
 26, 27–8, 30, 33, 41, 42, 45, 49,
 50, 55, 58–9, 60, 61, 75, 77, 78, 90,
 115, 124, 128, 136, 153, 165, 167, 171,
 172, 173
in relation to religion 1, 10–12, 13–14, 27,
 28, 36, 59, 91, 131, 172
in relation to space(s) 1, 2, 4, 11, 14, 15,
 16, 17, 18, 19, 21, 23, 24, 25–6, 27,
 28, 29–30, 37, 41, 42, 44, 48, 49,
 50, 51, 52–5, 56, 57, 58, 59, 60, 61,
 64, 66, 70–1, 73, 77, 78, 80, 88, 89,
 90, 91, 96, 100, 103, 129, 132, 153,
 162, 164, 165, 166, 167, 168, 172
in relation to time 2, 11, 17, 24, 26–7,
 29, 37, 48, 49, 51, 57, 80, 136, 165,
 168, 172
'What Home Could Be' 10–16
Homes, A. M., *Music for Torching* 73–4

Hoover, President J. Edgar,
 'Commonwealth Club' address
 126
Hopper, Edward:
 Cape Cod Evening 69–70
 East Side Interior 65
 Evening Wind 65
 High Noon 67–8
 Hotel Room 108
 Hotel Window 108–9
 House by the Railroad 20
 People in the Sun 75
 South Carolina Morning 67, 80
Hopper, Jo 68
 'Edward Hopper and Hovering'
 64–71
horizon(s) 12, 13, 20, 21, 22, 39, 55, 56, 61,
 66, 67, 70, 73, 80, 116, 121, 124; *see
 also* 'Inner Horizons'
 'Folding Frontiers and Lost Horizons'
 125–52; *see also* frontier(s)
 'Home and Horizon' 153–74; *see also*
 home/home life
host(s) 1, 3, 16, 17, 18, 20, 25, 26, 44, 46,
 64, 79, 83, 85, 93, 103, 106, 109,
 114, 156, 166, 172–3; *see also*
 guest(s)
host-assassin 173
hotel(s) 8, 19, 20, 45, 89, 165
 'family hotel' 102; *see also* family/
 families
 hotel-action 109
 hotel-anonymity 103
 hotel-apartment 102, 110; *see also*
 apartment-hotel
 hotel corridor 46, 92, 99–105
 hotel-homes 109; *see also* home(s)
 hotel room(s) 18, 91, 102, 103, 105, 106,
 107, 108, 109, 110, 122
 'Hotels, Motels and Bathrooms' 91–124
Houdini, Harry 169

Index

housewife 17, 27, 29, 30, 31, 72, 73
 housewife-dweller 72
Howell, William Dean, *A Boy's Town* 6
Hurston, Zora Neale, *Their Eyes Were Watching God* 80–1
Hurt, John 147
Hustvedt, Siri, 'Yonder' 63

identity/identities 2, 10, 13, 24, 35, 45, 46, 55, 57, 62, 65, 78, 79, 80, 93, 95, 96, 100, 102, 103, 104, 113, 123, 124, 126, 139, 144, 146, 154, 159
 identity crisis 135, 144, 145
 room-identity 45; *see also* room(s)
imagination(s) 2, 3, 4, 5, 7, 9, 11, 12, 13, 18, 20, 21, 22, 24, 25, 26, 28, 33, 35, 37, 38, 39, 40, 41, 42, 49, 51, 52, 61, 62, 63, 64, 69, 71, 85, 89, 90, 95, 97, 100, 104, 106, 108, 109, 119, 120, 121, 124, 125, 126, 128, 129, 130, 132, 138, 141, 143, 147, 149, 153, 157, 158, 169, 171, 172, 173, 174, 191
 unimaginable 141, 143
individual(s) 6, 13, 15, 16, 24, 28, 43, 44, 46, 47, 55, 56, 57, 63, 66, 72, 79, 89, 93, 99, 100, 102, 108, 117, 128, 132, 137, 138, 147, 153, 160, 171
indoor(s) 2, 4, 11, 44, 46, 61, 71, 80, 150, 155, 156, 162, 163; *see also* outdoor(s)
inner 1, 3, 4, 11, 13, 20, 30, 33, 37, 40, 44, 61, 62, 64, 65, 72, 75, 137, 155, 158, 166, 167; *see also* outer
 'Inner Horizons' 142–6; *see also* horizon(s)
inside(ness) 12, 14, 17, 39, 58, 62, 65, 70, 71, 72, 76, 80, 88, 89, 97, 104, 112, 119, 125, 144, 147, 150, 152, 162, 163, 165, 172; *see also* outside(ness)
 insider 26; *see also* outsider(ness)

interior(s) 1, 2, 3, 4, 11, 14, 15, 25, 33, 34, 42, 46, 53, 62, 65, 66, 93, 94, 107, 108, 122, 123, 152, 153, 155, 156, 160, 173; *see also* exterior(s)
Isenstadt, Sandy, *The Modern American House: Spaciousness and Middle Class Identity* 24

Jackson, John Brinckerhoff, *A Sense of Place, A Sense of Time* 172
Jackson, Wallace, '*To Look*: The Scene of the Seen in Edward Hopper' 65
James, Henry 54, 111, 114
 American Scene, The 45–6, 100, 110
 Europeans, The 40, 47–8
 'Jolly Corner, The' 40–1
 Portrait of a Lady, The 100–1, 109
James, Jesse 155–6, 157–8, 161; *see also* Dominik, Andrew
Jarceki, Andrew, *Capturing the Friedmans* 166–7
Jefferson, President Thomas 5–7, 92, 131
Johnson, Eastman, *The Other Side of Susan Ray's Kitchen – Nantucket* 33–4
Jones, Indiana 123
Jones, Tommy Lee 135

Kang, Michael, *The Motel* 116
Keen, Robert Earl, 'Front Porch Song' 81
Kennedy, President John F. 126, 132–3
Khrushchev, Premier Nikita Sergeyevich 126
Kidman, Nicole 146
kitchen(s) 2, 27, 33, 42, 52, 53, 54, 56, 57, 58, 68, 71, 73, 74, 88, 101, 117, 156
 'Dreamy Kitchens, Tidy Parlours' 29–37; *see also* dream *and* parlour(s)
 'kitchen debate' 126
 studio-kitchen 74

Index

Kubrick, Stanley:
 Lolita: 84–5, 116; *see also* Lyne, Adrian and Nabokov, Vladimir
 Shining, The 92, 104–5
 2001: A Space Odyssey 104

LaBute, Neil, *In the Company of Men* 94
Lachman, Ed, *The Virgin Suicides* 85
Ladies Home Journal, The 66, 95, 122
Land Ordinance 6
Lane, Fitz Hugh 140
Lassie Come Home 69
lawn(s) 18, 28, 47, 61, 69, 72, 73, 74, 88, 154, 160, 162, 163, 164, 167
 'The Lawn' 82–6
Leave it to Beaver 85
Lefebvre, Henri, *The Production of Space* 66, 73
Lee, Harper, *To Kill a Mockingbird* 19
Leibovitz, Annie 87
Leonard, Robert Sean 113
Libbey-Owens-Ford 51
Life magazine 168
Linklater, Richard, *Tape* 113–15, 119
Lyne, Adrian, *Lolita* 117; *see also* Kubrick, Stanley *and* Nabokov, Vladimir
Lynch, David:
 Blue Velvet 73, 85–6
 Straight Story, The 86
 Wild at Heart 120–2

Mamet, David, *Glengarry Glen Ross* 132
manifest destiny 7, 59, 116, 140, 154
Marcus, Greil, *Invisible Republic: Bob Dylan's Basement Tapes* 170, 171
Massey, Doreen, *For Space* 41, 50, 52
McCarthy, Cormac 130–1, 133, 137, 155
 Blood Meridian 130–1
 Border Trilogy 137, 138
 No Country for Old Men 134–7, 157; *see also* Coen, Ethan and Joel

 Crossing, The 138–9
 Road, The 139–40, 141–3
McCullers, Carson:
 Ballad of the Sad Café, The 77–9
 Heart is a Lonely Hunter, The 79–80
Melville, Herman, 'I and My Chimney' 33
memory/memories 4, 11–12, 25, 26, 34, 36, 37, 50, 59, 80, 87, 88, 90, 112, 113, 119, 138, 157, 163, 170
Mendes, Sam, *American Beauty* 88–9, 168–9
Midwest(ern) 5, 7, 16, 71–2, 155, 157
Miller, Arthur:
 All My Sons 86–7
 Death of a Salesman 89–90, 91, 123, 132, 140
 Crucible, The 172
Mitchell, Joni:
 'Blue Motel Room' 119–20
 Hejira 119
 'Hissing of Summer Lawns, The' 72–3, 128
motel(s) 18, 19, 20, 116, 124, 144
 motel room(s) 105, 107, 111, 112, 113, 114, 115, 116, 117, 118, 119, 120, 121, 122, 123, 135
 'Hotels, Motels and Bathrooms' 91–124
myth(ology) 10, 49, 87, 88, 118, 127, 130, 131, 132, 133–4, 136, 139, 158, 159, 166, 167, 169

Nabokov, Vladimir, *Lolita* 83–5, 86, 115–17, 163; *see also* Kubrick, Stanley *and* Lyne, Adrian
Nation/nation 5, 7, 8, 9, 10, 11, 21, 24, 27, 28, 29, 35, 36, 42, 44, 45, 46, 71, 72, 82, 86, 87, 88, 91, 93, 101, 117, 118, 125, 126, 127, 130, 132, 133, 137, 139, 144, 148, 149, 154, 157, 159, 164, 165, 166, 168, 169, 170, 171
Nation-builders 158

nation-space 149
nation-state 86
National Guard 127
native 44, 45, 124, 133, 163
 Native Americans 137
 non-native(s) 60, 127
Nature/nature 1, 5, 10, 11, 13, 14, 15, 16, 19, 20, 21, 27, 28, 33, 34, 38, 39, 44, 45, 52, 54, 55, 57, 61, 62, 64, 67, 68, 69, 70, 73, 75, 82, 94, 100, 109, 111, 113, 114, 117, 118, 120, 126, 131, 137, 138, 140, 141, 144, 145, 147, 150, 151, 152, 153, 158, 164, 166
 naturalist 7, 13, 25
 unnatural 83, 151
neighbour(hood) 6, 8, 55, 69, 72, 74, 79, 81, 82, 83, 84, 85, 87, 99, 103, 104, 160, 162, 165, 167
Nelson, Deborah, *Pursuing Privacy in Cold War America* 87
Neutra, Richard 54
Newton, Benjamin Franklin 12–13
New York 7, 8, 18, 32, 42, 45, 65, 92, 95, 99–100, 101, 101–2, 106, 110, 123, 144, 145, 169
 New Yorker 91
Nichols, Mike, *Silkwood* 93
Nixon, President Richard 56, 126
Nolan, Christopher, *Memento* 112–13
North/north 5, 48, 51
North Carolina 120
Northwest Ordinance 5

Olmsted, Frederick Law 82, 162
Olson, Charles, *Call Me Ishmael* 1
outdoor(s) 16, 18, 19, 20, 38, 51, 60, 85, 92, 130, 154, 155, 156, 162, 163, 164, 165; *see also* indoor(s)
outer 1, 3, 4, 11, 21, 30, 37, 40, 41, 61, 62, 64, 65, 72, 110, 137, 143, 144, 155, 158, 166; *see also* inner

outside(ness) 2, 11, 17, 19, 20, 25, 26, 29, 38, 46, 53, 62, 63, 65, 66, 68, 70, 71, 73, 74, 75, 76, 80, 88, 106, 110, 112, 114, 118, 119, 120, 122, 125, 139, 142, 149, 150, 152, 161, 162, 171, 172; *see also* inside(ness)
outsider(ness) 6, 26, 31, 34, 70, 104, 148; *see also* insider

Park, Robert 51–2; *see also* Burgess, Ernest
Parker, Dorothy 99, 102, 105
 'I Live on Your Visits' 103–4
 Ladies of the Corridor, The (with Arnaud D'Usseau) 102–3
 'Too Bad' 100
parlour(s) 2, 11, 17, 25, 26, 27, 38, 40, 44, 50, 53, 82, 88, 154, 156, 157
 'Dreamy Kitchens, Tidy Parlours' 29–37; *see also* dream *and* kitchen(s)
Pattison, Mary 16, 53
 Principles of Domestic Engineering 51
Payne, John Howard, 'Home, Sweet Home' 11
Pearce, Guy 112
Pearl Harbor 9
Perec, Georges, *Species of Space and Other Pieces* 3, 62, 107
picturesque 11, 13, 14, 15, 18
 'The Picturesque Daydream' 23–9; *see also* dream
pioneer(s) 21, 22, 49, 72, 82, 104, 124, 126, 127, 128, 132, 136, 140, 158, 159, 10, 161, 163
 pioneer-killer 136
 hunter-pioneer 28
Pitt, Brad 158
place(s) 3, 12, 20, 25, 33, 40, 50, 60, 70, 78, 79, 82, 83, 84, 86, 91–2, 93, 94, 95, 97, 102, 103, 105, 106, 113, 115, 116,

117, 119, 122, 126, 127, 135, 137, 138,
 145, 148, 149, 151, 155, 159, 165, 168,
 170, 173
displacement(s)/displaced 58, 59, 68,
 114, 119, 120, 123, 143
 in relation to home 1–2, 3, 4, 10–11,
 11–12, 13, 14, 15, 17, 18, 19, 21, 24,
 26, 27–8, 30, 31, 32, 25, 41, 41–2,
 44–5, 49, 50, 54, 55, 57, 58–9, 60,
 61, 69–70, 71–2, 74, 75, 77–8, 79,
 89–90, 99, 115, 124, 128, 136, 153,
 154, 158, 160, 165, 167, 168, 171,
 172, 173
 misplacement/misplaced 36
 in relation to objects/things 2, 16, 18,
 32, 34–5, 55–6, 97, 103, 106, 107,
 108
 in relation to religion 11, 12, 13–14, 21,
 61–2, 139, 142
 resting place 11, 31
 in relation to space 1–2, 4, 15, 16, 18, 26,
 42, 44–5, 49, 50, 58, 64, 70, 77,
 78, 80, 81, 82, 90, 92, 99, 110, 111,
 125, 126, 135, 136, 137, 139, 147, 149,
 150, 168
 'Space into Place' 16–22
 as temporary 18, 106–7, 115, 117, 122,
 145
 in relation to threshold 3–4, 12, 30, 40,
 79
 in relation to time 26, 31, 32, 45, 46, 49,
 50, 57, 59, 71, 81, 99, 139, 142, 145,
 148–9, 172
Plath, Sylvia 75
 'Lesbos' 74
 The Bell Jar 95, 167–8
Poe, Edgar Allan 39, 154
political 9, 18, 27, 72, 78, 86, 87, 91, 93, 106,
 126, 131, 133, 147, 149
 geopolitical 38, 44, 126
 sociopolitical 126

porch(es) 18–19, 28, 47, 61, 67, 81, 82, 83,
 86, 88, 89, 98, 158, 163
 'Out on the Porch' 75–8
 porch-dweller 75
 porch-show 78
 porch-stage 77
 'Porch Talk' 79–81
prairie(s) 21, 66, 67, 68, 124, 128, 129, 130,
 158
 prairie home/house 16, 21, 54, 66, 124,
 138
 prairie-land 123
 'Prairie Optimism' 71, 157–60
 prairie-state-of-mind 72
 prairie-style 57
privacy 1, 7, 9, 11, 13, 14, 19, 20, 23, 24, 25,
 27, 28, 30, 31, 41, 42, 43, 44, 45,
 50, 57, 65, 67, 72, 73, 75, 78, 80,
 86, 87, 88, 89, 90, 91, 92, 93, 94,
 95, 96, 97, 98, 101, 102, 104, 105,
 108, 109, 110, 111, 112, 113, 116,
 117, 132, 169, 171, 172, 173; *see also*
 public(ity)
 'Public and Private Perimeters' 41–5
Prouty, Olive Higgins, *Stella Dallas*
 109–11
psychogeography 21
public(ity) 2, 9, 13, 14, 15, 19, 25, 27, 30, 31,
 41, 45, 46, 50, 57, 65, 72, 73, 75, 78,
 80, 82, 88, 89, 90, 92, 93, 94, 96,
 101, 102, 109, 113, 126, 144, 162,
 166, 170, 171, 173; *see also* privacy
 'Public and Private Perimeters' 41–5
Puritan/puritan(s) 1, 14, 39, 40, 58, 59, 61,
 63, 71, 125, 129, 166
Pynchon, Thomas 21
 Mason and Dixon 8–9

railroad 7, 20, 57, 111
 railway(s) 7, 10, 20, 39, 57, 111
Ramsay, JonBenet 166

Index

Reagan, President Ronald 127, 132, 133
 Reaganism 131, 132
 Reaganist 143
Relph, Edward, *Place and Placelessness* 70
Remington, Frederic 133
return 2, 3, 10, 13, 34, 37, 38, 39, 41, 45, 58, 59, 64, 70, 71, 83, 85, 95, 96, 98, 113, 122, 124, 130, 131, 139, 141, 154, 161, 163, 164, 169
Rich, Adrienne, 'Notes Towards a Politics of Location' 126
Richards, Ellen 16
Richter, Conrad, *The Sea of Grass* 136
road(side) 7, 8, 10, 20, 74, 86, 107, 111, 115, 117, 119, 120, 121, 124, 130, 137, 139, 140, 141, 142, 143, 144, 154, 163, 165, 170, 171, 172; *see also* highway(s) *and* street/street(s)
 off-road/off-the-road 20, 119
 'Off the Road and in the Dark: The American Motel' 111–24; *see also* motel(s)
 road trip(s) 86, 119, 121, 170
 road trip-pilgrimage 86
Robertson, Robbie, 'Yazoo Street Scandal' 170
Robinson, Marilynne:
 Home 174
 Housekeeping 58–60, 61
room(s) 4, 6, 15, 17, 18, 23, 26, 30, 31, 32, 33, 34, 35, 36, 40, 42, 43, 44, 45, 46, 48, 49, 50, 51, 53, 54, 55, 56, 58, 59, 60, 62, 65, 68, 70, 77, 78, 80, 88, 89, 91, 93, 96, 99, 101, 102, 103, 105, 106, 107, 108, 109, 110, 111, 112, 113, 114, 115, 116, 117, 118, 119, 120, 121, 122, 123, 132, 135, 139, 143, 147, 150, 154, 155, 156, 157, 158, 159, 161, 166, 167, 168, 169, 171, 173
 'room-characters' 46

room-crossings 23
room-identity 45; *see also* identity/identities
room-universe 107
room-void 108
Rosenberg spies 168
Roth, Philip:
 Portnoy's Complaint 96–7
 Sabbath's Theatre 97
rural 8, 14, 111, 116, 161
Ruskin, John 14–15, 28
Rybczynski, Witold:
 'America's Growing Obsession with Bathrooms' 90
 'Flushed with Pride: How the Bathroom Became America's Latest Status Symbol' 93
 Home 15

Salinger, J. D., *Fanny and Zooey* 97–9
Salvidar, José David, *Border Matters: Remapping American Cultural Studies* 127
Scott, Frank J., *The Art of Beautifying Suburban Home Grounds* 82, 85
Scribners 40
Sedgwick, Catherine, *Home* 11
Seidel, Frederick, *Sunrise* 153, 154
Self, Will 21
settle(ment) 1, 4, 5, 6, 22, 43, 54, 55, 56, 58, 62, 70, 76, 77, 82, 101, 105, 124, 132, 136, 137, 149, 155, 157, 159, 160, 172
 pre-settlement 71
 settler(s) 1, 6, 22, 33, 49, 61, 71, 124, 132, 133, 136, 149, 157, 158, 159, 160, 161, 163
 unsettled 60, 63, 69, 107, 148, 174
 unsettling 104, 124
Shepard, Sam 117, 125, 133

Fool for Love 117–18
Motel Chronicles 118–19, 120
Turista 122–4
Sinclair, Iain 21
Skarsgaard, Stellan 148
Smith, Harry, *Anthology of American Folk Music* 169
Smithson, Robert 141
Spiral Jetty 141–2, 143, 145, 147
South/south 19, 67, 75, 77, 78, 79, 80, 81, 99, 117, 124, 127, 166, 177
southerner 75
souvenir(s) 4, 34, 36, 103, 153
space(s) 1, 19, 20, 23, 31, 33, 39, 41, 64, 65, 67–8, 70, 74, 79–80, 86–7, 89, 91, 92, 93, 94, 98, 99, 100, 101, 102, 193, 104, 105, 107, 108, 109, 110, 111, 112, 114, 115, 117, 118, 119, 126, 127, 135, 137, 139, 148, 150, 151, 152, 154, 155, 165, 168, 172, 173
 in relation to expansion 1, 2, 5–9, 18, 20, 21, 51, 54, 55, 66, 71, 74, 76–7, 81, 89, 117, 118, 125–7, 129, 132, 139, 146, 147, 149, 154
 in relation to home(s) 1–2, 4, 11, 14, 15, 16–17, 18, 19, 21, 23, 24, 25–6, 27, 28, 29–30, 31, 32, 34, 36–7, 38, 41, 42–3, 44, 45, 46, 47, 48, 49, 50, 51, 52–5, 56, 57, 58, 59, 60, 61, 64, 66, 67–8, 69, 70–1, 73, 74, 75, 76, 77, 78, 80, 82, 86–7, 88, 89, 90, 91, 96, 100, 103, 129, 132, 153, 154, 160, 162, 164, 165, 166, 167, 168, 172, 173
 mental space(s) 4, 5, 13, 20, 21, 26, 36, 42, 48–9, 51, 61–2, 64–6, 68, 76, 80, 95, 99, 104–5, 109, 122, 138, 144, 149, 167–8, 171, 172
 in relation to objects 16–17, 26, 33–4, 35–6, 43, 44, 66, 97–8, 99, 105, 108, 150, 161, 164

 philosophy of 3, 21, 36, 41, 49, 52, 54, 61, 66, 73, 95–6
 in relation to place 1–2, 4, 11, 15, 16, 18, 24, 26, 42, 44–5, 49–50, 58, 64, 70, 77, 78, 80, 81, 82, 90, 92, 99, 110, 111, 125, 126, 135, 136, 137, 139, 147–9, 150, 168
 'Space into Place' 16–22
 in relation to religion 1, 11, 13, 28, 61–2, 71, 91
 'Spatial Cramps' 160–4
 in relation to time 1–2, 4, 7, 8, 11, 17, 24, 26, 28, 29, 34, 36–7, 40–1, 42, 45, 46, 48, 49, 57, 62, 64, 73, 76, 80, 81, 99, 104, 112–13, 114, 120, 122, 123, 124, 136, 139, 140, 144, 145, 146, 155, 163, 165
Stegner, Wallace:
 Here the Bluebird Sings to the Lemonade Springs: Living and Writing in the West 5, 55, 160
 Wolf Willow 124, 128–9
Stein, Amy 19
Stein, Gertrude, 'The Gradual Making of the Making of Americans' 55, 58, 81, 127
Stevenson, Robert Louis 76
Stewart, Jimmy 69, 99
Stewart, Martha 93
Stowe, Calvin Beecher 32
Stowe, Catherine Beecher 27
Stowe, Harriet Beecher 27, 32–3
 letter to Mary Dutton 32
 Minister's Wooing, The 30–1, 33–4
Stowe, Henry Beecher 27
Stowe, Isabel P. Beecher 31
strange 4, 41, 59, 63, 103, 104, 172, 173, 174; *see also* uncanny
strangely 77, 134
strangeness 20, 47, 103, 112, 138
strangers 102, 103, 112

Streep, Meryl 93
Street/street(s) 6, 7, 15, 38, 39, 75, 78, 79, 80, 82, 83, 84, 102, 106, 109, 147, 148, 154, 163, 166, 170; *see also* highway(s) *and* road(s)
 historical-street 40
sublime 14, 75, 137, 138, 140, 141, 143, 151, 152, 153, 157, 164, 191
suburban 7, 8, 18, 19, 24, 51, 52, 53, 54, 56, 71, 72, 73, 74, 76, 82, 83, 84, 85, 87, 88, 89, 153, 160, 161, 162, 163, 164, 165, 167, 172
Suvari, Mena 168–9

Tarantino, Quentin, *Kill Bill* series 133–5
territory/territories 1, 2, 3, 4, 5, 6, 18, 39, 42, 46, 54, 59, 60, 61, 63, 76, 77, 83, 87, 88, 91, 96, 98, 103, 110, 113, 120, 125, 127, 130, 132, 133, 146, 147, 154, 155, 159, 163, 169, 173
 'Domestic Territories' 48–51; *see also* domestic(ity)
Texas 81, 120, 121
 Texas–Mexico border 134
Thoreau, Henry David 7, 12–13, 16, 17, 28, 39, 40, 43, 46, 144, 153, 154, 155, 166, 170, 173, 174
 Walden/Walden Pond 13–14, 16–17, 20–1, 25–6, 28–9, 44, 48, 55, 57, 111, 129, 170
 Walking 138, 139
threshold(s) 2, 3, 9, 10, 12, 17, 18, 20, 23, 25, 30, 48, 53, 59, 61, 62, 67, 70, 79, 84, 137, 138, 144, 150, 163, 163, 168, 174
 'Threshold Dramas' 37–41
 'On the Threshold' 3–4
Thurman, Uma 113, 134
time(s)/temporality 12, 13, 23, 24, 26, 27, 28, 34, 44, 46, 75, 76, 80, 82–3, 94, 98, 112, 113, 114, 121, 126, 130, 135, 136, 140, 141, 143, 145, 159, 162, 167, 169, 170, 179
 dream time 31
 in relation to history/past 2–4, 33–4, 36, 37, 40, 45–6, 49, 53, 59, 63, 89, 108
 in relation to home 2, 4, 11, 17, 24, 26–7, 28, 29, 31, 32, 34, 36, 37, 40, 41–2, 45–6, 48, 49, 51, 53, 57, 71, 73, 80, 99, 136, 165, 168, 172
 at the hotel/motel 104, 110, 112, 112–13, 114, 118, 119, 120, 121, 123, 124
 'moontime' 81
 in relation to place 26, 31, 32, 45, 46, 49, 50, 57, 59, 71, 81, 99, 139, 142, 145, 148–9, 172
 in relation to space 1, 2, 4, 7, 8, 11, 17, 24, 26, 28, 29, 34, 36–7, 40–1, 42, 45, 46, 48, 49, 57, 62, 64, 73, 76, 80, 81, 99, 104, 112–13, 114, 120, 122, 123, 124, 136, 139, 144, 146, 155, 163, 165
timeless(ness) 81, 140
untimely 32
Trilling, Lionel, 'The Sense of the Past' 3–4, 9
Trollope, Anthony 109
Tuan, Yi-Fu:
 Passing Strange and Wonderful: Aesthetics, Nature and Culture 2
 Dominance and Affection: The Making of Pets 95–6
Turner, Frederick Jackson:
 Frontier in American History, The 5
 'Significance of the American Frontier, The' 125–7
Turner, Victor, *Dramas, Fields and Metaphors: Symbolic Action in Human Society* 79

Turrell, James, Roden Crater project 151–2
Twain, Mark 36, 43
 Adventures of Huckleberry Finn, The 59, 61, 134–6, 154
 'House Beautiful, The', *Life on the Mississippi* 35
 Roughing It 55, 111

uncanny 9, 19, 59, 95, 147, 172; *see also* strange
'Unheimlich' 19
Up 165
Updike, John 160
 Couples 94
 Rabbit tetralogy 122, 160–6:
 Rabbit at Rest 164–65, 166
 Rabbit is Rich 161
 Rabbit Redux 162
urban 7, 8, 51, 96, 99, 101, 102, 132, 153, 161, 164

Victorian 11, 13, 14, 15, 26, 30, 49, 51, 66, 76, 88, 92, 93, 109, 179
Vietnam War 136
Von Trier, Lars, *Dogville* 5, 146–9

Wallace, David Foster 21
 A Supposedly Funny Thing I'll Never Do Again 5
Walter, Eugene, *Milking the Moon: A Southerner's Story of Life on This Planet* 75
War of Independence 5, 126, 176
Wayne, John 133, 143
West/west 4, 5, 55, 60, 94, 101, 104, 117, 118, 122, 124, 125, 126, 127, 129, 130, 131, 132, 133, 136, 137, 139, 140, 144, 145, 151, 155, 156, 157, 158, 159, 161, 164, 166
 western (genre) 131, 133, 155

westerners 39
West Front 132
Wharton, Edith 42, 45
 The Decoration of Houses (with Ogden Codman Jr) 42–5, 59
Whitman, Walt 129, 139, 141, 144, 149, 160
WideSpread Panic, 'Porch Song' 81
Wilder, Billy, *Sunset Blvd.* 151
Wilder, Laura Ingalls, *Little House on the Prairie* 21–2, 124, 158–60; *see also* prairie(s)
wilderness 59, 69, 82, 127, 131, 132, 142, 144, 149, 157, 158, 163
wilderness-downsizing 28
wilderness-in-miniature 162
Williams, Tennessee 78
 Cat on a Hot Tin Roof 76–7
 Streetcar Named Desire, A 20, 95, 117
Wills, Gary, *John Wayne's America* 143
Wills, Royal Barry 52–3
window(s) 3, 17, 18, 21, 23, 25, 27, 35, 37, 38, 39, 41, 42, 43, 44, 46, 47, 51, 52, 59, 60, 63, 69, 72, 73, 74, 99, 106, 107, 108, 112, 118, 129, 156, 158, 159, 160, 161, 162, 164, 166
 'Doors and Windows' 61–90; *see also* door(s)
window-eye 39
window-gazing 39
windowless 74, 166
window-position 59
window-screen 68, 69, 71, 73
window-seat 50
Winthrop, John 6–7, 63, 129
 'A Model of Christian Charity' 61
Wister, Owen, *The Virginian* 55–6
Witzel, Michael Karl, *The American Motel* 115
Wright, Frank Lloyd 16, 53, 54, 56–7, 161, 166
 American Architecture, An 66

'Building the New House' 16
'A Home in a Prairie Town' 66
'In the Cause of Architecture' 59
'Prairie Concept' 66
Wyeth, Andrew:
 Christina's World 128–9, 136
 Soaring 129–30

Yates, Richard 160
 Revolutionary Road 172
Young, Victor 133

zone(s) 5, 6, 51, 55, 81, 96, 144, 149, 150, 154, 165
zoning laws 6